R Berns

Fashion Retailing

The Delmar Fashion Series

An Introduction to Fashion Merchandising
Rath, Peterson, Greensley, Gill

AutoCAD for the Apparel Industry
Miller

Exporting and Importing Fashion:
A Global Perspective
Stone

Fashion Retailing
Diamond

Fashion Retailing Video Series
Diamond/Vidcat

Retail Buying: From Staples to Fashions to Fads
Clodfelter

Fashion Retailing

Ellen Diamond

Delmar Publishers Inc.

NOTICE TO THE READER

Photo Credits

Cover photo by Keeble-Cavaco and Duka, Inc.

Section Opener Photos: Section 1, courtesy of Filene's Basement; section 2, courtesy of Western Development Corp.; section 3, photo by Ellen Diamond; section 4, photo by Ellen Diamond; section 5, courtesy of Bloomingdale's, Chicago; photo by Ellen Diamond.

Insert 1: 1-1 (left) A&S Plaza, courtesy Melvin Simon & Assoc.; (right) courtesy Harrod's, Knightsbridge, London; 1-2 (top left) courtesy Melvin Simon & Assoc.; (top right) The Fashion Mall at Plantation, courtesy Melvin Simon & Assoc.; (bottom) photo by Michael Gallitelli; 1-3 (left) courtesy Space Design International; (right) courtesy Space Design International; 1-4 (top) courtesy Western Development Corp.; (bottom) courtesy Space Design International; 1-5 (top) courtesy Western Development Corp.; (bottom) courtesy Space Design International; 1-6 courtesy Macy's; 1-7 (top) A&S Plaza, courtesy Melvin Simon & Assoc.; (bottom) courtesy Merry Go Round; 1-8 (left) courtesy Space Design International; (right) courtesy Space Design International.

Insert 2: 2-1 (top) courtesy Merry Go Round; (bottom) courtesy Neiman Marcus; 2-2 photo by Ellen Diamond; 2-3 (top) courtesy Men's Fashion Association of America, Inc.; (bottom) courtesy Men's Fashion Association of America, Inc.; 2-4 photo by Ellen Diamond; 2-5 (left) courtesy ATEC; (right) photo by Ellen Diamond; 2-6 (left) courtesy Bloomingdale's, North Michigan Avenue; (right) photo by Ellen Diamond; 2-7 (top) courtesy Bloomingdale's, North Michigan Avenue; (bottom) courtesy Neiman Marcus; 2-8 (top) courtesy of Macy's; (bottom) courtesy of Bloomingdale's, North Michigan Avenue.

Delmar Staff

Senior Acquisitions Editor: Mary McGarry
Project Editor: Judith Boyd Nelson
Production Manager: John I. Mickelbank
Design Coordinator: Karen Kunz Kemp
Art Supervisor: Judi Orozco

For information, address Delmar Publishers Inc.
3 Columbia Circle, Box 15-015,
Albany, NY 12212-5015

Copyright © 1993 by Delmar Publishers Inc.

Printed in the United States of America
Published simultaneously in Canada
by Nelson Canada,
a division of The Thomson Corporation

1 2 3 4 5 6 7 8 9 10 XXX 99 98 97 96 95 94 93

Library of Congress Cataloging-in-Publication Data

Diamond, Ellen.
 Fashion retailing/Ellen Diamond.
 p. cm.
 Includes index.
 ISBN 0-8273-5621-8
 1. Fashion merchandising—United States. I. Title.
HD9940.U4D53 1993 92-20912
687'.068'8—dc20 CIP

Contents

Preface ..x

Acknowledgements ...xii

About the Author ...xiii

Section 1
Introduction to Fashion Retailing1

Chapter 1
Fashion Retailing: An Introductory Analysis2

Classification of Fashion Retailers4
Multi-market Fashion Retailing18
The International Scene19
Trends of the Nineties26
Small Store Applications32

Chapter 2
Organizational Structures37

Organization Charts38
Small Specialty Store Organizations40
Small Department Stores42
Large Department Stores45
Organization of Chain Stores55
Small Store Applications58

Chapter 3
The Fashion Consumer63

Consumer Motivation64
Maslow's Hierarchy of Needs65
The Concept of Decision Making67

The Self-concept Theory68
Sociological Groupings69
The Family Life Cycle...............................73
Demographic Implications for
 Fashion Retailers...............................77
Psychographic Segmentation........................84
Small Store Applications..........................86

Chapter 4
Problem Solving: The Role of Retailing Research ..91
The Nature of Retailing Research92
The Research Process...............................96
Small Store Applications106

Section 2
The Fashion Retailer's Environment...............113

Chapter 5
Store Location114
Choosing the Location115
Classification of Shopping Districts119
Site Selection127
Store Location Trends for the Nineties129
Small Store Applications131

Chapter 6
Designing and Fixturing the Fashion Facility136
Planning the Design Concept.......................137
Store Fronts and Window Structures140
Interior Layout142
Fashion Department Classifications
 and Designs...................................146
Decorative and Functional Materials150
Fixturing ..152

Department Layout155
Small Store Applications156

Section 3
Management and Control Functions...............**163**

Chapter 7
Human Resources Management**164**
The Recruitment Process.............................165
Training.................................174
Evaluating Employees180
Methods of Compensation181
Employee Services and Benefits..................185
Building Employee Morale...........................187
**Unions and Human Resources
 Management**187
Small Store Applications188

Chapter 8
Merchandise Handling and Protection**193**
Merchandise Handling194
Protection..............................202
Small Store Applications210

Chapter 9
Accounting Procedures and Operational Controls.**216**
Financial Statements...........................217
Retail Method of Estimating Inventory220
Cost Methods of Determining Inventory221
Inventory Control223
Expense Controls...........................230
**Computerized Accounting and
 Inventory Control**232
Small Store Applications233

Section 4
Merchandising Fashion**241**

Chapter 10
Buying Principles and Procedures**242**
Fashion Retail Buyers....................................243
Resident Buying Offices261
Small Store Applications267

Chapter 11
Inventory Pricing ...**273**
Pricing Considerations...............................274
Mathematical Concepts of Pricing279
Pricing Policies...284
Price Points ..286
Small Store Applications287

Section 5
Communicating with and
Servicing the Fashion Clientele**293**

Chapter 12
Advertising and Promoting Fashion**294**
Management of the Advertising
and Promotion Functions295
Types of Fashion Advertisements................298
Cooperative Advertising303
The Media..304
The Costs of Advertising312
Evaluation of the Advertisement.................314
Promotional Programs315
Publicity..322
Small Store Applications322

Chapter 13
Visual Merchandising327
Responsibility for the Visual
 Merchandising Function328
The Environments of Visual Presentation332
Elements of the Visual Presentation336
The Principles of Design344
Maximizing the Visual Program's Success...347
Small Store Applications349

Chapter 14
Selling: In the Store and In the Home355
Selling in the Store356
Selling to the Customer in the Home369
Small Store Applications376

Chapter 15
Customer Services and Credit381
Customized Services383
Traditional Services387
Credit ...390
Small Store Applications397

Appendix A
Careers in Fashion Retailing402

Appendix B
Retail-oriented Mathematical Problems413

Glossary
Language of the Trade416

Index ...425

Preface

Never before in the history of retailing have those involved in fashion-oriented businesses been challenged as they are today. Until recent times, department stores and specialty chains successfully coexisted along with some sole proprietorships and newcomers such as discounters and off-price operations. The nineties, however, began as a decade that saw many of the mainstays of the industry disappear and the introduction of different types of organizations. *Fashion Retailing* was written to explore the many facets of the field, drawing upon the traditional principles and practices that have been in existence for many years, coupling them with the latest innovative concepts. Those who wish to enter the field, or are already everyday practitioners, will find a wealth of practical as well as theoretical information that fashion retailers live by each and every day.

The text is divided into sections and further subdivided into specific chapters. Each deals with a specific aspect of the field. Section 1, "Introduction to Fashion Retailing," explores the industry's historical beginnings and traces it up to today: the international scene, trends, organizational structures, the fashion consumer and his or her decision-making motivations, and the research undertaken by fashion retailers to problem solve.

Section 2, "The Fashion Retailer's Environment," deals with the various techniques employed by retailers to find the most appropriate locations for their stores and the design and fixturing approaches used to create exciting environments for fashion merchandise.

Section 3, "Management and Control Functions," examines the procedures used to properly staff the store, the handling and protection of the inventory, and the procedures used by accountants and operations executives to control the financial aspects employed in the industry.

Section 4, "Merchandising Fashion," investigates the buying principles and procedures used by buyers and merchandisers and the resources they utilize for decision making and the techniques employed in pricing the inventory.

Section 5, "Communicating with and Servicing the Fashion Clientele," covers all of the innovative advertising and promotional endeavors and visual merchandising approaches used to capture the potential customer's attention, how selling is accomplished through personal in-store sales and in-home shopping through catalog usage, as well as the services offered to motivate shoppers to become customers.

In addition to the text's fifteen chapters, two appendices are presented. Appendix A offers a full section on careers, complete with specific job opportunities and preparation for entering the field. For those who wish to practice mathematical skills used by fashion merchants, a variety of problems are offered in

appendix B. A glossary titled "The Language of the Trade," features a compilation of the various terms, briefly defined, used by the field's participants.

Interspersed among the various chapters are "Fashion Retailing Spotlights" that focus upon specific companies that have made enormous impacts on the field through creative and exciting innovations. Among those cited are Nordstrom, Galeries Lafayette, Lerner New York, Bloomingdale's Other Flagship, Saks Fifth Avenue, The Limited, Filene's Basement, and Neiman Marcus. In addition to the fashion retailers are companies like Du Pont, SRI International, The Fashion Centre at Pentagon City, Security Tag Systems, Inc., ACI, and Henry Doneger Associates.

Along with the wealth of textual information, *Fashion Retailing* is highlighted with a substantial number of photographs and other illustrative materials from such sources as Marshall Field, New York Prêt, Macy's, Lord & Taylor, Tiffany & Co., AnnTaylor, Henri Bendel, Harrods, Merry-Go-Round, and numerous others.

Much of the book centers upon the major retail organizations and how they run their businesses. In order to give the reader an insight into smaller fashion retail organization operations, each chapter features a section called Small Store Applications.

Each chapter features a series of learning objectives, highlights of the chapter, discussion questions, case problems, and exercises. An instructor's manual is provided that includes solutions to all of the problems as well as a test bank for each chapter.

Acknowledgements

Fashion Retailing was written with the assistance of many professionals in the field. They provided pertinent information, illustrative examples, photographs, and drawings to make the text up-to-date and visually exciting. Their participation is acknowledged:

Lorie Flater, Keeble, Cavaco & Duka; Donald Damask, Henri Bendel; Richard Crisman, The Gap; Geri Savidge, AnnTaylor; J. Schacter, I Kleinfeld & Son; Marcie McMillan, Neiman Marcus; Daria Retian, Neiman Marcus; Laura Sandall, Marshall Field; Peter Fressola, Benetton; Fran Coleman, Tickle Me! Tackle Me!; Vivian Tubiano, AETEC; Andrea Spaar, Advanced Cybernetics, Inc.; Robert Connors, Chicago Apparel Center; Jack Marquette, *California Apparel News*; Billie Scott, Melvin Simon Associates, Inc.; Norman Karr, Men's Fashion Association; Barbara Lewinski, Macy's; Kellie Tormey, Nordstrom; Karen Chamberlain, Western Development Corp.; Andrew Gallina, Union Station; Colette Beaudry, Lord & Taylor; Peter Willasey, Harrods; Lloyd Winkler, VBW Associates; Suzy Bettinger, Bloomingdale's North Michigan Avenue; Isaac Kauffman, Merry-Go-Round; Doug Chovan, Diebold; Gene Moore, Tiffany & Co.; Maria DiChiara, Filene's Basement; Larry Feurich, Retail Reporting Corp.; Jane Driscoll, Greater North Michigan Association; Jennifer Niehaus, Bonnie Keller, Inc.; Natalie Friend, Security Tags Systems; Jessie O. Kempter, International Business Machines Corporation; Geoffrey McNally, SDI.

The author wishes to acknowledge the many helpful suggestions made by the reviewers:

Carolyn Jenkins, Bauder Fashion College, Atlanta, GA
Elaine McCain, Lee College, Baytown, TX
Lynda Gamans, New Hampshire College, Manchester, NH
Richard Clodfelter, University of South Carolina, Columbia, SC
Edith Jerd, Montgomery County Joint Vocational School, Clayton, OH
Kay Cooke, Mayfield Community College, Mayfield, KY

Ellen Diamond

About the Author

Ellen Diamond is an adjunct member of the Marketing, Retailing and Fashion department at Nassau Community College in Garden City, NY where she teaches fashion subjects.

After graduation from New York University where she majored in art, she became a partner in a small women's clothing chain, Helen Diamond, where she utilized her art background as the director of visual merchandising. Although she remained a retailer for more than fifteen years, she never lost her love for the art world. She regularly produced paintings and limited edition lithographs which were featured in galleries across the United States. Her distinctive art ability was formally recognized when she was asked to become a member of the National Association of Women Artists.

Coupled with a wealth of experience in art, retailing and education, was her desire to write. She is the co-author of two fashion-related texts, *The World of Fashion* and *Contemporary Visual Merchandising*, and her next two writing projects are *Fashion Apparel and Accessories* and *Fashion Advertising and Promotion*, both of which will feature her drawings and photography.

section

1

Introduction to Fashion Retailing

Fashion Retailing: An Introductory Analysis

Learning Objectives

After reading this chapter, the student should be able to:

1. Discuss the various types of fashion retailers.
2. Differentiate between the full-line department store and the specialized department store operation.
3. Describe the international scene in fashion retailing and discuss some of those stores in Europe that have gained worldwide reputations.
4. List five trends of the nineties and their impact on retailing.

While retailing in the United States dates back to the fifteenth century and the trading post, it was not until the industrial revolution in the mid 1800s that fashion retailing was born. Until that time, consumers could satisfy themselves with little more than fabrics that were found on the general store's shelves from which garments could be made. Only the rich could afford the luxury of fashionable merchandise, which they had made to order by designers, dressmakers, and tailors. Clothing was basic and functional and unlike anything that was eventually to come.

By the late 1800s general stores gave way to their specialized counterparts, the limited line stores or specialty stores as they are now called. Merchants limited their assortments to just one category of goods and consumers were able to become more selective with their purchases. So successful were these specialty merchants that scores of them expanded their businesses to additional locations heralding the beginning of chain organizations. At this time, there were some retailers who believed that consumers would be better served if they could find

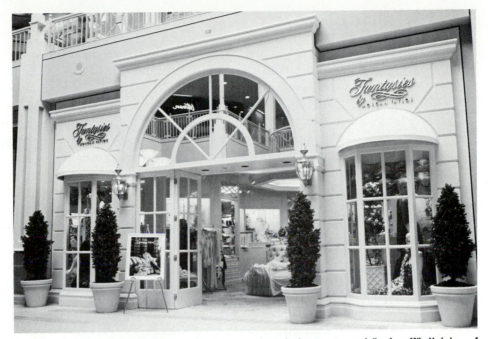

more than just one classification of goods under one roof—they founded the department store concept. While a wide assortment was that retail operation's forte, the vast majority of those merchants concentrated mostly on clothing and related items such as shoes, jewelry, and other accessories.

By the turn of the twentieth century, more and more retailers turned their attention to the fashion needs of the consumer. No longer subscribing to the functional requirements of dress, shoppers turned their attention to the latest in fashion. People of lesser means were now able to buy, off the rack, merchandise that simulated the higher-priced, custom-made couture products.

Today, fashion retailing is on a plateau never reached before. No longer are shoppers relegated to the traditional department and specialty stores which were once the "only games in town," but are now able to take advantage of a host of new retail operations to make their fashion selections. Places like boutiques, off-pricers, flea markets, manufacturers' outlets, cable television, franchises, and catalog operations have been added to the conventional retail outlets. Not only have new types of fashion environments been added to the list, but so have the places where customers can do their shopping. They may visit stores in a variety of locations, or shop in the comfort of their homes from catalogs or television programs that specialize in fashion merchandise. Whatever their pleasure, the American consumers' needs can be easily met.

Classification of Fashion Retailers

Throughout the United States, and abroad, there are many different types of fashion retail operations from which consumers may make their purchases. As has been noted, some such as Macy's and Lord & Taylor have been in existence for more than 100 years while others such as The Gap, AnnTaylor, and Victoria's Secret are relatively new to the industry. The changing lifestyles and needs of the shoppers have meant that the status quo is no longer a viable approach to take, and thus the introduction of the various types of stores.

Some retailers, department stores for example, have experienced difficulty in maintaining their customer bases and have, by necessity, entered into other fashion retailing ventures. Many, such as Macy's, have opened new divisions that specialize in narrower merchandise mixes. Some stores have developed catalog divisions to attract shoppers who simply do not have the time to make in-store purchases. The Limited, Inc., which is the largest and most successful specialty chain, now has a catalog division directed at the working woman whose time limitations have caused lower store attendance. Conversely, some catalog operators, such as Eddie Bauer, have opened stores to capture that retailing consumer segment that is not satisfied with catalog purchasing.

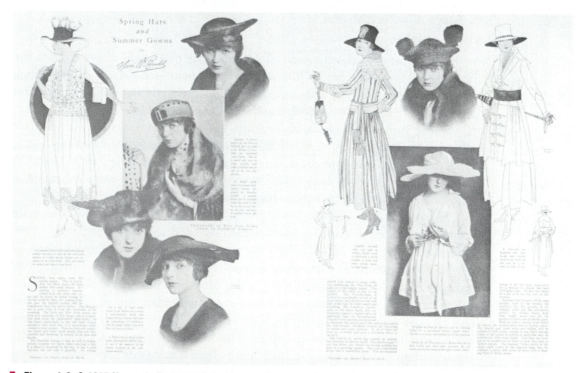

Figure 1-2. A 1917 Harper's Bazaar advertisement featuring fashions of the times from Henri Bendel, a long-time specialty store that has kept its targeted customer base over the years. (Courtesy of Henri Bendel)

Whatever the reasons, fashion retailers now operate under more organizational classifications than ever before. These structures are composed of both small and large organizations. While the department stores are generally oriented toward big business, entrepreneurs are still making their marks in boutiques, specialty stores, and flea markets and as franchisees and licensees of companies.

Specialty Stores

As the name implies, **specialty stores** are those organizations that restrict their merchandise offering to one classification. It might be broad, as in the case of apparel shops—which sell a host of items ranging from clothing to a wide array of accessories—or narrow, as in the case of shoe stores that concentrate on footwear. Stores like The Limited are exemplary of the first type with its merchandising of sportswear, dresses, suits, coats, and accessories, and Zale's, of the second category, which restricts its product line to jewelry. They also make certain to appeal to specific target groups such as teenagers, pregnant women, extra-size individuals such as tall men and women, and other segments of the market. For example, Tall Town is a chain that specializes in merchandise for above-average-height women; Reborn Maternity does the same for expectant mothers.

Specialty stores, or **limited line stores**, as they were once called because of the restrictiveness of their offerings, vary in terms of size. They range from very small businesses that occupy only one location to industry giants that have more than 1000 units. Whatever their size, the concept is virtually the same.

Their success is based upon a number of factors. First, they offer a very broad assortment of specialized merchandise in one place. That is, a shoe specialist might provide the shopper with more than 100 styles from which to choose in a color selection and size range hard to duplicate in any other type of operation. Second, the units are generally small in physical space, enabling the consumer to quickly find the merchandise, unlike the department store whose size makes it difficult to find the desired merchandise in a brief period of time. Third, individual service is usually the specialty store's forte. Customers receive personalized service from staffs that are knowledgeable in their merchandise offering. The department store, with all of its segments, often falls short on the service aspect.

The success of the larger specialty chains is due in part to their economical methods of transacting business. Because of their size, they are able to buy in larger quantities, thus buying at lower prices. Since the vast majority of the specialty chains operate from a home office or central headquarters where all of the decision making is accomplished, specific expenses are reduced. A relatively small executive team can manage the operation, thus significantly saving on high-level salaries. Tasks such as buying, promotion, visual merchandising plans, and merchandise handling, all accomplished centrally, save the companies from higher operating expenses.

An examination of all of the prime shopping locations in the United States reveals that specialty stores are enjoying more success than ever before.

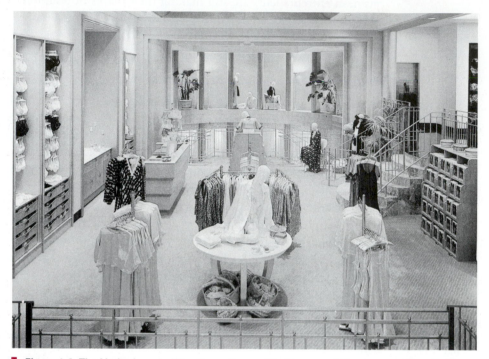

Figure 1-3. The Limited exemplifies the epitome of fashion specialty store retailing. It offers a broad assortment of goods in easy-to-find segmented areas. (Courtesy of Space Design International)

Department Stores

As retailing entered the twentieth century, a new type of retail venture emerged. An outgrowth of the earlier **general store**, with its host of different merchandise categories, the department stores set up shop in the commercial centers of the country's major cities. Unlike their general store predecessors, which featured merchandise in very small quantities and in haphazard arrangements, these new retailers offered large assortments of a variety of goods, with each merchandise classification installed in separate sections or departments. Hence, the reason for the name **department store**.

In earlier times, these retail institutions were stores that featured a wide assortment of both hard goods and soft goods, the former including furniture and appliances, the latter, clothing and related items. For many years the department stores flourished with that merchandise mix, although the majority of the items

FASHION RETAILING SPOTLIGHTS

THE LIMITED

Who would have ever dreamed that Leslie Wexner's Limited, with only eight stores in 1971 and sales of $4 million, would become the largest fashion retailing specialty chain in the United States? Its success is unparalleled in American retailing history. Unlike other retailing giants, which are publicly held companies, The Limited is an independent operation still headed by its founder.

Today, The Limited has nearly 4000 units throughout the United States. In less than thirty years it has gone from obscurity to unequaled fame in an industry that is often fraught with failure. Its closest competitors in fashion specialty retailing, in terms of sales volume and numbers of outlets, are companies like The Gap, Inc., with about l000 units, and Marshall's and T.J. Maxx, each with approximately 300 stores. It should be noted that of its closest rivals, only The Gap is a traditionally priced operation, with the others operating as off-price merchants. In reality, The Limited has no equal.

The Limited expanded remark-ably in its short history. At first, expansion was reserved for additional units, throughout the United States, bearing its corporate name. Recognizing that there were other segments of the market to be served, the company opened another division, Limited Express, which caters to a slightly younger clientele. It too was an immediate success. Not satisfied with just two formats, Wexner was determined to enter other merchandise classifications, this time by way of the acquisition route.

Lerner Shops, now renamed Lerner New York, was a chain operation of about 700 units that catered to a lower income group. Using the same merchandising flair that was so successful in his original venture, Wexner restructured the Lerner division into a more fashionable one, but maintained the lower price point structure. Today, the newest Lerner shops boast exquisite surroundings, usually reserved for higher priced goods, in larger spaces and are realizing greater sales volume and profits.

Another acquisition was Lane Bryant, a company that specializes in fashions for the large-size female. Before The Limited acquired Lane Bryant, its merchandising image was matronly. Wexner felt that the fuller-figured woman would gladly embrace more youthful silhouettes and proceeded to merchandise the stores with styles that were translated from The Limited's other divisions.

Victoria's Secret is another link in the successful chain. Unlike the others that are clothing and accessories oriented, these stores are strictly for lingerie. Also an acquisition, it has become one of the nation's most successful lingerie companies. The stores resemble elegant female boudoirs complete with fancy wall coverings, chandeliers, and other intimate surroundings. The merchandise is moderately priced, but gives the impression of being more expensive because of its environment.

Unlike the other divisions in the organization is Abercrombie & Fitch, which features clothing and

continued

travel gear for men and women and appeals to a segment unlike the other Limited companies. It closely parallels some of Ralph Lauren's merchandise philosophy, but at more moderate prices.

Whether it was for purely prestigious purposes, or an investment in another area, Wexner acquired one of fashion retailing's jewels, Henri Bendel. A New York landmark that has catered to the wealth of New York for a century, Henri Bendel's merchandising philosophy is anything but that of the other Limited companies. All of the others feature inventories that are almost exclusively private label. That is, the merchandise is designed by company product developers or well-known designers who have licensing arrangements with The Limited divisions. Henri Bendel, on the other hand, has had a long tradition of featuring the finest offerings of the world's most renowned designers. With only one store in all of its history, Wexner has begun to expand that division with other units, the first two of which are in Chicago, Illinois, and Columbus, Ohio. Since these units are much larger than those in Wexner's other divisions, and the markets they could serve are much more limited, expansion will not be the same as the company is used to.

Today's efforts for the entire organization continue to be aggressive. The company has determined that the men's wear market is a viable one for its merchandising philosophy and has opened a new division, Structure. Prices and focus are similar to those of its female-oriented shops such as The Limited and Limited Express.

Many of the units now enjoy multilevel locations in the country's most prestigious malls. Additional expansion is taking place with other merchandise classifications. Other men's wear and children's wear separate stores, or adjuncts to existing stores, are being slowly introduced to the American consumer. If the success story of each of The Limited's other divisions is realized in these new ventures, The Limited Corporation will soon dominate men's and children's wear specialty retailing.

were soft goods. Today, most of the major department store organizations concentrate most heavily on the soft goods, leaving the hard goods to specialty retailers who feature such items. In fact, many of the giants such as Macy's and Bloomingdale's have eliminated major appliances to make room for more fashion-oriented goods. The reason for the change is usually attributed to the fact that appliances are generally sold at discount prices, leaving the department store short on the profitability of such goods. Those stores that still feature hard goods and soft goods are called the traditional department stores by the industry's largest trade association, the National Retail Federation, Inc. Examples of such stores include A & S, Carson Pirie Scott, Marshall Field, Hecht's, and Burdine's. Other stores that concentrate on soft goods or clothing and related accessories are called multidepartment soft goods stores or **specialized department stores**. This group is one with a fashion orientation and includes such names as Saks Fifth Avenue, Nordstrom, Neiman Marcus, and I. Magnin.

Department store success over the years prompted the opening of new units. Generally, the main store, or **flagship store** as it is commonly referred to, is central to the organization's operation. The management team that merchandises the company and determines policy operates from the flagship. The other stores in

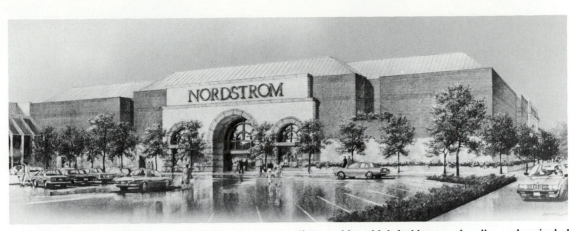

Figure 1-4. Nordstrom is a specialized department store that combines high-fashion merchandise and unrivaled service. (Courtesy of Nordstrom)

the organization are called branches and twigs, or spinoffs. Some department stores are regional in that they serve only a limited geographic area of the country, such as A & S and Filene's, while others are nationally oriented with units in many parts of the United States, such as Macy's, Bloomingdale's and Saks Fifth Avenue. When the company expands from coast to coast, such as in the case of Macy's, the company sometimes uses a system of regional flagships, each with its own management team so that the geographic location can better serve its consumers. In this case, an overall philosophy is established by the company to make certain that although each region merchandises its stores, there is a degree of uniformity throughout the organization.

Branches

Initially, department stores expanded by opening smaller versions of their flagships in suburban areas. Each **branch** carried a representation of the merchandise of its "parent" store with slight adjustments to better accommodate the needs of the community in which it was located. The branches were merely sales centers, with management relegated to employee scheduling and some other decisions such as the hiring of sales personnel. The main decision making was left to the flagship management team. Today, some department stores have become less "centralized" with some stores using managers to determine the merchandise assortments and make other decisions so that the individual stores could be more responsive to their shoppers.

Twig Stores

While most department stores expanded via the branch route, some locations under consideration were oversaturated with similar stores. With the need for

full-line branches seemingly unnecessary, some department stores opted for establishing limited line or specialty operations in certain locations. For example, if an area was still in need of a specialty operation instead of a regular branch, the department store would open a unit that sold one specific merchandise classification. Although the concept never really gained widespread popularity in the past, today the **twig** or **spinoff store** is becoming very popular. Carson Pirie Scott, for example, has opened a twig called Corporate Level in Washington, D.C. In its downtown Chicago flagship, the department was so successful that the company decided this would be a winner for the Washington market. Macy's, too, has enthusiastically embraced the spinoff concept. Later in this chapter, in the "Trends" section, the spinoff phenomenon will be explored, as will one of the Macy's ventures as a "Spotlight."

The success of the department store organization has been attributed to a number of factors. It provides the consumer with one-stop shopping. Those interested in purchasing many diverse products need merely to patronize a full-line department store rather than move from specialty shop to specialty shop to satisfy their needs. No other retail institution provides the services offered by department stores. Personal shopping, gift wrapping, bridal registries, restaurants, merchandise alterations, delivery, and interpreters are just some of the services provided.

Although the department store concept is still a dominant force in retailing, it is receiving a great deal of competition from other types of retailers, such as the specialty stores and catalog operations, which has led many people to speculate on its future viability. A discussion of the department store's future will be addressed later in this chapter.

Catalog Operations

In every part of the country there is enormous growth in the numbers of consumers who have taken to catalogs for their fashion merchandise needs. Although catalog retailing is not new, it was once relegated to shoppers who sought hard goods or more basic soft goods that had little fashion orientation. The early catalogs were introduced by Sears and Montgomery Ward and were semiannual editions that featured a host of items. The consumer market for this type of purchasing was the rural inhabitants or those who had little transportation available to get to the stores.

The explosion in the catalog business started in the mid 1980s and has gained momentum ever since. The major factor that has contributed to this craze is the working woman. With less time to shop and more fashion needs for use in the workplace, the marriage between the employed female and the catalog is a natural.

There are basically two different types of fashion merchandise catalog retailers. One is the department store or specialty chain that operates conventional retail

FASHION RETAILING
NORDSTROM
SPOTLIGHTS

One of the most successful and fastest growing specialized department stores with a fashion orientation is Nordstrom. What began as a shoe store in 1901 has flourished into one of the country's most profitable fashion organizations. For many years the company grew into the largest independent shoe chain in the United States under the leadership of the sons of the company founder, John W. Nordstrom. Everett, Elmer, and Lloyd Nordstrom, John's heirs, continued to expand the operation, with the Seattle, Washington, store becoming the country's largest individual shoe store. After unparalleled success in the shoe business, and with operations in Washington, Oregon, and California, the family decided to try their hands at the apparel market.

In 1963 they purchased a Seattle-based clothing store, Best Apparel, and then another fashion retail outlet, Nicholas Unger. The two acquisitions were then merged with the shoe stores—the new name to greet customers was Nordstrom Best.

In 1973 the company was recognized as the largest West Coast fashion retailer, with sales of more than $100 million. While most of its stores were based on the West Coast, Nordstrom decided to enter the highly competitive East Coast market. In 1988 the first East Coast venture at Tysons Corner, a major mall in McLean, Virginia, took place. Like all of its other locations, this new entry into fashion retailing was a winner.

Many people still marvel at the success of such a company, which has as its competitors such fashion empires as Bloomingdale's, Saks Fifth Avenue, and Neiman Marcus. Careful study of the store and its customers reveals that the success is due not only to its merchandise mix, but its dedication to serving the needs of the customer. The company prides itself on the best service available in any retail operation. Few merchants have stopped to analyze the customer's service requirements as has Nordstrom. Tired customers are supplied with upholstered chairs for their comfort, something unavailable at most other stores. Changing rooms are available for mothers to attend to

their babies and individual attention is given to every need, such as bringing merchandise to the customer's home for examination.

The result has been sales per square foot (a formula used to determine success) at double the national average. These remarkable sales figures are attributed to the high level of attention given by the store's sales associates. With each salesperson paid on a commission basis, the average income is significantly greater than at any of Nordstrom's competitors. In fact, many fashion retailers have gone the Nordstrom route and now pay their sellers on a commission basis in the hope that service will improve and sales will increase.

If success is measured in terms of expansion, then Nordstrom is very successful. Between 1990 and 1995 Nordstrom will have added 21 new branches to its empire with locations all across the country. It will give the fashion retail world the opportunity to see if its success will continue when it takes on the country's other leading fashion department stores.

outlets for shoppers who choose to visit stores and the other is the merchant without stores whose only method of selling is via the catalog route.

At one time, retailers sparingly used catalogs as a means of reminding shoppers of their retail environments and encouraging them to make in-store purchases. For those whose appetites were whetted by the catalogs, and for whom in-store shopping was difficult, this format brought additional business to the company. The catalogs were distributed at peak selling periods, such as at Christmastime and perhaps the beginning of a new season. Stores like Bloomingdale's, Macy's, Lord & Taylor, and Neiman Marcus always used the Christmas catalog as their major in-home effort. Today, these stores and most other major traditional retailers of fashion goods mail scores of catalogs to their customers each year. It is rare that a shopper at a particular store does not receive a catalog every few weeks from each store where he or she has a charge account.

The fastest segment of the catalog business is the pure fashion retail **catalog operation**. Most of the companies engaged in this sort of business produce catalogs with very carefully targeted merchandise. J. Crew, for example, targets the preppy-type consumer as does Smythe & Company. Clifford & Wills aims for the young female executive, and Spiegel features fashion merchandise with a designer orientation for a broader market.

In a later chapter, catalog retailing will be fully explored along with the other in-home shopping outlets.

Boutiques

Throughout the United States, just about every upscale fashion community features small shops that offer limited-quantity, higher-priced, fashion merchandise. These stores, called **boutiques**, serve the needs of those consumers who seek high-quality fashion goods that are not readily available in the typical specialty chains or department stores. Many of the boutiques specialize in custom-made clothing and unique accessories. Service is personalized, special-order merchandise is often available, and exclusivity is a certainty. These shops are usually one-store entrepreneurships since they are targeted for highly segmented markets. Chains, on the other hand, have more universal appeal, and thus the possibility to serve many communities. Although they are an insignificant entry in terms of overall retailing, boutiques nonetheless serve a need.

Off-price Merchants

In the early 1900s enthusiasts of high-fashion merchandise were treated to something that had not before been experienced. In a small space in the home of Frieda Loehmann, in Brooklyn, shoppers were able to purchase designer apparel

The
1990 Christmas Book

Neiman Marcus

▌ **Figure 1-5. The Neiman Marcus Christmas catalog features a host of unique fashion selections. (Courtesy of Neiman Marcus)**

at a fraction of what the traditional specialty and department store retailers charged for the same goods. Her idea was to scout New York's garment center on a daily basis, seeking merchandise that manufacturers wanted to dispose of. Because she offered cash, many famous design operations disposed of their leftovers and odd pieces to Mrs. Loehmann. So successful was the operation that she soon found her home to be too small to accommodate the word-of-mouth following she

quickly established and she opened her first store. It was full of high-quality fashion items, at prices far below what the traditionalists charged their customers. This was the beginning of **off-price** fashion retailing.

Today the Loehmann's empire with stores throughout the United States is just one of many organizations that operates on this reduced-price concept. Stores such as T.J. Maxx, Syms, Marshall's, Hit or Miss, Dress Barn, and the Burlington Coat Factory have joined Loehmann's bandwagon to sell fashion merchandise, off price, to consumers. The concept requires that these merchants constantly scan the fashion markets of the world for merchandise at prices lower than the original wholesale. When manufacturers overcut items, produce styles that are slow sellers, or find they are left at the end of the season with an assortment that the conventional stores can no longer use, they use the off-price outlets for disposal. By buying for less, these retailers are able to sell for less while remaining profitable.

One of the biggest off-price retailers is Filene's Basement, a subsidiary of the parent store that carried the same name until it underwent a buyout by management in 1988. Once a division of the traditional Filene's that was used as a basement sales floor to dispose of merchandise no longer desired by "upstairs" customers, the business has expanded with many units that sell merchandise acquired via the off-price route.

In order to be able to purchase from the same manufacturers as their traditional fashion retail counterparts, the off-pricers operate from locations in which the traditional department and specialty stores do not. The giant off-price merchants such as Loehmann's and Marshall's generally develop their own small centers, away from the major traditional malls and downtown, central districts. In this way, they pose no direct threat to the merchants who mark their merchandise higher.

It should be noted that, unlike the conventional retail operations, which have continuity in their purchases from the same manufacturers as long as they want, the off-price merchants pursue an "opportunistic" approach. That is, their major concern is price, and they are only able to buy when the particular supplier feels it is appropriate to dispose of certain goods. For this reason, customers who frequent the off-price stores cannot expect to find a particular manufacturer at all times.

In times when business is poor, and the manufacturers must turn their goods into cash, the off-price merchant prospers.

Fashion Manufacturers' Specialty Stores

Since the early 1980s, some fashion designers and manufacturers have opted for still another retail format through which they can exclusively retail their collections. Some have chosen an approach of opening regular price, service-oriented operations in major malls and downtown areas. In these units, companies feature

their full lines of garments and accessories, competing with the department stores and other specialty retailers that surround them. Designers like Liz Claiborne and Adrienne Vittadini have opened such shops and have found yet another retail channel to sell their goods. The philosophy is that each designer can feature a full line of merchandise without the competition found in traditional stores.

Another, faster growing concept involves the opening of "outlets" that feature slow sellers, leftovers, or odd lots at reduced prices. Rather than sell to the off-pricers, many of these manufacturers have found greater success in selling their own goods, at bargain prices. Famous designers such as Ralph Lauren, Liz Claiborne, Anne Klein, Calvin Klein, Joan and David, Oleg Cassini, Pierre Cardin, and Gucci have opened units to sell their overruns. In order not to conflict with their traditional retail customers, and their own regular-priced shops, these ventures are located in out-of-the-way areas. They are a safe distance away from the regular major malls or downtown areas. Some of the largest centers that house these operations are Freeport, Maine; North Conway, New Hampshire; Secaucus, New Jersey; and Harriman, New York. Each of these is an open-air shopping street that features as many as 100 different outlets. In the late 1980s, a

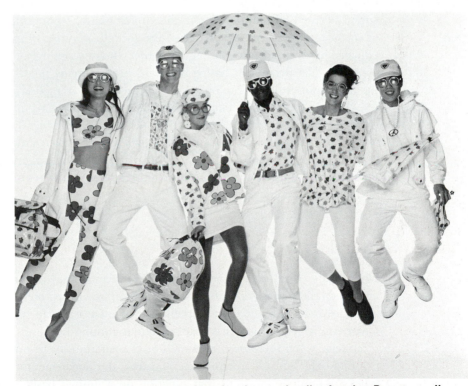

Figure 1-6. A promotional poster featuring the merchandise found at Benetton, a licensed retail operation. (Courtesy of Benetton; photographer Oliviero Toscani)

prototype for an enclosed off-price and designer outlet mall, Potomac Mills, was built in Woodbridge, Virginia. So successful has the venture been that similar subsequent discount malls have opened in Philadelphia and Fort Lauderdale.

Franchises and Licenses

Franchising and licensing are forms of retailing businesses that enable individuals to capitalize on the reputations of established companies. These formats enable those with little or no experience who wish to enter the field the opportunity to try their chances at retailing without the usual problems associated with starting a business from the ground up, such as location evaluation, pricing, and employee training. The franchises and licenses offer the participants the advantage of name, reputation, and consumer awareness. When one chooses to establish a new retail company, more risk is generally involved than when joining an established company of franchises and licenses.

There are some differences between these two types of retail organizations. Franchising generally requires an initial fee that is paid to the franchisor for the privilege of becoming a franchisee. Licensing, as in the case of Benetton, the largest licensed fashion business in the United States, requires no initial fee. Both of the arrangements, however, do require specific amounts of capital before individuals are accepted into the organizations, and the signing of highly restrictive contracts that dictate purchasing requirements, company policy and the rights of the franchisor or licensor to be the overall decision-making body of the company.

While these forms of retailing afford individuals an opportunity to join a recognized team, it should be understood that such arrangements eliminate the possibility for unlimited expansion and individual creativity. In conventional retailing, for example, when a company is successful, it thinks of expansion to another unit, thus establishing a chain. Expansion under these plans requires franchisor or licensor approval and additional fees.

Flea Market Vendors

Unlike the traditional retail operations which require large investments for permanent sites, the **flea market** offers individuals a place to sell merchandise without a great dollar investment. Flea markets, also known as "swap meets" on the West Coast, are large selling arenas that operate in parking fields of drive-in movies or racetracks, when these businesses are not in operation, or from abandoned facilities that once housed supermarkets, theaters, and department stores. The former types are outdoor locations that function on a limited basis because of climate conditions, the latter on a more regular basis because of their indoor advantage.

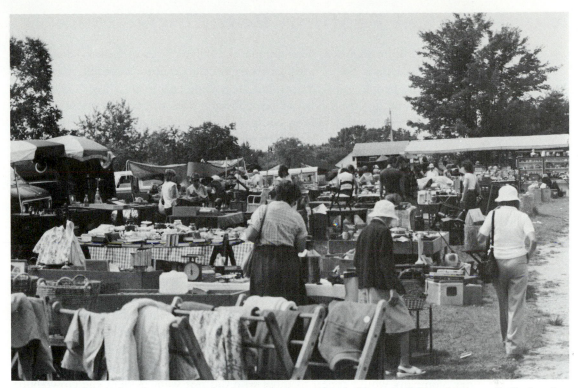

■ **Figure 1-7. Flea markets feature a variety of apparel, accessories, and household items haphazardly displayed.**

In both situations, however, the markets operate on a part-time basis, perhaps two or three days a week, with a few operating as full-time businesses.

Flea markets give individuals the opportunity for self-employment. Many keep their own regular jobs, and supplement their incomes from these part-time endeavors. Others have achieved such success in flea markets that they have opened stalls in other places and have become full-time chain retailers. With as many as twenty flea markets in a radius of 100 miles, some of these merchants have established businesses that rival the small, conventional chains.

The merchandise offered at these markets generally includes a host of fashion products including apparel, shoes, and accessories. The price ranges vary from very inexpensive to merchandise offerings of well-known designers. Whatever the price point, the major emphasis is on bargains. Deep discounts, achievable because of the low overhead, are the major draw.

With their carnival-like atmospheres, the flea markets have become places where people like to go for an entire day to have fun and to shop.

Other types of fashion retail operations include subspecialty stores, spinoffs, and cable television formats. These will be closely explored later in this chapter in the section "Trends of the Nineties."

Multi-market Fashion Retailing

As has just been discussed, there are many different types of fashion retail operations in the United States, with each organized to capture a specific market segment. Some people want services and are willing to pay for them, while others want the same quality goods but favor lower prices and a willingness to forego service. More and more fashion companies are addressing these differences and gaining wider distribution of their products by opening different types of retail operations. Two well-known fashion names that are currently enjoying this multi-market approach are Ralph Lauren and Liz Claiborne. Both have started their fashion empires as designers, leaving the distribution of their goods to department and specialty store operations. Both, however, have enthusiastically entered the retailing world with their own retail divisions.

Liz Claiborne's fashions for men and women may be found in stores all across the country. Their customer appeal is much in evidence by the amount of space the retailers devote to the Claiborne lines. In the late 1980s, the company decided to expand its operation to include retailing.

The initial venture was called First Issue. It was a Claiborne-designed line that featured merchandise different from that found in the department and specialty stores. With similar price points and styling to the other Claiborne goods, the new division achieved significant success. Many attribute the success to the fact that this new company would appeal to those who did not want to fight the crowds normally associated with the larger retail operations and thus never had the opportunity to sample Claiborne goods. With that operation intact, and many units opening around the country, the Claiborne company embarked on another retail venture. For this venture the company used the name Liz Claiborne on its stores. In these shops, found in fashionable regional malls, customers can explore the full Claiborne labels without the need to enter stores that feature other merchandise. Since the name Claiborne is so widely accepted, it seemed natural to open stores that enabled the products' devotees the opportunity to see them by themselves.

Liz Claiborne, like all other major fashion manufacturers, often finds that some of its merchandise has not sold as well as expected, and is left with goods that cannot be disposed of via its own stores or the independent retailers to whom it sells. Thus, another division was born. The company now operates discount outlets where slow-selling merchandise is sold at reduced prices. These outlets, two of which are located in off-price centers in Secaucus, New Jersey, and Kittery, Maine, are company successes. Shoppers familiar with the name flock to these places for quality goods at bargain prices. In order not to alienate those traditional merchants who sell Claiborne at regular prices, and not to interfere with the business successes of their own regular shops, the company makes certain that the outlets are opened in places away from the traditional markets so that competition will be avoided.

The abundance of exterior lighting used by A&S in America (left), and Harrods in London (below), dramatize both retail environments. Shoppers are quickly made aware of the excitement that awaits them inside these stores.

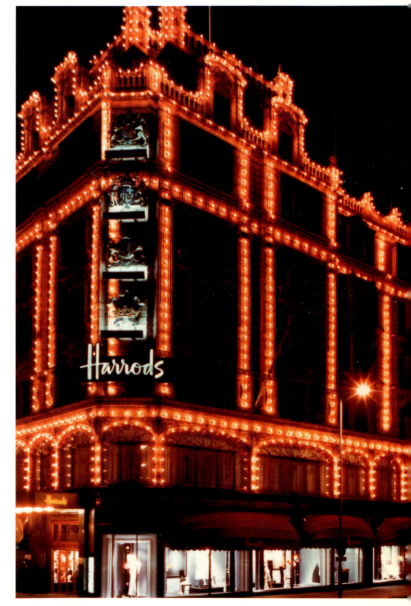

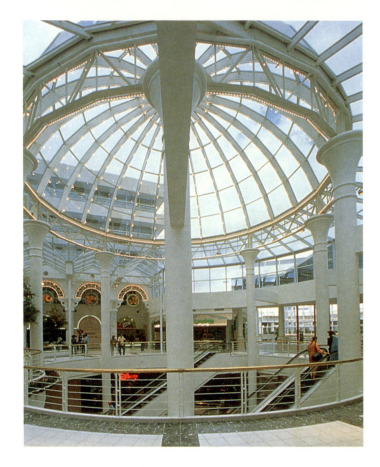

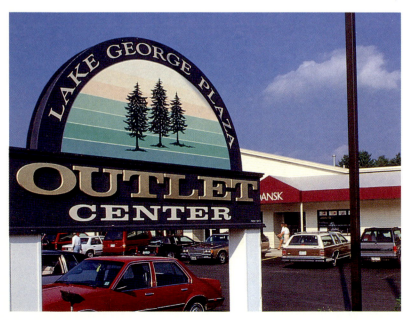

Glass domes not only add dramatic flair to mall designs (above), but also create a feeling of spaciousness. The towering columns add architectural grandeur to the setting. Outlet centers, such as the one pictured (left), provide pleasant environments in which customers can shop for bargains.

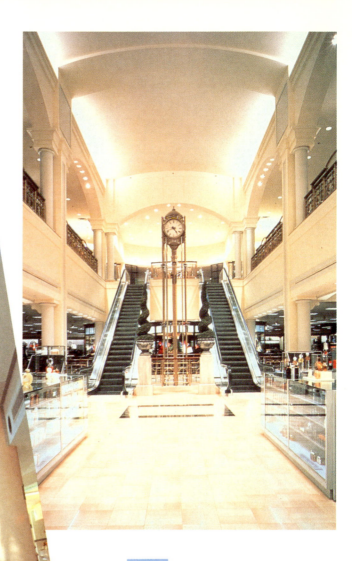

The towering, free-standing clock, surrounded by stylized topiary trees (above), acts as the centerpiece for this contemporary store interior. The food court, embellished with lush greenery, makes dining a pleasurable experience.

The enormous food court at Franklin Mills (above) features a huge variety of food for the entire family, and is "overseen" by an enormous caricature of Benjamin Franklin. Limited Express (left) provides the customer with a contemporary, spacious setting that typifies visual merchandising at its best.

Outlet malls are no longer lackluster environments. The "Mills" concept (above) represents retail outlets in settings that feature surroundings that rival upscale malls. Magnificently placed criss-crossed escalators (right) are both functional and visual treats for shoppers.

Aeropostale (left), a spinoff store owned by Macy's, features unisex clothing in an environment that recalls those "magnificent men in their flying machines." Food courts (above) are becoming exciting facilities in which shoppers may pause before continuing their pursuit of merchandise. Boogies Diner (right) is a unique store that incorporates fashion merchandise and dining facilities.

Retail interiors are uniquely customized today. Bloomingdale's in Palm Beach Gardens, Florida, mixes contemporary and "art deco" periods to create a magnificent setting. High-in-the-sky display windows and gigantic stylized flowers give the store individuality.

Ralph Lauren, like Liz Claiborne, has also entered the multimarket fashion retail world. The company operates regular specialty shops, bearing the Lauren name, in major shopping centers, and outlet operations in twenty off-price centers in the United States. Its entry in the retail field, however, is even more extensive than Claiborne's.

Besides the small Lauren shops owned by the company, Lauren operates a flagship store on New York City's Madison Avenue that features all of the designer's merchandise. It is a five-story shop that is housed in the former Rhinelander Mansion and is unlike any other retail operation that bears the name of one designer. The mansion has been totally restored to return it to the turn of the century elegance it once enjoyed as a private residence. The Lauren collection, set among antiques and period furniture, is reminiscent of a museum. The treasures inside, however, are the designs of Lauren and are available for sale.

Another avenue to increase its retail empire is through franchising. The company now franchises many Ralph Lauren shops in major shopping areas. Each must meet the rigorous standards established by the company, especially in the area of visual merchandising.

Other designers who have taken the multimarketing fashion retail route are Tommy Hilfiger, Joan and David, and Adrienne Vittadini.

The International Scene

The retailing scene is one that is changing all over the world. Many retailers with fashion orientations who have established themselves abroad are opening units in the United States, and conversely, many of America's fashion merchants are pursuing expansion in foreign markets. Some internationally acclaimed foreign fashion retailers have chosen to confine their operations to their own countries, catering to their own citizens and those who come as visitors from all over the world.

Major Fashion Retailers Abroad

Throughout the world, numerous fashion retailers have distinguished themselves with their merchandise offerings. Whether it is London, Paris, or some other fashion center, some merchants have gained international reputations without ever leaving their own shores.

Most world travelers, when asked to name a store that is steeped in fashion tradition and unsurpassed service, most often mention the name Harrods. Housed in a magnificent structure in the Knightsbridge section of London, Harrods continues to attract the attention of native Britons as well as travelers from all over the world. Not only does it tempt the tastes of fashion connoisseurs with its exquisite,

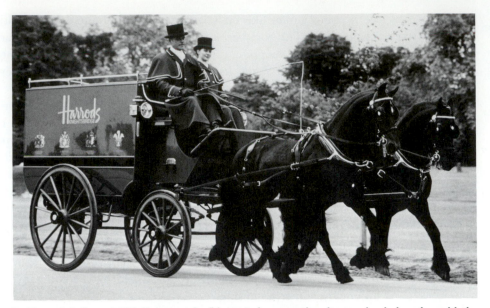

Figure 1-8. Harrods' "delivery service" is part of a promotional campaign in keeping with the store's tradition of unsurpassed service. (Courtesy of Harrods)

quality British cashmeres and clothing, but it features the offerings of the leading fashion designers from around the globe. In addition to the merchandise, shoppers from every nation are immediately assisted with interpreters who quickly make the language barrier disappear. Tea service at Harrods, a British tradition, makes every traveler quickly understand the reason for shopping the store. The restrooms, usually sterile-looking environments in the United States, are exquisitely appointed, much like drawing rooms. They serve as places where shoppers can relax in comfort before they resume their shopping. Harrods is a department store that makes the shopper's experience pleasurable.

While Knightsbridge, anchored by Harrods, is universally accepted as the conventional shopping area in London, Brompton Cross is an area that abounds with expensive, fashionable merchandise. Britain's *Tatler*, a publication, describes the Brompton Cross shopper as "someone who wants to be seen as a certain type of person." Such persons consider ambience as important as merchandise. British citizens as well as international visitors have found this area to be one that satisfies the needs of the most fashion-oriented. The area is replete with specialty stores, each with its one distinct styling: Issey Miyake, with brilliant materials and designs; Tokio Kumagai, featuring a large selection of European designer men's and women's clothing and accessories; English Eccentrics, offering intricate silk prints; and others. The general location is one that resembles a cross between New York's Greenwich Village and Soho.

Other major shopping streets in London are Oxford and Regent streets. Both

fashion centers abound with a host of shops that feature women's, men's, and children's merchandise. In particular, the most discriminating male customer can find ready-to-wear clothing and furnishings as well as the finest custom tailors on these famous streets.

What Harrods is to London, Printemps is to Paris. Here is a store that can quickly satisfy everyone's fashion needs with the designs of Europe's greatest under one roof. It too offers impeccable service, in most any language. On its "Street of Fashion" the discriminating fashion shopper can examine the collections of Yves Saint Laurent, Christian Dior, Giorgio Armani, Karl Lagerfeld, Krizia, Gianfranco Ferre, and Christian Lacroix. The fashion designs are either *prêt-á-porter*—ready to wear—or couture.

Aside from the large department stores such as Printemps, Paris is also filled with designer specialty shops. For those seeking the complete lines of some of the designers already mentioned, fashion emporiums featuring each one's name are found in Paris. Customers can purchase "off the rack" in these shops or have custom couture designs made specifically for them.

Unlike London and Paris with their giant stores such as Harrods and Printemps, Rome and other fashionable Italian cities such as Milan address retailing via the specialty shop route. Smaller shops that exclusively feature such designs as Gucci, Armani, and Ferre, and boutiques that carry a mixed assortment of fashion items are the way in which Italian cities sell their merchandise.

Some of the other major fashion retailers abroad are AB Nordiska Kompaniet, better known as NK, in Sweden, and Switzerland's Bon Genie and Grieder, both fashion specialty chains. The lineup of designer clothing available at NK, such as Armani, Gigli, Rykiel, Valentino, Byblos, and Escada, rivals the inventories found at Printemps and Harrods. Bon Genie and Grieder are units of Switzerland's leading specialty store group. Both stores are smaller in size than those like Printemps, but cater to the same type of fashion-conscious clientele. They also feature a host of designer names, with Sonia Rykiel and Escada being the most important.

While Europe and other nations have their share of fashion emporiums, many no longer are exclusive to the countries in which they were originally founded as Harrods in London, and El Corte Ingles in Spain still are. With the convenience of jet flight putting foreign capitals within quick reach of travelers, many stores have opted to open branches in countries from which these visiting shoppers come. Thus, retailing is a field in the midst of worldwide expansion.

Worldwide Expansion

Americans who travel abroad and are familiar with foreign designer names and retail establishments are finding that branches of many of their favorite international haunts have opened in the United States. Similarly, people from overseas

Figure 1-9. Dickins & Jones is a contemporary fashion specialty retailer in London, England, with an upscale ambiance, offering distinctive merchandise. (Courtesy of HTI, Space Design International)

are finding the same phenomenon taking place in their own backyards: American operations are opening in their countries. Today we find that a vast number of retailers have opted for these foreign-based locations, with the outlook considered excellent for further expansion. Some of the leading countries to open their shops in America are discussed below.

England

With shops on Madison Avenue in New York City and in Town Center in Stamford, Connecticut, and the promise of ten more to open in each of the next few years, Alexon is one of the most aggressive of Great Britain's retailers to go offshore. The merchandise is designed and produced by the company for sale in its own stores. In addition to individual units, the company is also actively involved in opening shops within major American department stores such as Dillard's and D.H. Holmes.

One of the reasons for the success of subspecialty stores in the United States was the immediate appeal of Sock Shop International PLC, which specializes in legwear. While many Americans have joined the bandwagon and established "legwear-only" stores, few have had the success of Sock Shop. By building small units with colorful surroundings in America's busiest areas, the company is rapidly expanding.

Fashion accessories have been the forte of Sacha, a London-based shop that features the company's own designs. With stores all over the British Empire, the company decided to try its hand at an American audience and opened a store in Los Angeles. The business caught fire, and the company now operates freestanding stores throughout California and a unit on New York's Madison Avenue and enjoys merchandise "niches" in 350 stores in the United States.

France

Not satisfied solely with their Paris-based retail and manufacturing operations, Faust has opened shops in New York. Featured are the company's own designs. In addition to these company-owned, freestanding stores, Faust enjoys merchandise sections in some of America's best-known fashion stores such as Nordstrom and Saks Fifth Avenue.

Through France, Marithe & Francois Girbaud operate their well-known boutiques. Becoming a worldwide retailer with units in Tokyo, Florence, and Montreal, the company has expanded to the United States with shops in Chicago, Los Angeles, Washington, D.C., and in San Francisco. The company's products are sold by other retailers internationally and, because of universal acceptance, the new retail ventures have followed.

Hermes is the most famous Paris-based company specializing in silk scarfs and other accessories. Its introduction to America as a separate retail unit took place in 1950 when Lord & Taylor opened a shop on their premises for the exclusive merchandising of the Hermes collection. Today, Hermes operates many individual units in the United States in New York City, San Francisco, and Houston, and in many European and Asian countries.

Lanvin is a name long associated with haute couture ever since the company was founded in Paris in the 1880s by Jeanne Lanvin. In addition to the couture collection, the company has started to expand its ready-to-wear operations with stores on New York's Madison Avenue and in San Francisco and many other worldwide locations. In addition to fashions for men and women, Lanvin also merchandises a perfume line.

One of the most exciting companies to make its way to the United States is Chevignon. Through a licensed operation, Chevignon North America, Americans are now enjoying the company's spirited lines. The merchandise is for men, women, and children, with the vast majority—about 60 percent—devoted to male fashion. Specializing in basic sportswear that includes jeans, jackets, shirts,

and sweaters, the stores are found primarily on the East Coast with New York's Flatiron District serving as its flagship.

Other French-based companies that have gained international reputations through their network of stores around the world are J & F Martell, noted for leather goods; Alain Mikli, purveyors of fashion eyewear; Naf Naf, sportswear; and Revillon, furriers specializing in high-quality, high-fashion furs.

Germany

Compared to many other countries, Germany may be classified as a fashion new-comer. The three companies that have made the greatest impact on fashion from that region are Bogner International, Hugo Boss, and Escada.

When one mentions foreign skiwear and golfwear, Bogner is a name that comes to mind immediately. In New York City, San Francisco, and other American locales, fashion enthusiasts are being treated not only to the activewear lines, but also their women's wear fashion collections. Bogner is also one of the few foreign-based companies to use the American outlet approach to rid itself of slow-moving merchandise. In Freeport, Maine, one of America's off-price, discount outlet centers, Bogner opened a retail operation surrounded by famous American designers who sell their overruns off-price. The prestigious Bogner label coupled with down-to-earth prices have made the outlet a winner.

Hugo Boss is well known to Americans who purchase the goods from the traditional retail operations. Today, the company has established its own retail division with two stores in Washington, D.C., and more on the drawing board. They feature the finest clothing, sportswear, and accessories for men and women.

Escada, a Munich-based operation that manufactures apparel for an upscale clientele, has now added to its retail division in Europe stores in Cleveland, Fort Lauderdale, Houston, and Minneapolis. Their merchandise price point falls directly below couture and above the prices of the better American designers such as Jones, N.Y., and Anne Klein.

Other Countries

Other countries that have also boarded the worldwide train for expansion are:

Italy—Benetton, Il Bisonte, and Stefanel have all become international retailers.

Finland—Marimekko is its leading textile and apparel producer with international stores.

Spain—To date, Martinez Valero, the shoe designer, is the country's only world-wide retail operator.

Australia—Country Road, specialty retailer of men's and women's merchandise, has stores in New York, Virginia, and Boston.

Japan—represented by Yohji Yamamoto in New York, **Sweden**, with Marc O'Polo operating stores in Germany, America, and Belgium, and **Korea**, represented by Jindo Industries with fur shops all over the world, are some other foreign countries going the international fashion retailing route.

By taking up residence at New York City's fashionable Trump Tower, Galeries Lafayette is destined to become one of the most important foreign fashion emporiums ever to come to America. Unlike the smaller specialty stores that occupy a couple of thousand square feet and specialize in a very restricted merchandise line, Galeries Lafayette's New York environment is situated on the 85,000 square feet once occupied by the now-defunct Bonwit Teller.

The company was founded in 1895 on Rue Lafayette, across the street from its present day flagship. It began as a boutique selling such merchandise as feathers and novelties. Today it is recognized as one of the three top department stores in France. In addition to the flagship store, the company operates 17 branches throughout France,

and more than 100 units of food and variety stores.

The main Paris store is a study of contrasts. Inside the store there is a vast assortment of popular-priced merchandise and an upscale collection at very high prices. Outside, in many booths that flank the store, sellers for Galeries Lafayette sell anything from steam irons to budget lingerie. The Trump Tower branch will avoid this type of merchandise and concentrate on elegance and upscale price points. It will feature a vast array of perfumes, as does its French flagship, which boasts the largest perfumery department in the world, as well as haute couture and ready-to-wear from the world's leading designers like those found in the Paris location.

Private label is also expected to play a big role in the American

store. The company, in an effort to differentiate itself from other retailers, has undertaken an extensive plan to develop fashion collections exclusively for its own purpose. In Paris, names like Jodpur, Avant-Premiere, and Briefing have been introduced to make the store's merchandise unique. The same plan is being undertaken for the Trump Tower store so that it will be different from the other New York department stores.

With the disappearance of such department store names as B. Altman, Bonwit Teller, Gimbel's and Ohrbach's from the New York retail scene, and the competition offered by such fashion empires as Bloomingdale's, Macy's, Henri Bendel, and Bergdorf Goodman, only time will tell if the French invasion into American retailing will be profitable.

By far, the most aggressive worldwide expansion has recently come at the hands of Galeries Lafayette, the Paris-based department store. While many specialty organizations have crossed into foreign lands to expand their businesses, rarely has a European-based department store set forth with such a large-scale entry in another country. Printemps tried its hand at a much smaller-scaled endeavor in Colorado, only to have it close because of a disappointing showing. This time, Printemps' neighbor, Galeries Lafayette, is making an even bigger investment with its American branch in New York City.

Although many foreign stores are in evidence in the United States, it should be understood that a reverse trend is taking shape. Some American fashion retailers have taken to other shores to expand their markets. While the overseas expansion for our retail companies is not as large scale as is the growth in the opposite direction, some progress is being made.

By the end of 1990 Talbots, the conservative fashion clothing company, had four stores operating in Japan. Merchandise sold in Japan will come from American sources and will be a sample of what they offer domestically. Canada and Europe are the next targets for international expansion.

Until now, the major overseas expansion has been in toys and fast foods, with Toys R Us and McDonald's leading the way. On the horizon, other retail industries will probably follow their lead.

Trends of the Nineties

As retailers entered the nineties, they faced changes and innovations rarely encountered before. Many of the stalwarts of the field closed their operations and newer formats surfaced to replace them. Consumers were finding many new roads to take to satisfy their fashion needs, and retailers were scrambling to join the bandwagon to give them what they wanted. Some of the more visible trends that have made recent retail headlines and those that promise to intensify throughout the nineties are explored below.

Department Store Dominance Diminishes

During the past few years, the once-dominant force in retailing, the department store, has fallen on hard times. Whether it is the traditional department store with its vast variety of soft goods and hard goods, or the specialized companies where the accent is on fashion merchandise, alarms have been sounded. Famous emporiums such as Ohrbachs, Gimbels, B. Altman & Company, Bonwit Teller, and Garfinkel's have closed their doors because of losses.

Many reasons have been given for the department store's demise. Most

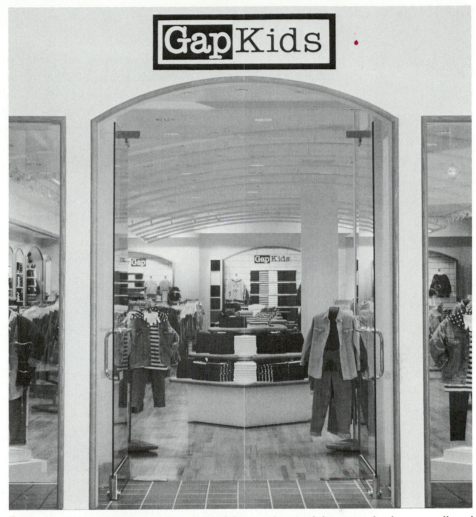

Figure 1-10. Gap Kids stores are typical of the popular specialty stores that have contributed to the demise of many department stores. (Courtesy of The Gap)

knowledgeable analysts believe of paramount importance is the limited time shoppers have to make their purchases. The enormous number of women—the store's primary shopping market—now in the workforce have little time to face the crowds of the department stores to buy a few items. Other analysts cite poor management and the competition from specialty stores and in-home shopping approaches as the reasons for the erosion of their popularity. Those department stores that are still in operation are fighting the competition by turning to new concepts to meet the competitive challenge: some are beefing up their direct mail divisions, while others are developing spinoff stores.

Spinoff Stores

The term spinoff is used to describe specialty stores whose origination was in the department store. That is, some department stores are opening freestanding units of departments that have achieved success as part of the department store operation. For example, Carson Pirie Scott opened its "Corporate Level" in its Chicago flagship. With the success that department achieved, the company decided to open a separate "Corporate Level" unit in Washington, D.C., to appeal to the executive and management market of the city. Since other department stores in the Washington, D.C., area already had the major share of the market, another traditional department store was unnecessary. One of the leading department stores to move swiftly in the area of spinoffs is Macy's. They now have three separate spinoff divisions, each first proving its success as a department in the regular

Figure 1-11. Charter Club is a spinoff fashion operation that features Macy's private label collection of sportswear and accessories. (Courtesy of Macy's)

The name Aeropostale evokes romantic images of daring young Frenchmen in their flying machines of the 1920s and 1930s. Macy's first chose to merchandise goods that would recall those eras in their department stores. The visual setting the store used to enhance this new, privately developed collection of casual wear was an environment that recalled the days of the early air pioneers. With the enormous success of the new department, the company decided to open shops that would specialize in this merchandise concept and call them Aeropostale.

The individual Aeropostale units are considered to be "retailing as theater," surrounding the customer with an environment richly evocative of the early flying era. The interiors are an imaginative interpretation of early airplane hangars and utilize dark wooden floors, beamed ceilings, and corrugated metal walls and ceilings. Props such as oil drums, air and gas pumps, authentic photographs of the era, wooden propellers, antiques, period furniture, and packing crates are used as decoration or display units

for the merchandise. Other innovative props include parachuting mannequins that appear to be crashing through the roof, a large wooden biplane suspended from the ceiling, and a giant globe showing old French airmail routes.

The merchandise mix is mostly unisex, ruggedly constructed leisure wear in a broad range of fashion colors and an assortment of accessories such as aviator scarves, distressed leather bags, and aviator glasses. The merchandise assortment and the environment it utilizes truly complement each other.

Charter Club's collection of women's ready-to-wear draws its inspiration from traditional American dressing. Like the other Macy's spinoffs, it too had its beginning as a separate Macy's department. With its immediate popularity and profitability, the company decided Charter Club would make it on its own as a separate specialty division.

The merchandise, as in all of the Macy's spinoffs, is private label, not available at any other retail organizations. In a fashion climate

where "yesterday's hot designers are today's stale news," Charter Club is a reliable source for wardrobe building blocks of classic blazers, skirts, blouses, sweaters, and trousers. It is steeped with a fashion orientation that is anything but trendy. Its customer base is the discerning woman who carefully assembles both her business and pleasure wardrobes.

Rounding out Macy's trio of spinoffs is Fantasies by Morgan Taylor, a group of intimate and sleepwear apparel boutiques. The rustle of precious silks and laces, the scents of floral potpourris and sachets, and the sumptuous feel of flowing soft gowns with the confidence of designer tailoring summarize the image of Fantasies by Morgan Taylor. Visually, the environments are at once reminiscent of a lady's boudoir. The lavishly appointed salons are filled with rich floral tapestries, luxurious lace pillows, and beautiful wooden vanities filled with decorative picture frames and jewel boxes. Customers

continued

stores. Aeropostale, Fantasies by Morgan Taylor, and Charter Club, each with a different target market, are the new ventures being quickly expanded by the company. From all indications, this is the route for Macy's expansion of the nineties.

Off-pricer Expansion

When Freida Loehmann started her off-price empire few knew it would be the forerunner for such an important part of retailing. Today, the off-price merchants, those who buy manufacturers' overruns and unwanted merchandise and retail them at prices far below those of the traditionalists, are rapidly expanding. From all indications, the expansion will aggressively proceed throughout the nineties. Not only are many of those already in this type of retailing, such as Marshall's and Hit or Miss, periodically opening new outlets, but others new to the field are beginning to take up residence in locations throughout the United States. The majority of the goods still remains in the fashion merchandising classification.

One-price Stores

An off-shoot of the off-pricers are the **one-price stores**. Like off-pricers, one-price stores concentrate on merchandise that is purchased at rock-bottom prices from manufacturers and wholesalers. The only difference is that one-price stores restrict their goods to a very narrow price point. Those that concentrate on fashion-oriented merchandise are One Price Shops, which sell their products for $9, Georgia Girl with a $10 price tag, and the Five Dollar Clothing Store selling goods for the amount in its name. While the merchandise found in these stores is by no means high quality fashion, some of the items bear the names of well-known manufacturers who use these outlets as a last means of disposal, thus the very low price.

Subspecialty Stores

Stores that concentrate on a merchandise line that is more restrictive than the specialty stores are called **subspecialists**. They include stores that sell only socks, for example. The outlook is for that type of operation to grow in popularity through-

out this decade. One of the entrants into the field is Units, an organization that only sells one-size, coordinated sportswear items for women, in one type of fabrication. The remarkable success of this company has enabled it to expand with hundreds of individual stores throughout the country. From every indication, the ease of merchandising in subspecialty stores and the success many have achieved in it indicate that this type of retailing will be advancing in the nineties.

Location Changes

With most of the best places already used for malls in the United States and the different types of retailers making inroads into the field, new types of locations are being developed. Power centers (places where small groups of stores surround major off-pricers or discounters), landmark centers (places like Baltimore's Inner Harbor and New York's South Street Seaport that were grossly underutilized), and vertical malls (the high-rise buildings that house a number of shops on as many as 10 floors) are all adding to the locations that retailers want to transact business. The importance of these and other retail centers is more fully discussed in chapter 5, Store Location.

Commission Sales

Although most retail sales associates are paid on a straight salary basis, the trend seems to be that more and more companies will motivate their staffs with commissions. Successfully used by Nordstrom and then adopted by Bloomingdale's, many retailers are preparing to switch to that type of remuneration for their salespeople. Not only does the concept stimulate sellers to become more assertive, but it also has proved to increase overall sales for the stores using the system.

Private Label

Many of the major retailers use the **private label** concept to counter the competition of the off-price merchants. By developing their own lines, they control their mark-ups without having to worry about the competitors' prices. Some stores have merchandised their offerings with a small amount of private-label goods, while others have taken to total, private-label inventories. Of the department stores, Macy's is the leader of this concept, with about twenty private lines; The Limited is the leader of the specialty chains with just about all of their items their own designs. Given the competitiveness of off-pricing and its continuous growth, private labeling will certainly continue to grow.

Manufacturers' Outlets

With fewer and fewer major department stores and more dependence on private labels, many manufacturers are facing a problem concerning the sale of their goods. While quality manufacturer and designer lines will continue to play a significant role in retailing, many of these producers sometimes find themselves in trouble when they must rid themselves of overruns. To compensate for this problem, a large number have entered their own retail operations and opened stores where they sell their unwanted goods at greatly reduced prices. Many also open regular shops that feature only their lines and minimize competition. Whatever the reason or whatever the format, the nineties will see an ever-increasing number of manufacturers open their own retail shops.

In-home Shopping

As more and more women work, less time will be available to shop in stores. For this reason there will be a tremendous effort on the part of retailers to sell to consumers in their homes. Both catalog and cable television sales will continue to grow at a rapid pace. Both of these concepts will be fully discussed in a later chapter.

Throughout the text, other trends of the nineties will be explored in appropriate chapters.

Small Store Applications

As we have learned in this introductory chapter, fashion retailing is a business dominated primarily by large organizations. Most of the concepts addressed in this text and in others are about the major retail giants. That is not to say that small retail businesses are unimportant and need not be given attention.

In all of the chapters throughout this book, a special section, "Small Store Applications," will offer information on how the small retailer handles certain tasks and some suggestions for the proper management of these companies.

Whether it is advertising, visual merchandising, special events, buying practices, employee relations, store location, facility design, or any other subject, the small retailer's situation will be explored.

Highlights of the Chapter

1. Retailing has reached a plateau unparalleled in its history. New classifications such as off-pricers, flea markets, manufacturer's outlets, franchises, and catalog operations have joined the traditional department stores and specialty shops.

2. While large-scale retailing dominates the field, entrepreneurs can still open their own fashion retail businesses with flea market stalls, as members of franchised or licensed groups, or as boutique operators.

3. Department stores are beginning to add to their empires with spinoff divisions to compete with the fashion specialty chains.

4. Numerous designers and manufacturers have taken to the "multimarket fashion route" to expand their operations. Not only are they producing goods, but they are selling them in a variety of stores that they own and operate.

5. Many foreign retailers are establishing branches in the United States and all over the world. So many Americans are traveling abroad; they have become familiar with these overseas operations and have convinced these companies that the market in the United States would be profitable.

6. The nineties will witness many fashion retailing trends. Among them are the expansion of the off-prices operations, the introduction of subspecialty stores, a boom in in-home shopping, and the increased use of private-label merchandise.

7. Of great importance to the nineties is the lesser role that the large department stores will play. Many of the industry's giants have closed their doors, and those remaining in business have attempted new divisions to bolster profits. Among the new ventures that fashion retailers will emphasize are spinoff stores, freestanding units that feature merchandise of specific departments.

For Discussion

1. How does fashion retailing differ today from fifty years ago?

2. In what way does the department store organization differ from the specialty chain?

3. Discuss the two routes that department stores take in the expansion of their companies.

4. Describe the two major types of fashion catalog operations and why they have become such important forces in retailing.

5. Where did off-price retailing have its roots, and who are some of the major operators of these types of businesses?

6. In what way have many major fashion designers and manufacturers started to dispose of their overruns, in addition to selling them to the off-pricers?

7. Explain the term "multimarket fashion retailing."

8. Discuss fashion retailing abroad, and how some of the fashion merchants have internationally expanded their operations.

9. Which leading French department store has opened an American branch in New York City, and how will that operation differ from its Paris flagship?

10. Why has the role of the department store diminished in the United States?

11. What is a spinoff store?

12. How are many major retailers motivating their sales associates to provide better customer service and increase sales?

13. Is entrepreneurship a viable route for most people wishing to enter the fashion retailing field?

14. In what types of retail organizations is success most achievable?

Prescott's is a major department store organization in the Midwest. It began its operation in 1910 as a small specialty retailer selling women's apparel. In 1913, after the company expanded to three units, it decided to restructure itself as a full-line department store. A large, multistory structure, adjacent to its first unit, became available, and the company decided that it would be the best location for the new flagship store.

Throughout its history, the organization has been extremely profitable. Opening branch after branch in five states, Prescott's became one of the area's most successful department store operations with a downtown flagship and eighteen branches. In all of the stores the company provided a merchandise mix that was primarily fashion oriented, but nonetheless offered a host of hard-good lines.

Last year, the company's top management team met to discuss new expansion routes to bolster the store's profitability, which had begun to slow somewhat. A variety of suggestions were made, and many reasons were offered for the lower profit picture.

Alexander Zachery, general merchandise manager, believed that the reasons for the problem lay with the fact that many of its customers were now working full-time and had less opportunity to shop in department stores. His recommendation was to enter the spinoff market and open specialty units that featured the store's most successful department, The Oak Room. With less hassle in specialty store shopping, Zachery felt that this would attract the busiest of customers.

Michael Joshua, director of store management, had another suggestion. He thought that the establishment of a separate division for catalog sales would be the answer. Instead of using the same methods as for their direct-mail business, which involved the store merchandisers and buyers, Joshua was of the opinion that a more aggressive approach, with a new direct-marketing division, would increase company profitability.

Still another suggestion came at the hands of Sheri Litt, the store's fashion director. She stated that with fashion retailing being an international business, overseas expansion would be a viable avenue to take. Many Europeans, for example, might take to American fashion merchandise, much the same as they embraced American music.

After a year of meetings, the company still has not decided on a plan. With sales still falling and profits shrinking, there is a need for something to be done.

Questions

1. Do you believe the store should remain with the same structure that brought it success for so many years? Why?

2. If you had to choose one of the suggestions offered by the members of the management team, which one would you choose? Why?

3. Are there any other roads that Prescott's could take?

Helen Avidon has worked for a fashion specialty retail chain for eight years. The company, Sophisticated Miss, initially hired her as an assistant store manager and, through the years, promoted her until she achieved her present position, sweater buyer. Her first five years were spent at the store level in management, the latter three years at the home office, developing buying plans for her department.

Helen's success was recognized through a series of raises with each promotion, and ultimately a profit-sharing arrangement with the company. While by most standards her remuneration has been excellent in terms of the position she held, she has always had a desire to open her own business.

Three months ago, Helen Avidon inherited $100,000. Her immediate reaction was to invest it in the business of her dreams. With eight years experience she thought that she had enough background to go along with the necessary dollar investment needed to open a fashion operation.

Through careful investigation, she learned that not only was there some opportunities to establish a business from scratch, but there were established franchises that she could join and become a franchisee. The initial investment for the opening of a new business and a franchise were about the same, $100,000.

After a couple of months of deliberation, she still has not made the decision.

Questions

1. What are the advantages and disadvantages of beginning a new business?

2. What are the advantages and disadvantages of becoming a franchisee?

3. Which avenue would you suggest she try? Why?

Exercises

1. Visit a traditional full-line or specialized fashion department store and an off-price fashion retailer in order to compare their operations. Using a form like the one below, complete the following categories to show their differences.

	DEPARTMENT STORE	OFF-PRICER
merchandise assortment	_____	_____
	_____	_____
services	_____	_____
sales assistance	_____	_____
	_____	_____
displays	_____	_____
price lines	_____	_____

2. Prepare a report on a franchised fashion operation. The paper should address such areas as capital investment, product line, locations of the various franchises, consumer market, and operational methods. The information may be obtained by writing to the specific franchise or researching such sources as the U.S. Department of Commerce and the Franchise Opportunities Handbook.

Organizational Structures

Learning Objectives

After reading this chapter, the student should be able to:

1. Differentiate between line and staff positions as shown on organization charts.

2. Prepare an organization chart showing lines of authority.

3. Discuss the major divisions of a large retailer's organization, citing the reasons for their separation from each other.

4. Describe the major differences between the organizational structures of small and large retail operations.

5. Explain how the Mazur Plan was developed and the purpose it now serves in contemporary retailing.

6. Discuss the advantages and disadvantages of centralized store organizations.

7. Distinguish between centralized and decentralized plans.

8. Explain why most major retail operations have separated the functions of buying and selling.

Once the decision has been made to begin a retail venture, it is necessary to plan its organizational structure so that efficiency and profitability will be maximized. Duties and responsibilities must be identified, and lines of authority must be carefully delineated so that each member of the organization will understand the role he or she plays. No matter how large or small the operation, each company must be structured in a way that best serves its needs and makes the business a success.

In order to clarify the organization's structure and make it comprehensible by all of the company's employees, most companies prepare a graphic presentation of their organization called an **organization chart**. The chart very carefully spells out the various divisions of the company, the roles they play, lines of responsibility

and authority, decision-making positions, advisory roles, and areas of responsibility. By constructing such charts, an employee at any level in the organization can immediately learn his or her place in the company, to whom he or she is responsible, and, in turn, his or her own paths of responsibility.

Each retail classification has certain traditional organizational structures that have been established throughout retailing history. Department stores, for example, operate along lines that are dissimilar to those of chain operations and small independent stores. It should be understood, however, that while most department store organizational structures are similar in nature, each company tailors a chart that best suits its specific needs.

This chapter will explore the construction of organization charts, the various types of organizational structures and the functions of the major divisions of each.

Organization Charts

As has already been discussed, the purpose of the organization chart is to depict the various divisions of a retail operation, the positions that lie within the organization, the relationships of these positions to each other, the decision-making positions as well as those that are advisory in nature, lines of authority, and the overall size of the company in terms of job titles.

While the charts are complete in terms of the various departments, divisions and employee relationships, because of space limitations, most charts do not spell out the duties and responsibilities of the indicated positions. Except for very small operations where these are listed directly on the charts, larger companies have companion information by way of **job descriptions**, which indicate the nature of each job graphically indicated on the organization chart. In chapter 7, Human Resources Management, these descriptions will be more fully explored.

In order to "read" organization charts and comprehend the meaning of the various figures featured throughout the chapter, it is necessary to understand some very fundamental principles. Since no two stores use identical arrangements, these basic concepts will serve to facilitate comprehension.

Line Positions

In every organization, no matter how large or small, decisions must be made in the running of the operation. The people who are the decision makers and have direct authority are said to hold **line positions**. In addition to the decision-making requirement, those "on the line" are also involved as the company's producers. That is, they are involved in directly making money for the company. When figure 2-1 is examined, it features three line people, all of whom are company

decision makers. They are all presented in a manner that places the most senior person at the top, the next in command second, and the least senior person at the bottom. Each position is presented in a rectangular-shaped box that is attached to the persons below with vertical lines.

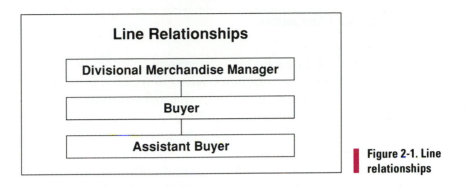

Figure 2-1. Line relationships

In this diagram, the divisional merchandise manager is the most senior person with authority over the buyer who, in turn, has responsibility for the assistant buyer, another step below.

Without ever having seen a particular chart before, the very nature of the placement of positions and the use of these traditional lines makes it easy for the reader to understand who is responsible to whom, who plays the most important decision-making roles, and the direct lines of authority and communication. In terms of communication, it should be understood that an employee is expected to follow the formal delineations when discussing company problems. For example, referring to figure 2-1 once again, the assistant buyer communicates only with the buyer—the immediate supervisor—and not with the divisional merchandise manager. Only the buyer may deal directly with the divisional merchandise manager. In some organizations, however, an informal structure might exist that enables some people to communicate with others out of the formal order.

Small retailers, most of whom do not have written organization charts, nonetheless use the line organization arrangement for their stores. That is, each member of the company is in some way a decision maker or a person who is engaged in an activity that brings profit to the company. In some companies, line personnel are called "producers," in that they produce profits for the business.

Staff Positions

As stores grow in size, the need arises for people who work in advisory or support positions. They are technically known as **staff personnel**. They are expressly employed to assist people on the line. They are specialists within the organization

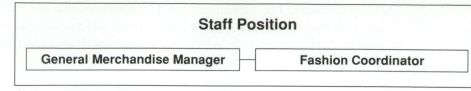

┌───┐
│ **Staff Position** │
│ ┌──────────────────────────────┐ ┌────────────────────────┐ │
│ │ **General Merchandise Manager** │───│ **Fashion Coordinator** │ │
│ └──────────────────────────────┘ └────────────────────────┘ │
└───┘

■ **Figure 2-2. Staff position**

who work at the behest of the line people to whom they report. Figure 2-2 illustrates a staff position and how it relates to someone in a line classification.

In this example, the general merchandise manager is a line executive with the ultimate power to determine guidelines and philosophies concerning merchandise assortments. While an individual delegates authority to such subordinates as the divisional merchandise managers, buyers, and assistant buyers to carry out those decisions, it is necessary to make specific determinations in terms of the fashion market conditions. The fashion coordinator is connected to the general merchandise manager's box with horizontal lines to indicate that the position is staff, or advisory, in nature. That is, the fashion coordinator advises the line individual on such matters as current fashion trends, color forecasts, and fabric preferences. The fashion coordinator does not have any decision-making powers in such areas as color selection, but merely advises the general merchandise manager and others on the line of the fashion potential and leaves the actual choices or decisions to them.

It should be understood that while there are organizational charts that are strictly line in nature, there cannot be any that are strictly staff. The larger a retail operation grows, the more staff positions are needed in specialized areas to make the company run more efficiently.

When retailers use a combination of line positions along with staff positions, they are called **line and staff** organizations.

A major portion of this chapter will explore the various types of organizational structures used for small specialty stores, small department stores, large department stores, and chain organizations.

Small Specialty Store Organizations

Small specialty stores and boutiques generally operate with a minimum number of people. There is little specialization but rather each employee often performs a variety of tasks. A salesperson, for example, might be called upon to unpack and ticket merchandise, stock the shelves, make returns to vendors, and so forth. At this level of retailing, most of the major decision-making tasks such as merchandising, buying, management of the sales staff, promotion, etc., are performed by

the store's owner, and perhaps, the store manager. In the very small operations, the owner and manager are one and the same.

Figure 2-3 features an organization chart typical of small specialty store operations. Each title or position on the chart is accompanied by some of the duties and responsibilities performed.

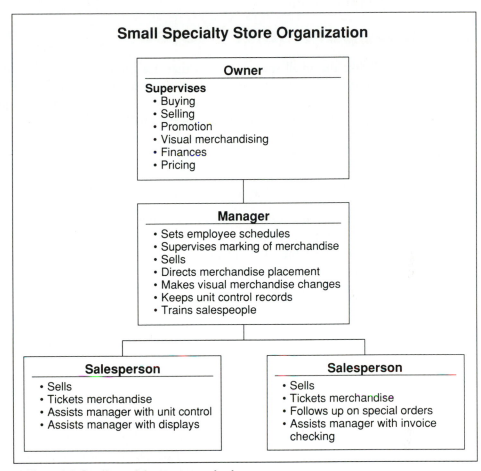

Figure 2-3. Small specialty store organization

In the above illustration it is clear that the owner supervises the store's entire operation, leaving certain responsibilities for the manager. It should be noted that although both salespeople have equal standing in the company (they are both at the same level, as the chart indicates) the various jobs they perform, in addition to selling, differ.

As a company grows, not only does the number of employees increase, but different types of people are hired to perform more specialized tasks. Some are

brought on board as additional line personnel and others are earmarked for the advisory staff positions.

Often these small specialty stores expand by opening additional units with some growing into major chains. These organizational structures will be explored later in the chapter.

Small Department Stores

Unlike the small specialty stores that deal in a narrow merchandise assortment, the department store merchandises either an assortment of hard goods and soft goods or specializes in numerous soft-goods departments. In either case, their operations are dissimilar to those of the small specialty stores.

Typical of these operations are departmentalization and specialization.

Divisions and Departments

In order to successfully operate a small department store, there is a need to separate functions into specific divisions and departments. The divisional structure is one in which the store's major roles or functions are separated and headed by a divisional director or manager. Within each of these divisions there are several departments that further help to delineate tasks. The divisions are always "line segments" and are decision-making units. While most of the departments are also line oriented, some small department stores add "staff" departments to their organizational structures. These departments are for the sole purpose of providing advisory assistance to the line executives.

Specialization

The degree of specialization in each small department store depends upon its size and merchandise mix. Unlike the small specialty stores that require a broad set of tasks to be performed by each employee, these organizations limit the tasks to be undertaken by their personnel. Instead of requiring salespeople to tag merchandise and stock the shelves, stock people are utilized for these roles. In that way, the salespeople are free to pursue their sales efforts. Instead of relying upon a single store manager to run the store's operations, individual managers are employed for each department or group of departments. Thus, there would be separate managers of men's wear, children's clothing, and appliances. Since each is now dealing with a specific merchandise classification, it is likely that there will be more knowledgeable people in each of the store's areas. This should lead to better profits for the company.

In figure 2-4 an organization chart is presented that is typical of small department stores. It is a line and staff configuration with the line divisions and departments being connected by vertical lines and the staff departments or positions connected to the line personnel they serve by horizontal lines. In cases where the horizontal lines are not connected to a specific line executive, but somewhere between two line positions, that staff position is advisory to those directly above and below the line.

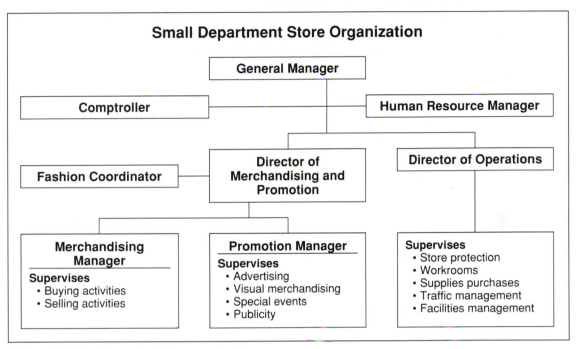

Figure 2-4. Small department store organization

This chart is commonly known as a two function or division line and staff organization chart. There are two separate divisions, merchandising and promotion, and operations, each of which is headed by a director. The use of two separate and distinct divisions enables each to specialize in a particular area of expertise. In order to make certain that each, although separate units, works in conjunction with each other and guarantees one overall store effort, the directors report to the general manager. It is this person's responsibility to make certain that the two divisions' efforts are coordinated and are in the store's best interests.

The merchandising and promotion division is segmented into two departments. Although their tasks are interrelated, their duties and responsibilities are different. In organizational structures of the larger department stores, these two departments are usually separated into two divisions.

It should be noted that there are three staff positions in this organization: human resources, fashion coordinator, and comptroller. Each is attached to the line horizontally but differently. The human resources manager and the comptroller connect to a line that falls between the general manager and the two store directors, indicating a relationship with each. The fashion coordinator, on the other hand, attaches directly to the director of merchandising and promotion's position. This placement on the chart spells out that the fashion coordinator serves as advisor only to that director.

As small department stores expand and develop into organizations that boast numerous branches, twigs, and oftentimes large direct retailing divisions, their organizational structures change.

After a great deal of success in retailing in the very early 1900s, the business community was hit with a recession between 1921 and 1923 that caused profits to decline. Following that recession, the National Retail Dry Goods Association organized a committee to study the major stores' operational plans so that they could make recommendations to their members as to the best approach to take in restructuring department store organization. An authority on the subject was Paul M. Mazur who was hired as a consultant by the retail trade association to study the subject and make recommendations.

Heading the committee, Mazur decided to investigate 13 stores of varying sizes and different types of structures. After 18 months, with the study complete, Mazur laid down a plan that was to become the benchmark for department store organizational structures.

The Mazur Plan, a name by which it is still known, is a four-function or four-division organization plan. It incorporates both line and staff positions into four separate areas under the authorities of controller, merchandise manager, publicity manager, and store manager. The plan was considered to be the perfect vehicle for department stores since it maintained

specialization in the four distinct areas, but allowed each to interact with the other to make the organization a cohesive unit. Lines of authority were clearly spelled out, enabling individuals to know to whom and for whom they were responsible and at which level in the organization they were placed. In order to provide a forum where the four divisional managers could regularly meet to provide input into the overall operation, Mazur established the board of managers.

Figure 2-5 features the Mazur Plan. Even today it serves as the basis for many large department store organizational structures.

Large Department Stores

At the turn of the twentieth century, small department stores started to expand their operations. In order to successfully meet the challenges of their growing organizations, many changed their organizational structures. From the two-division concept, some went to three, four, five, and even more divisions. There was no established standard at the time for the most effective structure. Few companies undertook research to determine how to change their charts to become most profitable.

The major trade association at this time was the National Dry Goods Association (later to be renamed the National Retail Merchants Association, and again changed in 1990 to the National Retail Federation). Through their efforts, a major concept was introduced that would eventually guide large department store organizations along the right path.

The Mazur Plan

In order to fully understand the workings of the Mazur Plan, each of its four major components will be explored.

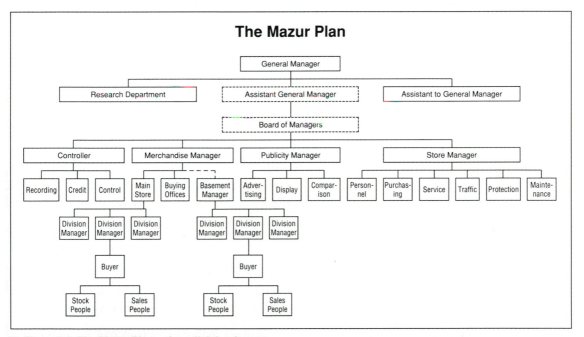

Figure 2-5. The Mazur Plan, a four-division format

The Merchandising Function

The largest division in the Mazur Plan is merchandising. It is the area that is responsible for all of the buying and selling activities of the main or flagship store and its branches. The division is headed by the **general merchandise manager** who oversees all of the store's purchases and is considered by many to be the most powerful member of the management team.

The general merchandise manager's realm of responsibility spans three separate areas, the main store (and its branches if there are any), the company's own buying offices, and the basement operation. In some retail operations, the basement is operated as a separate unit, as suggested by Mazur, because these operations often require different types of merchandising than the rest of the store.

Merchandising responsibilities are shared by several **divisional merchandise managers**, each having responsibility for a number of related merchandise classifications. That is, typically there are divisional merchandise managers, or DMMs as they are called, for women's wear, men's clothing and furnishings, furniture and appliances, and so forth. These DMMs have the responsibility to apportion the monies allocated for their division's purchases, to set the tone or image of the particular divisions, to select and supervise the buyers, and to have overall management of their areas.

Next in line are the **buyers**, with each in charge of the purchases for one or several merchandise departments. They work within the framework of a budget outlined by their supervising DMM, who bases purchase allocations on previous sales and sales forecasts.

Most buyers in the plan have assistants who, as the title indicates, assist the buyers with all of their duties. The buyers under the Mazur Plan have the responsibility to manage their department's sales staff and stock personnel. They determine the needs of their departments in terms of human resources based upon budgetary numbers, select the people for their departments, and have general supervisory control over them.

While some stores remain with this merchandising concept in which the buyer manages the sales staff, the majority of department stores have altered this plan and have removed the supervisory sales aspect from the buyer's domain. The reasons for such a move will be discussed later in the chapter.

In addition to the line positions in the merchandising division, there are several staff positions that are included in the plan as shown in figure 2-6.

These staff positions provide advisory assistance. They are indicated with horizontal lines that emanate from specific line titles or from places between two line designations. Briefly, the staff people in this plan accomplish the following tasks:

Fashion coordinator—Analyzes the fashion markets in advance of the purchasing periods and informs the merchandising teams of fashion trends, fabrication forecasts, new colorations, price changes, and so forth, so that the merchandisers and

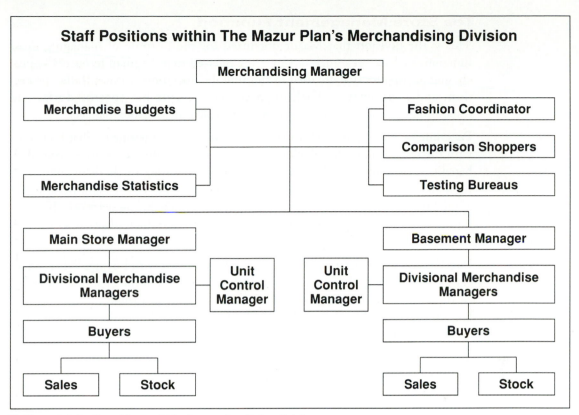

Staff Positions within The Mazur Plan's Merchandising Division

- Merchandising Manager
 - Merchandise Budgets
 - Merchandise Statistics
 - Fashion Coordinator
 - Comparison Shoppers
 - Testing Bureaus
- Main Store Manager
 - Divisional Merchandise Managers
 - Unit Control Manager
 - Buyers
 - Sales
 - Stock
- Basement Manager
 - Divisional Merchandise Managers
 - Unit Control Manager
 - Buyers
 - Sales
 - Stock

Figure 2-6. Staff positions within the merchandising division

buyers will be more knowledgeable when they make their purchases and so that the store will have a unified approach to the new season's fashions.

Comparison shopper—Regularly visits competing stores to check merchandise assortments, prices of the same merchandise, new lines, etc. In this way the store can get firsthand information about other stores and remain competitive.

Testing bureau—Tests, under controlled conditions, fabrics for qualitites such as color fastness and quality, or appliances for their durability, etc. Only a few giant retailers have such staffs in their stores, with the others relying upon the vendors to provide the necessary test results on specific items.

Merchandise budgets—Makes certain that the figures concerning budget allocations are up-to-date and within the division's guidelines.

Merchandise statistician—Prepares merchandise reports and statistical analysis of each for the divisional managers.

Unit control—Keeps records of the number of units sold in each department along with information on color, styles, prices, fabrications, sizes, etc.

The Store Management Function

This is the division that Mazur organized for the purpose of managing those functions such as personnel—today often referred to as "human resources"—purchasing of supplies that are used in running the operation, service, traffic, protection, and maintenance. Each of these departments has specific duties and responsibilities with overall management provided by the store manager.

Personnel—The department, often referred to as human resources, that is charged with the responsibility for employee procurement, training, evaluation, providing benefits such as medical and dental coverage, establishing methods of compensation, and other tasks. It should be noted that under the Mazur Plan, personnel is a line function, therefore granting it the power to make hiring decisions. In many organizational structures, personnel is a staff position, which places it as an advisory body, thus making only recommendations about hiring.

Purchasing—This department should not be confused with buying. When retailers speak of buying, they are referring to the acquisition of merchandise for resale. In this context, purchasing refers to the procurement of various supplies such as bags and boxes, office forms, light bulbs, etc.—those items that are needed to carry out the business of the company.

Service—One of the most important areas of the retail organization is the one that provides customer services. These range anywhere from gift wrapping to alterations.

Traffic—The flow of goods from the receiving platform to the selling floor comes under this department's jurisdiction. The accuracy of quantity and quality checking and the quick movement of the goods is necessary to make the organization profitable.

Protection—Without question, store security is one of the major problems confronting retailers. This department is responsible for the security of the merchandise, the apprehension of shoplifters, and the uncovering of internal theft incidences. In chapter 8, Merchandise Handling and Protection, this topic will be explored in more detail.

Maintenance—Cleaning the store, replacing of light bulbs, removing trash, and fixing equipment are just some of the tasks performed by this department. While on the surface these tasks may seem unimportant, they are necessary to provide a clean and safe environment for the consumer.

The store management function also has some staff or advisory positions. They are not as numerous as those found in the merchandising division. Some typical staff positions include statistical analysts who prepare charts and graphs for management, and budget supervisors who examine the budget process and make certain that the store is operating within budgetary constraints.

The Publicity Function

The purpose of this division, often termed "promotion" by many retailers, is to publicize the store's image and merchandise. Through advertising, display (now categorized as "visual merchandising"), and comparison shopping (today generally a staff function), the store's customers and potential customers are made aware of what is being offered for sale.

The role of this division has been significantly expanded by today's retail giants, which will be described later in the chapter. As Mazur envisioned the division it functions as follows:

Advertising—The department plans all of the advertising including artwork, copywriting, and layout, and selects the media in which the advertisements are placed.

Display—At the time of this table of organization's introduction, the major portion of the display budget was allocated for windows. Stores would devote a great deal of their space to large windows from which the customers could preselect their merchandise. Today, as we will learn later in this chapter and in "Visual Merchandising," contemporary retailers are significantly changing this department's emphasis.

Comparison—Almost extinct as a separate department in retailing today, Mazur suggested it as a means of checking out the competition in terms of merchandise offerings and prices. Examination of the merchandising function in figure 2-6 shows that "comparison" is often a staff or advisory role.

Chapter 14, "Advertising and Promoting Fashion," and chapter 15, "Visual Merchandising," will discuss the growth of this area and the vital role it plays in making certain that the retailers get their share of the consumer market.

The Control Function

Financial decision making comes at the hands of the controller who heads this division. It is this division that oversees all accounting practices, makes credit decisions, and controls expenses and budgets.

Recording—This department, now called accounting by all retailers, is responsible for accounts payable, payroll, taxes, and other financial duties.

Control—Sales audits, control of expenses and budgets, and the preparation of reports on financial matters are the roles of this department.

Credit—With many stores reporting that more than 75 percent of their business is achieved via the credit card route, this has become one of retailing's most important departments. It authorizes credit, conducts credit interviews, sets credit limits, and follows up delinquent accounts.

Factors That Lead to Mazur Plan Changes

When Mazur developed his plan, department store retailing was still suffering growing pains. The numbers of branches operated by the major companies were few and management of them could be easily accomplished by the parent, main, or flagship store. Today, however, not only have stores significantly expanded their branch operations, but many have added twigs or spinoff stores to their companies as well as enormous direct retailing or catalog divisions. These and other factors have necessitated organizational change from the earlier Mazur Plan. While the plan still serves as the basis of most department stores' structures, few use it as it was initially conceived by Mazur.

Some of the changes that have lead to adaptations of the plan are described below.

Separation of Buying and Selling

Many retailers still believe that Mazur was right when he suggested that the salesforce be under the buyer's jurisdiction. The buyer is the most knowledgeable person in the store in terms of merchandise, and his or her expertise could be easily conveyed to the sellers to make them more productive. The concept is perfect for organizations that have one store or perhaps a couple of branches that are easily accessible for the buyer. Without direct interaction between the buyer and the sales staff, there is a communication void and little management of these employees is possible.

As department store organizations grow, the buyer's role becomes more and more oriented toward merchandise procurement. With larger orders to place, more vendors to visit, and more extensive distribution plans to develop, little time is left to interact with the selling floor.

Not too many years ago, fashion merchandise and other products were domestically produced. Regional markets dotted the United States where buyers could make numerous visits to make their purchases. Fashion buyers had only to visit the New York Garment Center a few times a year to make their selections.

Today, the situation has changed drastically. The United States is no longer the primary source for goods, with fashion merchandise in particular coming from all over the world. The visits to these international markets is time consuming, leaving little or no time available for buyers to manage anything other than their purchasing responsibilities.

Many major department stores such as Macy's, Lord & Taylor, Neiman Marcus, and Dayton-Hudson are featuring an abundance of private-label merchandise in their stores. The development of these items sometimes falls to the hands of buyers who have become, to a certain degree, product developers as well as purchasers of regular merchandise. With this new added responsibility, even less time is available for supervision of a sales staff.

While it is generally agreed that the buyer must be able to assess customer needs in order to better serve them, few have the time to meet with salespeople to learn their customers' wants firsthand. With the sophisticated reports generated by the computer, customer wants and needs can be determined.

In order for the sales staff to be properly managed and supervised, most large department stores have moved selling from the buyer's jurisdiction and placed it under store management.

Branch Store Expansion

With the enormous success of the department store and the attempt to attract shoppers from different trading areas to the company, many organizations began to open branches. These stores were generally smaller than the main or parent store and carried merchandise assortments that were representative of the main store's offerings. So successful was this expansion plan that more and more department stores opened additional units at distances from the main store that often made it impractical for the main store managers to supervise the staffs of the branches.

Some companies expanded their store management divisions into two distinct departments. One would continue to manage the main store facility while the other assumed the same duties for the branches.

Spinoff Operations

As we saw in the preceding chapter, there has been a trend for department stores to open specialty shops that feature the merchandise or philosophy of one or more of its departments. Macy's has done this with their Charter Club, Aeropostale, and Fantasies by Morgan Taylor departments, Carson Pirie Scott with its Corporate Level, and Bloomingdale's with Bloomies Express. Each of these specialty units requires different merchandising approaches and management techniques from those used in their department stores. To meet the challenge of this new format for retailers, many have expanded their organizational structures to include the spinoff operations in a separate division.

Expansion of Catalog Sales

Many major department stores have been quite successful with their catalog operations. Never before in the history of retailing have so many retailers offered such a large number of catalog mailings to their customers. With the reasons already discussed, it is safe to assume that expansion in this area will continue. Some retailers have adjusted their divisional structures to include a separate one for catalog sales or direct retailing. Many stores in fact have separate buyers, product developers, and management teams whose responsibilities are only to the catalog, leaving the in-store operations to other management teams. Oftentimes, catalogs

will feature merchandise unavailable at the store, but most often many of the goods are available both at the store and through the catalog.

The enormous growth of catalog sales will be fully explored in a later chapter. These and other reasons have caused contemporary retailers to adjust their organizational structures. Since each merchant selects the plan that best suits the company's needs, it is unlikely that two organizations would use identical structures. Most department stores, however, opt for variations on the original Mazur Plan.

Variations of the Mazur Plan

While it is impossible to include every specific alternative Mazur Plan possibility, it is practical to include some that are typical. One retains the four-function or four-division concept and shifts some departments, two others utilize five-division arrangements, and another subscribes to a six-divisional approach. It should be kept in mind that these are merely general examples, with a host of variations of each used by large department stores.

Each example below will include only the major changes from the original Mazur Plan.

Plan 1

In this store, buying has been moved from the authority of the merchandise manager to the store manager (see figure 2-7).

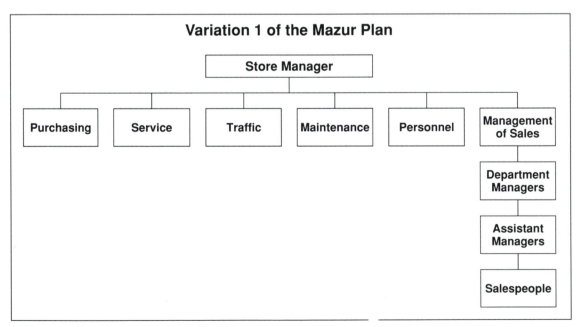

Figure 2-7. Variation 1 of the Mazur Plan

In this arrangement, the store manager supervises several department managers. Each department manager has an assistant, sometimes called a sales supervisor, who is responsible for selling in the department.

Plan 2

Plan 2 expands the structure to five divisions (see figure 2-8). They are controller, merchandising, publicity, store management, and store operations. In this plan, the store manager assumes the responsibility of supervising the managers in the selling departments, their assistants or sales associates, and the sales force. The store operations division assumes the departments once supervised by the store manager such as traffic, protection, service, etc. In some situations, personnel is found under store management.

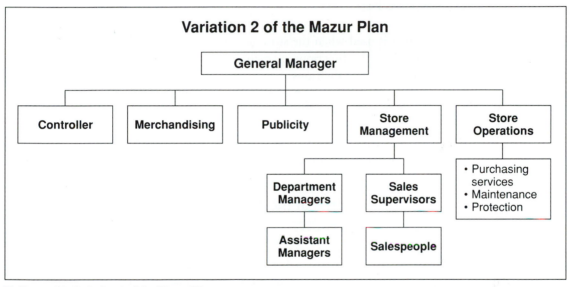

Figure 2-8. Variation 2 of the Mazur Plan

In this arrangement, the store manager has two separate areas, one for department management and the other for sales. Store operations heads all of those departments originally earmarked for the store manager in the Mazur Plan.

Plan 3

Plan 3 also uses five divisions (see figure 2-9). The original store management function now is divided into two separate departments: store management and store operations. The fifth division is for catalog sales.

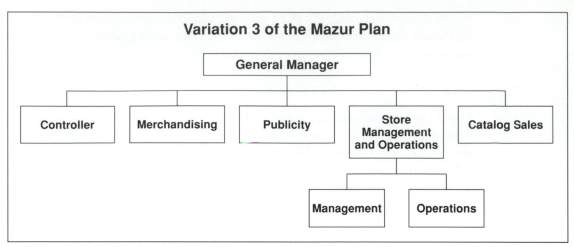

Figure 2-9. Variation 3 of the Mazur Plan

This plan is used when the store has entered catalog selling on a major scale. It also combines the functions of management and operations so that there are not too many separate divisions.

Plan 4

This six-division approach assumes that the store is a major operation with a catalog division and several spinoff stores (see figure 2-10).

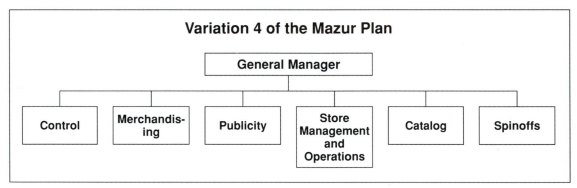

Figure 2-10. Variation 4 of the Mazur Plan

Organization of Branch Stores

As branch store expansion continued to grow, large department stores began to adjust their structures so that the branches might better respond to the needs of their customers. There are many different approaches used by companies for their

branches. The factors considered most heavily in the decision are based upon the number of branches in the organization, their size, and their distance from the main store.

In cases where the branches are smaller replicas of the parent catering to a similar clientele, the structure most often utilized is one in which the main store is responsible for all of the buying and merchandising as well as policy making for the branches and itself. The individual roles left to the branch units are those concerned with store and department management, human resources management, maintenance, and selling.

By employing this type of plan, the company is assured of uniformity of the merchandise mix, policies, and procedures. It also is a very economical arrangement, eliminating the expenses of separate buyers and merchandisers.

One of the most vital aspects of such an operation is a good reporting system. With the merchandising team often far away from the branches, it is necessary to generate a host of sales and merchandising reports for those responsible for purchasing. With the availability of such reports, the buyers and merchandisers can feel the pulse of each unit and make the necessary adjustments to inventory.

Figure 2-11 features a department store organization chart that is typical of stores that use the main store to merchandise the branches.

In some companies, where there are so many branches that it is not feasible for the main store to be responsible for all of the purchasing, buying is accomplished by the branches. This arrangement generally involves the company's merchandising managers to develop an overall plan or philosophy regarding price points, image, fashion statements, etc. which the branch store buyers must adhere to in their purchasing plans. While this does give each branch a good deal of autonomy, there is the possibility, if controls are not established, that the organization will lose its image and conceivably its purpose.

Organization of Chain Stores

A chain organization is a group of centrally owned and operated stores. Unlike the typical department stores, which generally have their base of operations at the parent or main store, chains operate from a home office or central headquarters where such functions as buying and merchandising, accounting, warehousing, research, real estate, and control are carried out. The individual stores or units are merely sales arenas where customers come to buy. Except for the hiring of salespeople and the task of scheduling, the decision making is determined at the company's headquarters.

Chains are considered the most economical form of retailing because they are able to reach the greatest number of potential customers while utilizing a relatively small management team.

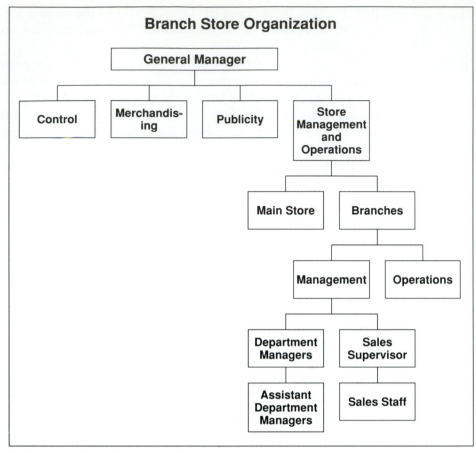

Figure 2-11. Branch store organization

The success of the chain organizational structure is based upon a number of factors:

1. The major decision-making functions are centralized. This plan allows for area specialists to make the decisions that might otherwise be assigned to lower-level store employees. This ensures uniform standards throughout the company.

2. Quantity purchases enable the buyers to secure the best prices. With just a few buyers often responsible for hundreds of stores, the purchasing power becomes a dominant competitive force.

3. Visual merchandising is often accomplished at company headquarters and carried out by store managers, thereby eliminating the need for trained trimmers to install displays.

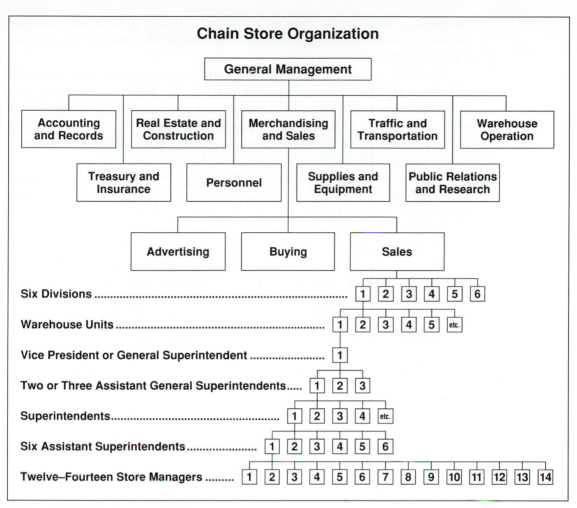

Chain Store Organization

Figure 2-12. Chain store organization

4. Good reporting systems enable management to keep in touch with the needs of each store.

5. Overall expenses are reduced because of the sharing by all of the units.

Figure 2-12 illustrates the organization of the typical major chain organization.

Centralization and Decentralization

While the chains are still predominantly centralized, critics have caused many to reexamine their operations, particularly in the area of buying and merchandising. Although the arguments to centralize accounting procedures, location selection,

warehousing, supplies procurement, equipment purchasing, advertising and promotion, and record keeping are sound, the justification for centralized purchasing is not as clear cut.

As a chain expands in size and moves into numerous geographical locations with different climates and trading areas that differ in socioeconomic demographics, merchandise needs often vary. The customer in Maine during the winter season will have many different clothing needs from her Florida counterpart. These and other factors have contributed towards a move to decentralization for some chains, especially those that are fashion oriented.

Today, many are using a concept called the **price agreement plan** in which the individual units of the chain approach merchandising in a more autonomous manner. The plan has been adopted by J.C. Penney, a company that has become increasingly more fashion oriented. Under this arrangement, the buyer in the home office visits the market and selects the vendors and merchandise. A list of these resources and items is developed from which each store manager chooses. In this way, the buyer has control over styles, price lines, terms, etc., and the store managers can select what best satisfies their individual store's needs.

Other decentralization has taken shape in warehousing. In the most centralized plans there is but one central warehouse from which merchandise is shipped to the various units. With many now opting for regional warehouses, merchandise may be sent more quickly to the stores. Many of these regional operations also have buyers who purchase specifically for stores in the region or district. In this way individual needs of stores can be more satisfactorily addressed.

With the enormous growth of chains and their locations all over the country, the movement towards decentralization will continue.

Small Store Applications

When a company is small, as in the case of one specialty store or boutique, there is little to think about in terms of organization. With very few people employed, the key management tasks are generally performed by the owner with some shared by a manager, if in fact there is a separate manager.

In companies of this size organizational plans should address situations such as when the employer is absent, away on buying trips, on vacation, or absent because of illness. In these situations a second-in-command should be assigned to take over. If there is a manager this naturally becomes his or her responsibility. In many cases, however, the store's employees are often salespeople. In this circumstance a particular salesperson should be given managerial responsibilities. These might include reordering merchandise, placing special orders, handling returns, making adjustments, etc.

When small retail operations expand either through the enlargement of the

premises or the opening of an additional unit or units, the organization must be more formally structured. Each additional department within one store should have a manager or assistant manager to deal with specific matters, or if the expansion is to other units, managers should be assigned to deal with decision-making problems.

While it is understood that small retail businesses cannot afford the luxury of staff or advisory positions, a well-defined line structure must be in place to maximize profits.

Highlights of the Chapter

1. Organizations, no matter how large or small, must be carefully structured so that efficiency and profitability will be maximized.

2. In any organizational structure, duties and responsibilities must be identified and lines of authority must be delineated so that each member of the company will understand the role he or she plays.

3. Retail operations are structured as either line organizations or line and staff organizations.

4. Small stores are always line organizations since their low volume does not allow for advisory assistance.

5. Most large department stores use the Mazur Plan or some variation of it for their organizational structures.

6. Some of the factors that led to the changes in the original Mazur Plan are separation of buying and selling, branch store expansion, the introduction of spinoff operations, and the growth of catalog sales.

7. Most branches are controlled by their flagship or parent store. This is particularly true for buying and merchandising.

8. By and large, chains are centrally operated and managed at the home office or central headquarters with the individual stores in the chain serving merely as a sales arena.

For Discussion

1. Differentiate between the organizational structures of small stores and large department stores.

2. Describe the major differences between line and staff positions.

3. Is it important for even the smallest retail operation to have a table of organization? Why?

4. Discuss the difference between store divisions and departments.

5. Who was responsible for the development of the concept of the four-function organization plan in America?

6. Briefly discuss the functions of the Mazur Plan.

7. Which of the Mazur Plan's four divisions have the greatest number of staff positions? Why?

8. Discuss the difference between the "buying" role under merchandising and the "purchasing" task found under store management.

9. Why did most major large department stores alter the four-division structure introduced by Mazur?

10. Explain some of the factors that eventually changed some department stores from five to six divisions.

11. For what reason do some large department stores operate their branches from one of their regular divisions but add a new division for their spinoffs?

12. Briefly describe the "price agreement plan."

13. Discuss some of the reasons for the success of the chain stores.

14. What are some of the reasons for decentralization in some chain organizations?

Tailored Woman began as a small retail operation with one unit in New Hampshire in 1978. After only two years the partners, Pam and Eleanor, decided to open another unit about forty miles from the first store. There, too, the store was greeted with enthusiasm, and Pam and Eleanor were on their way to having a successful chain operation.

With their third store, this one in Vermont, the partners began to realize that their informal approach to organizational structure was no longer appropriate for their business, but still neglected to develop a formal structure for the company. All of the major decision-making responsibilities were handled by the two. Pam was the buyer and Eleanor handled store operations for the three units. The only employees other than salespeople employed by the company were store managers for each unit.

At this time Tailored Woman is considering additional units in Maine and Massachusetts. Their profitability warrants the expansion but their informality in terms of organizational plans seems to be causing concern for Pam. While she agrees that they have achieved more success in such a short time than either of them expected, she believes that a more formal approach would maximize profits. She envisions a small central warehouse for receiving and ticketing merchandise,

an office for buying and merchandising, a small computer center for inventory control, and a shipping station for sending goods to the units. A small building that is central to the operation could be leased, and ultimately purchased, if the arrangements work well.

Eleanor, on the other hand, believes that the informal approach has been good to them and wants to continue that way. She still wants to use the first store's basement as their headquarters for record keeping. Merchandise should still be ordered separately for each unit, shipped directly to each by the vendors, and priced and ticketed by each. She believes that a computer is not necessary and that reports could still be manually prepared by the stores' managers and "called in" to the partners.

At this time no decision has been made concerning any possible organizational restructuring.

Questions

1. With which partner do you agree? Why?
2. Briefly describe a new organizational structure you would suggest for the company.

Beverly Hills is a fashion-oriented department store with its flagship in southern Florida and three branches all within 75 miles of the flagship. The company has always been traditionally structured with the Mazur Plan table of organization.

One of the major complaints of the company's buyers is that they never seem to have the time necessary to manage the sales staff in the main store where they work, let alone supervise the selling floors in the branches.

Mr. Arnold, founder and chief executive officer of the operation, feels that since its inception Beverly Hills' buyers have always managed the sales areas and should continue to do so. The buyers have responded by saying that buying has changed and the organizational structure must also change.

John Thomas, Mr. Arnold's manager of operations, agrees with the buyers and believes that a change is necessary so that the buyers could better attend to their purchasing responsibilities.

At this time Mr. Arnold is ready to entertain some adjustments to the table of organization if he could be convinced of the necessity.

Questions

1. Prepare a list of reasons why the buyers are not able to manage the sales staff as they once did.

2. Suggest an organization change that would make the company more manageable.

Exercises

1. Make an appointment to interview a member of a store's management team to learn about their organizational structure. Be sure to get information on all of the line as well as staff positions. Having acquired the information, prepare an organization chart that features all of the divisions and departments of the company.

2. Make an appointment to interview a store manager of a major fashion chain to learn about the store's operation in terms of centralization and decentralization. Every mall in the country has units of the nation's most important organizations. Discuss such areas as merchandise acquisition, employee hiring, advertising and promotion, and anything else that is important to the running of the operation. The information should be organized and presented as an oral report to the class.

chapter

3

The Fashion Consumer

Learning Objectives

After reading this chapter, the student should be able to:

1. Discuss the various factors that influence consumers with their fashion purchases.

2. Differentiate between rational and emotional motives and the role they play in the purchase of fashion merchandise.

3. Identify the demographic classifications and how they affect fashion purchasing.

4. Differentiate among the various sociological groupings and their characteristics.

5. List and explain the stages of Maslow's hierarchy of needs.

6. List the various stages of the family life cycle and each category's impact on the buying of fashion goods.

The success of any fashion retail business rests with the store's ability to understand consumer needs and offer merchandise that will satisfy those needs. Too often retailers are unaware of the fundamental principles of needs assessment and enter into businesses that are destined for failure. The practice of selecting merchandise that appeals to the store buyer without having addressed the potential customers' needs often results in an abundance of unsaleable merchandise and losses for the company.

While all merchants are faced with the task of merchandise selection, none is faced with more decision making than the fashion merchant. With new styles constantly being introduced by manufacturers and designers and quickly moving in and out of fashion favor, merchandising poses a serious problem. Stores that specialize in staple merchandise such as appliances do not have the same merchandising problems of their fashion-retailer counterparts. Color preferences for appliances do not change as rapidly or as drastically as those for clothing and

accessories, and the selling life for these products is comparatively long. A furniture operation generally resorts to special-order merchandising and only carries samples from which customers can choose. If some samples do not sell well, they are quickly replaced with others that might fare better.

The fashion organization must anticipate customer needs and place orders well in advance of the season, never knowing if the items will be accepted. Since fashion consumers generally want their selections at once, the stocking of a complete inventory is the rule. Not only must styles be selected, they must be offered in a variety of colors, sizes, and price lines to meet the customers' expectations.

The dollars expended for such a fashion merchandise collection is often very large. Before any decisions to purchase are made, the knowledgeable fashion retailer should examine all of the principles of consumer behavior, which will be explored in this chapter.

In addition to merchandise selection being aided by consumer behavior research, fashion merchants can also better understand the services that their customers want, the types of surroundings in which they prefer to shop, and anything else that would make their businesses more profitable.

Such concepts as consumer motivation, sociological groupings, the family life cycle, Maslow's hierarchy of needs, demographic categories, and psychographic segmentation should be explored.

With the enormous amount of competition facing the fashion retailer, the different levels of fashion merchandise available for purchasing, the various price points in the industry, and the different types of shopping environments and services offered, those most knowledgeable in terms of the fashion consumers' wants will regularly turn a profit.

Consumer Motivation

If every shopper who entered a particular store came there for the same reason, the retailer's job would be quite simple. That, however, is never the case. Some come to a specific shop because of the services provided, while others patronize the same store because of the available merchandise assortment. Others come for a still wider list of reasons such as convenience, price, and the assistance of knowledgeable salespeople.

In order to satisfy all of the potential customers' needs, many fashion retailers employ teams of psychologists and other researchers to study buying motives and, more specifically, consumer motivation. By understanding motivation—those reasons or forces that impel people to act in a certain manner—the retailer has a starting point from which to begin his or her assessment of the people in the store's trading area.

Rational and Emotional Motives

Motives are either rational or emotional. **Rational motives** are those that are logical or reasoned, and take into account such factors as safety, price, and security, while **emotional motives** are based upon romance, status, prestige, and social acceptance.

We know that different people considering the same merchandise are motivated to purchase for any one or more of these reasons. In order to reach the vast majority of the customers and potential customers through advertising and promotional programs, the retailer must make certain that the right motivational appeals are addressed. When featuring a Perry Ellis winter coat in an advertisement, for example, should the warmth of the garment be stressed (a rational reason for purchasing), or should status be underscored (an emotional reason) to capture the shopper's attention?

A simplistic and uneducated approach would be for fashion retailers to predetermine that all fashion purchases are made strictly because of emotional motives. While an abundance of fashion items that are bought by consumers are chosen because of emotional motives, we must not forget that price, durability, and serviceability are also important to some shoppers.

Most fashion purchases have both motives as the reasons for their consumption. A fur coat offers prestige (emotional) and warmth (rational); a fine watch, status (emotional) and durability (rational); and cosmetics, romance (emotional) and appearance (rational).

The task of choosing the appeal producing the most profit is no simple matter. The fashion retailer's continuous attention to the buying motives of those who are his or her customers will help in the selection of the most suitable merchandise and the correctness of the advertising and promotions that will bring those customers to the store.

Maslow's Hierarchy of Needs

One of the better-known theories that researchers of consumer behavior have subscribed to is Maslow's hierarchy of needs. This theory is based upon the belief that there is an order in fulfilling human needs. An individual must first satisfy the needs of the lowest classification before moving on to the next, and so forth. The five levels of needs are:

I. **The Basic Needs of Survival**. The basic needs of food, clothing, water, and shelter are most important. These are all rational needs and must be satisfied before any other needs can be considered.

II. **The Need for Safety**. Once the basic needs have been satisfied, the need for

safety comes into play. Rational purchases of sturdy walking shoes and sunscreens, for example, are important to this level.

III. **Social Needs—Belongingness and Recognition**. Purchases that are made to satisfy the needs at the first two levels have been rational and of minor consequence for fashion retailers. Beginning with this level, where purchases are made to gain acceptance by a group or to achieve recognition, the fashion retailers play an important role. Much of the purchasing is emotionally oriented with clothing and cosmetics leading the way. Clothing purchases are not simply for protection and serviceability, but for the purpose of attracting attention and feeling a sense of belonging to a particular social stratum.

IV. **The Need for Esteem and Status**. While recognition and acceptance are satisfied at the third level of the hierarchy, it is at this level that emotional purchasing plays the most important role. The need to be recognized as an achiever or a member of an upper social segment prompts individuals to satisfy their emo-

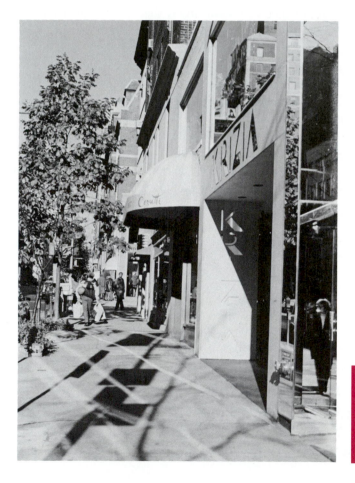

Figure 3-1. Those seeking esteem and status patronize shops such as Krizia, found on New York City's Madison Avenue. (Courtesy of Bonnie Keller)

tional needs with such high-priced merchandise as designer or couture fashions and accessories, and extravagant furs and jewels. Shops that are found on New York's Madison Avenue, Beverly Hill's Rodeo Drive, and Palm Beach's Worth Avenue all cater to the class that strives for self-esteem and status.

V. **The Need for Self-actualization**. People who are the highest achievers reach this level. Their world, in addition to the purchases suggested in level IV, involves self-fulfillment through the acquisition of artworks, travel, and knowledge. Their merchandise tastes very often turn to designers and couturiers who will assemble merchandise collections exclusively for them, although it should be noted that some individuals are so complete within themselves that they have no need for fashion.

In reviewing the hierarchy of needs it is apparent that the first two levels are of little importance to fashion merchants since purchasing is totally rational and must serve the basic needs for survival and security. The remaining levels have strong implications for fashion retailers who must determine how they could best satisfy the needs of recognition, acceptance, esteem, and status.

The Concept of Decision Making

By becoming familiar with the various stages of consumer decision making in terms of the buying process, the fashion retailer gains still another insight in satisfying the customer's needs. The process involves five stages.

1. **Awareness of a Need**. Some stimulus such as advertising, a visual presentation, or a promotion ignites the need for a product. It can also come from an invitation to a wedding, a planned trip, or any event that will result in purchasing.

2. **Gathering Information**. Once the mind has determined that the need is important, the next step will be to gather the necessary information to satisfy the need. In the case of the wedding invitation, a new dress might be warranted. Knowledge of places where the purchase could be made might come from advertisements, recollection of stores that had satisfied such needs in the past, or perhaps the suggestion of a friend.

3. **Evaluating Choices**. Oftentimes there are many selections from which to choose. The purchaser must evaluate each before a final decision can be rendered.

4. **Making the Decision**. Each item is carefully measured against established criteria that might include price, attractiveness of the product, alternate uses, and so forth. Once the items in question have been explored, a decision is

made to purchase or not to purchase. If a positive decision to buy has not yet been reached, the shopper continues the process until the need is satisfied.

It is at this level that the retailer plays an important role. Through understanding the principles of decision making, various approaches can be applied to assist the customer with the selection. This is where professional selling helps the consumer to narrow the choices and make a final decision.

5. **Satisfaction with the Decision**. After the sale has been consummated, the consumer's mind often considers whether or not the decision was appropriate. Was the red dress that was purchased as practical as the black one left behind? Was the price reasonable or more than should have been spent? Will the selection satisfy the shopper's emotional needs? These and other questions often tend to make the customer a "regular" or might dissuade her from again patronizing the store. It is therefore important for the retailer to be as helpful as possible by assisting the customer and making suggestions that will be both beneficial to her and the store.

The Self-concept Theory

In this theory, attention is paid to how the consumers perceive themselves. Fashion retailers can gain still another perspective of their customers by understanding the theory and applying it to the merchandising of their inventories.

1. **Real Self**. This describes what the individual really is in terms of ability, appearance, interests, etc.

2. **Ideal Self**. This is what the individual would like to be and is always trying to achieve. The fashion retailer who understands the ideal self-concept attempts to satisfy these shoppers by offering merchandise that would help them attain the desired image. The woman who saves and saves so that she can purchase a fur coat and feel successful and the man who uses the newest male-oriented line of cosmetics to achieve an impression of rugged, outdoors looks are two examples of this aspect of the theory.

3. **Other Self**. This is a combination of the real self and the ideal self. That is, what one's own self-image is.

4. **Ideal Other**. This aspect of the theory is how others perceive the individual and how the individual would like to be perceived by others. It actually combines the first three aspects of real self, ideal self, and other self.

If the retailer can feature products that would make the individual's ideal self emerge, sales would certainly increase. Fashion retailers are the merchandisers of luxury goods that often appeal to people who are trying to become their ideal selves.

Sociological Groupings

One of the concepts most utilized by fashion retailers in the determination of appropriate merchandise mixes and price points is one involving social classes. Groups of people are segregated into homogeneous divisions according to income, occupation, background, and other factors. Studies show that the different groups have different shopping preferences and merchandise needs.

The most popular approach to sociological groupings is to divide the population into six distinct classes. The following briefly examines each of the groups in terms of their characteristics, their fashion merchandise preferences, and the types of stores they generally choose for their purchases.

Upper-Upper Class

Those who are considered the socially elite and the possessors of old wealth account for approximately 1 percent of the population. They live in the country's most exclusive areas and generally own additional vacation residences. They attend the most prestigious educational institutions beginning with nursery schools and culminating in the best colleges and universities. They tend to be very charitable people, contributing money and time to a variety of causes. Many in this class have interests in the arts and are patrons and sponsors of museums, opera companies, and so forth.

Cost is rarely a factor in purchases made by the upper-upper class. Their fashion needs usually consist of fine quality, understated styles for their regular, daily activities and couturier-designed garments for the lavish dinner parties, charity balls, and other social events they regularly attend. They are the major supporters of the world's foremost designers.

The people in this class are regular purchasers at the world's most prestigious stores such as Bergdorf Goodman, Henri Bendel, and Neiman Marcus, and at such designer boutiques as Chanel, Yves Saint Laurent, and Gucci. Many frequent the exclusive designer salons in the United States and Europe to have clothing custom designed and tailored specifically for them. In addition to clothing purchases, they spend large sums on fashion accessories and extravagant precious jewelry.

Lower-Upper Class

Accounting for 2 percent of the population, these are the new rich of the country. The people in this class are generally professionals, executives in major corporations, or owners of businesses. Like their upper-upper class counterparts, they too

115A

Figure 3-2. The upper-upper class, considered America's socially elite, purchase the finest merchandise without cost consideration. (Courtesy of Neiman Marcus)

are well educated and participate in social activities, but their taste levels are more ostentatious.

Money is not a factor. They are conspicuous spenders and shop at the finest boutiques and specialty stores. Fashion merchandise selections are usually for clothing and accessories that will make them stand out in a crowd.

Upper-Middle Class

Among the best educated in the United States, the upper-middle class accounts for approximately 12 percent of the population. These people are concerned with prestige and status and seem to want to make the transition to the lower-upper class. They are professionals and owners of businesses and spend their leisure time trying to emulate those in the classes above them.

Although many in this class are high income earners, their wealth is sometimes less than needed to enable them to purchase as freely as they would like. In order to satisfy their fashion needs with designer clothing and other prestigious merchandise, this group regularly visits well-known fashion department and specialty stores at times when markdowns enable them to purchase high-fashion goods at reduced prices. The off-price shops such as Loehmann's and designer outlets like Anne Klein, Ralph Lauren, and Pierre Cardin found in off-price shopping centers are regular haunts for this class. Shopping there enables them to buy the same merchandise found in the traditional stores but for less money. Since recognition, by way of their fashionable wardrobes, is important to this class, they are the best customers for quality merchandise at bargain prices.

Lower-Middle Class

With approximately 30 percent of the population, the lower-middle class is the second largest group of people in the United States. They are primarily conscientious workers with conservative values and have a strong desire for their children to complete a college education.

Unlike the upper-middle class, they place less importance on "showy" fashions and consider price as a very important factor before making purchases. Where the "higher" classes shop prior to a season, they make their selections as needs arise. Thus, they purchase frequently, rarely spending large sums of money at one time for their needs.

People in the lower-middle class typically buy their fashion merchandise from department stores that specialize in popular-priced merchandise and from off-price specialty merchants such as Marshall's, Hit or Miss, and Filene's Basement. While they are interested in fashion, their selections very often center around

trendy merchandise. They are not terribly interested in quality or conservative styles, but rather tend to be motivated by the latest styles and colors. Fashion designer labels are not necessarily important to this group except in cases where they are deeply discounted by off-price merchants.

Figure 3-3. Lower-middle class shoppers seeking bargains are found shopping in stores like Filene's Basement. (Courtesy of Filene's Basement)

Upper-Lower Class

Accounting for approximately 35 percent of the American population, the upper-lower class is the largest sociological group. Generally poorly educated, they hold blue-collar jobs and have little left to spend on fashion merchandise.

The fashion merchandise that they do buy is generally very inexpensive. With price the most important factor, they often limit their purchases to discounters or department and specialty stores that specialize in the lowest price points. They are not designer conscious, but often choose the same brands over and over again.

Lower-Lower Class

With little or no education, the lower-lower class accounts for about 20 percent of the population. Many are welfare recipients and have just about enough to sat-

isfy their needs for survival. Fashion merchandise is generally out of the question except perhaps for an occasional outfit for a celebration. When they do shop for clothing and accessories they show little awareness for the styles of the times and often fall victim to high-pressure sales tactics.

Since fashion merchandise is available at just about any price point, it is necessary for merchants to know the makeup of their markets in terms of social class. In this way, they can satisfy the needs of their customers and potential shoppers by providing them with the types of retail operations they find suitable to their social stations, and the clothing and accessories they desire.

The Family Life Cycle

People who are at a specific stage in their life cycle generally have needs that are similar to others at the same stage of life. By studying these various segments or stages, fashion retailers can assess the needs of the particular groups in their trading areas. That is, if a geographic area is dominated by empty nesters, it is safe to assume that their needs and desires would have some similarity. It should be noted, however, that there are differences within each group in terms of income, occupations, educational levels and life-styles. These factors will be considered later in the chapter in the section "Psychographic Segmentation."

Single People

Typically, single people are among the lowest earners. They have few financial responsibilities other than rent and car payments. Today, more and more singles are reducing expenses by sharing apartments. Others are remaining at home with their families until the time comes when they get married. Those who choose the latter two routes have more to spend and are desirable customers at fashion shops.

A very small segment of this group is made up of young professionals. They are the largest wage earners of the single stage and spend great deals of money satisfying their wants.

Whatever the situation, the single group is generally focused on romance and recreation and the purchase of fashion merchandise. No matter what their incomes, a large proportion is spent on clothing and accessories that will enhance their life-styles. Fashion retailers at every price point value these individuals because they spend very freely and purchase very often. Whether it is a new outfit for the workplace or something for a social activity, they are always in the market for something new.

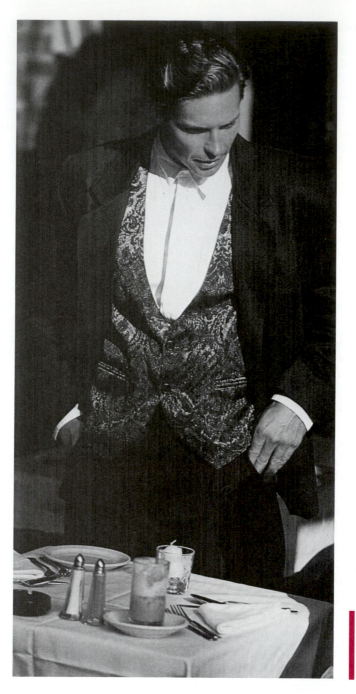

Newlyweds

One of the most sought-after groups by fashion retailers are the newlyweds. With two incomes, the newlyweds are big spenders. Even those with modest incomes

are better off than most of the other groups in the family life cycle because of their comparatively few financial responsibilities.

A new subcategory within the newlywed classification is DINKs—Dual Income, No Kids. These people often choose not to have families, and if they do, they wait a long time before embarking upon parenthood. They therefore earn more and more money each year and satisfy themselves with the most luxurious and prestigious merchandise. Fashion merchandise purchased by these people often includes sumptuous leathers, furs, designer wardrobes, and other status-symbol items.

Whether they are of the more affluent DINK classification, or just two-earner newlyweds, they are the favorites of the fashion retailing community. With price an unimportant factor and little time available for purchasing, they make their selections quickly.

Full Nest I

In this classification, the family has children, with the youngest under three years of age. In many situations a change in finances takes place because the wife chooses to stay home, leaving only one earner. In ever-increasing numbers, both the husband and wife continue to work, but a great portion of the income is used for child care, which cuts into the family's total income.

Where the wife chooses the traditional approach to child rearing and remains at home, there is generally a very tight financial situation. Spending is carefully approached and little is left for fashion purchases. The money that is spent on clothing now is reserved for special occasions, the remainder going for the purchase of children's wear.

In the case of the two working parents, more money is spent at the fashion retailer. The working mother needs clothing for her career and for social engagements that might be job related. This family, although not as comfortable in terms of income as they were before the arrival of their offspring, is still a better candidate for fashion merchandise than one that must rely upon one source of income.

The move from the newlywed group, where spending was more carefree, to this stage usually results in new shopping attitudes. More purchases are now made at retail discount outlets and off-price stores rather than the traditional, higher-priced department and specialty stores.

Full Nest II

Families in this category are in better financial situations than the group they just left. With the children between the ages of 6 and 18, most mothers who have not

already done so return to the workplace. The need for child care diminishes since all of the children are of school age.

The family's fashion needs become more pronounced, and significantly larger sums are spent on clothing for the entire family. The need to purchase bargain-oriented merchandise diminishes, and many families return to the traditional retail outlets for their fashion needs.

Full Nest III

At this stage, those children remaining at home are grown. Many work part-time, even if they are attending college, and pay for all or part of their support. Those who are working full-time often contribute to the family income.

Family income not only increases at this level but, since fewer expenses for children are required, there is more left for fashion-merchandise spending. The department store is again rediscovered by this group, and more fashion needs are satisfied. Higher-priced items are purchased and more attention starts to be focused on designer products.

Empty Nest I

At one time a majority of women left their jobs once the children left the nest. With less need for the additional income, work was not a necessity. Today, however, more and more women are remaining on the job until their spouses retire. It is this group that the fashion retailer wishes to attract to his or her store. The quality and quantity of fashion purchases increase since there is no longer a need to be regularly concerned with the expenses of child rearing.

Department stores, specialty shops, and boutiques are the places where this group spends its money for fashion items. In addition to purchases for their own needs, many in this category spend a great deal of money on gifts for their offspring. Much of it is for fashion merchandise.

Empty Nest II

When both the husband and wife retire, as in the case of these empty nesters, there is generally a decrease in income. Most people in this situation live on fixed incomes and drastically change their shopping habits. They shop less frequently for clothing and become increasingly price conscious. It is this group that returns to bargain shopping for their needs. The off-price retailer and discounter generally service this family. Fashion merchandise is n t generally directed to this group

since many no longer feel the necessity to regularly renew their wardrobes as they once did in earlier times.

Sole Survivor I

After the death of a spouse the sole survivor is the remaining partner. Still employed, the income level is sufficient to carry on a life-style that includes luxuries. Many sole survivors find a need to improve their images and begin to spend more heavily on cosmetics and clothing. The fashion merchant is finding that although their tastes are generally conservative, price is not as important as the merchandise they purchase.

Sole Survivor II

Now retired, this individual is primarily concerned with health and survival. The fashion merchant does not appeal to the people in this classification.

In reviewing the typical stages of the life cycle, it is apparent that a new group that falls within some of the categories needs exploration. There is an ever-growing population of divorced and single parents. The many problems confronted by these people, along with their often-limited finances, sometimes makes them different fashion purchasers. Some are gainfully employed and are purchasers of career clothing, while others, by necessity, stay at home to raise their children. In many cases, their fashion purchases are hampered because of their less than substantial incomes.

The fashion retailer cannot serve everyone's needs. The groups that are most tuned in to fashion merchandise are the singles, the newlyweds, the full nesters with grown children and the wife still working, and the empty nesters with the couple gainfully employed.

Each of the groups' fashion needs are satisfied at different price levels and at different types of stores. It is the fashion merchants who must understand the needs of the various groups and make every attempt to try to satisfy them.

Demographic Implications for Fashion Retailers

Marketers always use demographic studies in their quest to analyze consumers and their product needs. **Demographics** involves the study of population characteristics and the breaking down of the population into specific segments. Such areas of concern as population shifts, market size, family status and size, nationalities, and age groups play a significant role in addressing consumer wants and needs.

Fashion retailers also use demographic analysis to study their potential customers. Their involvement in this type of research, however, is not as involved as is that of the general marketers. Their concentration generally is confined to specific age groups and the shifting roles of their consumers. For example, the great number of women returning to the workplace necessitated a change in the way the retailer was able to reach that market.

Age Groups

By segmenting the consumer market according to age categories, retailers are able to determine the size of each group, its potential for growth or decline, and its distinguishing characteristics. In this way they can determine which groups are the best to target for fashion merchandise and, specifically, what their buying preferences are. The United States Department of Commerce segments the population in terms of age distribution as follows:

> Children (under 13)
>
> Teenagers (13–19)
>
> Young Adults (20–34)
>
> Young Middle-aged (35–49)
>
> Older Middle-aged (50–64)
>
> Elderly (65 and over)

While each group represents a prospective market for fashion retailers, each has specific merchandise requirements, and some are more important to the industry than others.

Children

A number of years ago, this group's fashion needs were not as important as they are today. With the enormous impact television makes on children, they are becoming more and more fashion conscious. No longer are most satisfied with functional, inexpensive clothing. They demand trendy fashion items that depict their favorite television characters and also want to emulate their favorite personalities by trying to dress as they do. The manufacturers who produce children's apparel are taking more fashion risks today to satisfy their customers' appetites. It should be understood that this market is especially difficult for fashion retailers since they must satisfy the demands of the children and the parents who are making the ultimate buying decisions.

Chains like The Gap and The Limited have recognized the growing impor-

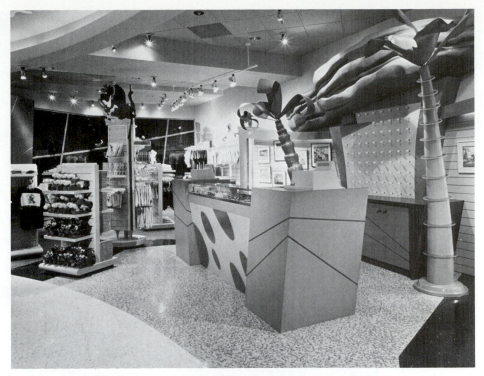

tance of this market and have opened many stores that feature fashion merchandise in sizes for those as young as six months.

Teenagers

No other group is as fond of trendy fashion merchandise as is the teenage market. Teenagers are usually quick to embrace almost anything that comes on the fashion scene. When short skirts are heralded as the latest style, they wear them shorter than any other group. If longer skirts are the fashion trend, the lengths that they choose often reach the shoes. Whatever color is promoted by the industry, they are sure to embrace it. They are the consummate shoppers, regularly visiting retail outlets to discover the latest fashion products.

This group is the perfect segment for fashion retailers who specialize in trendy styles. They generally choose less-costly garments since their needs are so great, they purchase quickly because they are easy to fit and their appetites have often been whetted by the fashion publications, and their purchases in terms of quantity are greater than the other groups.

Teenagers prefer the specialty stores to other types of retail environments.

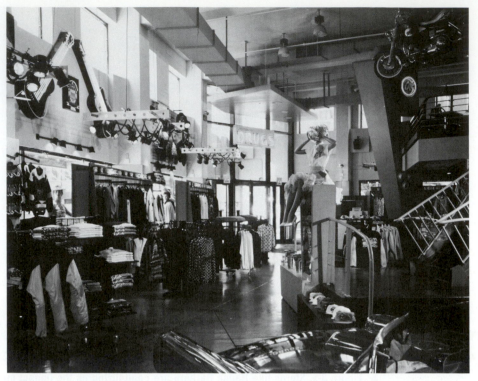

Figure 3-6. Companies like Merry-Go-Round attract the teenage market to their stores. (Courtesy of Merry-Go-Round)

Young Adults

The fashion needs of young adults fall within two classifications: clothing for careers and clothing for social occasions. With most young adults in the work force, and those completing college about to embark upon careers, their needs for fashion merchandise are significant. They generally spend more than their teenage counterparts since they are usually in better financial situations. Fashion purchasing takes place primarily in specialty shops where they can find merchandise assortments tailored to their needs and can accomplish the task in less time than in department stores. Stores like AnnTaylor, Merry-Go-Round, The Limited, Limited Express, and Victoria's Secret are paying close attention to the needs of this group.

Young Middle-aged

This group includes those with the highest incomes. They are the people who have reached the top levels in their corporations, are owners of businesses, or are professionals. Their incomes and life-styles make them the target for the best of

the fashion retailers. They patronize prestigious specialty and department stores and make significant purchases through fashion catalogs because their time for in-store shopping is restricted. Well-tailored quality designer merchandise is directed at this audience where price generally plays a subordinate role in their selections. Stores like Bloomingdale's, Neiman Marcus, Henri Bendel, Barney's, Saks, and I. Magnin cater to the young middle-aged and their fashion needs.

Older Middle-aged

The people in this group are often of two types. One is still career oriented and requires the fashions that are important to their everyday professional lives. They are often in the market for quality merchandise at upper-level price points. Since their careers often involve social obligations as well, they are the purchasers of fashionable occasional clothing. The other segment of this group has retired and spends more time in leisure activities such as travel and recreation. Their demands are still for fashion items, but often the classification is oriented more toward sportswear.

Whatever the case, this is an excellent market for the fashion retailer, particularly the department store where most in this group like to do their shopping.

Elderly

The elderly market is not typically as important for fashion retailers as are some of the others. The elderly are usually more concerned with health and other personal problems than they are about the latest fashions. Their purchases are usually for functional merchandise, often lower priced and more conservative in nature. They are said to be "difficult" shoppers because the majority live on fixed incomes and cannot spend frivolously.

Working Women

In ever-increasing numbers, women are returning to the workplace. The scope of their ages, careers, and life-styles has made this an important market for fashion retailers to embrace. Not only do they require fashion merchandise for their employment but with their improved financial situations they are participating in social environments often out of reach for single-income families. Many are joining country clubs or are making luxury trips, both of which require fashionable wardrobes.

While they are now able to afford better merchandise, many do not have the time to shop in the traditional manner. Retailers have had to make adjustments in their business operations to capture this market. Longer store hours and Sunday

openings have become necessary in order to cater to the working woman. Most major retailers have significantly expanded their catalog operations to gain a portion of this market's purchases. Stores like Neiman Marcus, Macy's, Bloomingdale's, and Saks that once infrequently used their catalogs have stepped up these operations with many mailing throughout the year. Not only have the numbers of catalog issues increased but so have the quality and styling of their offerings.

Some retailers have opened separate operations for this group with limited shopping time. Macy's, for example, has expanded its Charter Club department, found in its regular stores, by opening separate units in malls to sell to the working women who like the merchandise but cannot take the time necessary to purchase it in the department store. Liz Claiborne has opened separate retail shops for the very same reason. Their Liz Claiborne stores and First Issue operations are specialty units in which it take less time to purchase than in the stores that generally sell the Claiborne merchandise.

Special Size Groups

For many years, a segment of the population that was neglected by fashion retailers was the one that needed special sizes. Large-size women, tall and heavy men, tall women, and petites were some of the groups that found difficulty in satisfying their fashion needs.

Through careful study of these markets, some retailers determined that this segment of the population was larger than anticipated and that their fashion preferences were the same as the regular-size market. Once relegated to low-key, dowdy, unattractive merchandise, those in this group have quickly embraced the retailers who have paid attention to their needs.

In every major city and in every mall, shops for large and tall sizes have become commonplace. The Limited, Inc., in its Lane Bryant division, has addressed the problem and has come up with a winner. Many of the styles featured at Lane Bryant are adaptations of models sold in the company's traditional-sized stores. Colors, fabrications, and quality are equal to the merchandise found at The Limited. With a magnificent flagship on New York City's Fifth Avenue and branches in the most fashionable malls, Lane Bryant has captured an underserved market.

Attention to special sizes has not been exclusively focused on women. Large-size specialty men's retailers such as the He-man chain and the Big & Tall company carry a wide assortment of clothing and furnishings for above-average-height and -weight males. Through continuous demographic studies fashion retailers are able to make the changes necessary to improve their profitability.

Numerous retailers have captured the petites market by specializing in specifically proportioned merchandise for the smaller-figured female. Petite

By studying cohorts or groups, marketers are able to determine which would be the likely candidates for their products. Du Pont undertook research that would not only help them in their attempt to market the right fibers but would also enable retailers to examine their potential customer segments.

The study separated or segmented ten age groups, from 8 to 80, and investigated the values and consumption patterns of each. The findings of the study are presented below, along with the implications for the fashion retailer.

World War I Babies. The hardships brought about by the Great Depression had lasting effects on this group. They remain overly cautious in their purchasing of anything but necessities. This age segment is not one that is important to the fashion retailer. The merchandise purchased is often practical and functional and must last for many seasons. Little attention is paid to trendy or fashionable merchandise. When they do opt for merchandise with a fashion orientation it is usually bought at chains or department stores that specialize in lower price points.

Roaring Twenties Babies. They are not preoccupied with possessions but rather prefer to spend on travel, entertainment, etc. They are more fashion conscious than their World War I counterparts, but they too are not considered prime targets of fashion retailers. Their budgets for such goods generally decline when they are in their later years. Purchasing for apparel and accessories is often accomplished at off-price stores and discount operations, and at department stores during sales periods.

Depression Babies. Although a good deal of their income is spent on college tuition for their children, a significant amount is also spent on entertainment, travel, and luxury items. They are status spenders and are the prime targets of the fashion designer's offerings. Upscale department and specialty stores, boutiques, and designer shops are places where they shop.

World War II Babies. While much of the income is spent on rearing children, those in this segment are often devotees of fashion products. Many of the women are in the work force and require clothing and accessories that are fashionable. Since they have less time for in-store shopping than they would like, many shy away from the traditional department stores where purchasing is time consuming, and opt for the specialty store or the enormous number of catalogs that are sent to their homes. A large number of men and women in this age group are divorced, requiring less extravagant spending. Many, still determined to make fashion statements, shop at the off-price outlets that feature designer merchandise at prices below those of the traditional department store.

Mature Boomers. At ages 40 to 45, the mature boomers would like to spend on fashionable clothing but are often preoccupied with the costs of raising their families. They like nice things but cannot always buy in the amounts that they would like. Merchandise for this group would be fashionable but

continued

functional, with purchasing accomplished at chains, off-price centers, and specialty department stores.

Mid-Boomers. This age segment is from 33 to 39 years of age. The people in this classification spend more on fashion merchandise than any other group. Many work, therefore significantly increasing their family's finances, and spend to reflect their increased income. Making a fashion statement is a must for them. They shop at boutiques, specialty stores, upscale department stores, and places where their fashion appetites can be satisfied.

Young Boomers. Unlike their older siblings, these 26- to 32-year-olds are today focused on making

money and spending it as quickly as they earn it. Their fashion requirements are often trendy, with purchasing taking place primarily at specialty chains.

Mature Busters. The 20- to 25-year-olds are generally influenced by their peers when it comes to purchasing fashion items. They are greatly influenced by the fashion publications. They patronize lower price point stores since their incomes are usually too low to afford better. Quantity is more important than quality in terms of their clothing purchases.

Young Busters. At ages 14 to 19, these shoppers are not self-sufficient. Their part-time earnings go towards fashion purchases at the

trendy chain stores such as Merry-Go-Round and Pants Place.

Mature Boomlets. Although they are only 8 to 13 years of age, this group is one whose members are highly indulged by their parents. Many are already aware of style and fashion and influence their parents to purchase such merchandise for them. They are more "sophisticated" in terms of fashion than any others of that age group that came before them. Their needs are primarily satisfied at specialty chains.

Each of these age segments provides a market for fashion retailing. Merchants aware of the size of these markets and their fashion preferences will be better able to address their needs.

Sophisticates is such a chain that has found its niche by catering to their needs.

A demographic study that has implications for fashion retailers is one undertaken by the Fibers Department of Du Pont's Textile Division.

Psychographic Segmentation

While market segmentation helps retailers to assess their markets, **psychographic** segmentation, a more sophisticated approach to segmentation, enables them to better determine consumers' buying preferences and habits. For example, market segmentation might reveal that two individuals have incomes of $100,000. While this indicates a particular price point of merchandise he or she could afford, it does not indentify specific needs. If one is a business executive, a suit might be appropriate for work, while the other, a farmer, might not need executive business attire. When carefully used, psychographics not only tells what people buy, but why and how they arrive at their purchasing decisions. A study by SRI International on life-styles and values indicates how important such research is to fashion retailers.

After studying many of the concepts that attempt to classify consumers, it should be understood that trying to understand their behavior is no simple matter. A retailer

The first psychographic segmentation study was undertaken by SRI in 1978 and, based upon its value to the industry, it has been updated to examine its potential impact on today's consumers. The study suggests that each of the groups it defines has distinctive attitudes, life-styles, and goals that motivate the individuals within the groups to buy certain products. To the fashion retailer, each segment in the study, based upon characteristics such as education, income, self-confidence, intelligence and energy level, offers certain courses of action.

The study categorizes individuals into eight values and life-styles groups that are referred to as VALS 2 segments. After a brief description of each segment, their potential, in terms of fashion purchases, is discussed.

Actualizers. They are successful, sophisticated individuals with a great deal of self-esteem and income. They like change and are willing to try new things. Since they are considered to have cultivated taste and enjoy the finer things in life they are excellent prospects for fashion retailers who offer quality merchandise at the highest price points. Well-known international fashion retailers such as Bloomingdale's and Neiman Marcus in the United States, and Harrods and Printemps abroad, are typical of the shops in which they might satisfy their fashion needs.

Fulfilleds. These are mature, satisfied people who have achieved success in their lives, mostly as professionals. They are not prone to buy high-fashion merchandise, but are more content with quality, conservative apparel. Although they have the resources necessary to satisfy their needs at most price levels, they are practical consumers who consider function, value, and durability when shopping. They would certainly be at home at the traditional department stores for their fashion needs.

Believers. Traditional and conservative would best describe this group's taste level. They favor American-made, established brands that combine style and function. Middle-price-point stores such as Stern's, Burdine's, and Jordan Marsh are stores in which they would purchase their clothing and accessories.

Achievers. This successful class of people is career oriented, stable, and conventional in its approach to shopping. They generally prefer established products and traditional stores for their purchases.

Strivers. They are striving for a secure niche in life. They are low earners and are constantly seeking the approval of those in higher places. Because of their limited financial resources they are unable to obtain those goods that they would like. They shop at discount and off-price stores and lower-level specialty chains.

Experiencers. These young, vital, enthusiastic individuals are much sought after by fashion retailers. They will choose offbeat, high-fashion merchandise without usually considering the price. They will certainly be the ones to take fashion risks. They are avid shoppers and patronize the boutiques and fashion specialty shops for their clothing.

continued

must carefully examine each of the theories in terms of his or her specific retail operation and apply those that seem to be most pertinent. The study of the fashion consumer market should be an on-going project, since there are always changes that might alter the retailer's approach to getting his or her share of the market.

Small Store Applications

Rarely do small retail operations take the time to formally investigate the theories and concepts concerned with analysis of the consumers' wants and needs. Their approach to inventory procurement is generally based upon experience, intuition, or the information that is spread by trade periodicals and manufacturers' salespeople. Those who try to determine the needs of their customers do so from their experiences with them. That is, what sold last season, and what was left for the markdown rack, usually educates them in terms of future purchases.

While it is important to study past sales records to determine customer preferences, this approach is insufficient for today's fashion retailers. There are many new groups of people, yuppies and DINKs for example, that might be potential new customers that the store never before considered.

Unlike the giants of the industry who have researchers on their staffs to study the consumer or who utilize research organizations to tackle the task, the small retailer cannot afford the expenditures it takes to study the consumer in this way. By reading a basic textbook on retailing that offers information on consumer behavior, the small store will get a basic understanding of the principles involved. Subscribing to the trade periodicals such as *Stores Magazine, Women's Wear Daily, Daily News Records* and others, current, up-to-date information on the topic will provide much of what they need to understand their consumer market.

Highlights of the Chapter

1. With the enormous amount of competition facing the fashion retailer, only those most knowledgeable in terms of the fashion consumer's wants and needs will most likely be able to turn a profit.

2. Buying motives are either rational or emotional and need to be addressed before being able to determine the customer's wants.

3. Maslow theorized in his hierarchy of needs that there is an order of needs fulfillment that begins with satisfying the needs for survival before any other can be satisfied.

4. The self-concept theory consists of four types of self. They are the real self, ideal self, other self, and ideal other.

5. One of the most-utilized concepts used by fashion merchants in their determination of appropriate merchandise mixes is the one that deals with sociological groupings.

6. The family life cycle examines different groups of people at the various stages in their lives and addresses their needs and how they satisfy them.

7. Fashion retailers use demographic analysis as a means of studying their potential customers. They generally investigate age groups, working women, and special-size groups for information that would enable them to stock the right merchandise.

8. Numerous studies such as Du Pont's "Cohort" investigation and SRI International's VALS 2 study draw attention to the manner in which consumers make their buying decisions.

9. Psychographics employs a sophisticated technique of market segmentation.

For Discussion

1. What are the various factors that influence consumers with their fashion purchases?

2. Differentiate between rational and emotional motives.

3. Is the purchase of a dress a rational or emotional purchase? Defend your answer with sound reasoning.

4. List the five stages of Maslow's hierarchy of needs.

5. At which stage in Maslow's hierarchy does emotional purchasing become a motive? Why?

6. Distinguish between the real self and the ideal self in the self-concept theory.

7. In what way is the upper-upper class distinguishable from the lower-upper class? Discuss how their needs differ.

8. At what level of the sociological groupings does price become a factor when making purchases?

9. Which is the largest of the sociological groups? What kinds of shoppers are they?

10. Explain the terms "yuppies" and "DINKs."

11. How has the Full Nest I classification started to change in recent years, and what does it mean to the retailing world?

12. How does the teenage shopper differ from the young adult?

13. What types of fashion products have become more available since women have returned to the work force?

14. With in-store shopping requiring a great deal of time, how has the working woman been able to satisfy her clothing needs in less time?

15. What are the "special sizes" in fashion merchandise? Which major retailer has made a great effort to satisfy the needs of the people who wear the special sizes?

Five years ago, Sue Gallop and Muriel Litt entered into a partnership agreement for the purpose of purchasing a small, established specialty boutique. The store, located in an affluent Midwestern suburb, had been owned and operated for eight years by Margie Paxton. Its success was immediate, and Margie enjoyed the rewards of her business for all of the years of her involvement.

Her concept was to offer high-fashion, quality merchandise with an equal amount of designer clothing and custom-made models. Her clientele, initially drawn from friends and acquaintances, ultimately expanded to make hers one of the area's most distinguished fashion boutiques.

When Sue and Muriel purchased the store from Margie they put some of their own touches on the business, and the venture became one that was more successful than when it was purchased. Couturier designs from around the world were added to the merchandise mix, and they became an important part of the store's collection.

As the sales volume began to grow, so did the two partners' desire for expansion. They thought of adding a wing to their existing location but scrapped the idea, feeling it would take away from the intimacy that helped make the store such a winner. The other choice was to open another unit.

After a great deal of searching they came upon a location that seemed perfect. It was situated fifty miles from their first shop on a busy main street in a community that resembled their other location. The size of the vacant store was appropriate for their needs, as was the rent. A drive through the surrounding area drew their attention to the same types of houses that made up their first trading area. Their immediate response was that this was an ideal situation for a new venture.

Questions

1. Should the same type of housing for the new venture, as the first, be sufficient for Sue and Muriel to go ahead with the additional store? Why?

2. What demographics should they consider before they expand their operation to the new location?

3. What other types of consumer information should they seek before they make an ultimate decision?

Pauline Edwards is the name of an established, fine tailored shop for women. It has been in business at the same location for 25 years, serving the needs of the upper-upper class. The reputation was founded on impeccable service and a merchandise assortment that was "low key." Although the store's patrons could afford the glamour and style of the world's leading couturiers, they preferred a more conservative, elegant product.

When Pauline's son joined the company last year, he was full of new ideas that included expansion into other affluent areas. After examining many potential sites, he set his mind on one. It had about the same square footage as the other store, was already equipped with fine fixtures, and would rent for a price that was in line with what they could afford for the operation.

One problem that seemed to disturb Pauline was the area that surrounded the location. By the vastness and styles of the homes, it was obvious that this was an environment that was filled with the lower-upper class, people who are often referred to as the new rich. Her son Alex believed that this would be a benefit, since these people often spent more on clothing than their upper-upper class counterparts.

At this time they still have not decided if the new location will become a reality.

Questions

1. With whom do you agree on the assessment of the new area's class of people in terms of potential as the store's future customers? Why?

2. Aside from income, what other factors should they consider before making their decision?

Exercises

1. Select five fashion advertisements of retailers in newspapers and magazines and evaluate each in terms of their motives. Each advertisement's message and illustration should be assessed to determine whether it is rationally or emotionally oriented. Describe the key words in the message that indicate motivational orientation.

2. Divide the class into two groups and assign the students in each to a major shopping district, such as a mall or downtown area, to explore the consumer market according to the stages, distinguishing features, and buying patterns of the family life cycle. Using the format featured in the chapter as a guide, 100 people should be approached to determine where they fit in the cycle. Once the information has been collected and sorted, a report should be prepared showing the particular shopping district's population in terms of the family life cycle.

Problem Solving: The Role of Retailing Research

Learning Objectives

After reading this chapter, the student should be able to:

1. Discuss several areas of research used by fashion retailers to solve their problems.
2. Develop a study utilizing all of the steps in the research procedure.
3. Differentiate between the observation and questionnaire techniques for the gathering of data.
4. Distinguish between primary and secondary data.
5. Explain the importance of focus groups to the fashion retailer.
6. Prepare a questionnaire form to be used by stores for the study of their customers and potential clientele.

In the early days of retailing, merchants made most of their decisions based on intuition. They purchased what they believed best suited the needs of their customers in terms of style, quality, function, and price. They offered the services they felt were appropriate to their stores and hoped that the consumer would see fit to patronize them. For many merchants the plan worked well. They established successful businesses and enjoyed the fruits of their labor. Others were less fortunate and often were forced to close their doors because of their inability to attract a sufficient number of shoppers to make the businesses profitable.

Were the successful merchants just plain lucky, and those who were unsuccessful the victims of misfortune? While unseasoned people talk about success in terms of luck, the educated retail community speak in terms of being prepared to tackle problems of concern, such as being able to focus in on the right location,

designing the appropriate environment, selecting the merchandise assortment that suits the market's needs, providing the services required by the clientele, etc. Success comes from expertise, not luck.

Those who specialize in the business of fashion retailing have more concerns than those in any of the other types of retail operations. Not only must they face the various problems associated with retailing in general, but they must also deal with sudden changes in fashion, color changes, seasons, weather conditions, and so forth. The concept of "survival of the fittest" surely applies to the fashion retailer.

In order to meet the challenges of each day's problems, most of the major fashion operations prepare themselves by studying the marketplace. They might want to learn more about consumer behavior and habits, the demographics of their trading area, their potential customers' life-styles, the types of services required by their clientele to make them want to return again and again, and their fashion needs in terms of price, style, and quality.

Through research, many fashion retailers have addressed these and other problems and will continue to do so. They do so through a number of means and through the utilization of in-house research teams or outside agencies.

This chapter will explore all of the major areas of retailing research and the techniques employed to bring the information to the stores.

The Nature of Retailing Research

Retailers are faced with a significant number of problems that need attention before decisions are made. Those typically addressed include store location, the consumer, merchandising, advertising and sales promotion, customer services, human resources, sales methods, and competition. Each must be studied so that the organization will be able to function in the most profitable manner. The scope of each area will be examined in terms of questions that often arise and must be researched.

Store Location

1. What is the size of the trading area?

2. What are the demographics of the trading area? Specifically, what are the inhabitants' ages, occupations, education levels, and income?

3. Who are the competing stores, and are they in numbers that would enable another store to be potentially successful?

4. Is the particular type of retail environment appropriate for the intended business?

5. Do the available parking facilities provide a sufficient number of spaces for automobiles?

6. Is there a public transportation network that will bring shoppers who do not have their own transportation?

7. Are there competing shopping centers that are more conducive to the consumer's needs?

8. Is the specific site under consideration surrounded by compatible stores?

The Consumer

1. Will the consumer's needs be satisfied with the store's merchandise assortment?

2. Does the consumer in this trading area have the finances to purchase at the store's price points?

3. Will the store's hours of operation fit in with the consumer's availability to shop?

4. Is the target market psychographically segmented to fit the store's merchandising philosophy?

5. Are the consumer's shopping habits in line with the store's policies?

6. Are those within a particular sociological group matched to the store's image?

Merchandising

1. Does the merchandise mix feature the right assortment in terms of national-brand items?

2. Is there an assortment of private-label merchandise that will help meet the challenges of discounters and off-price organizations?

3. Is the price structure appropriate for the trading area?

4. When should fashion merchandise that is most appropriate for the consumers in the store's market be introduced?

5. How many times must the inventory turn over for the company to be profitable?

6. Should markdowns be handled as the need arises or should they be taken at more traditional times, such as after Christmas and the Fourth of July?

7. Is the automatic markdown system an appropriate vehicle for the store?

8. Would more frequent markdowns help to turn the inventory faster?

9. Should a small number of key resources be used for inventory procurement or should numerous resources be utilized?

Advertising and Sales Promotion

1. Which of the available media should be used to advertise the store's merchandise, image, and special events?

2. What proportion of the promotional budget should be spent on newspaper advertising?

3. Should advertising be promotional or institutional or a combination of both?

4. How often, if ever, should direct-mail pieces be sent to the store's customers?

5. What types of promotions should the store produce?

6. Should visual merchandising be handled by an in-house staff, or should freelancers be used?

7. Would the store be better served with an environment that could be enhanced with seasonal changes, or is a basic approach that spans the seasons a better choice?

Customer Services

1. Would a staff of personal shoppers increase sales?

2. Should gift wrapping be free or should a fee be charged for each customer's package?

3. Would a child-care center be beneficial to the store's overall sales?

4. Is home delivery appropriate to the store?

5. Would the use of foreign-language-speaking personnel increase sales?

6. Should third-party credit cards be offered in addition to the store's own charge accounts?

7. Would a gift registry increase sales?

8. What types of eating facilities would be appropriate?

9. Would free alterations improve sales?

10. Would opening the store earlier benefit the working man or woman?

Human Resources

1. Which sources of supply will provide the best employees?

2. What types of motivational techniques will reduce employee turnover?

3. What types of training are most appropriate to teach new employees about the store's policies?

4. Would an outside shopping service be a means to evaluate employee performance?

5. Should the human resources department have the final say in hiring salespeople?

6. Which benefits and services will motivate employees to stay with the company?

Sales Methods

1. Is self-service a viable approach to selling?

2. Should salespeople concentrate on one customer at a time or try to assist more than one?

3. Should employees be assigned to a specific merchandise classification or be placed in areas as the greatest needs arise?

4. Should a mix of service and self-service be incorporated into the store's policies on sales methods?

Competition

1. Should the store employ comparative shoppers to assess the competitor's inventory?

2. Should the number of competitors be evaluated in terms of the size of the market?

In order to make decisions concerning these and any other problems, the retailer has two courses of action open. The less-scientific approach involves decision making based upon management's belief as to how the problem should be addressed. After informal meetings are held, the problem at hand is tackled according to the wishes of the management team.

While many problems are handled this way, the formal approach is the better route to take. This involves conducting a study that utilizes an assortment of data from which conclusions can be scientifically drawn.

The Research Process

When retailers decide that important decisions must be made concerning any of the aforementioned areas, they may engage in formal retailing research. The task may be accomplished by using an in-house research staff, as is the case in many of the largest organizations, or by an independent research company. In some situations, the combination of an in-house staff and an outside consultant might be beneficial. Whichever approach is used, the methodology for studying the problem is the same.

Identifying the Problem

The problem might be one of determining the customer's acceptance of private-label merchandise. Another could address the restructuring of price points and the potential problems associated with it. Still another might involve the viability of spinning off several departments into separate, freestanding stores. Whatever the situation, the problems must be identified so that further action can take place.

Defining the Problem

Before the research can begin, the problem at hand must be clearly stated so that the researchers can provide a solution. The problems stated in the preceding paragraph are not sufficiently specific and need further defining. For example, in terms of price points, is the company trying to alter the price structure of every department or just one? Is the store considering private-label programs in all of its departments or just one? Are they going to spin off one department or many? These problems have been identified in overly general terms that must be narrowed before a study can be successfully formulated.

These same problems could be specifically defined as follows:

1. Would the store benefit from "trading up" in the dress department, eliminating the lower price points and adding higher ones?

2. Will private labeling be accepted in the shoe department?

3. Is the market for career clothing sufficient to warrant spinning off the "career shop" as separate, freestanding units?

With the problem statements now narrowed and better defined, the specific problems can be addressed. Without following this important procedure, retailers will not be able to tackle the problem. Once this is done, the research team can continue its efforts.

Gathering Data

Having specified the problem to be studied, the process moves to another stage. Data must be collected that will be meaningful to the problem being solved. The data come from two sources, secondary and primary.

Secondary Data

Data that is already available to the researcher is classified as **secondary data**. It may come from such sources as the company's records, studies that were conducted by governmental agencies and trade associations, private research organizations, and periodicals.

Company records. A great deal of valuable information may already be available from the company's records. With the numerous computer software programs available, retailers are able to keep records on every phase of their companies. Records of sales by every department and merchandise classification, customer returns, vendor analysis, catalog sales, employee turnover, commissions, and so forth are regularly generated and may be used to solve problems.

Governmental agencies. A great deal of information is generated by every level of government. The Census Bureau undertakes periodic studies of the general population, housing, and businesses, all of which provide valuable information for the retailer who is considering expansion. The Department of Commerce provides a great deal of timely information on business conditions that are appropriate for retailer use. The Monthly Catalog of U.S. Government Publications provides a host of materials that might relate to a researcher's project. Regular reports on new home construction, employment figures, and cost of living adjustments made available by the federal government may have implications for retailing studies.

Departments of resources and economic development on the state level and planning boards on the local level are also good sources of secondary information.

Trade associations. There are many trade associations that deal specifically with one aspect of retailing. It might be a local chamber of commerce or merchants' group that provides information about a particular trading area. The NRF, National Retail Federation—an outgrowth of the NRMA—is the world's largest trade association. It has thousands of retail members and regularly holds meetings where current problems facing the retailing community are addressed. Each year, at its annual general meeting in New York City, merchants from all over the world gather to give and receive information on the field. Many reports are generated as a result of the involvement of the world's leading retailers. Some of this information could be used to help solve many retailers' problems.

Private research organizations. There are numerous research organizations that engage in original studies. Many of these companies can provide pertinent information that might help retailers solve their problems. A.C. Nielsen surveys and ranks the television industry's programs in terms of viewership. In this way, when retailers such as Bloomingdale's and Saks Fifth Avenue consider the shows during which it might be most beneficial to run their advertisements, they can make their assessments based on the information provided by Nielsen. Other important research companies that could provide secondary information include IMS International, Research International, Market Facts, and Louis Harris & Associates.

Periodicals. Numerous trade papers and magazines regularly engage in research projects that may have an impact on the field of retailing. Such Fairchild publications as *Women's Wear Daily (WWD)* and *Daily News Record (DNR)* are full of information that often serves the needs of the fashion segment of retailing. *Stores Magazine*, a periodical published by the NRF, carefully explores every facet of retailing with emphasis on fashion and presents studies that assist retailers at every level. *Visual Merchandising and Store Design (VM&SD)*, a monthly periodical, examines the latest trends in display, visual presentation, and retail environment interiors and alerts the retailers to the latest in the industry's offerings. *Chain Store Age Executive* is another good trade publication that regularly examines the latest developments in the field.

In addition to these and other popular trade journals, consumer periodicals also can provide significant insight into contemporary problems faced by the retailing world. Many of the daily newspapers and monthly magazines gather data that can serve as indicators of retailing trends, many of which are pertinent to store studies.

After all of the secondary data has been explored, there might be a sufficient amount of information to solve the problem. If this is the case, the research should move on to analyzing the data and preparing recommendations for a course of action to solve the problem.

Often, though, the secondary sources do not provide enough information from which conclusions might be drawn and decisions made. In such situations, if it is deemed practical in terms of time and finances, original research should be undertaken.

Primary Data

Primary data are the data that must be obtained firsthand through original research. The information is gathered from customers, potential customers, employees, vendors, market representatives (such as resident buying offices), and the media. The major techniques employed in the gathering of data for retail studies are questionnaires, observations, and focus groups.

NEWSPAPER 2ND CLASS

California Apparel News®

Volume 46, Number 27, July 13–19, 1990
$1 ($1.50 outside California)

Figure 4-1. The *California Apparel News*, a trade periodical, typically engages in fashion-oriented research. (Copyright The Apparel News Group, Los Angeles)

Questionnaires. The questionnaire is the method used most often for information gathering. It is more costly than any of the other techniques and takes more time to gather than the others, but by and large it provides the broadest range of data. Questionnaires may be distributed through the mail, filled out over the telephone, or used as the basis for a personal interview. The type chosen is dependent on such factors as the trading area to be examined, the size of the research team available for gathering the data, finances, and the time allocated for the collection of the data. Each has advantages and disadvantages that must be considered by the research team before the decision to use one is finalized.

Before deciding which questionnaire technique is most appropriate, other decisions must be made.

- The length of the questionnaire is important. It should be as brief as possible, rarely occupying more than one page. This is particularly true when using the mail. Many potential respondents will often discard the questionnaire if it seems to be too long.

- The language used in the questions must be easy to understand. In using the mail, when interviewers are not present, ambiguous questions might be incorrectly perceived or merely passed over. Even in the case of personal or telephone interviews where individuals might clarify the question's intent, interviewer bias might cause answers to be unfairly given.

- Questions must be arranged sequentially so that a smooth transition from one to another can be made.

- Every question must be specific. When words such as "generally" or "usually" are used, there is too much room for interpretation. The two words might have different meanings to the respondents and could alter the reliability of the research.

- Wherever possible, choices should be provided for the possible answers. In this way, the data will be easy to tabulate and will not necessitate researcher interpretation. Where open-ended questions are considered important, sufficient space should be provided for the responses.

Mail Questionnaires. When a very large market is to be surveyed and it is deemed that more time is necessary to study the questions, the mail questionnaire is often used. This format is sometimes favored by researchers because interviewer bias is eliminated. Only the respondent, without outside influence, will answer the questions. Costs are generally lower than those of the telephone and personal interview formats since questioners are not used to elicit answers. One of the costliest aspects of the telephone and personal interview techniques is the salaries of the interviewers.

Of course, the mail questionnaire has its disadvantages. The rate of response is very low, with a 10 percent response considered excellent. The time it takes for respondents to return their forms may be very long. Many research companies are offering money to those who respond, with additional amounts for early replies. Some stores using the mail format often promise merchandise discounts for completed questionnaires. Sometimes, even with considerable attention paid to the development of the questionnaire, questions might be difficult to understand, and the unavailability of interviewers might result in an incomplete response.

Telephone Questionnaires. When time is of the essence, the telephone brings the quickest responses to the researcher. Not only does the time factor provide an advantage, so does the cost. With WATS lines, calls can be made anywhere with little expense. Another advantage of the telephone questionnaire is that calls can be made from a central location, thus eliminating the field staff needed to make personal interviews. Questions that are not easily understood can be explained, but this of course necessitates professional, unbiased interviewers.

While the benefits are certainly evident, the use of the telephone has some shortcomings. Interviewees are often reluctant to divulge information of a personal nature to those they cannot see. With this negative aspect, the number of respondents may be severely limited. Since so many women have returned to the workplace, there is less time for them to take telephone interviews. Even when they are at home, they may be too busy to want to participate. Although it is still the quickest approach for consumer contact, the success rate has also diminished because of telephone answering machines, which are activated when people are not home or when they want to monitor their calls.

Many researchers employ computer-assisted calling systems, in place of humans, for their surveys. A voice describes the research and proceeds to ask the questions. Some companies are finding that this reduces the cost of interviews, and if the call is unsuccessful the machine can quickly and automatically dial the next number.

Personal Interviews. Companies that prefer the personal interview type of questionnaire approach people in a variety of places. In-home interviewing, once an important approach, has lost some of its appeal. First, fewer people are at home today because of the two-income family, and when they are available, there is often a resistance to spend any available time for interviews. Even when someone might be willing to participate, there can be a reluctance to open the doors to strangers.

In an effort to overcome the adverse reactions of many to being questioned in the home, many retailers use their own premises for the survey or the malls in which they are located.

Whatever the place, there are advantages and disadvantages to personal inter-

viewing. On the plus side, experienced interviewers are trained to convince people to participate. They also may help clarify questions for the respondent or make visual observations (such as the dress of the individual) if this is deemed important, and can elicit more information than offered for open-ended questions. On the negative side, expenses associated with personal interviewing are high, bias can be reflected in the responses, and answers might be exaggerated out of interviewee embarrassment. For example, if age or income is a requisite for answering the questions, the interviewee might make "amends" and color the information.

Dear Charge Account Customer:

In our attempt to bring you the timeliest, fashion-forward clothing and accessories, we have always scouted all of the domestic and international designer markets. Because we believe that many of you would appreciate a fashion collection that includes merchandise exclusive to our company, we are developing a new, private label that is designed with you in mind. We will continue to feature all of your designer favorites along with the new private-label merchandise. Since we value your judgment and opinions, we would like you to participate in a survey so that our new concept will reflect your fashion needs.

Please complete the attached form and return it with a stamped, self-addressed envelope. If you would respond within one week from today, we will show our appreciation by sending you a 10 percent discount certificate that can be used on your next purchase.

We want to assure you that your answers will be kept anonymous.

1. What percentage of your fashion needs are purchased in our store?

2. In which department(s) do you buy most of the fashion items?

3. What prices are most indicative of your fashion purchases?
 dresses_____ sportswear_____
 suits_____ coats_____
 shoes_____ accessories_____

4. Which designer names do you consider to be your favorites?
 _____ _____
 _____ _____

5. In which product categories would you favor private labels?
 _____ _____
 _____ _____

6. Would you like the private-label items to be featured along with regular designer items in the same department?
 _____Yes _____No

7. Could you suggest a name for our new private-label line?

8. (To be answered only by female respondents.) Are you employed outside of the home?
 _____Yes _____No

9. What is your approximate family income?
 _____under $20,000
 _____$20,000–$29,999
 _____$30,000–$39,999
 _____$40,000–$59,999
 _____over $60,000

10. How would you describe your family status?
 _____Single
 _____Newlywed
 _____Married with small children
 _____Married with grown children (at home)
 _____Empty nester (still working)
 _____Empty nester (retired)
 _____Divorced

Figure 4-2. A questionnaire aimed at charge account customers.

An article by Randall Rothenberg in the *New York Times*, "Surveys Proliferate, but Answers Dwindle," perhaps best sums up the seriousness of the problem faced by researchers in finding people to answer questions. He states, "Deluged by a growing number of telephone solicitations and increasingly jealous of their time, more and more Americans are refusing to participate in market-research surveys. Miami, Fort Lauderdale, and Los Angeles have the least-cooperative residents, interviewers have found, and more than a third of all Americans contacted routinely shut the door or hang up the phone on their questions."

Figure 4-2 features a questionnaire typical of those used by fashion retailers.

The other two research techniques employed by retailers to study their markets, observations and focus groups, are easier to use. The former requires no participation by anyone other than the observers, and the latter uses a leader and a very small number of participants who are paid for their time.

Observations. In specific circumstances, retailers use the **observation** technique to gather data for their surveys. Those considering prospective locations for their stores must, in addition to studying the typical demographics of the area, determine if there is a sufficient amount of traffic in a particular locale to warrant opening the business there. A **traffic count**, a type of observation, is undertaken to study not only the amount of vehicular traffic passing the proposed site, but the types of vehicles and the number of passengers aboard each vehicle. Through these recorded observations, conclusions can be drawn to evaluate the numbers of passersby and their sexes, ages, appearance, and so forth, all of which may be meaningful to the decision about locating the store.

Another type of observation is the **fashion count**. Some fashion retailers use this method to record the specific styles worn by a particular group to help determine if their fashion projections are in line with customer preferences. The theory is based upon the premise that if people are wearing certain styles, they like them enough to warrant purchasing them. Thus, if a large percentage of women in the study are observed wearing leather boots with high heels, it would signal the retailer to purchase more boots.

The fashion count is particularly important in times of radical fashion change. When the past five years, for example, indicates that women are happy with longer-length skirts and the industry promotes extremely short skirts, the buyers are uncertain of how to replenish their inventories. While fashion-forward retailers must always embrace the latest styles to retain their images, they must also be aware of the dangers inherent in overstocking what the industry is trying to promote. Too many times merchants have had to take enormous markdowns (reductions from the original selling price) when they discover that their customers do not always take to the fashion market's dictates. By taking fashion counts in such situations, a safer position can be determined.

Some of the advantages of both traffic and fashion counts are their low costs,

```
+-------------------------------------------------------------------+
|                        Fashion Count                              |
|                      Ladies' Swimwear                             |
|                                                                   |
|  Style                   Fabric Type              Color           |
|  _____  |
|                                                                   |
|  1 piece, maillot        latex                    white           |
|                                                                   |
|  1 piece, 1/2 skirt      spandex                  black           |
|                                                                   |
|  1 piece, high cut side  woven cotton             red             |
|                                                                   |
|  1 piece, boy leg        knitted                  yellow          |
|                                                                   |
|  2 piece, bikini         jersey                   orange          |
|                                                                   |
|  2 piece, string bikini  mylar                    light blue      |
|                                                                   |
|  2 piece, boy leg                                 navy blue       |
|                                                                   |
|  other _____        other _____         purple          |
|                                                                   |
|  _____              _____               print           |
|                                                                   |
|                                                   stripe          |
|                                                                   |
|                                                   other _____   |
|                                                                   |
|                                                   _____    |
|                                                                   |
|  Location of Survey: _____          |
|                                                                   |
|  Instructions to Recorder:                                        |
|    Place a circle around one appropriate item in each category.   |
|  If the swimsuit observed does not fit a particular item, write   |
|  a description of it in the spaces provided.                      |
+-------------------------------------------------------------------+
```

Figure 4-3. Fashion count for ladies' swimwear.

the ease in which they are organized, and the little time it takes to gather the data. What is most important is the accuracy of the recorded information.

Traffic counters most often must record such information as the types of vehicles that pass the location, the times they pass, and general descriptions of the occupants. Forms are developed that enable the counters to quickly note what they have seen.

Fashion counters are usually called upon to record three or four different style elements worn by a preselected group. They are sent out in teams, with prepared forms in hand, to places where people they wish to count congregate. If high-fashion evening wear is being investigated, the opening night of the Metropolitan Opera in New York City might be an appropriate choice. If funky fashion is the topic, the "hot" discos might serve as the proper arenas for such research. Whatever the situation, the right place must be targeted if the results of the count are to be meaningful.

Figure 4-3 features a fashion count form that was used by college students in taking a retailer's sponsored research study.

Focus groups. A technique that has been given a great deal of attention by researchers is the one that utilizes small groups of people. A panel of eight to ten individuals is chosen to voice their opinions about a variety of concerns facing the company. Retailers might choose regular customers from their charge account rosters or others because of their potential as customers. The problems they are asked to address include store service, prices, merchandise assortment, advertising, employee assistance, hours of operation, and so forth.

Some retailers elect to use these groups on a regular basis, such as once a month, or for only one session. The costs are comparatively little, perhaps $1000 for each meeting.

One of the most important considerations in the use of focus groups is the selection of the moderator. The person chosen should have a background in industrial psychology and the ability to communicate with the participants.

It should be understood that this is merely one approach to gathering information and the results should not be a signal to change store policy. Other investigation must be undertaken before changes are made.

Once the format is determined for the research project, a decision must be made in terms of how many consumer participants are needed to make the investigation meaningful. As we have just learned, focus group sizes are easy to determine. The numbers used in questionnaires and observations vary.

Sampling

When a market is being studied, it is neither necessary nor practical to survey everyone in the market. When the A.C. Neilsen organization, for example, evaluates the size of television audiences, it uses 1200 families for research. This seems like an insignificant number when the population of the United States numbers more than 250 million. Such a group, used by Neilsen and other researchers, is called a **sample**. A sample is a representative group of the people to be studied. The size, selection, and scope of the sample is extremely important to any research and should be decided upon with the assistance of a statistician.

Collecting and Tabulating Data

Once the decision has been made to undertake the project and all of the forms have been constructed, the data must be collected. If the observation approach is used, the locations of the count should be selected and the observers chosen and trained to carry out the survey.

If a questionnaire is the instrument to be used, the methodology for data collection, such as the mail, telephone, or personal interview, should be decided. In the cases of telephone and personal interviewing, the information gatherers must be trained so that bias will not enter into the questioning technique, and that everyone understands the nature of the project.

When professionals are used to gather data, less attention must be paid to training. On the other hand, when novices are being used, or the project employs untrained housewives or college students, extreme caution must be exercised. The manner in which one approaches the customer, either on the phone or in person, the handling of unwilling participants, the recording procedures, and so forth must be addressed so that accurate data will be forthcoming.

After the data have been collected, they are compiled and processed. With the use of the computer, researchers can more easily tabulate the data so that the analysts can prepare their findings.

Data Analysis and Report Preparation

The data collected for the project are compiled and summarized. Charts, graphs, and other instruments used in research are constructed and made ready for use in the findings and recommendations. Each project requires a different amount of time and effort for data analysis and report preparation. The information gathered from a focus group is simple to analyze when compared to major surveys that have several hundred responses from questionnaires. Whatever the size of the study, it is always important to present the findings, along with the recommendations, in a written report.

The report should summarize all of the stages of the research process, the methodology used in the collection of the data, analysis of the data, recommendations, and an appendix that includes the data and their secondary and primary sources.

For a more intensive study of data analysis and report preparation, it is suggested that the reader examine a text that specializes in marketing research.

Small Store Applications

Many small retailers wrongly believe that research is too costly and therefore only appropriate for the giants of the industry. While small stores do not have the need for in-house staffs or cannot afford the expenses associated with private research organizations, they can utilize simple studies that would be very inexpensive and easy to conduct.

A small, independent fashion retailer wishing to learn customers' preferences

firsthand could assemble a focus group of ten people from his or her customer mailing list. A student majoring in industrial psychology could be employed at minimum expense for a few hours to lead the group. Those who participate could be rewarded with merchandise discounts on their next purchases. In this way, a host of topics could be explored ranging from merchandise selections to salesperson courtesy.

Another approach would be for the small retailer to contact a local college's marketing research class for their assistance in a survey. Many college professors welcome the opportunity to have their students gain hands-on experience. Such a class would develop the questionnaire or observation forms and collect the data. With the help of the professor, suggestions could be made for the problem's solution. A donation to the college would generally suffice as payment for the participation.

Highlights of the Chapter

1. Retailing research cuts across many areas including store location, merchandising, customer analysis, advertising and sales promotion, customer services, human resources, sales methodology, and competition.

2. In order to take the guesswork out of their decision making, retailers use either in-house staffs or outside professional agencies to help solve their problems.

3. Before original research is used, it is appropriate for researchers to explore all of the available secondary sources of information.

4. Primary research involves the study of people through the use of questionnaires, observations, and focus groups.

5. It is not necessary to study each individual in a potential market—just a small, representative body known as a sample.

6. After data has been collected and analyzed, it is important to prepare a written report showing all of the methodology used in the survey along with recommendations.

7. Small retailers may utilize cost-effective research to study their markets.

For Discussion

1. List five areas that must be researched before a company should sign a lease for a new unit.

2. Differentiate between "identifying the problem" and "defining the problem."

3. What are secondary data?

4. Which secondary source of information is most readily available and most important to the retailer?

5. How might the governmental agencies provide assistance for retailing studies?

6. Define the term "primary data."

7. Which type of questionnaire provides the researcher with the quickest responses?

8. Why is the use of in-home personal interviewing becoming a difficult approach to employ?

9. What are the two types of observations employed in fashion retailing research?

10. Discuss the workings of a focus group.

11. Define the term "sample" as it pertains to research.

12. Why have collected data become easier to tabulate and analyze in recent years?

13. What is the final stage of the research process?

14. How can small retailers participate in research with little financial investment?

Cameo Fashions is a small retail organization. They have been in business 12 years and have been able to expand their operation to three units. Each year, sales have increased and the company has become extremely profitable.

The store's merchandising philosophy has been **fashion forward**, providing the latest in styling for their customers at price points that would be considered moderate. Dresses, for example, range from approximately $90 to $195, sportswear from $25 to $150, and accessories from $15 to $100. They offer a host of services and enjoy a very loyal customer base.

During the last year, the Cameo partners, John, Marc, and David, have become aware of a situation that might be meaningful to their organization. Real estate value has soared, and many homes have started to bring prices never before witnessed in their trading areas. Along with the higher-priced homes have come more affluent families. Another factor with implications for the company is the construction of two new luxury developments in locations close to two of Cameo's stores.

After a great deal of discussion, the partners remain divided on how to approach the area's wealthier population. John believes trading up to higher price points would be the best approach. Marc suggests that they have been successful for all these years and should not look for trouble. David believes that a broad price range would be most practical and would ccommodate the old and new customers.

Questions

1. Should the partners follow any of their own beliefs? Why?
2. How should they approach the situation in a more scientific manner?

Fashionable Feet is a women's shoe store that features a variety of footwear for casual, business, and evening dress. They carry many of the designer lines along with a selection of imports from Spain and Italy.

Although they are still a profitable shop, they have noticed that sales are not increasing at the rate to which they were once accustomed. In fact, this past year's financial statement indicated a decline in sales.

The partners are concerned since no changes have been made in the operation to warrant the downturn. They carry the same lines they always have, at prices that have only increased because of inflation, and have retained virtually the same staff to serve the customers.

After careful inventory analysis, the store's owner, Margaret Elliot, noticed a drop in sales in the casual shoe classification. The customers still enthusiastically responded to the business and dressy shoes, but have lately shown a declining interest in the casual type. Margaret was puzzled since she carries the same casual lines as in the past, and in the same styles that were always customer favorites.

In two months she will be faced with making her purchases for the next season and does not know how or if she should adjust her inventory.

Questions

1. Should she drop the casual shoe classification totally?
2. How could she, with minimum expense, research the problem?
3. What do you think are the reasons for the decline in casual shoe sales?

Exercises

1. The class should decide upon a topic that would best be researched through the use of the observation technique. It might be a fashion or traffic count. Once the subject to be explored is selected, a form similar to the one featured in the text should be developed. After selecting the appropriate place for the research to be conducted, teams of students should be sent into the field to collect the data. After the data have been sorted into categories, a report should be presented to show the findings of the study.

2. A fashion retailer in the area should be contacted to discuss the possibility of doing a research project for the store. It might focus upon the store's merchandise assortment, customer services, or anything of interest to the retailer. After gaining the retailer's approval to conduct the study on the store's premises, the stages of the research process should be followed. A questionnaire should be developed, the data collected and analyzed, and a report written. Sometimes a merchant is willing to present the school with a reward such as discount cards for future purchases for the participants, the purchase of a piece of equipment, or the donation of funds for a school social event.

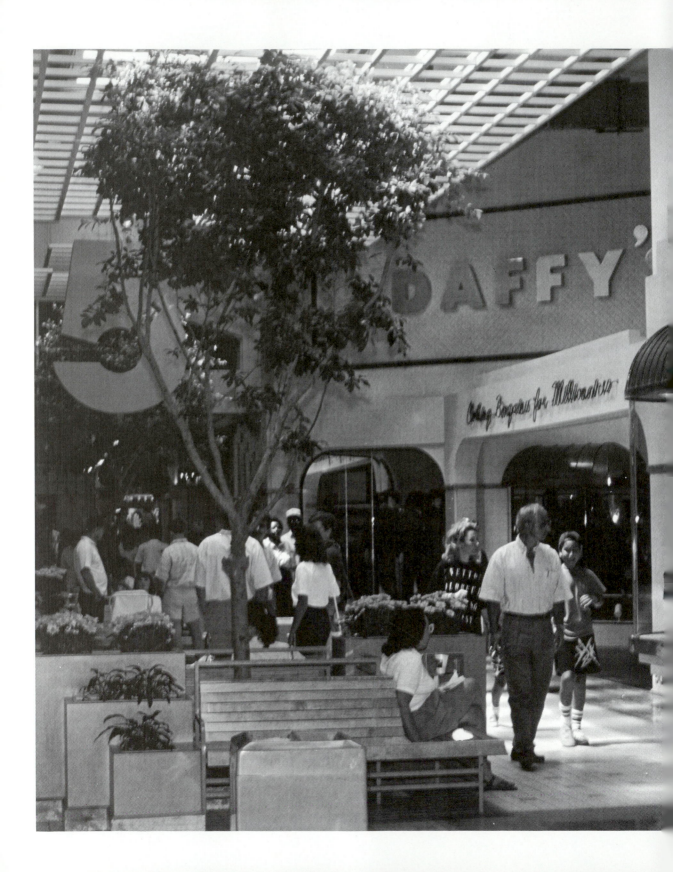

The
Fashion
Retailer's
Environment

Store Location

Learning Objectives

After reading this chapter, the student should be able to:

1. Explain how a location is analyzed before the retailer determines its viability for a successful operation.

2. Discuss the importance of population, area characteristics, and competition to store location.

3. Describe the various types of shopping districts for fashion retailer use.

4. Discuss site selection in terms of competition, neighboring stores, and travel convenience for the potential shoppers.

5. List several trends in store location.

When seasoned retailers are asked which three factors they consider most important to the success of a new retail venture, the answer most often given is "Location, location, location!" This is not meant to undermine the importance of the many other factors to be considered before embarking upon a new venture, but to underscore the vast significance played by location in terms of retail success. All too often, inexperienced would-be retailers elect to forego a choice location in favor of a lesser one simply because the costs of leasing a prime site are considered too high. Considerable sums are thus expended by individuals on store design, fixturing, visual merchandising props, and so forth, only to painfully discover that the one element necessary for success was overlooked. There is nothing as disheartening in the field as a store that is elegantly designed in a place where consumers never seem to venture. While it is occasionally true that a merchant finds good fortune in an "off the beaten path" location, this tends to be the exception rather than the rule.

The choices for store location are more varied than ever before. While once it was the downtown, or "central district" as it was often called, or the huge regional malls that were considered to be the most viable retail locations, today merchants are discovering a host of new environments in which to begin or expand their businesses. Careful analysis of the many trading areas and shopping districts is

essential before leasing or purchasing any retail property. Fashion merchants are choosing places never before considered to be appropriate for their needs and are achieving unparalleled success in them. Abandoned factories, reclaimed historical landmarks, superhighway arteries, and "power centers" have been added to the traditional roster of major retail locations. It is a combination of location analysis and creative thought that has given the retailers new homes for their businesses.

Choosing the Location

Selection of the most suitable location involves a three-pronged approach, beginning with the choice of a trading area that best serves the needs of the particular company, followed by the exploration of the available shopping districts within the desired trading area, and ending with the choice of the exact site. Each of these will be carefully explored to show their importance to the process and how they interrelate to the others.

Analysis of the Trading Area

How far a customer will travel to a particular store depends upon that store's drawing power and the customer's need for the specific merchandise offered for sale. When a person is looking to buy a container of milk or a pack of cigarettes he or she will go to the closest possible place. If the potential purchase is for an exclusive dress, the individual will often travel great distances to satisfy her needs. The place or places from which stores can expect their customers are called **trading areas**. Freeport, Maine, has become a center for off-price designer merchandise at prices that defy competition. With that reputation, the stores that have outlets in Freeport enjoy a large trading area. Their customers come from all of the neighboring states as well as Canada. Most regional malls, on the other hand, enjoy much narrower trading areas. In Fort Lauderdale, Florida, major malls are found approximately every ten miles. Since the offerings at these malls are all virtually the same, it is unlikely that a consumer will travel past one to go to another that is farther away. Thus, the trading areas for these malls are very narrow. In order to determine the extent of the trading area and its appropriateness to the potential retailer, factors such as population, area characteristics, and competition should be considered.

Population

The size of the population alone is not sufficiently indicative of the type of people who inhabit an area. Their income levels, ages, occupations, living conditions, and so forth should be considered in the overall assessment. This information is

available from sources such as the Census Bureau. Since the general population census is taken every ten years, major retailers generally undertake their own studies that are more timely and also better tailored to their specific needs.

- Income levels play a significant role in the evaluation of an area. For fashion retailers, this is probably the most important of the population considerations. While fashion merchandise is available at numerous price points, it would be unwise to begin an operation in a socially and economically deprived area. Although retailers of food and other necessities are found in disadvantaged communities, those who sell fashion would not consider such areas for their businesses. On the other hand, people of modest incomes as well of those of more extravagant means are the purchasers of fashion. Since the fashion industry makes goods available at such diverse costs, the retailer must determine if the income level in a specific geographic area is appropriate for the particular retail operation.

- Different age groups have different fashion needs. Young professionals generally choose merchandise that offers status without considerable attention to price. Senior citizens, on the other hand, are more generally very careful shoppers with price and value often their prime considerations. Similarly, each age group has specific needs and buying preferences. Since the wants and needs of all of the groups are different, the retailer must study the population to determine if the predominant age group in the trading area is likely to be one the retailer can accommodate.

- Occupations also play an important role in the fashion needs of consumers. Career women, a population segment that is constantly increasing, are major purchasers of fashion goods. Not only do they need clothing and accessories for their professional lives, but their social needs must be satisfied as well. While a shop to serve the needs of this population would be best located in a major city where these women work—and often live—such a venture in a suburban location, inhabited by families with infants and toddlers, would likely fail.

- Marital status and sex might also play an important role. In some trading areas there could be a dominance of unmarried people. This is particularly true in places like the Upper East Side and West Side of New York City where a significant number of singles live. Since unmarried individuals enjoy different spending patterns from marrieds, the retailer should be aware of the marital status of potential customers. Singles, for example, are big spenders on romance-oriented clothing and thus would be a natural market for retailers of formal clothing that would appeal to the opposite sex. Some trading areas have a preponderance of one sex. In senior-citizen locales, there is a definite majority of women because of their longer life expectancy. This would

signal a greater need for fashion retailers who specialize in clothing and accessories for the more mature female population.

- The degree of stability in terms of household permanency can be a determinant. Places where the population resides on a full-time basis enable the retailer to consider business on a year-round basis. For the majority of retailers, this is necessary for success. There are, however, resort areas that provide shopkeepers with transient people who are in the trading area for an abbreviated period of time. This often becomes a plus for the retailer since it is generally conceded that people on vacation spend more freely than when they are at home. On the other hand, if the resort is one that flourishes for a short period of time, such as a ski area, the retailer must determine if the business potential for a few months is sufficient to bring a profit that would be appropriate on an annual basis. While seasonal ventures are often profitable, care must be exercised when embarking upon such an endeavor.

- Religious affiliation should also be considered to make certain that there is nothing in the retailer's method of operation that would be offensive to the group. In the United States there are specific religious concentrations that subscribe to behavioral codes determined by the teachings of a particular sect. These might be in the form of particular dress preferences or hours of store operation. A retailer who estimates the need to maintain a day of operation that could be offensive to a religious group might find this condition inappropriate for his or her specific business. For example, Orthodox Jews do not shop on the Sabbath, which could mean a considerable loss of business to merchants who view this as their most important day of operation. Although this problem might be one of a minor nature, when everything else is considered, it should be carefully addressed before any investment is made.

- Population shifts are common and should be explored. It is not sufficient to merely determine the size of the population, and many of the characteristics discussed in order to assess the value of the trading area in terms of business potential. While an area might presently house an appropriate number of people who are potential consumers, this figure alone will not reveal whether the population is increasing or declining. It will also not divulge if the characteristics of the population are stable. In situations of population explosion in a trading area, there might be a trend toward a different consumer group moving in. While the mere population numbers indicate growth, those entering the area could be lower or higher socioeconomic groups. Often the populations of inner cities remain the same, while the more affluent move to the suburbs. Although the population of a particular area may not necessarily change, the needs may be different. In this case they might require differently priced merchandise or goods with characteristics foreign to the retailer's organization.

Area Characteristics

In addition to the population characteristics, or demographics, fashion retailers should study the particular area under consideration to determine if it offers certain advantages that would make the location beneficial or disadvantages that would be deterrents. Some of those often considered include the following characteristics.

- New York City, London, and Paris are considered to be prime trading areas for fashion merchants not only for their regular inhabitants but for the tourists attracted to these cities throughout the year. One of the primary reasons for the attention to these places is the excitement offered in terms of entertainment and culture. People visit New York City for theater and museums, Paris for its art and beauty and London for its historical richness. While the initial attraction might not be that of making purchases, consumers who visit places as tourists tend to buy more than they ever would at home.

- The accessibility of the trading area is of vital importance to the retailer. In places where public transportation is insufficient, it is important for the area to have adequate parking and an excellent network of roads to bring in the shoppers. How sad it is for the retailer who has the merchandise needed by the consumer, but finds that getting to the area is a chore.

- Local legislation must be investigated to determine if the retailer will face prescribed obstacles that would prevent the business from operating freely. For example, some communities forbid Sunday openings, a day considered by many retailers necessary for conducting their business. Some areas have local sales taxes that could deter people from patronizing the area. When a trading area spans two states, for example, and the one that would house the retail operation is in the state with high taxes, business from the other state with lower or no sales tax could be lost.

- The number of competitors in the area should be assessed to make certain that there is room for another similar business. Competition should be recognized as a positive factor, since this is indicative that the trading area is appropriate for the type of company being considered. While competition is a good sign, the oversaturation of a location with too many similar stores can be a problem. Too much competition might spell trouble in terms of price wars and the ability to enter the market. On the other side of the coin is the fact that lack of competition could indicate that other companies did not have much faith in the area and chose not to open there. Thus, competition should be carefully analyzed before embarking on the new venture.

- Promotion for most fashion retailers is a must. Relying upon word of mouth to gain a share of the market is not sufficient for most retailers. In order to

capitalize on the available market and bring the greatest number of shoppers to the store, fashion retailers generally make use of the advertising media. It should be determined whether the trading area has a sufficient number of newspapers and other media with which to promote the business.

• The availability of human resources is of paramount importance to the success of the fashion retailer. Companies like Nordstrom and Neiman Marcus, merchants of the highest level of fashion retailing, carefully explore areas not only for good customer bases, but for qualified personnel to carry out their businesses. With the enormous amount of competition in the fashion retail industry, merchants are more than ever before recognizing the need to satisfy the customer.

Classification of Shopping Districts

If it has been determined that the proposed trading area meets the criteria established by the prospective fashion retailer, the next decision to be made involves the selection of the specific type of district in which to open the store. At one time merchants were limited as to the types of available districts, with the downtown or central shopping districts and the malls being the most dominant in the field. Today, retailers of fashion merchandise are discovering other types of areas in which to open new businesses or expand existing ones. To these have been added power centers, mixed-use centers, outlet centers, downtown vertical malls, landmark centers, and theme centers. Old suburban malls are being refurbished and expanded, neglected historical sites have been restored and repositioned as exciting shopping districts, and downtown areas once blighted by hard times have been resurrected as vital shopping centers. Not every shopping district is appropriate for every fashion retailer. Careful analysis of each should be undertaken before the choice is finally made.

Downtown Central Districts

The downtown area has been home to major retailers ever since large-scale retailing began. Just about every giant department store organization has been headquartered in a downtown area. These districts not only provided a customer base from area residents but they were also treated to a daily influx of workers and in some cases a throng of tourists. The regular inhabitants, coupled with the visiting population, resulted in a steady flow of shoppers.

Although the downtown areas are alive and well in most parts of the United States, there was a period when many merchants were falling on hard times. The

inner cities were being abandoned by many families who headed toward the suburbs. Their replacements were generally of lower socioeconomic backgrounds and their buying power was different from that of their predecessors. The downtown areas were transformed from viable business districts to places that were less than appealing. Today, however, the revitalization of the downtown shopping district is in full swing. Cities are spending enormous sums to redevelop the areas and make them more attractive. Those who have lived in these areas are now being replaced by members of suburban families who want to make the cities their homes. In places like New York City, Chicago, and Washington, D.C., the downtown centers are once again thriving and fashion retailers are finding great success there. Some company flagships like Macy's at Herald Square in New York, Filene's in Boston, and Hecht's in Washington are achieving new heights in sales. In addition to the individual stores that line the streets of these districts, urban renewal projects have incorporated structures that house vertical malls (a topic that will be explored separately in this chapter).

While the major-city downtown districts are flourishing, their small-city counterparts are not faring as well. Their central districts have been severely damaged by

the huge regional malls that often lie a mile or so from the downtown centers. With the advantage of parking and the offering of a vast number of stores, the small-city central districts have been less fortunate than those in the major cities. Most of the stores' branches that once were plentiful in these areas have moved to the malls, leaving these central districts ghosts of what they once were.

Regional Malls

When the suburban movement reached major proportions in the 1950s, the stores that dotted the main streets were inadequate to serve the needs of their inhabitants. Some department stores had branches in these areas, which brought significant business to their organizations, but there were no major centers such as those found in the important downtown central districts. In the mid 1950s, in two suburban areas that flanked New York City, developers opened what were to become the prototypes of future regional malls in the United States. Both Green Acres, on the New York City line, and Roosevelt Field, a little further east on Long Island, opened to much fanfare. With these two successes the regional malls were born. They were not of the magnitude that we have witnessed in recent years, but they did provide one-stop shopping for suburbanites. A few years after their introduction, another mall in the general area opened, but with a new twist. Walt Whitman, in Huntington, New York, initiated the concept of building an enclosed mall for the first time. Not only did it provide shoppers with a wide assortment of stores, but it did so in an environment that was climate controlled. By comparison with the malls of today, they were just shadows of what was yet to come.

The early entries in the field were usually of the "controlled" variety. That is, competition was controlled to enhance the probability for each store to realize a profit. Without the control concept, stores might be rented on a first-come, first-served basis with the result of too many shoe stores, for example, and an insufficient number of dress shops. The draw of the mall was its anchor stores, as it still is today. There were usually two, one at either end of the structure. The anchors were well-known department store branches with immediate recognition. Since the department stores were, and still are, retailing's major advertisers, they attracted large numbers of consumers to the shopping area. Not only did the anchors achieve success, but the runoff was appreciated by the other stores in the mall.

Today, the regional malls bear little resemblance to their predecessors. They are often built as multilevel environments with as many as six anchors, movie theaters, and food courts to attract large crowds. People who patronize these centers may spend a full day, enjoying themselves with shopping, eating food, and entertainment.

Aside from sufficient parking and ease of access through highway arteries, the mall's success is due to a number of factors. It has become a place to spend time, in addition to shopping. Many malls are used by physical fitness enthusiasts who

enjoy the controlled climate for their workouts. Retailers also enjoy the many organized promotional activities undertaken by the regional malls. The presence of Santa Claus, the Easter Bunny, automobile shows, fashion shows, art events, and the like are the efforts of the mall's management, expenses of which are either paid by the developer or shared by the mall's tenants. This certainly affords the individual store the benefit of large crowds without having to spend a large amount.

Today, every major city boasts one or more regional malls. The new ones have vastly improved on the old, and now the older malls are undertaking modernization programs. All across the country the face-lifts are becoming commonplace, with new floors being added for additional retail tenants. The reason for the revitalization is that the older ventures no longer serve the needs of the existing market, and since land has become scarce and more costly to develop, renovation seems to be the solution.

Although the United States is by far the leader in the regional mall game, other countries have joined the bandwagon and, in some instances, have outdistanced the United States with some of their entries. Canada, for example, boasts the world's largest mall in Edmonton. Not only does it feature more than 800 individual stores in a variety of themes but it features a giant pool complete with waves, rides and attractions, and a full-size ice-skating rink.

Akin to the typical regional malls that are generally found in the suburbs are two variations that are worthy of discussion. They are the vertical malls and mixed-use centers.

Vertical Malls

As land became less available in the downtown central districts and the areas became more and more populated with household tenants, workers, and visitors, retailers found it impossible to find space in which to open their businesses. In order to accommodate these new retail ventures and to make the prime locations better revenue producers, realtors began to think about the high-rise or **vertical malls** to house scores of tenants in places that would generally be occupied by just one major company. Some buildings were erected from the ground up, in place of older existing structures, and others were constructed by revamping vacant buildings. In Chicago, one of the most profitable of the vertical malls began as a new complex called Water Tower Place. Much like the sprawling suburban malls, it has two anchors, Marshall Field and Lord & Taylor, and a host of upscale fashion specialty retailers. Its customer draw comes from a mix of people who work in the area, those who live close to the center, and tourists, many of whom frequent the Ritz Carlton Hotel that towers above the shopping center. In New York City, two major vertical malls were developed in places that once housed single department stores. The first entry was named Herald Center and was housed in the building that was

Figure 5-2. Today the food court is a major part of the shopping mall experience. (Courtesy of Western Development)

once tenanted by the E. J. Korvette department store. While the transformation was physically splendid, success was never achieved there. The cause for failure was its tenant mix. The mall was made up of fashion retailers whose forte was haute couture and upscale merchandise. The area was not conducive to this structuring, and the clientele needed to make it profitable never showed up. It is being repositioned as a more moderately priced fashion center. One block from the Herald Center stands A & S Plaza, named for its anchor, the A & S department store. It stands in a site once home to Gimbel's, a major department store that is now defunct. At the core of the building, A & S occupies space on every floor, with fashion specialty retailers tenanting small spaces surrounding it. The premise was that the A & S draw would bring shoppers to each floor once they exited the department store.

Mixed-use Centers

One of the newest major shopping districts to be built is the **mixed-use center**. As the name implies, its composition is not strictly retail oriented as are the major regional malls, but incorporates office workers, hotel guests, and entertainment seekers along with the traditional shoppers. These centers are being built all over the country and are achieving enormous success. One of the country's most ambitious mixed-use centers is featured in the accompanying "spotlight" story.

The Fashion Centre at Pentagon City took up residence in a trading area containing two leading fashion malls. One competitor is Tysons Corner Center in McLean, Virginia, which houses as its anchors Bloomingdale's, Hecht's, Nordstrom, and Raleighs, as well as more than two hundred other upscale fashion retailers. Standing in close proximity is The Galleria at Tysons II with Macy's, Neiman Marcus and Saks Fifth Avenue as the anchors. Why then start a project that seemed to be doomed from the start because of the competitive nature of the trading area?

The developers believe there is a captive audience in the area headed by the massive Pentagon building with almost 4 million square feet and thousands of office workers. Not only does the area house this vast number of working people, but the nature of the Pentagon brings scores of people each day to the area. These two groups, plus the tourists that visit nearby Washington, D.C., could produce an unusual customer base.

The Fashion Centre is part of a complex that includes Washington Tower—a high-rise office building—a 17-story Ritz Carlton hotel, and a high-rise residential facility. Not only does it feature all of these components but it is situated on the Metrorail, one stop away from the Pentagon and a few from Washington, D.C. Since the area is so congested with vehicular traffic, its proximity to the public transportation system of Washington gives it an edge. Aside from the already-mentioned captive audience and its convenience to Washington inhabitants and tourists, the complex is right at the core of Northern Virginia's most affluent residents.

The center's anchors are Macy's and Nordstrom, which are surrounded by such fashion specialists as Britches, Talbots, AnnTaylor, Charter Club, Units, Victoria's Secret, and the Coach Store.

Time will soon tell whether or not the center will be successful and if it can beat the competition of its two closest challengers.

Power Centers

Comprised of 20 to 25 stores, the **power center** is a complex that utilizes high-volume, high-profile outlets to draw the customers. Most of these centers have at their core off-price or discount operations such as Marshalls, Hit or Miss, Dress Barn, or Mandy's, which feature fashion merchandise at lower prices. The power centers occupy anywhere from 250,000 to 500,000 square feet and are located on major arteries or highways. Today there is a trend for these districts to be composed totally of off-pricers and discounters. Some even feature stores that belong

to specific manufacturers who use these locations to dispose of overstocks of merchandise that did not sell as well as expected in the traditional retail outlets.

Off-price Centers

Off-price fever has reached just about every corner of the United States. So successful is the concept that manufacturers and designers of fashion goods are opening more and more outlets to dispose of their leftover merchandise. The heaviest concentration of the off-pricers is in centers that exclusively feature this classification of merchandise. The vast majority of the items sold are fashion-oriented clothing and accessories for men, women, and children.

The center that was the prototype for others to emulate is Potomac Mills in Northern Virginia. From all outward appearances, it is the same as any regional mall except that the merchandise available for sale is all off-price.

One of the newest of this category is Franklin Mills in Philadelphia. With 1.7 million square feet devoted exclusively to manufacturer and designer outlets, it is the country's largest. The mall features Benjamin Franklin as a symbol of the mall because his often quoted phrase, "a penny saved is a penny earned," is perfect for anyone selling bargains. Stores like Filene's Basement, Clearinghouse (an off-price division of Saks Fifth Avenue), Guess, Ann Taylor, Chess King, and Garage occupy space there.

With the success of Potomac Mills and Franklin Mills, the next major projects are Sawgrass Mills in Fort Lauderdale, Florida, Gurnee Mills near Chicago, and Ontario Mills in Ontario, California.

Aside from the enclosed-mall variety, off-price centers are featured on thoroughfares and strip centers in many parts of the United States. Maine features two such environments. In Kittery, there are several small strip centers that feature the overruns of such names as Liz Claiborne, Anne Klein, Joan and David, Calvin Klein, and Harve Benard—all fashion leaders. In Freeport the main street and side streets are laden from end to end with fashion shops featuring off-price merchandise by Ralph Lauren, Patagonia, Jones, Evan Picone, and others. Centers such as these are also located in North Conway, New Hampshire; Secaucus, New Jersey; Harriman, New York; and Flemington, New Jersey.

In the majority of these off-price centers, the manufacturers themselves have become fashion retailers. They are able to sell off merchandise that finds less favor at the traditional stores and can control the methods by which the merchandise is disposed of.

Central to the success of all off-price centers is their location. They must be in places that are easily accessible to consumers and far enough from the traditional retailers, who sell the same merchandise at higher prices.

Landmark Centers

When Faneuil Hall in Boston was "rediscovered" in the 1970s, a developer with foresight saw it and the immediate surrounding area as an ideal location for a new shopping environment. Situated close to Boston's waterfront—which was run down—a revitalization program was initiated that resulted in the now-famous Quincy Market. Serving as the prototype for others to follow, Quincy Market features a host of specialty stores such as a giant-sized Limited, that offer a wide assortment of fashion merchandise.

With word of its success spreading through the industry, developers all across the United States began to explore abandoned, rundown, or underutilized sites for the construction of exciting shopping districts.

The waterfront area in New York City at the site of the old Fulton Fish Market was underutilized. While some fishing enterprises were still in existence, there was a great deal of available space that was lying dormant. The first phase of the renewal project involved the erection of what is called South Street Seaport, a facility primarily inhabited by a food court and restaurants with about twenty stores surrounding the structure. A second phase was oriented toward fashion retail. A wharf known as Pier 17 was cleared and revitalized as a multilevel fashion center. Its tenants include names such as The Gap, Banana Republic, and The Limited. Others that have made names for themselves in this type of retail district

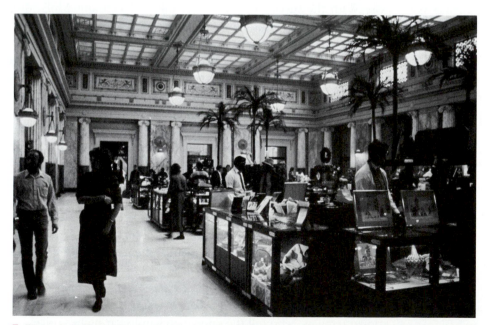

Figure 5-3. Union Station in Washington, D.C., is a railroad travel hub and fashion retail locale. (Courtesy of A. Moore)

are Riverwalk in New Orleans, Inner Harbor in Baltimore, and, the latest to achieve recognition from the world of fashion retailing as well as consumers, Union Station in Washington, D.C.

Union Station still serves as the hub for railroad travel in and out of Washington. As with other terminals, its beauty was marred by the effects of time and neglect. Still graced with its original magnificent architecture, it has been transformed into an enclave that serves the area as a hub for travelers and a tourist attraction for visitors to the city. Its two-level retail configuration houses some of the best-known fashion specialty merchants in retailing.

Fashion "Streets"

Throughout the country, there are several places where fashion retailers of the highest quality have set up shop. They are not in malls, landmark centers, downtown central districts, or any of the other formats that have been discussed. They are merely found on area main streets. These strips or streets have become legends in the fashion retailer's world. Rodeo Drive in Beverly Hills, California; Worth Avenue in Palm Beach, Florida; and Madison Avenue in New York City are home to the likes of shops such as Gucci, Martha, Yves Saint Laurent, Giorgio, Ralph Lauren, Givenchy, and Pierre Balmain, all fashion merchants extraordinaire.

Miscellaneous Districts

In addition to those already discussed, there are other locations in which some retailers operate their stores. None is particularly meaningful to the fashion retailer, but on occasion some do locate in these places.

Neighborhood clusters are small centers in which there are between 10 and 15 stores, most of which are not fashion merchandisers but butchers, grocers, etc. In some instances a small private shoe store or specialty sportswear shop might have an operation there.

Site Selection

Once location analysis has been satisfied in terms of the potential trading areas and the various types of shopping districts have been explored, specific site selection should take place. As with the other two areas of concern already examined, the selection of the site warrants considerable evaluation.

Competition

While assessment of the competition is a factor to be considered in the selection of the general trading area, it once again must be studied in terms of the specific site that the retailer is considering. Too many competitors will probably result in an insufficiency in the number of available people necessary to make each one profitable. On the other hand, a lack of at least some competition does not allow the shoppers to make comparisons before purchasing and could act as a deterrent. Many people simply will not go to a specific place unless there are other stores available to them. The proper mix, therefore, is necessary before a site should be considered.

Neighboring Tenants

The choice of a location that lies between two established stores is advantageous to the retailer on that site. It should be understood that on either side, direct competitors would be unadvisable. The adjacent stores should be types that bring customers to the spot so that the new retailer can capitalize on their clienteles. For example, if a women's specialty shop is considering a site, it would be advantageous to be flanked by stores that specialize in shoes, handbags, or fashion accessories. Each of these merchandise offerings will complement the others and provide potential customers for each other's businesses.

If a site next to a mall's anchor department store is available, it will provide a natural flow of customer traffic since not everyone coming to the department store can be satisfied with its goods. Although the anchor often brings the traffic to the malls through extensive advertising, the consumers usually venture into the mall itself to do more shopping.

Other neighbors that provide potentially high traffic are food courts and movie theaters. Each attracts large numbers that are drawn to adjacent stores purely because of their proximity.

Travel Convenience

If customers cannot get to the site easily, it is unlikely that it will serve as a viable store location. The best choice, although not always available, is the location that can be reached by public transportation and automobiles. The Fashion Centre at Pentagon City is a winner in these respects. It is conveniently served by a stop on the area's Metrorail system, buses, and a modern highway system that brings automobiles to a substantial number of parking spaces. All too often, people come to shop at places in their cars only to be turned away by lack of adequate parking facilities.

Entertainment Attractions

Malls in particular are becoming mixes of retail operations and amusement centers. It seems that the more fun and entertainment offered by the malls, the more likely it will be for families to patronize them and spend longer hours there. So successful has the concept become that many malls are being designed to set aside more and more space for fun. The Forest Fair Mall in Cincinnati, Ohio, utilizes 35,000 square feet for such attractions as a themed miniature golf center, a carousel, children's rides, video games, and coin-operated action machines.

The most aggressive project in terms of combined amusement and retail shopping is the Mall of America in Bloomington, Minnesota, with 4.2 million square feet, of which 2.6 million are going for stores and the rest for amusement areas. As of this writing, being planned for the opening in late 1992 are such fashion retail anchors as Bloomingdale's, Nordstrom, Macy's, and Carson Pirie Scott. The specialty retailers will number between 600 and 800 with the vast majority specializing in fashion merchandise.

Zoning Regulations

Occasionally, local zoning laws run contradictory to the needs of the specific retailer. For example, there might be legislation that requires standardization of structures for all retailers. McDonald's, although not a fashion retailer, is a good point. With its easily recognizable golden arches, the company has established a facade that is easy to recognize. In Hilton Head, South Carolina, a zoning law requires the uniformity of structures and forbids the company to use its familiar characteristic. In Santa Barbara, California, zoning laws require that all retail establishments be built with a Spanish motif.

In addition to building characteristics, such laws could require limitations of size and height of buildings. In Ponte Vedra, Florida, buildings of more than two stories require hard-to-come-by variances.

If the retailer has specific needs in these areas, attention should be paid to the zoning requirements before the project is undertaken.

Store Location Trends for the Nineties

Although the various shopping districts previously examined all seem to be viable candidates as location centers for this decade, and the factors already explored will still be important in site selection, there are several trends developing concerning store location. Those that seem in the forefront for fashion retailers to consider are examined.

Revitalization of Existing Malls

With prime land less available than in the past and the slowing of movement to the suburbs by consumers, many regional malls have already looked to revitalizing their existing sites. Not only are the environments being given a facelift, but the tenant mixes are being changed to meet the needs of the present trading area. With many malls now becoming more fashion oriented than was originally conceived, more fashion retailers are taking the places of other stores that preceded them. In Towson, Maryland, Towsontown Centre is being revamped from its original configuration to a full-blown fashion-oriented mall with Nordstrom as a new anchor. Tysons Corner Center, a winner since its inception in McLean, Virginia, in 1968, was renovated and expanded at a cost close to $2 million. Its new face features some of the country's top specialty stores as well as such anchors as Bloomingdale's, Woodward & Lothrop, and Nordstrom.

Mixed-use Centers Increase in Numbers

By incorporating office buildings, hotels, and other attractions in a complex that houses a retail component, a captive audience is present that fuels the retail segment of the center. So successful have these new centers been that the next decade will see many new developments join the ranks of those in existence. Tower City Center in Cleveland, Ohio, and The Fashion Centre at Pentagon City, Virginia, are just two of many mixed-use centers that retailing will see.

Off-price Centers Are on the Increase

Whether they are in malls like the one at Potomac Mills, Virginia, or in small strips and power centers such as those found in Kittery, Maine, or on main streets as is in evidence in Freeport, Maine, the concept of locations that are solely for the use of off-price retailers is on the rise. More and more fashion manufacturers are entering the retail business to rid themselves of merchandise overruns instead of selling them off-price to independent retailers. It is hard to find a part of the country where off-price centers are not located.

Multilevel Retail Structures in Downtown Areas

Fewer and fewer fashion retailers are able to afford the rental costs associated with occupying street-level sites. In order to use space more effectively and thus make the rental factor less prohibitive for retailers, more and more multilevel, vertical

malls are appearing in the downtown central shopping districts. In Chicago, 900 North Michigan Avenue is one such environment that houses a host of upscale fashion retailers including Bloomingdale's and Henri Bendel. With the cost of real estate in these desirable locations, this is a trend that is catching fire in most major cities.

Power Centers Emerge as Winners

The small centers that feature a few off-pricers such as Dress Barn and Marshalls at their locations, the power centers as they are called, are springing up all across the country producing square-foot sales as high as $1000. Since the locations are not in the high-traffic areas, their rental costs are comparatively low, a natural for retailers who work on a lower markup than the traditional retailer's markup.

Small Store Applications

The small fashion retailer is at a distinct disadvantage in terms of availability of location. While the entrepreneur might have the determination and drive to open a fashion operation in a major mall, for example, it is more than likely that he or she will be preempted by a more established retail organization for the choice of a particular site. The lifeblood of major malls is the department store organization and the vast number of established specialty chains that are regularly found in these environments. It is not that the mall developer intentionally wishes to discriminate against the small store owner, but it is the giants in the industry who have the capital necessary for staying power. Too many small retailers are undercapitalized and cannot meet the costs of doing business in down periods. The big retail organizations are therefore given the first opportunities for prime locations.

All, however, is not lost when it comes to locating a fashion retail business in malls and other shopping districts. While the prime choices are quickly grabbed up by the giants, there are often less-desirable sites in "spurs," for example, that the majors do not want, and, by necessity, they are available to smaller merchants.

Although the top locations in downtown shopping districts are also earmarked for the big companies, side streets are sometimes available for the smaller stores. The locations might not be as desirable, but the rents are comparatively lower, an edge that the entrepreneur often needs for survival. Smaller-city downtown districts or secondary central downtown areas are often available for the small fashion retailer, because the giants are usually attracted to the top spots. These locations often provide sufficient traffic in which the retailer can turn a profit.

Neighborhood clusters, small strip centers, and suburban main streets are usually good choices for the smaller fashion businesses. They attract a significant

amount of local traffic and consumer interest. Since the retailer does not have to vie with the giants of the industry for these spaces, they are excellent choices for those who have been shut out of the prime retailing locations.

It should be understood that even the smallest retailer should approach site selection carefully, much the same as the industry's leading counterparts do. The trading areas, available shopping districts, and factors associated with site selection should be analyzed before the lease is signed.

Highlights of the Chapter

1. Selection of the most suitable location should begin with the investigation of the potential trading area, followed by the exploration of the types of shopping districts it has, and finally the characteristics of the specific available sites.

2. One of the most important considerations in choosing a particular trading area is the population it serves. Such factors as income, occupation, marital status, household permanency, religious affiliation, and population shifts should be analyzed to make certain that they are appropriate for the proposed fashion retail business.

3. Often, particular area characteristics may increase the trading area's value. For example, New York City with its wealth of tourist attractions has appeal not only for its inhabitants but for the tourists who visit every day of the year. Other characteristics to study are local legislation to determine if the particular business would face specific obstacles in the running of the store, competition, accessibility of the area, and the availability of trained staff.

4. Shopping districts come in all sizes and shapes and should be examined to determine which would provide the best opportunity for the company. They include downtown central districts, regional malls, vertical malls, mixed-use centers, power centers, off-price centers, landmark centers, and famous fashion streets.

5. Other important factors in choosing the site are competition, neighboring tenants, travel convenience, entertainment attractions, and zoning regulations.

6. The nineties present numerous trends in store location. Existing malls are being revitalized at a significant rate because prime locations are not as readily available as they once were. Mixed-use centers are increasing in number since they bring a captive audience to the shopping portion of the area. Other trends include an increase in the number of off-price locations, the building of multilevel retail structures in downtown districts, and a greater number of power centers.

7. The small store has less available to it than its large-store counterpart because a developer is at less risk leasing to a well-known retailer than to an independent one.

8. Small fashion retailers' choices of location are usually the "spurs" in a major mall, side streets off main downtown streets, neighborhood clusters, strip centers, and suburban main streets.

For Discussion

1. Explain what is meant by a store's trading area.

2. To what extent must an area's population be studied to determine if it is appropriate for the proposed fashion retailer's business location?

3. What are some of the area characteristics that make a particular trading area better than others?

4. Why did most major department store organizations chose a downtown central district for their flagship operation?

5. Discuss some of the advantages of opening a store in a regional mall.

6. In what way does the vertical mall differ from the suburban mall?

7. Explain the reasons for many fashion retailers to choose mixed-use centers for their companies.

8. Where are the off-price shopping centers locating, and why have they chosen these places?

9. What are landmark centers?

10. Discuss the pros and cons of competition in terms of site selection.

11. Should zoning regulations be considered when a particular site is being considered?

12. Why have many developers chosen to revitalize existing malls in favor of establishing new ones?

13. Can small retailers generally lease the same sites as their large store counterparts?

14. Where are the places small retailers are likely to locate?

The Sophisticated Woman is a major fashion retailer with approximately 800 stores in the United States. Their success story is unparalleled in retailing in that they opened their first unit twenty years ago and have become one of the most profitable fashion retail specialty chains in the country. The proper merchandise

mix and appropriate location choices have given them this enviable position. Whenever a prime location in a suburban or vertical mall has become available, the company has opened a unit.

At the present time The Sophisticated Woman is facing a location dilemma that needs addressing. One of their most successful units has been located in a suburban fashion mall in southern Florida. The mall is anchored by two of Florida's leading department stores, which draw a considerable amount of traffic to themselves and the other specialty stores in that shopping district. So successful has business been that the company has recently acquired the adjoining space and expanded and remodeled it into a very profitable shopping environment.

The Sophisticated Woman is always on the lookout for locations that would be as appropriate as the one just described. Generally, the primary consideration is the distance of one unit from the other, with approximately 8 to 10 miles being considered ideal. The problem that must now be addressed concerns the projected development of a major mall that will be built just two blocks from the one in which they are located. The mall will be anchored by two of New York's major department stores and will be built as a multilevel structure that promises to be the most beautiful in the South.

Mr. Drummond, vice president in charge of site selection, believes that the company should close the existing store and move to the newer location. Ms. Conners, a senior executive in charge of merchandising, is of the opinion that they should remain in the present location because of its profitability and forego the chance to open in the newer environment. Another route proposed by members of the senior management team is to maintain the old unit and, at the same time, open another in the new mall.

With space going quickly at the new facility, The Sophisticated Woman must come to a decision if the new mall is to be the choice.

Questions

1. If you were the individual making the decision, which route would you take?
2. What factors did you consider in making your choice?

Fashions For Less is a small fashion retailer that specializes in designer labels off-price. The owners of the store, John and Caryn Gallop, opened their business three years ago and have become so successful that they are considering a second location.

With very little capital but good merchandising sense and connections to purchase the overruns of many manufacturers at greatly reduced prices, they chose to enter business with the lowest possible overhead. For this reason they

chose a location "off the beaten path" and hoped for "word of mouth" to spread the news of their company. Everything that followed was perfect. They turned a good profit after being in business just six months.

As most other fashion merchants would do, the Gallops are looking to expand their business by opening another unit. They have been looking at new retail locations for the past three months and have yet to make a decision. Their choices are either another spot off the beaten path, a neighborhood cluster that presently houses 15 stores, a power center, and an off-price shopping mall.

As the new season is approaching, the Gallops have yet to decide where the next unit of Fashions For Less should be opened.

Questions

1. Should the Gallops choose the same type of location in which they found their initial success or choose another type of location?

2. Discuss the factors to consider before making the final location decision.

3. Which location would you choose and why?

Exercises

1. Investigate any one of the newer types of shopping districts such as the vertical mall or centers that describe themselves with the words "power," "landmark," "off-price," or "mixed-use." Discuss in an oral report why you believe they fit the category. In addition, describe any of the additional "draws" or attractions that make these areas viable shopping districts.

2. Analyze the general trading area of your city in terms of its demographics and characteristics. Prepare a written report highlighting those aspects of store location that make it appropriate as a trading area.

Designing and Fixturing the Fashion Facility

Learning Objectives

After reading this chapter, the student should be able to:

1. Discuss the importance of store layout for all retailing classifications.
2. Describe the concept of store designs that utilize the environmental concept.
3. Explain the importance of developing a "personality" in the store's design.
4. List and discuss all of the component parts of the store's interior that make up its design.
5. Discuss why specific areas are reserved for particular departments.

For many years, a sameness of store design was immediately apparent to those who visited American fashion retailers. There was often a lack of originality in the way the stores were physically organized and in the types of fixturing that were employed. Retailer after retailer chose the same types of layouts, materials, and fixtures for their environments. If the style was "provincial," then the stores used that period for the design of their interiors. When attention changed to contemporary design, focus was placed on that concept. If high-tech was the rage, steel was the element that carried forth in many of the stores' interiors. It was the design "fashion" of the time that dictated the approach that was to be used, rather than the image of the merchandise being offered for sale.

It seemed that retailers would be satisfied with the same surroundings used by their competitors. Store design was often as boring and unoriginal as the merchandise mixes that the stores stocked. With so many retailers featuring huge inventories of lines such as Liz Claiborne, Evan Picone, Jones, N.Y., and the like

in settings that were similar to their neighbors, it became hard to distinguish one retailer from the other.

Recent years have seen a radical change in the approach taken in store design and fixturing. Just as merchants have attempted to individualize their inventories, so have they undertaken design programs to make their selling environments more unique. They have recognized the need not only to provide an interesting place for their goods to be offered for sale, but the value and necessity of individuality.

When fixtures and merchandise complement each other in settings that are memorable, the consumer will be able to differentiate one store from the other.

A departure from the mundane was initiated by Banana Republic. From entrances to back walls, the units in this chain are anything but boring. The approach utilized involves fixturing, materials, and props that complement the organization's travel- and safari-oriented merchandise. Some units employ jeeps that seem to be breaking through the store windows, giving the immediate impression of shopping in the bush country. Interiors use crates for stacking merchandise, rustic wooden floors, and lighting that enhances the surroundings. Customers are at once "transferred" to a faraway place when they open the entrance doors. The store's image is immediately conveyed to the shopper and more than likely remains in his or her memory.

The Banana Republic approach, with its departure from the commonplace, is a sign that more attention is being paid to store design. Stores all across America have begun to address the merits of uniqueness and have started to spend more time and money on their retail environments. Store management has expanded its planning committee to include not only architects and interior designers, but also visual merchandisers who bring a different perspective to the plans.

Careful examination of today's new stores and the refurbishing of others indicates that retailers are on target in their attempt to attract their share of the consumer market.

Planning the Design Concept

Before any decisions are made concerning what shape the store's exterior and interior will take, it is important to first examine the company's objectives, image, and choice of location. If, for example, the operation is one that specializes in off-price fashion merchandise, uses the self-selection method for selling, and is located in an outlet power center, the design needs will be different from those of the store that specializes in high-fashion, designer labels and emphasizes service as its forte.

Whether it is a small venture or one that involves a major, giant retail operation, finances must be addressed. A budget must be established that includes costs for construction, fixturing, lighting, floor and wall decoration, heating and ventilation, and so forth. Once the financial considerations have been finalized, it is time to begin on the store's design.

The best approach is to employ the services of an architectural firm that specializes in fashion retailing store design. While small retailers often tend to consider this approach too costly, the dollars spent will be worthwhile. Experienced

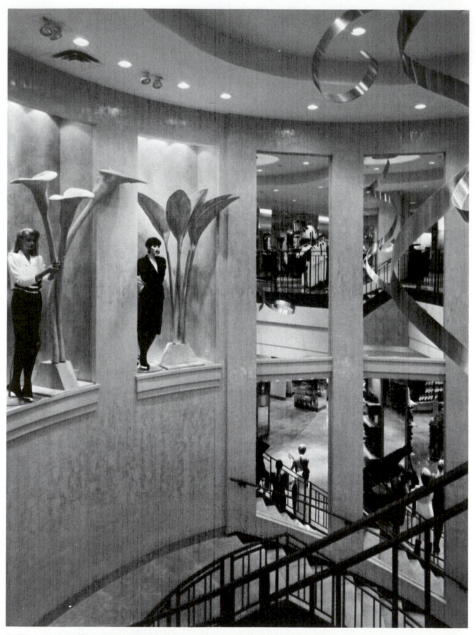

Figure 6-1. The "grand" design scale gives Lerner New York an elegant environment. (Courtesy of Space Design International)

FASHION RETAILING SPOTLIGHTS

LERNER NEW YORK

The challenge facing the design team of Space Design International, an architectural, design, and marketing consultancy based in Cincinnati, Los Angeles, and Tampa, was the renovation of Lerner New York's flagship store on West 34th Street in New York City—to take a no-frills clothing store and turn it into a stylish, upscale showcase for the firm's newly upgraded merchandise offering. Before Lerner was acquired by The Limited organization, its stores were functionally designed using inexpensive, understated environments and fixturing.

In their attempt to dissociate the future from the past and completely change the store's image, the designers decided to play up the building's Art Deco character in the completely revamped interior design. They added a circular staircase, complete with a grand piano on a raised platform. The sweeping staircase provides a touch of glamour from the 1930s and entices shoppers up to the second floor far more effectively than the store's elevator. Hand-painted murals, sumptuous furniture, and iridescent finishes are all in keeping with the Art Deco splendor.

The atmosphere of high style and feminine luxury is enriched by the peach-and-cream color scheme, marble flooring, hand-painted wallpapers, and plush seating. A dramatic two-story rotunda topped with a stepped ceiling and a domed medallion greets shoppers as they enter the store. The gently curving aisles and ceiling forms reinforce the feminine nature of the design and guide the shopper through the store. Large walls are broken by pilasters and curved elements that help define a series of in-store shops.

Unlike other stores in its price range, the new Lerner New York flagship store is lush, romantic, and unabashedly feminine. It romances the budget shopper, offering her a luxurious shopping environment that is usually found in much more expensive stores.

In such a setting, the merchandise takes on a greater fashion orientation and makes the shopper feel that she is able to make a fashion statement without spending the sums associated with the higher-priced designs.

architects can help the merchant avoid mistakes that could be more costly than the fee charged for the design. Some major retail chains have their own design staffs, thus eliminating the need for outside consultation.

Once the store designers have been selected it is imperative that a meeting be held between the store's decision makers and the designers. Such areas as store image, target customers, merchandise mixes, services, and the type of location that have been selected should be discussed so that the design will be appropriate for the store's operation. Having gathered all of the pertinent information, the project should be ready for development.

It should be understood that some types of locations, as discussed in chapter 5, "Store Location," may place limitations on some aspects of the design such as store fronts, entrances, and window structures. Freestanding stores generally provide the greatest freedom of exterior design, while sites within an enclosed shopping mall might severely restrict the plan.

Store Fronts and Window Structures

One of the best ways to make shoppers aware of a store's image is through its exterior design. Those who are considering entering the store should be given some indication of what will be found inside. Exquisite marble, brass, and other expensive materials, for example, will give the observer a feeling that quality, higher-priced goods will comprise the store's inventory.

Freestanding stores allow for the greatest flexibility of exterior design. Since the unit is not adjacent to any other retailers, there is freedom to use any combination of materials to show off the store and its image. When stores are inside of malls, however, there is less opportunity to differentiate one store from the other except for the materials and designs of the window structures. Whatever the situation, careful attention to design will help to bring the shoppers inside the store.

A very important factor to consider in the planning of a window structure is the store's overall space. When a site is leased, space allocations must be provided for the selling floor, offices, stockrooms, fitting areas, and entrance windows. While most retailers would agree that windows are very important to help presell the customers, the cost of space has become so prohibitive that many must reduce the amount set aside for visual presentations. Bearing this in mind, many retailers have opted for designs that allow for more selling space at the expense of large show windows.

Parallel-to-Sidewalk Windows

The ideal arrangement for making the greatest impact on the customer is the one that utilizes the **parallel-to-sidewalk** configuration. The design, traditional to the giant downtown flagship department store, requires a large frontage. The main entrance to the store is flanked by two or three large windows on either side. Each window is approximately 12 or 15 feet wide and about 8 or 10 feet deep. Windows of this nature enable the store to present imaginative fashion presentations. Stores like Lord & Taylor, Macy's, Bloomingdale's, Saks Fifth Avenue, and Neiman Marcus spend considerable sums on these windows in their flagships to bring their fashion images to the passersby. Only stores with a great deal of space and dedication to visual presentation use this type of structure.

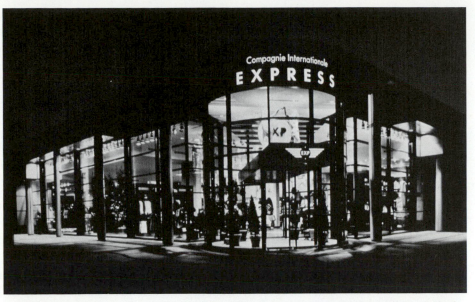

Figure 6-2. The towering glass facade of Limited Express replaces the traditional display windows and makes the entire store visible from the outside. (Courtesy of Space Design International)

Windowless Store Fronts

In the major enclosed malls throughout the country, many fashion merchants subscribe to the "windowless" window or store front where formal display windows are replaced by large glass walls that separate the interior from the exterior. With space so costly and limited in these giant selling environments, the vast majority of it must be utilized for selling. The entrance is often a large glass front through which shoppers may see the entire store. Instead of using formal display presentations as in the parallel-to-sidewalk window, the store's merchandise on the selling floor serves as the display. In many malls, the trend is to eliminate stationary glass structures or windows and merely install sliding glass panels that are pushed out of sight when the store is open for business. This type of front allows for the greatest amount of accessibility from the mall's corridors.

One of the pitfalls of such design is the potential for increased shoplifting. With such open spaces, it is easier to enter and leave the store with stolen merchandise than it is where conventional doors are used.

Arcade Fronts

Stores that have little frontage but need window space to feature their merchandise sometimes build **arcade windows**. In this arrangement, the store's entrance is

recessed 10 to 15 feet from the building line. A large, rectangularly shaped window is constructed on either side of the entrance. This enables the retailer to feature merchandise to the passersby which might tempt them to come inside. One of the disadvantages of this type of arrangement is that it reduces the amount of available selling space.

The use of these windows and store fronts for visual presentation will be discussed chapter 13, "Visual Merchandising."

Interior Layout

Once the decision has been made for a particular store front and window structure, the remaining space must be apportioned for the store's operation. The largest and most important areas are those used to sell the store's merchandise. While these are the locations from which customers will make their selections, there are other spaces that must be set aside for nonselling functions such as receiving, storage, merchandise alterations, visual merchandising, promotion, buying, and store management.

If the store is the company flagship, then there will be a greater need for nonselling areas since most of the company's decision makers are housed there. When branches or units of chains are designed, little else but selling departments are needed. Whatever the situation, the location of the selling and nonselling departments must be addressed.

Locating the Selling Departments

There are many factors to consider in the location of the selling departments. Among them are the size of the store, the number of levels it occupies, the merchandise assortment, entrances, and the means employed for moving customers from floor to floor.

Single-level Stores

Most stores that occupy one level are usually specialty stores. Since the merchandise assortment is limited, and so is the store's selling floor, the task of department location is simpler than that of the multilevel type. In fact, the merchandise classification is often so narrow that merchandise is freely placed throughout the selling floor with little attention to its type. Stores such as The Gap, for example, which restricts its assortment to sweaters, pants, and some sportswear and is generally a one floor operation, do not separate their merchandise into departments. The newest items are usually placed near the store's entrance until the supply dwindles

and are then replaced by the next item to arrive. In this way the passersby and those who actually enter the store are made aware of the store's latest arrival.

Stores such as Petite Sophisticate, Casual Corner, Ups and Downs, and Merry-Go-Round, where the assortments are more diversified, have a greater task in merchandise location. These stores generally separate goods into distinct departments and must decide where each will be located. Sometimes stores of this nature place a few pieces from each department at the store's entrance to make certain that prospective customers can quickly observe the breadth of the store's offerings. These spaces are regularly changed so that the most exciting merchandise holds "center stage" for a period of time. The remainder of the goods are featured in such departments as casual dresses, evening wear, accessories, and so forth. The departments that are closest to the store's entrance are usually those that the store is expecting to generate the greatest sales volume.

The lower-volume departments are located toward the back of the store, with the farthest selling locations often reserved for the more expensive items.

Multilevel Stores

Some specialty chains such as AnnTaylor and The Limited have expanded their inventories and have opened larger units that occupy two or more levels. Not only has inventory size been the reason for the multilevel environment, but in many locations a large selling space on one floor has become prohibitive to lease. In some of the newer downtown vertical malls, stores that typically preferred one level have become occupants of two or more. On Chicago's fashionable North Michigan Avenue, the occupancy of several levels by specialty stores has become commonplace. AnnTaylor, for example, operates a unit in Chicago that spans three floors, and The Limited, on Madison Avenue in New York City, utilizes four floors.

While this arrangement is somewhat new to specialty retailing, it is typical of the department store. Not only do these stores have to grapple with as many as ten floors, but they also have to deal with selling space allocation for a vast number of hard-goods and soft-goods departments.

There are several "rules" that are followed by the retailers in multilevel operations.

1. The main, or first, floor is usually reserved for merchandise that is either bought on impulse, is at the store's lower price points, is high-margin, or which, if placed anywhere else in the store, would cause sales to decline. Cosmetics, a money-making fashion "enhancement," occupies a wide area on most main floors. Many women purchase their cosmetics and fragrances without planning to buy them. That is, when passing through the main floor, an attractive display, an exciting demonstration, or the spraying of a fragrance by a company representative often motivates women to buy. Since the main floor is the most heavily traveled, it is the only place where cosmetics and fra-

grance sales are sure to be profitable. Similarly, fashion accessories are located on the first level because they too are often bought by passersby who have been attracted by their presence. A mainstay for the first floor has always been men's wear. While women traditionally spend more time seeking out their needs, men often demand that their needs be satisfied with a minimum amount of effort in the least amount of time. By placing the men's department on the main floor, the need to get caught up in crowds has been eliminated, making the male customer happier and a better prospect. Since men spend less time in malls than women, it might be appropriate to assign the men's department to space that is close to the main parking lot. In stores that cannot afford to assign a large area to men's fashions, or any other fashions for that matter, to the first floor, "satellite" departments are featured on that floor with the remainder of the inventory on an upper level. The satellite is supposed to whet the shoppers' appetites and motivate them to visit the other part of the department in a less-accessible area of the store.

2. The store's most profitable departments should be given location priority. Those that have the greatest potential should be reached by shoppers with a minimum of effort. They should be close to escalators and elevators and

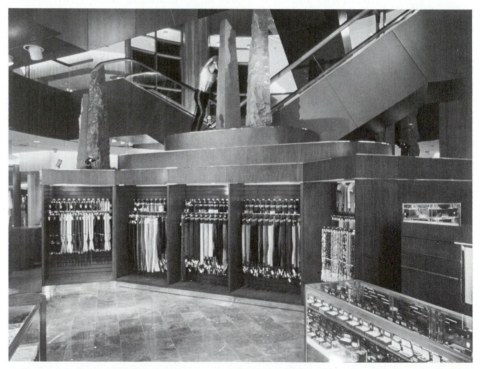

Figure 6-3. The men's department, such as the one in Rich's Riverchase Galleria, is located on the main floor. (Courtesy of HTI, Space Design International)

within the shopper's view when he or she enters the selling floor on which they are located.

3. Higher-priced fashion merchandise such as designer collections need not be in high-traffic areas. Since they are considered to be specialty goods, customers will seek them out. This is often the store's costliest merchandise and is best kept away from heavy traffic areas, out of the reach of would-be shoplifters.

4. Compatible departments should be located next to each other. Fine shoe departments are often located next to the store's better-apparel departments so that the purchaser of a dress can easily be satisfied with a pair of coordinated shoes. Not only does this make the task of shopping easier for the customer, but the store is the beneficiary of a larger sale.

5. Since most department stores generate more business from fashion goods than hard goods, the former should always take location preference over the latter.

While these are rules that are often adhered to, some retailers opt for other arrangements. It is vital to bear in mind that customer comfort and convenience are most important, and that more and more shoppers have less time than ever before to spend in stores. Their needs should always be addressed when determining where the selling departments should be located.

Locating the Nonselling Departments

Administrative and sales-support departments should be located in places that are less desirable for selling. More and more stores are minimizing the space traditionally allocated for the nonselling areas and using as much as possible for the sales floor.

As a general rule, single-level stores place their nonselling functions at the store's rear, and multilevel units utilize the upper levels or rear portions of a few floors for these departments.

In present-day retailing, many fashion merchants are reducing the sizes of their inventories and are eliminating extra stock and stockrooms. While reserve merchandise was once the order of the day, many merchants are avoiding the "deep" reserves of merchandise and are replacing the sold goods with new styles. This allows for a steady flow of fresh merchandise to constantly make its way to the selling floor. Departments that sell shoes, for example, still utilize stockrooms for their goods, and such space must be provided for in the store's layout. In situations where stockrooms are needed, they are usually located within the selling department to make the goods readily available to the sales staff.

Receiving departments also tend to be smaller than those found in yesterday's retail operations. By having the merchandise shipped to warehouses where it can be checked and ticketed and then sent to the stores, a great deal of in-store space once used for such practices may be used as selling space. The receiving departments are usually confined to out-of-the-way areas that are less conducive to selling. In times gone by, many major retailers used significant portions of their basements for storage and receiving. The practice has generally been eliminated since basement floors have become primary selling environments. Stores like Macy's with its famous Cellar and Carson Pirie Scott with its successful basement operation Corporate Level, have convinced other merchants that receiving is better located somewhere else.

Many stores are locating their administrative offices on the highest floors. Some use a separate floor exclusively for their administrative functions. Offices for buying and merchandising, advertising, promotion, publicity, record keeping, human resources, control functions, and others are found in these places.

Fashion Department Classifications and Designs

Once the general space allocations have been addressed and department sizes and places have been delineated, it is time to design the environment for each. Although the overall concept had been previously established in terms of store image and interior design direction, it is generally considered appropriate for each selling area to have a distinctive personality. In the case of the smaller fashion-oriented chain units, there is usually one design theme that follows throughout the store. Only where specific areas need further definition is it sometimes appropriate to plan a number of different decors. It is in the department store, with its host of merchandise departments and different market segments to focus upon, where interior design distinction is a must. The junior department will certainly want to impart a different feeling from that of the store's large-size fashion classification. Different price points, consumer markets, fashion directions, and so forth warrant individualized environments.

Traditionally, fashion retailers have segmented and classified their departments according to standard designations such as junior department, budget dresses, fashion accessories, evening wear, and so forth. While many merchants still departmentalize according to these conventional rules, there are different approaches being used by today's major fashion stores. Instead of subscribing to these designations, many are using more exciting and distinctive names to describe their fashion departments. Many stores are broadening their merchandise mixes and are finding that the traditional department names are not always appropriate choices. Some fashion merchants are offering the highest-priced

Dejaiz

PERRY ELLIS

Window and interior displays help motivate shoppers to become customers. The contemporary window structure at Dejaiz (above) is the perfect setting for avant-garde menswear. The Perry Ellis window at Neiman Marcus (left) demonstrates a tie-in between interior and exterior visual presentation.

The children's wear window (left) utilizes stylized mannequins to underscore the contemporary nature of the merchandise. Life-like photography (above), and the poster that utilizes a Saturday Evening Post cover (right), enhanced by braces and timepieces, vividly promote menswear.

T he elegance of women's high fashion apparel and accessories is promoted through the use of exquisite displays and fashion presentation. The Ungaro shop window (far left), the runway fashion show (left), and the in-store intimate apparel presentation all underscore the dramatic impact of effective promotions.

A brilliantly dressed mannequin surrounded by winter foliage and angels heralds the Christmas season (above). In the store, shoppers are treated to a fashion show which is used to introduce the season's latest offerings.

EUROPE'S RISING ✦ STAR
spain

Bloomingdale's exciting promotions are highlighted by their "salutes" to foreign countries as exemplified (above) by the Spain extravaganza. The carousel pony (right) serves as a perfect display prop for children's accessories.

Extravagantly mounted promotions bring significant attention to the savvy retailer. The bigger-than-life helium-filled balloon (right) in Macy's Thanksgiving Day Parade and Bloomingdale's in-store promotion for merchandise inspired by the "Dick Tracy" film (below) are designed to inspire shoppers to come to these stores.

designer fashions in their stores and are featuring separate areas for each of the collections. Still other fashion merchants are erecting in-house "separate" shops for specific, well-known merchandise offerings. Whatever the approach, it is imperative that the design team understand the merchandising concept for each department and create an environment that makes each one unique and conducive to shopping.

Traditional Fashion Departments

Within most stores, the traditional fashion departments generate a great percentage of the volume. Whether they are conventionally named Moderate Sportswear, Lingerie, Hosiery, Coats, and Suits, or classified with more updated nomenclature such as the Action Shop, Junior Innovations, After Five, The Contemporary Woman, and so forth, they must be designed to reflect the image for which they were conceived. Merchandise in these departments is usually plentiful, racks and counters are often close to each other, and the environment generally follows the basic design concepts of the store. Fixturing is generally functional.

Figure 6-4. Traditional store design subscribes to the theory of placing related merchandise in one department, such as this men's shop in Marshall Field, Chicago. (Courtesy of Space Design International)

Designer Salons

Most fashion department stores such as Saks Fifth Avenue, Marshall Field, Bloomingdale's, Bergdorf Goodman, and Neiman Marcus differentiate their fashion couture and prêt-à-porter (ready-to-wear) collections from the standard fashion fare by installing separate departments for these offerings. Since the fashions are of the store's highest price points, their merchandising requires a different approach than anything else the store has to offer. Individual "salons" are generally the choice so that each collection can receive the shopper's undivided attention. Internationally renowned names grace these small salons or boutiques, as they are often called, with each featuring the most elegant decor and appointments. Marshall Field, in its Chicago flagship on State Street, has refurbished its fashion salon floor to make it

Figure 6-5. Chanel, Gianni Versace, and Giorgio Armani boutiques are individually located in Bloomingdale's. (Courtesy of Space Design International)

one of the most exciting environments in fashion retailing. The salon areas are totally segregated from the store's other departments so that the couture customer is made to feel that she is shopping in each designer's own private shop. In this way, the store is able to cater to different types of customers under one roof.

In-house "Separate" Shops

A trend has developed that separates specific collections of merchandise from everything else in the store by means of installing individual "stores" within the store's premises. In the designer salons, which are small and are not totally separate from each other, the same salesperson may service the customer in more than one salon. These separate shops, however, often are enclosed environments where individual staffs only service those areas. One of the reasons for this approach is the insistence of the manufacturer. Ralph Lauren, for example, makes it a rule for stores that carry his complete men's wear line to build a separate facility specifically for the Lauren line. Some of Macy's stores have glass-enclosed shops that bear the Lauren name and are designed and visually merchandised in a manner that is desired by Ralph Lauren. The merchandise fixtures and displays are all antique or antique-inspired pieces that have become the hallmark for displaying Lauren merchandise. Stores that do not subscribe to this separate-store philosophy are likely to lose the right to carry the merchandise. Esprit is another company that requires the in-house separate store format. Its environment complements the Esprit offerings. As manufacturers become more important in the fashion industry, many begin to dictate how their lines are to be merchandised by stores. The most desirable lines seem to be moving in the direction of these separate, in-house shops with the success enjoyed from the Lauren and Esprit ventures. Designers such as Donna Karan, Gianni Versace, Emmanuel Ungaro, Christian Lacroix and Yves Saint Laurent are marketed in this manner.

Collection Areas

Somewhere between the salon approach and the separate shops are the collection areas. These are defined locations within specific merchandise classifications, such as better sportswear, which house a variety of sweaters, skirts, pants, and so forth, and set aside area segments for particular lines. Liz Claiborne, Perry Ellis, Jones New York, Adrienne Vittadini, and Anne Klein generally are found in these collection areas within larger departments. By featuring merchandise in this manner, the customer is able to see the line's body of work and choose pieces that relate to each other. This plan often leads to larger, individual purchases.

Each of these departments must now be furnished with a host of materials that will be decorative as well as functional.

Figure 6-6. All of Liz Clairborne's women's lines are housed in a "collection" area in Jordan Marsh. (Courtesy of Space Design International)

Decorative and Functional Materials

Having determined the location of the various departments and the different arrangements that the store will feature, it is time to select the materials that are to be used in the design. Those that are chosen for the floors and walls must be decorative as well as functional. An attractive floor might have considerable eye appeal but might not be sufficiently durable to meet the challenges of heavy traffic. Similarly, durability does not always guarantee attractiveness. The perfect marriage of the two must be assured to derive the maximum benefits of the chosen materials.

Floors

There are many types of flooring materials that are used in retail environments. While supermarkets and hard-goods discount operations rely upon those that will

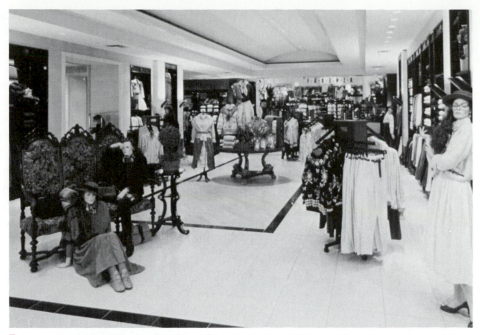

Figure 6-7. The Limited in Northland Mall, Columbus, Ohio, combines decorative and functional materials. (Courtesy of Space Design International)

handle the crowds and can be easily cleaned, this does not serve the needs of the fashion retailer. Appearance and comfort, as well as durability and ease of care are among the considerations that must be addressed.

Little else provides the feeling of luxury like carpet. Available in many textures, grades, and colors, it is often the material of choice when upscale fashion merchandise is the classification to be featured. At one time carpet was considered to be an extravagant choice since it was costly, difficult to clean and not deemed to be a durable product. Today, fashion retailers have a host of carpets from which to choose that satisfy every requirement. Fibers such as nylon provide extreme durability and are easy to clean. Color choices are numerous and, because of technological advances, fading and discoloration are rarely problems needing to be dealt with. The commercial carpet industry has such a wide assortment available, in many price ranges, that just about any retailer can find carpet to fit the budget.

Another advantage of carpet is that it can easily be installed over any type of subfloor, and those that are not in the best condition can be quickly and successfully covered with one layer of dense padding. Since installation is quick and relatively inexpensive, carpet is the right choice for any fashion sales floor.

Many retailers in their quest for distinctive design for their floors choose wooden planks and other shapes. The artistry of competent installers guarantees

the most interesting patterns. With the prefinished treatments of polyurethane, the floors are virtually scratchproof even when subjected to the harshest heels. In small salons, parquet floors are sometimes used and are covered in some places with area rugs. This combination of wood and rugs provides the retailer with an environment that simulates the most exquisite home, a desirable setting for such a department.

A wide assortment of ceramic tile, marble, vinyl, and brick is also available for flooring. Each has its own special characteristic that makes it an appropriate choice.

One must never forget the comfort factor when choosing floor materials. Although the aesthetic qualities are very important, as are the durability factors, it is important to make certain that the chosen material affords comfort to both the shopper and the sales personnel. Some materials are unkind to those standing on them. When workers spend a large number of hours standing on their feet, they should not tire quickly because of the wrong flooring choice. Caution must be exercised when making the final decision.

Walls

There are many wall coverings available from which fashion retailers may choose. Paint is still the most commonly used material since it is relatively inexpensive, comes in any color, and is easy to change whenever it becomes necessary. Other coverings include wallpaper, fabric, wood, mirror, stone, brick, and metallics. The choice depends upon the company's finances, the image it is trying to achieve, and the durability of the material.

Many interior designers are using a combination of materials to achieve distinctive effects. The use of matching wallpapers and fabrics gives the impression of rich quality, while the use of mirrors, with their reflective quality, gives the impression of larger space. Whatever the choice, like floor selection, careful consideration must be given before the final decision about wall coverings is made.

Fixturing

The image of the department is further enhanced by the choice of fixtures. There are two fixture categories: those used to hold the merchandise, and those used to illuminate the merchandise and the department. The variety available within each group is enormous and must be selected with appearance and function in mind. A beautiful counter that does not hold a sufficient amount of merchandise will prove to be as poor a choice as a lackluster display rack that was chosen to feature designer gowns.

Merchandise Fixtures

The wealth of merchandise fixtures available today is quite a contrast to what was offered to yesterday's fashion retailers. In years past, function was the main concern, with style playing a secondary role. Today designers may select from a variety of types, each helping to achieve a particular image without sacrificing function. Before actual selection takes place, consideration must be given to the methods used by the store to sell to their customers. If self-selection is emphasized, then open counters are a must. If individual presentation to the customer is the approach, closed floor counters may be needed to house the merchandise that will be shown to each customer. Most fashion retailers use a combination of fixtures since they often utilize both self-selection and personalized selling.

In addition to serving the retailer's selling techniques, merchandise fixtures play an important role in **visual merchandising**. When a shopper enters a store or a particular department, his or her attention should be directed to the featured merchandise. The appropriate counters, aisle tables, wall cases and other fixtures help to show the merchandise to the best advantage. The Gap's use of tiered counters that grace the center aisle of every store and feature the company's most colorful sweaters has helped sales soar. The merchandise offering did not change, just the fixturing and how it was used to feature specific items.

Each store must select fixtures that enhance the merchandise. Ralph Lauren prefers wooden antique table reproductions for sweaters and other folded merchandise. Not only does this type of fixture serve a purpose, it adds to the store's image. Harrods' use of elegant glass and brass show counters for their precious jewelry department makes each item look like a valuable treasure.

Fixtures range from the most traditional to the ultra contemporary to fit every store's needs. They are available ready-made at commercial vendors who specialize in store fixtures, or if the budget allows, may be custom designed. Whether it is wood, glass, steel, brass, laminates, or combinations of these materials, the choice is up to the retailer.

Lighting and Lighting Fixtures

One of the most exciting areas of store design is lighting. Once relegated to fluorescent lighting for general illumination and incandescent for highlighting and emphasis, the lighting designer now has a host of products from which to choose.

Again, as in the case of other design decisions, store image, merchandise, and finances must be considered. While fluorescents are still the most economical light sources, they are not the appropriate choices for most fashion environments. Even retailers who deeply discount their fashion goods or operate off-price shops find that the fluorescent light leaves much to be desired when trying to show the merchan-

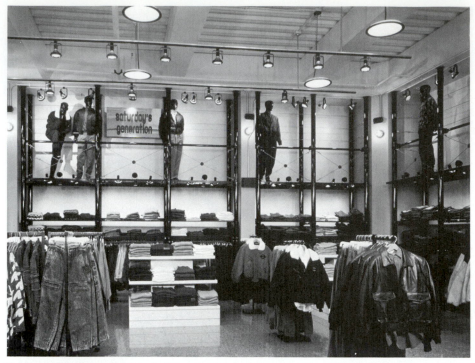

Figure 6-8. Track lighting in Bloomingdale's, Chicago, makes lighting adjustments simple. (Courtesy of HTI, Space Design International)

dise at its best. If controlling expenses is a factor, as it might be in such operations, a combination of fluorescent lighting with some incandescents can be used.

Spotlights and floodlights are **incandescents**. The former highlight merchandise by throwing a narrow beam of light, and the latter cover a wider area. Both may be housed in fixtures that are recessed into the ceiling or in tracks that give greater flexibility for illumination.

Today, much attention is being given to the use of **halogen/quartz** lamps and **high-intensity discharge** bulbs and fixtures. They both provide very bright, intense lighting and are generally used to emphasize particular merchandise and areas of the store.

Visual merchandisers rely heavily upon the dramatic effects achieved by lighting. The use for such situations will be explored in chapter 13, "Visual Merchandising."

Image has been addressed in various parts of this chapter. While store fronts, interior designs, wall and floor materials, and merchandise fixtures contribute considerably to the creation of an impression or an image, few if any can make the impact that is achieved by lighting. Subtle, dim lighting can create an elegant mood for the designer salons, while harsh, bright lighting can enhance the contemporary offerings of junior fashions. When lighting is used correctly, the store can take on any personality.

When the design firm Hambrecht Terrell International (HTI) was commissioned to design Bloomingdale's Chicago, a special source provided inspiration for the interior setting. Frank Lloyd Wright, the master architect with roots in Chicago, provided the keynote for the scheme's all-important decorative motifs. The HTI designers thoroughly researched materials and styles evoking the distinctive design of Frank Lloyd Wright. The result was the epitome of sophistication achieved with the use of the grandest available materials and fixtures. With elegant, spacious interiors incorporating elements of turn-of-the-century grandeur such as rich wood detail, marble promenades, and soaring vaults, the design reaches back to the period of Chicago's architectural eminence.

The store features unprecedented rationality and graciousness in department layout. There is an obvious marriage between the sophisticated merchandising philosophies that have given Bloomingdale's its fine reputation and a shopping environment that is destined to remain current for several decades.

The influence of Wright, and the Prairie School he helped to establish, is present in every aspect of the store's design. The colors of the store were chosen to reflect the Prairie School ambiance, and more importantly, to highlight the merchandise and create effect. The rich wood enhancements serve to convey an image of elegance, as does the marble that graces the main floor. Freestanding columns with rich crown moldings further accentuate the grand design, as do backlit ceiling panels for dramatic illumination, wall lights that reflect Wright's window pattern designs, neon light insets, granite chip flooring that sparkles, and stained glass.

Known as the retail organization that is prone to theatrics, the Chicago flagship certainly conveys that message with some of its elements. HTI constructed a dramatic circular stage on the main floor, which can be used for full-scale runway fashion shows. The use of glass walls between the escalators provides another theatrical touch. Not only do the escalators serve the shoppers functionally, but the setup between them provides an open view where visual merchandisers can install exciting displays.

The designers have successfully created an element of theater, making every shopping experience an adventure.

Department Layout

An important part of the development of each department's interior is its layout. Where and how the counters are arranged, how the selling aisles are designed to aid traffic flow, placement of mirrors and other furnishings, all contribute to the success of the department. Each department of a store has unique requirements

dictated by the type of merchandise and the amount of customer traffic that is expected. In departments where precious jewelry is sold, security is an obvious factor to consider when designing the layout. Counters must be strategically placed to prevent direct customer access. In designer salons the layout might call for one that simulates an at-home feeling. Merchandise might be kept in an adjacent storage area and brought out to the customers. In this case the layout would necessitate comfortable chairs and very little clutter. Traffic flow is not a prime consideration in such cases because departments of this nature do not attract large crowds.

Many stores are subscribing to interior design concepts that provide flexibility. Swim wear departments with their seasonal merchandise might be used as coat departments during the cold weather periods. By choosing a plan that is appropriate to both merchandise classifications, the store will make more productive use of its space.

Whatever the situation, the layout should provide for customer convenience, satisfactory traffic movement and security of the merchandise.

When all of the elements of design have been addressed, the retailer can concentrate on staffing the store and providing it with salable merchandise.

Small Store Applications

Many who open small fashion operations are more concerned with merchandise philosophies than they are with store design and fixturing. While merchandise considerations are paramount to the store's success, it is the appropriate utilization of the space that is important to maximize profits. With the high cost of space, the proper use of it is imperative. Just as the giants of the fashion industry employ designers for their facilities, so should the smaller merchant.

The inexperienced retailer often considers professional design assistance too costly and decides to attack the problem alone. While designers are paid for their time and expertise, the costs certainly make up for the errors that can arise from inappropriate design. Often, the cost of the store designer is actually very little. It might be just a few hundred dollars for a consultation and a proposed design that would provide the essentials for the store`s environment.

More detailed planning costs more, but the expense is often offset by the designer's ability to purchase fixtures and materials at lower prices then the retailer would have to pay. When architectural firms are used for store design, they generally have several companies bid for the job, thus making the cost of construction more competitive.

No matter how small, every fashion retailer should use professional assistance for planning their environments.

Highlights of the Chapter

1. The fashion retailer's proposed merchandising philosophy must be carefully addressed so that the proper design can be created to enhance the store's offerings.

2. Stores are made up of two types of departments, selling and nonselling. The selling departments occupy the store's most accessible areas with the remainder set aside for management offices and sales supporting functions.

3. There are several department classifications that are used by the larger fashion retailers. They are the traditional fashion departments such as junior clothing, designer salons, in-house "separate" shops, and collection areas.

4. Collection areas are used to separate certain manufacturer label merchandise from others. Many stores merchandise such collections as Liz Claiborne and Jones New York in this manner.

5. While fixtures must be functional, their appearance should coordinate with the merchandise to promote a specific image.

6. Lighting is a very important design element and its selection is important not only for illumination but also for creating moods.

7. A department's layout should consider customer convenience, the merchandise to be sold, and traffic flow.

For Discussion

1. Which fashion retail chain initiated a departure from the mundane approach in store design and what elements did it use for its accomplishment?

2. Why should the small fashion merchant utilize the services of an architect since fees are usually high?

3. Describe Lerner New York's interior design concept in its flagship and how it transformed the store from its past image to its present one.

4. What type of retailer makes use of the parallel-to-sidewalk window structure?

5. In what types of retail environments are the windowless store fronts gaining the most prominence?

6. Why do some merchants choose the arcade fronts for their shops?

7. In multilevel fashion-oriented stores, which merchandise classifications are usually located on the main floor?

8. Why are many of the major department stores' receiving departments smaller than they once were?

9. Discuss the reasons for the use of individual designer salons in the major department stores?

10. Describe in-house "separate" shops and the reasons for their existence in large retail operations?

11. In addition to aesthetics, why are some floor materials chosen by retailers?

12. Why do some fashion merchants use halogen/quartz lighting in addition to the more traditional incandescents?

13. On whose basic ideas was the Bloomingdale's Chicago flagship designed?

14. Can the small fashion merchant employ the use of a store designer without actually spending more than has been set aside for the development and construction of the entire project?

Jane Parker recently inherited a substantial amount of money and decided to invest it in a fashion boutique. For the past five years she has worked as a fashion coordinator at Cranston's, a department store with six branches. Now that she has what she considers to be a sufficient amount of experience and an appropriate amount of money to use, she has decided that it is time to start her own company.

Jane has always been recognized for her excellent taste in fashion apparel and accessories. Her frequent trips to the market accompanying Cranston's fashion buyers helped her to develop an excellent understanding of the industry and merchandising techniques. She has already decided upon the approach she will take in the new store's merchandising philosophy and is now ready to tackle the problems associated with store design and fixturing.

In order to prepare herself, she has studied the layouts, fixtures, and materials used in many of her city's fashion stores. Although there are not many boutiques in her general trading area to study, she feels that she can adapt the plans utilized by larger stores for her own venture. By combining a great deal of legwork with her practical experience, Jane believes she can develop a suitable store design and fixturing approach that will suit her needs. By eliminating the use of architects and designers she feels that she can save a great deal of money.

Questions

1. Do you think Jane has the necessary competence to design her own store facility? Why?

2. What approach would you suggest she use to make certain that her plans are appropriate for the venture?

Collins and Sander's, a full-line department store with several branches, has decided to open another unit. Unlike the other branches, this one will confine its merchandise mix exclusively to fashion merchandise. The reason for the decision is that the company has realized that there has been a decrease in the store's hard-goods sales. The new store will serve as a prototype for the company, and will hopefully be the first of many fashion units to be developed.

As successful merchants for more than 45 years, Collins and Sander's has been through many expansion programs. They have always used the same architectural organization for their stores and have been satisfied with the results. The architects and designers meet with top management for guidance in terms of space requirements for merchandise and to learn about any design preferences. Throughout the years the company always subscribed to the traditional approaches for their fashion department layouts, as well as for the rest of the store, and business generally flourished.

Before approaching the architects, Collins and Sander's held a meeting of their top management team and those responsible for visual merchandising. The meeting resulted in two different schools of thought for the new store's department designs. Top management believes that the traditional approach always worked for the company and the same approach should be taken. The visual merchandisers feel that the store should utilize a more contemporary approach to interior design. They believe that with the new store's emphasis totally on fashion, the company would be better served with the establishment of several different department classifications.

Questions

1. With which group do you agree? Defend your answer with logical reasoning.
2. Discuss the concepts of traditional fashion departments and the newer approaches to fashion department classifications.

Exercises

1. Photograph the windows of a downtown major department or specialty store and those of stores in a regional mall or power center. Mount five of the best pictures on separate pieces of paper and describe the window structure category into which each fits and the reasons for your belief that it belongs in that classification.

2. Visit a major fashion-oriented department store and make a list naming ten of the store's departments and the type of merchandise in each. The format should be similar to the one featured below.

STORE NAME: _____

Department Merchandise

3. Examine the lighting in three fashion shops and describe the types of lights they use to illuminate the interiors and windows. The form below would be appropriate to use for the exercise.

 STORE A STORE B STORE C

Windows

Interior

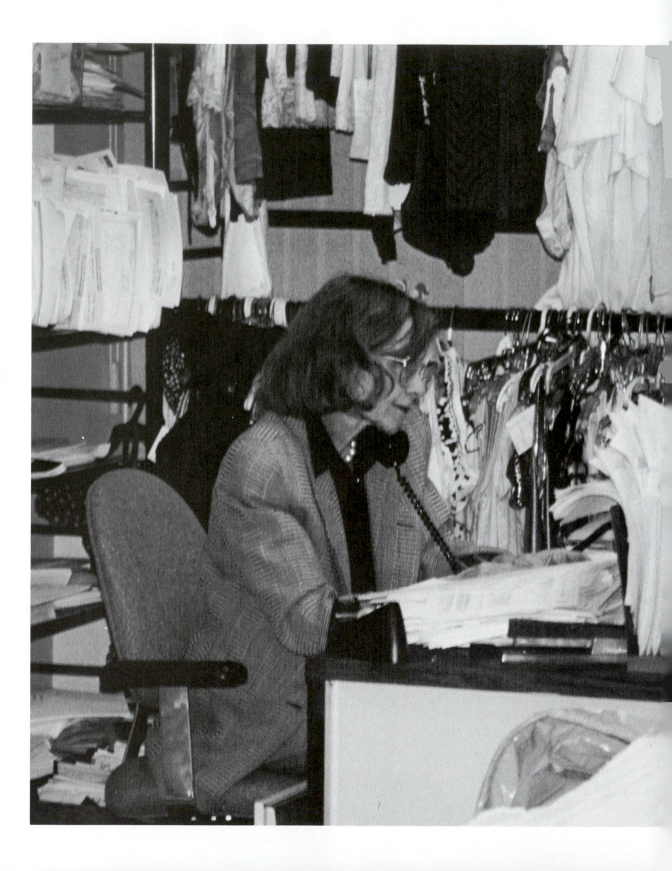

Management
and
Control
Functions

Human Resources Management

Learning Objectives

After reading this chapter, the student should be able to:

1. Discuss the various tasks performed by the human resources department.

2. Describe the typical procedure used in the evaluation of potential employees.

3. Identify several sources of personnel supply.

4. Explain the different types of tests administered by the department before a hiring decision is made.

5. List and describe the techniques used in employee training.

6. Discuss remuneration plans that motivate employees to maximize their efforts on the job.

7. Identify the services and benefits offered to employees in large retail organizations.

8. Discuss the role of the department in terms of labor relations.

The lifeblood of any organization is its staff. Without competent employees at every level, it is unlikely that the store will be able to function properly. Whether it is the decision makers at the organization's highest levels, the middle managers, the people who have direct contact with the shoppers at the sales level, or those who provide support services for the company, excellence is necessary in the running of a profitable store.

The task of attracting the best employees is no simple matter. Many fields of business are more attractive to potential employees than retailing for a number of reasons. Except for the top positions, retailing has an image of underpaying its workers. This, coupled with the potential for long hours and weekend attendance, often discourages would-be participants from entering the field. Many of the country's most talented graduates, embarking on a career, opt for other means of employment. Confronted with such negatives, the organization must be able to

attract qualified individuals who are willing to take the challenges offered by a retailing career. While the image might not be positive, it should be noted that retailing does provide many pluses. Salaries at the middle-management levels are comparable to other fields, fringe benefits are usually excellent, and employee discounts enable a wealth of merchandise to be purchased well below the retail price.

The personnel department, or the human resources department as many retailers refer to it, has the responsibility of locating the best available personnel. The successful candidates for the jobs must then be trained to ensure comprehension of the store's mission and of the various tasks to be performed. They should also be regularly evaluated to improve performance and to ascertain which of them are potential candidates for promotion. These roles, along with recommendations on remuneration and employee services and benefits, make the human resources department a vital part of the company.

When one refers back to chapter 2, "Organizational Structures," and examines each organization chart, it becomes obvious how many different types of people are needed to make the store a successful operation. Each position on the charts represents a different employee need for the store and underscores the enormous role played by those in human resources to fill these needs.

The choice of whether or not those in the department are decision makers and have the responsibility for making hiring decisions, or merely advise managers with their suggestions in regard to hiring, varies from company to company. Some companies regard their human resources departments as line management and give them responsibility for hiring, while others regard them as staff and require that they only provide advisory assistance when the company is seeking new employees. Some stores use a combination approach, utilizing the human resources personnel sometimes as decision makers and other times as advisors. In the employment of salespeople, for example, the human resources department may have the responsibility to hire these individuals, while the final decision regarding upper-level employment may remain the function of division and department managers. Whatever the approach, each company must spell out the role of the human resources department and how it will function in the organization.

The Recruitment Process

One of the most difficult tasks facing today's retailers, and in particular those who specialize in fashion merchandise, is to find prospects who have the potential to become productive employees. As the size of the employee pool shrinks, and every informative source indicates that it continues to do so, human resources managers will have to initiate new techniques for the purposes of recruitment. New approaches to finding prospective workers will have to be employed as will new methods of determining the value of those being considered for jobs.

The recruitment process addresses many stages before any one candidate can be considered suited for the company and a specific job. In cases where the organization has been in business for a number of years, there is a recognition of the requirements of the particular jobs it has to offer. For newly established stores, research known as job analysis must be undertaken to discover the requirements and specifications of the many jobs in the company's structure. Occasionally even companies with long histories must engage in such research when new job titles are being added to the store's roster of employment positions. **Job analysis** is the study of a specific job to learn all about its duties and responsibilities. From this analysis, **job specifications** are spelled out listing the qualifications needed to perform the job. Finally, a **job description** is written, outlining the title of the job, the division in which it belongs, the specific department, the title of the immediate supervisor, and a brief description of the duties and responsibilities. Each job description is kept on file using individual file cards or on a computer for easy access. Such a system enables the recruiter to quickly examine the job description for such purposes as placing a classified advertisement or preparing for an interview. The job descriptions assist the human resources team in matching the potential employee with the appropriate job.

Figure 7-1 is a typical job description used in a fashion-oriented retail organization.

JOB DESCRIPTION

DIVISION: Merchandising
TITLE: Assistant Fashion Director
SUPERVISOR: Fashion Director

DUTIES AND RESPONSIBILITIES:
Works closely with the fashion director in carrying out the store's fashion policy in the flagship and branches. Specifically the duties include:
1. Accessorizing the interior apparel displays.
2. Assisting in the preparation of fashion shows.
3. Advising buyers on fashion market conditions.
4. Preparing for store appearances by designers.
5. Writing commentary for fashion shows.
6. Visiting branches to evaluate fashion promotions.
7. Visiting fashion market to evaluate new resources.
8. Accompanying visual merchandisers to display shows.

APPEARANCE:
Fashion oriented in terms of hair, cosmetics, and attire.

▌**Figure 7-1. A job description for an assistant fashion director**

Personnel Sources

Companies that rely upon the same resources for new employees that they have used in the past are finding that these might not satisfy their needs. As already mentioned, retailers have many competitors when it comes to recruitment. Those responsible for hiring should not restrict themselves to the older methods but should try some new approaches. Both the traditional and innovative methods used to attract prospects to the store include those described in the following paragraphs.

Classified Advertisements

The method used most often for announcing available retail positions is the classified ad. Generally the advertisements are listed in the typical classified section of the newspaper when lower-level or middle-management positions are being offered by the store. In cases where the retailer is promoting its executive development program or is trying to fill an upper-level management position, the vehicle often used involves running an ad in a major newspaper's business section. The Sunday edition of the *New York Times*, for example, is a place where ads for retail executives are placed. An advertisement placed there is more visible to the executive seeking employment than the typically listed classified advertisement. Whichever section of the newspaper is used, the type of ads are either **open ads** or **blind ads**. The former lists the name of the retailer in addition to any information considered pertinent to the prospective applicant. The latter omits the company name, supplying only relevant information about the available position. Those who use the blind format often do so because it preserves the anonymity of the company and avoids unwanted telephone inquiries. Sometimes the use of the blind ad discourages the job seeker from applying for fear that he or she might be applying for his or her own position, alerting the present employer that a job change might be forthcoming.

CUSTOMER SERVICE

Position available for organized, high energy, detail oriented individual. Must be computer & data processing oriented and have good phone skills. 2 years experience in customer service with department and chain stores for a large apparel firm preferred.

**Call Carlos at California Dynasty
(213) 538-0808**

Figure 7-2. Trade paper classified advertisement (Courtesy of *California Apparel News*, copyright The Apparel News Group, Los Angeles)

Classified ads should not be limited to consumer newspapers. When fashion positions need to be filled, many retailers find that such publications as *Women's Wear Daily* and the *Daily News Record* quickly serve their needs. These newspapers are often read religiously by people with fashion experience and can alert the best-prepared individuals to the store's needs.

Recommendations

Retailers sometimes find that approaching present employees or posting notices concerning the need for additional people results in the hiring of superior personnel. Those who are currently employed by the store and are satisfied with their positions might be willing to recommend individuals for the jobs. Employees who are happy with their employment often serve as goodwill ambassadors for the company and help sell relatives, friends, and acquaintances on the merits of the company.

Employment Agencies

Some retailers prefer to have job applicants prescreened before they decide to consider someone for an interview. By providing agencies with job descriptions, they can then limit their time to interviewing those with potential. Agencies usually specialize in specific industries and particular levels of employment. Fashion retailers who utilize the services of an agency that specializes in their types of positions are more likely to have better-qualified applicants recommended to them. They might also want to deal with two different agencies for their needs at different levels. One might serve their purposes for entry-level prospects and the other for management personnel. Finding a suitable individual to fulfill the company's needs at a high level is often difficult. For these positions, retailers generally use executive search firms or "head hunters" as they are often known. Head hunters do not wait for individuals to come to them for top-flight positions, but research competing organizations for the purpose of luring the talented away with superior job offers. Most fashion retailers find that this is the best technique to attract the most prized employees.

Walk-ins

One of the most successful means of staffing the store comes from people who seek employment directly by coming to the store. Many retailers have outstanding reputations and attract numbers of people who wish to work for them. Most retailers agree that a substantial number of salespeople are found this way, and that they turn out to be among the most productive of the store's employees. One of the reasons for the effectiveness of such recruitment comes from the individual's self-motivation. With a willingness to go from place to place, many demon-

strate an eagerness to succeed. At levels other than entry, however, this route rarely produces qualified people.

Interior and Exterior Signage

Small retailers often use signs in their windows to announce the availability of positions. Very often those who are customers of these stores are willing to work there because of their familiarity with the operations as customers.

Many of the giant retail operations use in-store signage to alert shoppers to their need for employees. They strategically place signs in their stores that list the benefits of working there. Since many who see the signs are customers, the indication of merchandise discounts attracts some to apply. The signs are used to appeal to segments of the population who might otherwise think they were ineligible for employment in the store. Housewives, for example, are made aware of part-time arrangements that do not conflict with their household responsibilities, senior citizens may be apprised of the store's policy on hiring the elderly, and young high-school students might be notified of the store's willingness to train them and arrange flexible hours that do not conflict with their schooling.

Schools, Colleges, and Universities

Some educational institutions organize job recruitment fairs that bring retailers onto their campuses. Individual booths are set up for each store participant where students can learn more about the operations. Human resources managers distribute literature describing the store's image, opportunities for employment, advancement routes, and employee benefits. The fairs enable students to compare the various participating stores and consider potential employment. Very often applications are made available to those who are interested and preliminary interviews are conducted to determine the applicant's qualifications.

Many colleges and universities arrange individual campus visits by established retailers. The stores are usually interested in recruiting candidates for their executive development programs and find this the best market to fill their future management needs. Such famous stores as Macy's, Bloomingdale's, Filene's, Jordan Marsh, and Saks Fifth Avenue make this approach a regular part of their management track recruitment.

Another on-campus source of personnel is the job placement center found at many educational institutions. Specific jobs are called in to the placement offices, which provide the participating companies with a steady stream of applicants.

Mall Walkers

With many of the traditional approaches failing to meet the retailer's needs, some are turning to a technique called **mall walkers**. The system involves store repre-

sentatives who scout the malls in which their store is located for the purpose of seeking out shoppers to work in their stores. The system is akin to the one used to offer store credit cards to shoppers. People in the mall are approached, given information about the store and its employee benefits, and are escorted into the store if they are interested. Things Remembered stores turned to this type of recruitment when the traditional use of advertisements and window signs no longer worked for them.

Employee Networking

Another new approach involves employee networking. Store managers are taught communication techniques to use when approaching customers or competitors' employees in malls and strip centers about the possibility of working for their company. By providing bonuses to managers as incentives, the system often produces positive results. One major retail chain reports that this strategy has supplied the store with many new, competent workers.

Retirement Centers

One personnel source that has brought capable employees to retail organizations is the retirement center. Senior citizens often spend their days in these complexes participating in social activities. Many of the participants, because of the high cost of living and their inability to handle their own financial responsibilities, are returning to the work force. In a program initiated by the McDonald's organization and adopted by retailers, senior citizens work part-time shifts alongside their younger counterparts. With dedication to the work ethic and a need for additional income, they have become productive employees.

Recruiters have been known to visit senior day-care centers and housing complexes that cater to these citizens to encourage them to work in their stores. The success has been overwhelming. Both the needs of the retailer as well as the needs of the returning worker are served.

The Hiring Procedure

After contacting the appropriate sources to attract prospective employees, the human resources department must evaluate those individuals to see if they meet the store's requirements for employment. The hiring procedure that a store uses depends upon the level of the position and supply and demand.

A company seeking to replace a divisional merchandise manager is certainly going to use a different approach than if it were hiring a salesperson. The former position is at the level of top management and requires significant decision-mak-

ing ability and a substantial background in merchandising. A candidate for the latter position might merely need to be appropriately groomed and dressed and display a willingness to work. It is obvious that the procedure used to evaluate the candidates for the manager position will be considerably more extensive than the one used to hire the seller.

Employment Application

Name / Please Print / Last	First		MI	Social Security #
Address / No & Street	Town / City	State	Zip	Telephone #
Position(s) Applying For	Hours Available (FT / PT / Wknds / Other)		Available to start on Date _____ Are you under 18 Yes / No	

Were you ever employed with us, or had you previously applied for employment with our Company? No / Yes

If yes, when ?_____ Location _____ What Happened? _____

Any relatives or friends working for us? No / Yes

Give names and locations _____

Employment History
(Starting with most recent)

If not currently working, indicate here how you spent your time between your last employment and now

Present or Last Employed From Mo.____ Yr.____ To Mo.____ Yr.____	Company Name	Salary Start Last	Title / Duties
	Address		
	Tele. ()	Name / Title of Supv.	Reason Left
Employed From Mo.____ Yr.____ To Mo.____ Yr.____	Company Name	Salary Start Last	Title / Duties
	Address		
	Tele. ()	Name / Title of Supv.	Reason Left

If currently employed may we contact your current employer for reference purposes? No _____ Yes _____ If yes, give name, position and telephone number of person to be contacted. Name _____ Position _____ Telephone #_____

If you ever worked under another name, please state former name so that references may be checked _____

READ CAREFULLY AND SIGN

1. I hereby declare that the information provided by me in this application is true, correct and complete to the best of my knowledge; and that any misrepresentation or falsification of this information shall be cause for dismissal.
2. I authorize you to investigate and check any of the foregoing data and references.
3. I agree to conform to the policies and procedures of my employer and I understand that work schedules are subject to change and that overtime may be required.
4. I understand there is no contract of employment between the employer and myself, and I have not been promised any definite period of employment.

Date _____ Signature _____

■ **Figure 7-3. Application for employment**

Supply and demand are other factors to consider in the hiring process. In times when there are many capable prospects applying for retailing positions, the human resources department can be more selective and employ a great number of evaluative steps before selecting the successful candidate. If, however, the merchant needs to fill a vacancy quickly and the personnel supply is severely limited, the hiring process will be significantly abbreviated. Supply-and-demand cycles constantly change, and the human resources people must be ready to use the hiring procedure that is most appropriate for the time.

Whichever approach a retailer uses, the object is to screen applicants. Each stage of the process is supposed to eliminate a number of candidates, with only one left to be offered the available position.

The stages described below are typically used to screen applicants.

Application Forms

Many recruiters use the application form as their first step in the hiring process. Unlike yesteryear, where questions pertaining to age, marital status, height and weight, and number of dependents were found on many job applications, today's forms are carefully developed to avoid anything that might be considered discriminatory. The federal Civil Rights Act of 1964 makes it illegal to request such information.

The forms ask for information concerning education, previous employment, and anything else deemed pertinent to the company, such as how the applicant was referred to the store and if any friends or relatives are employed there.

Preliminary or Rail Interviews

When the application is completed, a human resources staff member examines it and decides if the applicant merits further consideration. Those whose applications show little potential for employment are dismissed, while others showing some promise are briefly interviewed. These are known as **preliminary** or "rail" **interviews** and take just a couple of minutes. At this time, a staff member quickly evaluates the candidate's appearance and ability to communicate. Since these are two areas vital to successful retailing employment, they must be considered before the next step in the hiring process can be addressed.

Sometimes the application and preliminary interview stages are reversed, depending upon the company's policy for screening applicants.

In situations where lower-level positions need to be filled promptly, the process might be terminated at this point. At peak times such as the Christmas season, part-time salespeople could be hired without going through a more formal employee search. When positions of greater responsibility are offered, the process continues through other steps.

References

Employee references may come from the applicant's friends or relatives, teachers, or past employers. They are used to evaluate the individual's character and verify the information on the application. Some stores use a standard form that is mailed, while others rely upon the telephone to elicit the information.

Testing

Many different types of tests might be administered as another means of evaluating the candidate. They include aptitude tests, which determine the applicant's capacity for work; intelligence tests, which indicate how much learning has taken place in the past; interest tests, which indicate whether or not there is a sincere interest in the available type of work; personality tests, which evaluate the individual's characteristics and personality traits; and pen and pencil honesty tests, which help determine the honesty and integrity of the person applying for the job. The polygraph or lie detector test has been declared unconstitutional and cannot be used any longer by retailers.

A new type of test in which some retailers have shown interest is one that uses video cassettes. Casey Jones, vice president for SRI Gallup in Lincoln, Nebraska, has designed a test that shows the candidate a video portrayal of the job that is based on actual stories or incidents. After each short skit showing a customer dealing with an employee, the tape stops and asks the viewer to select an answer from among the many offered responses. The tape features about thirty such incidents and allows 15 seconds for each response. Each candidate's responses are then evaluated in terms of the store's needs. These and other types of visual tests might enable recruiters to better evaluate those with potential, but who do not feel comfortable with written exams.

Final Interviews

For those candidates who have satisfactorily passed through all of the other stages, one or more interviews might be necessary before the position is offered. Unlike the preliminary interview, these are lengthy and could take a few hours or longer.

Some retailers use human resources personnel to conduct the first of these interviews and the supervisor of the available position to conduct another. These interviews enable the interviewers to ask numerous questions pertaining to previous experience, educational background, interests, and other areas. They also permit the candidate to learn more about the company in terms of salary, advancement potential, company policies, benefits, and so forth.

Since the divisional or department head is the one under whom the applicant will have to serve, it is that person's responsibility to render the final decision.

Training

Training is important to make certain that the amount of work accomplished each day and the quality of the performance of each employee are at a level that satisfies the needs of the store and its objectives. Without adequate training it is unlikely that the store's goals would be achieved.

Training takes place at different stages of employee development and is accomplished by numerous means. Each level of employment demands specific attention and is addressed differently according to the size of the organization. Small stores, for example, are less formal in their approach and often limit their instruction to on-the-job training. Larger stores generally utilize a program that includes classroom instruction, vestibule training, and on-the-job training.

The programs in larger operations are usually developed by the human resources department and carried out by experts on their staff and members of the store's supervisory team. Small stores generally rely upon owners or managers to familiarize their new employees with the tasks of the operation in a less structured manner. Since these organizations are small, they are not cluttered with the variety of procedures and forms used by their large-store counterparts, thus eliminating the need for more than an orientation to the store and learning the inventory.

Some training methods are appropriate for all levels of retailing while others are specifically oriented to the larger establishments.

New Employee Training

When people join a company, it is important to teach them as much as possible about the organization in terms of its philosophy, goals, and procedures. When the store is fashion oriented, the challenges of training are even more complex and include teaching about the store's fashion image and direction. It should be understood that the level and scope of the position dictate the types and depth of training that must be provided before the new staff members can tackle their jobs. The people to be trained are described below.

Executive Trainees

The most important groups to be trained are those who will share in the management of the company. The success of the store is, for the most part, based upon management's ability to develop creative ideas and programs and to make certain that the staff will carry them out satisfactorily. At the upper level of every retail organization, tasks involving merchandise analysis and forecasting, customer services, promotion, visual merchandising, and so forth are addressed and implemented to make the organization more profitable. Fashion retailers face even

greater management challenges since they regularly are faced with such decisions as the introduction of new styles, color selection, fashion cycles, and purchasing offshore.

Each store uses its own approach to the training of new executives. Some programs, such as the ones subscribed to by Macy's and Bloomingdale's, are so extensive that they are considered to be the "Harvards" of executive development. With such rigorous and demanding training, graduates of these programs are regularly pirated by others seeking top-level managers.

Evaluator's Name _____

Name of Sales Trainee _____

THE SALES PRESENTATION **SCORE**

APPROACH: Evidence of preapproach preparations, confidence, poise, friendliness, sincerity, achieved interest of prospect quickly _____

SALES PERSONALITY: Proper appearance, tact, voice, grammar, attitude, absence of objectionable mannerisms .. _____

BUYING MOTIVES: Skill in creating interest in product and arousing a desire to buy ... _____

PRODUCT AND COMPANY: Knowledge of product and company necessary to convince prospect to buy ... _____

SALES STORY: Well planned and executed, thorough, held prospect's interest, believably enthusiastic, illustrated how prospect could benefit from buying product .. _____

DEMONSTRATION: Imagination and appropriateness, encouraged prospect participation when suitable ... _____

MEETING OBJECTIONS: Skill in overcoming barriers to completing the sale, application of proved techniques to handle objections _____

TRIAL CLOSES: Ability to detect clues or buying signals, attempted closes when feasible... _____

CLOSE: Skill in application of closing techniques, order-filling proficiency, absence of idle chatter ... _____

FUTURE BUSINESS: Encouraged return visit to store _____

 TOTAL SCORE _____

As an individual judge, score the sales presentation on each of the areas listed by assigning points from 1 to 10. Total the points to get the score. A conscientious and unbiased rating helps the salesperson to learn how well he or she performed and to recognize strengths and weaknesses.

SCORING GUIDE: Excellent (10), Good (8), Fair (6), Poor (4)

Figure 7-4. Sales trainee evaluation form

Mid-management Trainees

People who are department managers and assistant managers are not called upon to make policy decisions but are given the tasks of carrying out the decisions made by top management. They are trained to perform such duties as tallying the day's receipts, organizing meal breaks, determining employee schedules, handling customer complaints and other matters.

Sales Personnel

It is the responsibility of the sales staff to assist the customers with their selections by offering product knowledge, making suggestions, and providing other assistance. Without properly trained sellers, sales that would otherwise be made could be lost. People new to selling need more training in this area than those who come with previous experience. Both groups, however, must learn all about company procedures and equipment used at the time of purchase, such as point-of-sale terminals, proper handling of credit cards, sending of merchandise, and removal of security devices on certain items.

Nonselling Personnel

Those responsible for receiving and marking merchandise, store security, customer services, control, stock keeping, and other tasks need training that is specific to their jobs. Each must learn the store's overall philosophy and procedures and apply them to their individual responsibilities.

Retraining Employees

Different situations might account for the training of those people who are already on the store's payroll. This newly needed knowledge may come as the result of a promotion or transfer, the introduction of a new system, or the addition of a new department.

Transfers from one department to another usually involve the use of procedures already understood by the transferee. The new training might require familiarization with different merchandise. When an assistant buyer is transferred from men's wear to junior sportswear, for example, the store's buying procedures will be the same, but the merchandise knowledge will be different. Retraining in terms of product knowledge might be necessary.

With promotions come additional responsibility. A group manager whose responsibility was to execute merchandising plans for several departments might be promoted to buyer. Although the former position is one of responsibility, its challenges and decision making are different from those of buying. Training that includes development of a model stock, pricing, negotiation with vendors, open-

to-buy calculations, and other skills is generally needed for the new job.

In these times of technological advances, the installation of new systems requires retraining of the staff. It might be a new point-of-sale terminal that uses scanners in place of previously used input devices or a new automated system for moving merchandise from the receiving room to the selling floor. Some new systems require the retraining of the entire staff, such as in the case of a new computer system, or merely just one department as in the case of a new receiving conveyor system.

Sometimes fashion retailers will expand their operations by adding new departments to their stores. When such retailers want to trade up for example, they might establish a boutique section in the store that features fashion-forward, designer merchandise. The boutiques might require more personalized selling and better servicing of the customer. Dealing with this new area and different customer types might necessitate additional sales and service training for the individuals involved in the new departments.

Training Methodology

Different jobs and circumstances require different approaches in training. Among the most common methods are vestibule training, classroom instruction, and on-the-job training. Those and some other techniques are explored below.

Vestibule Training

When specific tasks such as using a point-of-sale terminal for recording sales are being taught, most retailers elect to simulate the conditions of the task rather than train the individual on the selling floor. This enables the new employee to handle the equipment and transactions without the fear of making costly mistakes. The trainer can provide the necessary information to the trainee and allow as much time as necessary for the comprehension of the machine. If teaching were to take place on the selling floor, it would interfere with the store's actual transactions, causing delays and possible misuse of the equipment.

Classroom Instruction

Most major retailers have instructional facilities that include a classroom. Such facilities are used for different purposes: orientation sessions to introduce new employees to the store's systems, retraining current employees, and instructing executive trainees. Whatever the reason for the use, numerous teaching methods are employed in the classroom settings.

Lectures followed by question-and-answer periods are generally used for teaching such tasks as servicing the customer, handling suspected shoplifters, and

dealing with customer complaints. Today, video cassettes are used to augment the lectures and are often used in place of them.

Most of the giant department store organizations hold regular classroom sessions in the development of their future executives. These groups have scheduled times when various members of the management teams instruct them on specific topics. Since newly hired executive trainees generally rotate assignments, they must learn what each division of the store offers to the operation. In that way, they will be better prepared to handle any job. These trainees are regularly addressed by divisional heads of merchandising, management, promotion, and control, as well as by human resources specialists who coordinate the training effort.

On-the-job Training

In most small stores the only training that takes place is accomplished on the job. The store owner or manager usually familiarizes the new employee with store policy, merchandise, selling techniques, and anything else necessary to perform the job. Large stores sometimes use a combination of vestibule, classroom, and on-the-job training to accomplish their goals.

Individualized Video Instruction

Some major retailers are using individualized video instruction for their managers. Dr. William G. Harris of the Stanton Corp. in Charlotte, North Carolina, developed an instructional video for managers to use in honing their interviewing

FASHION RETAILING
DU PONT AND "SWIM"
SPOTLIGHTS

One of the shortest sales periods for fashion retailers is the swim wear season. Not only does it traditionally last only a few months, but sales results can be hampered by adverse weather conditions and the inability of the sales associates to make sales. In a jointly sponsored study between Du Pont and the Swimwear Manufacturers Association (SWIM) startling information surfaced that underscored the seriousness of the problem.

Eighty percent of those women who try on swimsuits fail to purchase them, an even greater percentage of women who enter a department never even try them on, and three times as many women purchase their bathing suits at service specialty stores than at department stores. Such information made many of the fashion retailers' merchandising managers sit up and take notice and decide that something had to be done to improve swimsuit sales.

In addition to these figures, other meaningful information surfaced during the study. Women expressed nervousness about buying a swimsuit: the item would be the most figure-revealing garment ever purchased, extra pounds added during the winter would be seen, the no-return policies caused apprehension, and merchandise displays did not always help with the proper assessment of the various styles. With enormous inventory investments and the potential for significant losses, fashion retailers such as Joslin's in Denver, Woodward & Lothrop in Washington, D.C., Burdine's in Miami, and Marshall Field's in Chicago agreed to participate in a test sponsored by Du Pont and SWIM that would hopefully improve sales. Proper training was the key to solving the problem.

Each of the participating stores chose two sales representatives to be trained by the Swimwear Manufacturers Association. The program included selecting swimsuits, identifying styles, understanding the appropriate styles for specific body types, construction, fiber characteristics, and swimsuit care. After three intensive days of training, the representatives returned to their respective stores to pass along their newly acquired knowledge. The result was an almost 50 percent increase in sales!

The joint effort of the fiber manufacturer Du Pont and the industry's trade association helped retailers recognize the need to make swimsuit customers more comfortable and also how vital proper customer servicing is when such purchases are made.

After the study a valuable kit, "How to Sell Swim Wear with Sweet Success," was developed. It outlines the importance of understanding the customer's needs and matching them to the appropriate swim wear.

skills. One of the cassettes features a 30-minute back-to-basics lesson for managers who were not getting enough instructions on interviewing techniques. The video reinforces the importance of the initial interview and of knowing what you are going to do when you begin, as opposed to shooting from the hip. It focuses

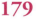

on learning to ask the right questions and listen well. While such instruction can be given in the typical classroom setting with a teacher, this format enables each individual to examine the tape at his or her convenience and to review it as often as it takes to master the skills.

Computer-aided Instruction

Some retailers are using the computer to teach math-oriented tasks. Many programs are available that teach various mathematical concepts necessary for retail use. They may be as simple as learning the basic skills or as advanced as teaching markup/markdown calculations and open-to-buy. Computer-aided instruction permits one to learn at his or her own pace and to review the areas that need additional attention.

Evaluating Employees

Once the employees have been trained and assigned to specific jobs, they are able to demonstrate their value to the store through their performance. Although each individual may be given the same training and opportunity for advancement, not everyone is capable of the same results. Some are outstanding in their assignments and might merit future promotions, others might demonstrate the ability to perform but the present job does not sufficiently satisfy their own personal needs, and still others might show signs of incompetence or an unwillingness to succeed. Each of these situations will eventually need attention from those in charge, such as promotion to positions of greater authority, transfers to areas that will better suit needs and abilities, and terminations.

In order to evaluate employee performance in a fair and equitable manner, the human resources departments in the larger organizations develop a plan for employee evaluation. Not only does it separate the talented from the unworthy but it also serves other purposes.

1. It helps the supervisor to evaluate the employee according to certain established criteria, thus giving the ensuring fairness to everyone.

2. Salary increases can be awarded based upon the employee's commitment to the store.

3. When positions at higher levels become available, those best suited can be easily recognized.

4. When employees are evaluated, their strengths and weaknesses can be addressed and productivity can be improved.

5. Generally, employees are motivated to perform better if they are given regular, positive feedback about their performances.

Characteristics of a Productive Evaluation Plan

Whether the store is a small venture with a few employees or one that ranks among the giants in the field, there is a need to have a sound plan for the evaluation of employee performance. In small stores with their less formal structures, evaluation procedures—if they are used—are often haphazardly administered. Workers in the smallest stores will perform better if they know they are being evaluated. In these retail environments, the use of carefully developed rating forms and other materials used by the giants is unnecessary. The procedure should be spelled out at the time of the initial hiring and might include a brief written evaluation that is followed by a discussion. If everyone is evaluated in the same manner, the manager will be able to address any problems, award the worthy with salary increases, and terminate those who have failed to perform according to the store's needs.

Larger organizations, because of their size and the many people charged with the evaluation process, must use formal employee evaluation systems. Such systems should include the following ideas.

1. Carefully structured evaluation forms should be used that focus upon all of the major areas of importance to individual performance. There should also be space for a written summary outlining strengths and weaknesses.

2. Evaluations should be taken at specific intervals, never greater than six months.

3. The performance should be evaluated by the employee's immediate supervisor with a face-to-face discussion to make the individual aware of areas that need improvement. An effort should be made to discuss the individual's positive characteristics as well as those that are negative. At the time of the discussion, the worker should be given time to respond to any negative comments in the report.

4. If possible, rewards such as salary increases should be given to the better-performing employees.

Methods of Compensation

The vast majority of people consider compensation as the most important factor when seeking employment. The human resources department is involved in determining which methods of remuneration are most appropriate for the various levels of employment and what the salary range should be for each job title.

There is a vast difference in the earnings potential for people who are in lower-level jobs such as selling and those in top management. Not only are the dollar figures different but so are the ways in which they are paid.

Whatever the job, there are certain considerations that must be studied before any decisions, in terms of remuneration, are made. Good plans should consider the following criteria.

1. There should be a direct relationship between productivity and salary.

2. Jobs that are similar to each other should offer similar salaries. This is not only important in terms of employee fairness but it is a requirement of the Equal Pay Act which requires equal pay for equal work.

3. Motivation is an important factor to consider. Additional income potential and promotion are two motivational techniques that could be part of the plan.

4. Employees should receive a constant minimum amount of money each week. While this is inherent in straight salary programs, straight commission plans could also be adapted to include regular income guarantees.

5. Salaries should be based upon the prevailing wages of the retail industry and adjusted upward to attract the most qualified people.

6. Comprehension of the plans is essential for all employees. While straight salary arrangements are easy to understand, plans that involve "draws against commission" and "quota bonuses" are more complicated and must be carefully described.

Straight Salary

Although many fashion retailers are now moving in different directions, most of their employees are still paid a straight salary. While this plan is simple to understand and guarantees the same salary each week, it does not provide the necessary incentive to motivate employees to maximize their efforts. It is often easy to recognize when salaries are not based upon incentives by the minimum attention those employees pay to their customers.

Salary Plus Commission

One of the ways of combining a salary guarantee with the incentive to be more productive is to use the salary plus commission method of remuneration. Each employee receives a set amount based upon the number of hours worked each week and an additional amount based upon how much merchandise was sold. In these plans, the commission usually ranges from one percent to three percent.

Saks Fifth Avenue features the "sales incentive program" in all of their stores, which subscribes to the salary plus commission philosophy. Since its introduction in July 1988, Saks reports that they are generally pleased with the program. Although most sales associates' records indicate improvement since the incorporation of commissions, they feel that customer service has not necessarily improved. While the plan definitely strives for better customer service, the new program has made some sales associates too aggressive, resulting in customer complaints. Saks customers are generally not appreciative of the hard-sell philosophy. In order to correct the situation, the store recognized that retraining employees was necessary to enable the sales associates to deal with the customers in a better manner.

Straight Commission

The greatest amount of attention in fashion retailing compensation has focused on straight commission. Simply stated, this plan offers the employee the greatest earnings potential because remuneration is based solely upon productivity.

The leader in this area has been Nordstrom, Inc. The company pays virtually all of its sales associates in this manner and reports that earnings can reach levels of $75,000 and more. In addition to providing their sales staff with the opportunity to earn as much as they are capable of, the store believes that their customers are serviced better than by any other retailer because of this payment plan.

Following the lead of Nordstrom is Bloomingdale's. Beginning with their branch in Boca Raton, Florida, as a test store, Bloomingdale's introduced commission selling in their Chicago unit and then in the New York flagship. Soon after, the system was changed at their other branches.

In some stores such as Saks Fifth Avenue where other compensation plans dominate, departments that feature the highest-priced merchandise reward their associates with straight commissions.

While straight commission motivates employees more than any other plan, it does not guarantee uniformity of earnings. That is, one week's commissions might come to $750 and the next, $300. In order to enable employees to budget themselves, most stores offer them a "draw" against future commissions. Employees are given a draw each week and, at the end of the month, the draw is compared to the actual earned commissions. In cases where the commissions are higher than the draw, the employees receive the compensation due them. On the other hand, where the draw exceeds the commissions, the difference is subtracted from the next month's commissions. In cases where the draw is generally greater than the actual earned commission, the draw might be adjusted or the ineffective employee might be terminated.

Quota Bonus

In this system, the retailer determines a level of sales it expects from each salesperson. Those who surpass this amount are paid additional monies. A variety of systems and formulas is used by retailers who employ this compensation method. Most report that it provides the necessary incentive to improve sales as does straight commission, but it eliminates the uncertainties of many who are fearful of straight commission selling.

Dayton Hudson department stores use the "performance plus" program. A management information systems team worked for 18 months to develop a program that would be able to satisfy sales staff needs. Each person is expected to sell a certain amount depending upon the department in which he or she works and receives a financial reward for sales over that amount. The system involves the assignment of an hourly rate for each employee that is multiplied by a rate assigned to the department. If the hourly rate, for example, is $6 and the department multiplier is 20, the hourly rate of sales comes to $120. If the individual works 200 hours for the period, then he or she should sell $24,000. If sales for that employee are actually $50,000 for the period, then a bonus is paid on $26,000 ($50,000 − 24,000 = $26,000). A predetermined percentage is then paid on the extra sales. If, for example, the amount is 5 percent, the employee would receive an additional $1,300 ($26,000 × .05 = $1,300).

Other stores merely assign an expected amount for everyone in a particular department and pay a bonus on sales that exceed the amount.

About 20 percent of the fashion retailers are now using quota bonus plans in their organizations.

It should be understood that many major retailers extend the quota bonus arrangement to management as well as salespeople. In the case of management bonuses, the system might reward individuals on the overall sales of their particular departments or on the store's sales volume.

Other Methods of Compensation

Most of the plans described above focus on compensation for sales personnel. In order to provide incentives to those who might be paid on a straight salary arrangement, such as management employees, retailers frequently use a variety of plans.

Profit Sharing

In companies like Sears all of the employees are given the opportunity to share in the company's profits. This type of plan generally fosters company loyalty and encourages staff members to maintain long-time employment.

Stock Options

Retailers often offer their management teams the option of buying company stock at prices that are lower than those available on the open market. In times of prosperity, these stock options have contributed significantly to employee savings.

Prize Money

In cases where retailers want to encourage the sale of slow-moving merchandise, it is common practice to offer **prize money**—or **PMs**—to employees. The PM might come in the form of a commission on each of the items sold or a preestablished dollar amount. Sometimes merchants reward their sales associates with free trips or other incentives instead of cash.

Employee Services and Benefits

Retailers generally complain that their employees are not as dedicated as they once were, and that the turnover rate continues to grow each year. Finding faithful, knowledgeable, well-motivated employees is not an easy task in these times where other industries seem to have greater career appeal. While many merchants offer wages that are competitive to the other retailers in the field, some neglect to consider other incentives that could improve employee loyalty. One of the best means of attracting the best people to the store, aside from attractive compensation plans, is to pay closer attention to the services and benefits packages that so many people seek.

In a 1990 job market survey sponsored by the Career Development and Placement Office of Michigan State University, 28 academic majors were examined in terms of entry-level salaries and only five were found to start below $20,000. Retailing scored fourth from the bottom of the 28. If the industry cannot offer attractive salaries, then it must try something else to encourage talented people to enter the field.

Health Insurance

Large retailers generally offer a health package that provides for medical and dental coverage for employees and their families. Some employers pay the entire premium for their workers while others share in the costs.

Employee Discounts

Most retailers offer their employees merchandise discounts that range anywhere from 20 percent to 40 percent. In the large retail organizations the typical discount is at the low end of the scale, with small retailers often providing the larger discounts. Small fashion merchants often encourage their employees to purchase and wear the merchandise that the store sells by offering it at cost. Many times customers are attracted to the merchandise worn by store employees and ask where it may be purchased. This helps to make selling easier and warrants the awarding of such a benefit to employees. Some retailers who wish to encourage their employees to dress in the store's image give employees monthly clothing allowances to be used towards purchases. Ralph Lauren makes such monthly allowances in its Madison Avenue flagship.

Dining and Recreation Facilities

Many of the giants in the industry provide places where their workers can relax during breaks and eating facilities that feature low-cost meals. Not only do these provide direct benefits to the employees but they enable staff members to socialize and relate to each other away from the selling environment. Quite often friendships are established in these dining and recreation areas that help employees work better with each other.

Pension Plans

One of the means by which companies can reduce the amount of employee turnover is by providing pension plans. With the costs of inflation plaguing retired people, the knowledge of a pension plan could encourage people to stay with one company. Some retailers offer such programs that range anywhere from the employer providing for the entire payment to those that require contributions from the employer and the employee.

Child-care Facilities

Although the concept has been embraced by other types of industrial giants, few retailers have initiated programs that would provide in-house child-care centers. With so many capable workers prevented from returning to the workplace because of the expense of child-care facilities, retailers would profit by offering such a service to their employees. Other businesses report that the expense is certainly warranted because it provides a vital employee market to the stores.

Tuition Reimbursement

Many retailers provide tuition assistance for their staffs. Employees are encouraged to take courses that are appropriate to their jobs and that would help improve performance. Some of the plans provide full tuition payment while others pay according to the grades achieved in each course.

Miscellaneous Benefits and Services

Counseling services, social activities, athletic clubs, savings plans, credit unions, sick leaves, and maternity leaves are other fringe benefits that stores feature to attract better employees.

Building Employee Morale

Too many retailers complain about the insincerity of their employees, their lack of dedication to the store, and the enormous rate of employee turnover. Few recognize the needs of people in their employ and, even if they do, do not provide programs that recognize people as individuals. While money and benefits play an important role in employee retention, other programs can be provided to make the workplace one in which people feel they are making a contribution.

Bloomingdale's has regular breakfast sessions for employees, where those who have been singled out by customers for outstanding service are recognized.

At the Iowa-based Younkers, Inc., department stores, the company hosts an annual awards Hall of Fame Associates dinner where the best of the sales force are honored. More than $200,000 in the form of gift certificates, trips, and prizes are awarded each year to the program's inductees. Some of the top prizes awarded include shares of Equitable of Iowa stock and trips for two to Hawaii. Since its formation in 1975, more than 5000 people have been inducted into the Hall of Fame. The people in the group are considered to be Younkers' greatest asset.

Unions and Human Resources Management

The Human Resources department often finds itself in the unenviable position of acting as go-between for management and labor. Being a part of the store's management team, as well as being the arena in which employees can vent their frustration and complaints, makes the department one that must function with caution.

Many of today's major retail organizations are unionized. They might have more than one union in the store representing sales associates, maintenance people, and delivery people.

In most of the unionized stores, a highly placed vice president or director is given the responsibility to develop employee salary and benefits packages for union contracts and to negotiate the terms with labor. When management is trying to preserve its rights and labor is trying to improve salaries and working conditions, there is often an air of unrest that pervades these retail environments.

Aside from the negotiating task, the department must also handle grievances, oversee the carrying out of the guidelines of the contract, and help establish a harmonious relationship between labor and management.

Small Store Applications

For the most part, the management of the small store staff is much easier than that of their larger counterparts. In most small retail organizations, the owner is usually involved in making decisions such as hiring and awarding salary increases. He or she is directly involved in the day-to-day operations of the business and can immediately learn who is and who is not making the contributions necessary for the store to turn a profit.

Oftentimes, owners of these smaller companies fail to recognize the need for a system that deals with employee recruitment, training, evaluation, and complaint handling. The owner might be very well trained in one aspect of the business, such as buying, but lacks the skills associated with management of human resources. In some cases, owners wear many hats without having the expertise for all of their responsibilities. In order to run a more profitable operation, attention to the area of human resources is a must. While these merchants need not develop as formal a program as those found in the larger companies, there should be a plan that embraces all aspects of good human resources practices. Such established procedures help match the appropriate employees to tasks for which they seem most suited and provide a framework for their future evaluation. Any plan, no matter how large or small, should provide workers with store policy regarding such matters as discounts, sick day allowances, paid vacations, types of evaluations, and frequency of salary increases.

By developing such personnel procedures and practices, employees will know exactly what is expected of them and how they will be rewarded during their time of employment.

Highlights of the Chapter

1. The principle task of the human resources department is to provide the store with capable workers.

2. Before individuals are asked to join a company, they must go through numerous stages of the recruitment process so that they can be evaluated in terms of the store's needs.

3. Once the human resources department has explored each job title through research known as job analysis, the department staff must develop sources of personnel supply to utilize in finding potential employees.

4. Some of the personnel sources of supply include classified advertising, recommendations, employment agencies, walk-ins, and store window signage.

5. Although most retailers follow specific patterns in the recruitment of employees, the factor of personnel supply and demand plays a vital role in how carefully they use the recruitment plans.

6. Most hiring procedures use application forms, interviews, reference checks, and testing to evaluate those interested in joining the company.

7. Human resources managers utilize vestibule training, on-the-job training, and classroom instruction in teaching new employees about the company.

8. Employees should be regularly evaluated to improve their performance, maintain a high level of morale, and determine potential for promotion and salary increases.

9. The straight salary method of compensation is still widely used in retailing. Many fashion retailers, however, are now using incentive plans that include commissions and bonuses to increase productivity.

10. Employee services and benefits such as health insurance, discounts, paid vacations, reduced-cost meal plans, and tuition reimbursement are offered by most major retail organizations.

For Discussion

1. What is the main objective of the human resources department?

2. Discuss the purpose of job analysis.

3. Differentiate between blind and open classified advertisements.

4. In what way does the executive search company differ from the standard employment agency?

5. Describe how mall walkers are used for purposes of recruitment.

6. Which nontraditional group have retailers started to utilize as part-time employees?

7. How does the preliminary or rail interview differ from the final interview, and what purpose does it serve?

8. List several types of tests that personnel specialists use in the evaluation process.

9. Why do retailers sometimes need to retrain people who are already employed by them?

10. Describe vestibule training.

11. In what way has computer-aided instruction improved employee performance?

12. Briefly describe some of the characteristics of a productive employee evaluation plan.

13. What is meant by "draw against commission," and why is it used?

14. How does the typical salary plus commission plan differ from the quota bonus arrangement for employee compensation?

15. Are there any potential dangers in the use of straight commissions?

16. What is prize money?

17. List some of the employee services and benefits offered by large retailers.

18. Do small stores need to establish human resources programs?

Until the last two years Pendleton's, Inc., a high-fashion specialty department store, had little trouble in recruiting people to work for the company. Today, however, they are finding difficulty in attracting talented people to fill positions at most levels. They have remained competitive with the other stores in their trading area in terms of salaries and benefits, but they seem to be suffering from retailing's image of long hours and low entry-level wages.

The human resources department has indicated to top management that one of the problems is related to the salary scales in other industries. The higher salaries have attracted potential managers as well as lower-level personnel. The advantages of better wages coupled with more compact work schedules has left the store with personnel shortages in many areas. The obvious solution is to raise salaries to levels that would be competitive to other types of businesses. The company's financial advisors, however, report that considerable monetary increases would cause serious harm to the company and would make it unprofitable.

With their inability to offer higher wages, the next approach was to explore the company's current recruitment practices and employee services and benefits. Human Resources reported that they relied heavily on colleges and universities for their future managers and a combination of classified ads and walk-ins for their lower-level jobs. They also reviewed the fringe benefits and services they offered,

which included health insurance, reduced-cost meal plans, paid vacations, employee discounts, and recreation facilities, and assessed them to be comparable to other major retailers in the area.

At this time, Pendleton's still has not been able to correct their employment problem.

Questions

1. What other sources of supply could the company use to recruit executive trainees and employees for lower-level positions?

2. Are there other groups that the company might have considered to fill their needs?

3. What other benefits and services might help to attract greater numbers to the company?

Like most other fashion retailers Calvert's, Inc., does more than 40 percent of the year's business during the Christmas selling period. Throughout the year the company has a well-trained sales staff that caters to the needs of its clientele. With an inventory steeped in upscale merchandise at very high price points, servicing the customer is of great importance.

Calvert's business—except for the Christmas rush, which begins the day after Thanksgiving and ends Christmas Eve—is unlike that of most traditional stores. The number of daily sales is not high, but the amount of each is significant. Stores like Calvert's, with such expensive merchandise, have a small customer market from which to draw, but those who do patronize the store spend considerable sums.

In order to guarantee the best possible customer service, the human resources department spends considerable time and effort in the training of their sales personnel. Before anyone is sent to the selling floor, a great deal of attention is given to each new employee. Training includes extensive classroom lectures as well as role playing, where new employees participate in simulated sales presentations. Coupling this training with high rates of commission has contributed to the store's ability to attract qualified individuals.

The problem that Calvert's must deal with each year surfaces at Christmastime. During this period, the store is transformed into a different environment. Many more shoppers enter the store in search of Christmas gifts in addition to satisfying their own needs. To accommodate these large numbers, the store must recruit additional sales personnel. Those available are generally untrained and unfamiliar with Calvert's customer service philosophy. With little time for traditional training, the company has not been able to staff the selling floor with com-

petent people. With fewer and fewer people willing to work for such a brief period, they are finding it difficult to be selective. With such limitations, they have not been able to satisfactorily train the new employees to meet the needs of the company.

Questions

1. What training techniques might the company employ to deal with this group of sales associates?

2. Describe why such techniques are better for these circumstances than those traditionally used?

Exercises

1. Look through the classified advertisements in your favorite newspaper and cut out five fashion-oriented ads that interest you. Make a list of the information provided by each such as store name, job title, salary, experience requirements, and how to apply for the position.

2. Prepare an application form for employment that would meet the standards allowed by the government.

3. Write a list of 20 questions that might be asked during a job interview. As a role-playing technique, select a partner and pretend that he or she is applying for a specific position. The interview should utilize the 20 written questions.

Merchandise Handling and Protection

Learning Objectives

After reading the chapter, the student should be able to:

1. Discuss the methods used by retailers in the handling of the store's merchandise.
2. Describe the automated methods of moving the merchandise through the various stations in a receiving area.
3. Explain the importance of checking merchandise that comes to the store's premises from the vendors.
4. List several methods used by merchants to reduce the amount of internal theft.
5. Discuss a variety of controls that are used to deter shoplifting.

Providing the most desirable merchandise in a setting that motivates the shopper to buy is only part of the retailing story. Those who are experienced retailers know that behind the scenes there are people and systems that must be in place to guarantee the movement of the goods from the receiving area to the selling floor. Once there, the merchandise must be well protected from those who would take it without paying for it.

The procedures and practices used in the physical handling of the merchandise have not significantly changed in recent years. Some state-of-the-art systems, however, such as Just-in-Time (JIT) inventory systems, Quick Response (QR), and Electronic Data Interchange (EDI) have made the routine faster and more accurately accomplished.

One of the major problems associated with merchandise receiving is the verification of the accuracy of the shipments. While honest errors are occasionally

made by vendors that result in the delivery of unordered merchandise, many times the wrong merchandise is intentionally delivered to the store. This problem is generally unique to fashion retailers who find that suppliers make merchandise substitutions when they are unable to satisfy the order written by the buyer. Different styles, other colors, and variations in the size ranges are often discovered when incoming orders are checked against purchase requisitions. Unsuspecting receiving room personnel who are negligent in their performance often allow unordered merchandise to pass through their departments. Some suppliers are prone to use this tactic when the ordered merchandise is in short supply.

Many seasoned retailers agree that the greatest problem associated with the merchandise is its protection. The problem of pilferage is one that continues to escalate. Not only must the retail industry deal with the shoplifters but most have an even greater problem trying to reduce the enormous merchandise losses that come at the hands of their employees. Employee or internal theft is generally more difficult to control because those who work in the store often discover the ways to beat the system.

Merchandise Handling

Handling incoming merchandise carefully is imperative to retailers of all sizes. A series of functions must be accomplished before the goods go onto the selling floor to make certain that the right merchandise was delivered and the quantities shown on the invoice or bill were received. In addition to the necessary receiving and checking details, the items must be marked and sometimes stored until needed on the selling floor.

Receiving Arrangements

Retailers have the option of receiving their deliveries directly at the store or at a centralized location where the checking and marking activities may be accomplished. In the case of small operations, the merchandise is sent directly from the supplier to the store where it is examined, ticketed, and placed either in storage or on the selling floor. In larger organizations, receiving is usually accomplished at a central or regional facility.

Individual Store Receiving

In small stores there is no choice but to receive the merchandise at the store's location. Retailers either accept deliveries at the front door or, if the layout permits, at a separate rear entry. With space becoming increasingly more costly, many small

merchants eliminate separate receiving areas and use the selling floor as an alternative place in which to handle incoming goods. In such situations, the merchandise is usually kept in its containers until there is a slow period when the checking and ticketing can be completed. Separate rooms for receiving goods are located in the rear of the store or in a place that is least beneficial for selling.

Where the store is a multilevel unit, the functions associated with receiving are usually handled on the top floor where the space is less valuable.

Centralized Receiving Facilities

Larger stores generally subscribe to the centralized receiving concept. By using this plan, more store space can be utilized for selling. Small chains and department store organizations usually have receiving facilities that are central to their store locations. These premises are located in less costly areas than the company's stores and also serve as storage areas until the merchandise is needed by each unit.

In organizations with centralized facilities, the merchandise is checked, sorted, tagged, and shipped to the various store destinations. The stores in these larger organizations usually receive the goods ready to be placed on the selling floor.

Regional Receiving Facilities

In the very largest retailing enterprises such as The Limited, where several hundred individual stores may be geographically located from one coast to the other, regional receiving facilities are usually preferable to centralized operations. Companies strategically locate several merchandise handling facilities, with each serving a number of stores in its general area. By employing this method, it takes less time for merchandise to reach the stores.

Receiving Facilities

In large retail operations, the receiving facilities include a receiving platform where goods are taken from the trucks, a space where the number of packages is checked against shipping invoices, and a warehouse. It should be noted that in fashion retailing there is less emphasis on warehousing and storage than ever before. Most fashion merchants order quantities that are sufficient for their immediate needs and use reorders or new merchandise to replenish their inventories. When additional merchandise was warehoused in stockrooms, it was often easily forgotten and was eventually marked down. With improved merchandise turnover the goal (which will be discussed in chapter 11, "Inventory Pricing"), except for special types of fashion items, most retailers have eliminated their storage areas.

Receiving Equipment

After the merchandise has been delivered to the receiving platform or loading dock and has been checked to make certain that the shipment contains all of the cartons or racks indicated on the receiving invoice, it is then transferred to the marking area. It is very important that those responsible for receiving the merchandise check to make certain that there are no shortages. It is not just an occasional incident in which discrepancies are found at this point. Suppliers may make unintentional errors when preparing their shipping records which, if undetected, will result in the retailer paying for merchandise that was not received. It should also be noted that a great deal of pilferage takes place during the shipping procedure, and unsuspecting retailers may fall victim to such crimes.

The merchandise may be moved from the platform by means of movable racks, hand trucks, or conveyors. Large stores generally utilize mechanical or automated systems to maximize efficiency, while small stores merely carry the goods to the place where they are marked.

Generally, the most commonly used pieces of equipment are stationary tables, portable tables, and conveyor systems.

Stationary Tables

Many retailers rely upon the **stationary table** for all of their receiving operations. After the cartons have been opened, the merchandise may be quantity and quality checked, sorted, and marked. The tables provide a great deal of flexibility at a minimum cost to the retailer.

Figure 8-1. Flat package conveyor system (Courtesy of Key Handling Systems, Inc.)

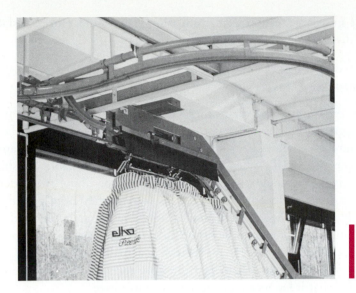

Portable Tables

Similar to the stationary table, the **portable table** has wheels that makes it simple to move from place to place without the need for loading and unloading. In stores where there are separate areas for checking, sorting, and marking, the merchandise is merely wheeled from place to place for each operation. This piece of equipment saves time and effort and therefore maximizes efficiency.

Conveyor Systems

Most of the larger retail organizations have installed conveyor systems, which enable merchandise to be moved quickly from one stage of handling to the next and ultimately to the selling floors. The systems continue to become more and more sophisticated each year, making the handling of merchandise more efficient.

Companies that install the major conveyor systems are generally those that have centralized merchandise handling facilities. These systems are used in receiving, checking, and marking the goods and in the movement from the central facility to the individual stores. Most of the units in these organizations receive their goods in cartons or on racks and move them to the departments without the assistance of conveyors.

Saks Fifth Avenue is one fashion operation that once subscribed to individual store merchandise processing that required each unit to match receipts against orders and do quality control checks, inventory paperwork, and tagging. At a time when the company was undergoing expansion, management decided that a centralized approach would make the system more efficient in terms of costs and the time it took for the garments to reach the stores. The decision was made to

invest in a large, centralized installation that would more satisfactorily handle Saks' distribution of merchandise.

Checking Merchandise

When the buyers write their orders, they carefully indicate style numbers, colors, sizes, prices, and any other pertinent information concerning the merchandise. The purchases are made far in advance of the seasons and before any merchandise has been produced. When the goods are finally available for shipment to the stores, it is the vendors who are responsible for filling the orders. Sometimes retailers find discrepancies between the orders they have placed and what was actually received. Such practices as substituting one style for another or one color for another are commonplace in the industry. Shortages are also possible, with the invoice charging for more items than were actually delivered.

In order to make certain that the store receives what it has ordered and pays only for what it has received, checking is imperative.

Quantity Checking

Retailers of fashion merchandise use one of the following methods for quantity checking:

Direct checking. The most commonly practiced method involves checking the merchandise against the invoice to make certain that the quantities are as indicated. There are advantages and disadvantages in the system. The advantages are speed and economy. Some retailers, however, feel the disadvantages outweigh these benefits. Sometimes invoices do not arrive with the package, making it necessary to set aside such goods until the invoice arrives. This can result in stockpiling merchandise and a delay in getting it to the selling floor. With fashion merchandise time is of the essence and every lost day can mean less time in which to sell the goods. Even more serious is the problem associated with lack of employee dedication. Since the invoice already lists the quantities, styles, sizes, and colors, an employee might assume that the numbers are correct without bothering to check them. The store might then pay for undelivered goods.

Blind checking. In order to prevent the possibility of passing the merchandise through the system without the shipment being checked, some retailers use the method that requires all of the merchandise to be listed on forms. Since the invoice is withheld, it requires the checker to provide an actual count. Since it is a slower process than the direct method of checking, it is more costly to the store. It does, however, provide more accurate information and can guarantee that the retailer is paying only for goods received.

After consultation with Garr Associates, an Atlanta-based firm, Saks Fifth Avenue decided to made a radical change in its handling of incoming merchandise. They purchased a facility to be used as a national distribution center where all of the company's goods would be received, inspected, and marked and then directed to the various stores in the organization.

The merchandise handling encompasses three main processing areas. One is used to process merchandise that is received in cartons and then is shipped in cartons to the stores, another receives cartons of merchandise that are then transferred to hangers and shipped that way, and the third is for items that are received from the vendors on hangers and reshipped on hangers.

There are separate receiving docks for flat goods (in cartons) and hanging garments. When a carton is received on the dock, a worker enters the order number in a computer terminal and receives instructions as to whether the merchandise will be "processed flat" or be put on hangers.

Those that are flat processed are placed on roller conveyors to a processing center where paperwork concerning the merchandise is prepared and tags are generated for marking. The merchandise then moves to another area where the cartons are opened, tags are affixed to the items, and the items are repacked in the cartons for shipment to the stores. Each box is keyed with a store identification code that directs it to its final destination. At this point an automation system moves the goods to chutes, then onto the loading dock and into the trucks for the trip to the stores. Hanging garments are placed on a trolley conveyor that moves the goods through the various processing stages. The garments are then placed in metal cages for shipping to the stores.

With this state-of-the-art system at the distribution center, Saks is able to maintain total physical control of the merchandise from receiving through shipping. Integration with a sophisticated computer system enables the company to know exactly what has been received, where it is in the system, and when each store has received the goods. In addition to the improvement of the handling of its merchandise, Saks reports that it has realized a savings in both processing and transportation costs.

Semi-blind checking. In this system, the checker is supplied with a list of everything that is expected in the order except for the quantities. This system speeds up the process but still requires the merchandise to be counted.

Spot checking. This is the least effective method of checking merchandise. It requires the checker to make certain that the right number of cartons have been delivered with actual quantity checking limited to some of the packages. Actual

counts may be taken only on a small percentage of the delivered merchandise. While it does save time, it permits merchandise shortages to go undetected.

Quality Checking

More than any other types of retailers, those in the fashion business must check for quality to make certain that merchandise is the same as that which was ordered. Anyone who has been responsible for fashion buying and merchandising will attest to the fact that merchandise discrepancies, in terms of quality, are commonplace. Vendors have been known to substitute lesser-quality fabrics for those in the original samples, have made changes in the product's trimmings, and have used less costly construction methods than those promised in the original samples.

With the enormous amount of merchandise being produced offshore, quality has often been seriously affected. The samples from which the buyers choose their items are made with care in domestic facilities while the actual goods are produced abroad under less controlled circumstances.

The problem associated with quality checking is generally the distance between the buyer, or one who can judge quality, and the store's receiving and distribution center. If the buyer is unable to participate in such checking—and that is usually the case in large stores—provision should be made for someone who is knowledgeable to judge the merchandise. Some retailers are employing people in quality control who are trained to recognize defective or undesirable goods. By using such a practice, the store is more likely to receive favorable merchandise. By not paying attention to such details, the store could ruin its image.

Marking Merchandise

Retailers mark their merchandise for a number of reasons. Included among them are the following.

1. Some states require that all merchandise be individually marked with tags that feature the price. This practice eliminates the possibility of charging different prices for different customers.

2. Merchandise tags that feature such pertinent information as price and size enable customers to serve themselves, thereby reducing the need for salespeople.

3. Shoppers are able to quickly assess the prices and determine if the merchandise suits their financial needs.

4. By placing information on tags such as vendor name, style number, color, merchandise classification, and size in addition to the price, the retailer is able to evaluate the customer's response to the merchandise. This is especially impor-

tant to fashion merchants who must continuously analyze their inventories so that future purchases can be adjusted to maintain customer satisfaction.

5. In order to evaluate merchandise turnover, a topic to be addressed in chapter 11, "Inventory Pricing," some merchants note the date that the merchandise was placed in the store's inventory.

6. Off-price fashion retailers and discounters operate with skeleton staffs in order to minimize expenses. By using marking tags, they can reduce the size of the selling staff and the store's overall expenses.

Marking Procedures

Fashion retailers use a variety of procedures to mark their merchandise. The vast majority of the major retailers use computers. Other procedures involve hand marking and premarking.

Computerized marking. The larger retailers use computerized systems for merchandise processing that automatically generate tickets featuring a variety of pertinent information. One of the most sophisticated systems is the one developed by Advanced Cybernatics, Inc. (ACI) called Retail Express. The program enables the retailer to use information from the purchase order, invoices, or checker's records, whichever is deemed most appropriate to the organization. The tags can automatically be printed with any of the information desired by the retailer.

In addition to ticketing, Retail Express integrates such merchandise handling functions as purchase order management, receiving and checking, warehousing, distribution, invoice matching, price changes, physical inventory control and register transactions. Other functions to be discussed in chapter 9, "Accounting Procedures and Operational Control," are also part of the Retail Express package and include merchandise planning, open-to-buy, inventory management, and vendor and brand analysis.

While many systems have been available to handle hard goods such as appliances and food products, few have been available to accomplish the needs of the fashion retailer. The Retail Express has filled the gap in fashion retailing.

Premarking. Some manufacturers service their customers by premarking the merchandise. Tags that indicate price, size, color, and style number are attached to each item. This saves the retailer the expense of providing in-house tagging but does not provide all of the information needed by some retailers for their inventory control. This type of tagging is used by the swimsuit industry and some fashion manufacturers who want to determine their suggested selling prices.

Hand marking. Small retailers handwrite their tags. Since the merchandise assortment is generally small in these stores, this serves their needs. The same

information can be handwritten as that found on the computerized tags and produced at very little expense.

Information Coding

The majority of fashion items such as dresses, coats, suits, skirts, sweaters, and pants have tags attached to them with string or plastic filament. Other merchandise such as shoes, which are kept in boxes, is marked with some type of sticker. The tags and stickers feature a variety of information that retailers use for inventory purposes. Some retailers indicate the cost of each item on the tag so that they can quickly refer to it if the need arises. Sometimes, for example, the customer might spot damage and would be willing to purchase the item if given a price reduction. For obvious reasons, it is undesirable to alert the customer to the cost, so many merchants use a coding system that only they and their employees can read.

The system used by many retailers involves the use of a ten-letter code, with each letter standing for a number. For example, using the cost code indicated below, a dress that costs $97.50 would be listed on the ticket with the letters UNIY.

$$\text{F A S H I O N B U Y}$$
$$\text{1 2 3 4 5 6 7 8 9 0}$$

The rest of the information such as retail price, size, color, department, and merchandise classification does not need to be coded since it is of no interest to the consumer.

Remarking Merchandise

When merchandise does not sell as well as expected, one solution used to motivate consumer interest is to reduce the price. Retailers follow different philosophies in the marking down of their goods. Some subscribe to the principle of retagging, which requires new tickets to be affixed to the newly priced styles. Others believe that it is better to utilize the original ticket and merely change the price. Those who use the latter technique rationalize that a lower price indicates a bargain and stimulates purchasing.

Whichever system is employed, forms are generally used to list the new prices so that the actual markup, a term that will be fully explored in the chapter 11, can be determined. It also enables those responsible for inventory control and accounting procedures to calculate the value of the inventory at retail.

Protection

Retailers are constantly struggling with inventory shortages. No matter how carefully they try to protect the goods, the shrinkage (merchandise shortages) figures

continue to climb. With shoplifting estimates near the $30 billion mark and an even larger figure attributed to employee theft, merchants are continuously searching for methods that will alleviate the problem.

Fashion retailers are most vulnerable to those responsible for causing the shrinkage. Many have resorted to uniformed guards and security measures that involve chaining the merchandise so that it cannot easily be stolen. While these approaches might reduce inventory shortages, their use often transforms the selling floor into a place that looks like a fortress. The impression that such an environment leaves on the honest customer does not benefit the store. Some are fearful that they are surrounded by a criminal element that might do them personal harm. Retailers who choose to use less obvious means of protection in order to preserve their store's image and make the customers feel comfortable seem to be in a no-win situation. The fewer the deterrents, the greater the risk for losses.

Since the problem is two-fold, **shoplifting** (merchandise losses attributed to individuals who pose as customers) and employee theft will be discussed separately.

Shoplifting

It is difficult to recognize the shoplifters because they share no specific characteristics. They come from every socioeconomic, ethnic, and religious persuasion and steal for a variety of reasons such as the thrill it may provide, economic pressures, drug addiction, mental illness, and profitability. With no composite, stereotypical portrait to follow, retailers are hard pressed to identify the would-be culprits before they commit their crimes.

Shoplifting causes management significant problems and costs that continue to spiral upward. Retailers spend large sums of money for equipment in the hope that it will deter shoplifting. The prices paid by honest consumers are usually increased because of store security and protection expenditures and the necessity for additional markups to cover the actions of the dishonest.

Retailers of every size, structure, merchandise mix, and type of location feel the pressure of shoplifting. Whether it is a freestanding store, one that occupies a downtown location, or one that is a tenant in a mall, the problem is everpresent. Those in fashion operations report substantial losses because the products are readily available for handling in most stores and the prices of such goods are relatively expensive. While the supermarket is plagued with shoplifting, their most expensive items are usually less costly than the fashion retailer's least expensive.

In a major study of retailers in New England and the Middle Atlantic states that followed people through stores, approximately 7 percent, or 1 out of every 15, were shoplifters, with females showing participation at a slightly higher rate than males. There was virtually no difference in the number of thefts when Caucasians were compared to nonwhites.

In an effort to curtail the number of incidents, retailers use a variety of deterrents and controls.

Hard Tag Family And Accessories

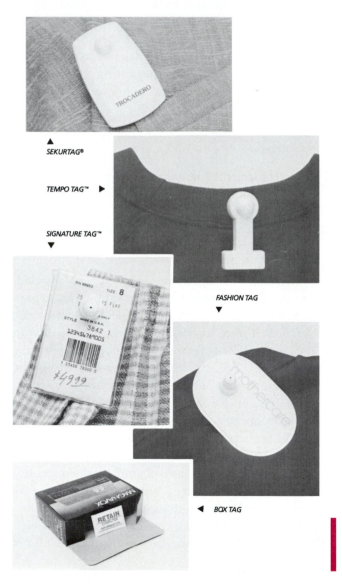

SEKURTAG®

TEMPO TAG™ ▶

SIGNATURE TAG™ ▼

FASHION TAG ▼

◀ BOX TAG

Figure 8-3. EAS tags used for security merchandise (Courtesy of Security Tag Systems)

Deterrents and Controls

Two major studies have focused on the use of deterrents to stem the increase in shoplifting. Although both pieces of research used totally different groups for their investigation, the results were virtually the same. The study by Ernst & Young/IMRA used retail loss prevention executives for their opinions while the other group, Shoplifters Anonymous, used shoplifters. The security tools that the subject were asked to evaluate were EAS (Electronic Article Surveillance) tags, trained personnel, guards and detectives, concealed closed-circuit television, fitting room staffs, and mirrors. Both groups concluded that the EAS tag systems were at the top of the deterrent list.

Video surveillance systems play a major role in some stores. Not only does such a system carefully watch shoppers, it also scrutinizes the company's employees. Initially used by the banking industry to thwart armed robbery, the retailing industry has embraced it as one of its most important deterrents for shoplifting and internal theft. One of the leaders in the field is Diebold, Inc., which produces a variety of video surveillance systems. The typical system incorporates the use of television monitors that are placed in strategic areas such as merchandise receiving rooms and shopping aisles. The very presence of these monitors inhibits the theft of merchandise. Not only does it enhance the confidence and safety of customers and employees, the system utilizes recording tapes that may be activated when individuals are suspected of committing crimes. In stores that accept checks, the system can be used to record the face of each customer issuing a check for the purpose of later identification in the passing of bad checks.

These surveillance systems enable store security to observe all of the store's potentially vulnerable areas from a central point and to sound warning alarms that alert security guards to crimes as they are taking place.

Security guards are used by most retailers. Some use uniformed personnel to stand guard at store entrances. While this might deter some shoplifting, it often poses a psychological problem for the honest shoppers. By their very presence, such guards indicate that there is trouble in the store, and customers might become concerned with their own well-being and the protection of personal property such as handbags. A less subtle approach that is used by stores wishing to keep their pilferage problems to themselves involves the use of plainclothes detectives. They pose as customers and patrol the store's selling floors looking for suspects. Most carry two-way radios that are used to alert other security people, and sometimes the police, when suspects are spotted concealing merchandise or attempting to take it from the store.

Try-on room protection is a problem faced by fashion retailers. Since the shopper is alone in a small cubicle, it becomes the perfect place in which to conceal merchandise that could be taken from the store without paying for it. Some stores installed two-way mirrors that enabled security personnel to watch the

FASHION RETAILING SPOTLIGHTS

SECURITY TAG SYSTEMS, INC.

Security Tag Systems, Inc., was founded in 1981 and is headquartered in St. Petersburg, Florida. The company deals exclusively in the design and development of electronic detection systems and accessories for retailing and other industries. In its short history it has become one of the world's leading distributors of products that are used to reduce losses attributed to shoplifting.

Among the products it distributes to the industry are electronic article surveillance (EAS) systems. Within that product classification, the company makes available a variety of tags that help deter pilferage. Some of the better-known are:

Securtag. The cornerstone of the security line, Securtag has become a reliable choice for retailers in thousands of installations all over the world. It deters and detects shoplifters and works in conjunction with an alarm system that alerts the store's personnel to individuals who are trying to leave the premises with merchandise that has not been paid for.

Tempo Tag. Similar to the performance reliability of Securtag, this product is smaller and lighter in weight and is used in the protection of delicate fabrics, or in cases where more discreet protection is desired.

Fashion Tag. For high-value merchandise, Fashion Tag is the choice. It is extremely lightweight, very thin, and available with graphics that might include the store's name or logo.

Signature Tag. This EAS tag serves the purpose of merchandise protection while at the same time being a vehicle for price tags. With its versatile pouch, it can receive merchandise tags that indicate such items as price, size, style number, and color. It too can be customized with the store's logo.

Inktag. Without question, the product developed by the company that has started to revolutionize the industry in terms of merchandise protection is Inktag. It is a tag that can be used alone or in conjunction with an electronic surveillance system. The concept is quite simple. Housed inside of a tough shell, vials of permanent ink stand ready to spill out on the merchandise whenever the tag is forcefully removed. Since ruined merchandise cannot be worn or resold, shoplifters have no more reason to steal. The tag's physical design and superior locking mechanism make it virtually impossible to remove by force. The use of posters, leaflets, and decals wherever the system is in place advises potential shoplifters of the product's features. When used in conjunction with the EAS alarm system, it alerts the retailer to those who might still attempt to steal merchandise. Stores like Lord & Taylor that use the Inktag report a decided decrease in shoplifting.

shoppers as they dressed and undressed. This was eventually outlawed in most states as an invasion of privacy. Some retailers post signs in their fitting rooms making shoppers aware that guards might be patrolling the area. Such notification is deemed appropriate by the law in most states. The most widely used form of

Figure 8-4. The Inktag significantly reduced shoplifting. (Courtesy of Security Tag Systems)

protection in try-on rooms involves the use of color-coded devices, each indicating the number of garments taken into the cubicle. A checker is responsible for counting the items before the shopper enters the area, dispensing the appropriate coded device, and recounting the number of items as the individual prepares to leave. In situations where the system is carefully monitored, shoplifting has declined.

Merchandise locking systems are those that involve securing the merchandise through the use of a lock on each garment. In stores that use a small selling staff in relation to the number of shoppers it serves, higher priced items are sometimes protected by chaining the goods to a fixture. Leather coats and jackets are often secured in this manner. While the system does reduce theft, it presents problems for the user. First, such devices give the impression that the store is a place where criminals may congregate, making shoppers feel uncomfortable. Second, the items that are secured in this manner are difficult to try on and necessitate the attention of a salesperson who might be hard to find. While the merchandise is protected, many merchants report that customers will not spend the extra time it takes to free the merchandise from its protective device.

Employee Theft

The vast majority of retailers agree that stealing by employees is a greater problem to eliminate than shoplifting. A number of factors contribute to the problem. First, employees are trained to learn the store's systems and by doing so often discover ways in which they might steal. Second, the store's security staff, whether uniformed or plainclothes, is known by the employee, making it easier to steal when they are not in sight. Finally, store employees handle the merchandise freely

and can easily conceal some items before leaving the store. When seasoned retailers congregate, the horror stories that they describe dealing with employee theft make shoplifting seem like a minor problem.

With better attention paid to job applicants such as testing for drugs and checking references, the problem can be diminished.

Deterrents and Controls

As in the case of shoplifting, merchants try to protect their inventories from people in their employ.

Applications enable the retailer to evaluate the potential employee's ability to perform on the job. A space on the form requiring an applicant to list convictions immediately alerts the employer to the possibility of a problem. Other areas that must be carefully addressed that are often carelessly examined deal with previous employment. Any gaps in the candidate's employment record or positions that were short-lived might signal trouble. While these concerns might prove to be meaningless, they should be approached if the candidate is offered an interview.

Testing is another way in which some candidates can quickly be eliminated from consideration for the job. Now that polygraph testing has been declared unconstitutional, retailers are beginning to use another type of examination called the "pen and pencil integrity test." The examination costs very little to administer—estimates run about $10 per test—and has proved to be effective. The applicant receives a test with several questions, each designed to measure honesty. A typical question might ask the individual whether or not he or she ever took something from a store that was valued at about $3. Thinking that the amount is insignificant, some people admit to the theft. This might be an indication of dishonesty and could alert the retailer to a potential problem. Stores that use these exams have acknowledged that internal theft has declined significantly.

Outside agencies are used by retailers to check the honesty of their employees. Companies such as the Willmark Agency "shop" new employees to assess their honesty in handling cash. By posing as customers, they can observe the salesperson and determine whether the correct amount of the sale was recorded and that the full amount of money was deposited in the cash drawer. Since the employees are unfamiliar with these people, they are unaware that they are being tested.

Some of the systems that were discussed in the section on shoplifting also serve to check on employees. Video surveillance and electronic article surveillance systems are just two that are equally effective to weed out dishonest employees.

In-store Theft Locations

There are a few places in the store where it is most likely that merchandise will be taken by employees.

Receiving rooms are places where all of the merchandise must pass before it goes into the stockrooms or onto the selling floor. Since the shipments are checked for quantity accuracy, it is a likely place where goods can be taken easily, with shortages being attributed to incorrect invoice totals. It is not unusual for management to uncover a situation where an entire receiving staff is collectively involved in merchandise theft.

Rest rooms provide private places for dishonest employees to conceal stolen goods. During meal breaks, it is quite easy for the dishonest employees to conceal merchandise under their clothing. Since they have access to the scanning surveillance apparatus, removing alarm-sensitive tags is easily accomplished, eliminating the activation of the system when they leave the store at the end of the day.

Checkout counters are major areas where employee theft takes place. Working with individuals who pose as customers, the salesperson or cashier can pack additional items in the package along with the item that has been legitimately purchased.

Storage rooms are excellent settings for theft. Employees can move freely throughout these areas pretending that they are looking for items that need replenishment on the selling floor or trying to assist a customer with a size or color that is not in stock. Since these are generally quiet, unpatrolled spaces, they make excellent places for employee theft.

Small Store Applications

Even the smallest retail operation must develop a system for merchandise handling. In order to determine the accuracy of the shipments coming from the vendor, attention must be paid to each and every package received. Manufacturers sometimes substitute styles for merchandise that was ordered if those items were not available for timely shipping. The substitutions could also be with different colors and sizes. In these cases, unordered goods could find their way onto the selling floor, jeopardizing the buyer's model stock.

While the techniques employed in the smaller stores need not be as sophisticated as those used by their larger counterparts, they should address all of the problems associated with merchandise handling. In the absence of computers or other automated equipment, which is usually the case in the smaller stores, a well-developed manual system should be put in place. Such a system requires only that merchandise be checked against the purchase order for accuracy and checked against the invoice to make certain that there are no shortages. After proper recording of the information in the inventory pages (again, recorded either by hand or computer), tags should then be prepared making certain that all pertinent information has been indicated for later use in inventory control. By paying close attention to the proper handling of the incoming shipments, it will be easier to assess the need for inventory replenishment and to check for merchandise shortages.

The size of the small store and the usual presence of the owner greatly reduce the amount of merchandise that is lost through shoplifting and internal theft.

Shoplifting usually thrives in areas that are understaffed or without the presence of management personnel. Since entrepreneurs are generally on the selling floor most of the time, shoplifters find these stores to be poorer targets than the larger companies. This does not, however, signal the small retailer to be remiss in terms of merchandise protection. The best way smaller stores can alleviate the shoplifting problem is by making certain that shoppers are properly serviced by an adequate sales staff. They should not only help the customers make selections, but assist them, if possible, in the try-on rooms where shoplifting can be accomplished.

Some small retailers who enjoy substantial traffic might consider the use of the same systems used by the larger companies to deter shoplifting. If the volume is sufficient, the expense involved in the installation of such deterrents and controls is warranted.

Although internal theft is not the same problem for the small retailer that it is for the giant operation, there are situations when the problem does occur. In the case of owner absence, a manager could become a serious culprit. Left to oversee such details as the handling of incoming merchandise and inventory management, this individual controls the merchandise. If there is absentee ownership, a careful inventory control system must be set in place to discourage theft. Such systems are available in the form of computer software and are relatively inexpensive for even the smallest store.

Whatever the size of the organization, if there are inventory shortages, the company's profits will be affected. Care must be exercised to prevent the losses.

Highlights of the Chapter

1. Merchandise handling includes various receiving arrangements, facilities, equipment, checking, and marking.

2. Many large retailers have installed conveyor systems for merchandise movement. Some installations utilize equipment that moves hanging merchandise from area to area as well as belts that automatically move goods that are in containers.

3. All incoming orders should be examined in terms of quantity and quality. Quantity checking is important to make certain that the goods received were ordered by the buyer and the amounts indicated on the invoices are accurately stated. To make certain that the merchandise is of the quality ordered, the buyer or representative should carefully check the shipments.

4. When merchandise is marked it might be done so by hand or special machinery. Whichever technique is used, it is important for the tag to list such information as department classification, style number, size, color, and price. With this information, it is easy to maintain inventory records that will be used for stock analysis and the planning of future purchases.

5. Inventory shortages are attributed to shoplifting and internal theft.

6. Most major retailers report that internal theft accounts for the largest number of inventory shortages.

7. Shoplifters are often difficult to spot because they pose as store customers.

8. In order to reduce the amount of merchandise shrinkage attributed to shoplifting, retailers use a variety of deterrents and controls such as electronic article surveillance, security guards, video surveillance, and fitting room patrol.

9. The innovative Inktag has significantly reduced the amount of shoplifting in stores that have installed that system.

10. One of the most important ways to control internal theft begins at the time of the interview for employment. By paying close attention to past employment records and convictions, potentially dishonest individuals can be eliminated from consideration for the job.

For Discussion

1. Differentiate between the receiving arrangements of individual and chainstore organizations.

2. Discuss the advantage of a conveyor system for merchandise handling in comparison to the more conventional stationary and portable tables.

3. List and describe the four most common methods of quantity checking.

4. Which method of quantity checking is most beneficial to fashion retailers?

5. Whose responsibility should it be to check the quality of incoming merchandise?

6. What are the reasons why fashion retailers mark their merchandise?

7. Define the term "premarking."

8. Why do many fashion retailers code the cost of merchandise on price tags?

9. Which two groups are primarily responsible for merchandise shrinkage?

10. Discuss the reasons why employees account for more inventory shortages than do shoplifters.

11. Describe the electronic article surveillance systems used extensively by today's retailers.

12. What recent innovation in merchandise tags has significantly reduced the amount of shoplifting in stores using the device? How does the tag work?

13. How can the application for employment form reduce the number of inventory shortages attributed to internal theft?

14. Describe "pen and pencil integrity" testing of potential employees.

15. What role does the outside agency play in determining an employee's honesty?

When Claudette Fashions opened their first store 20 years ago, it was a small operation that employed three salespeople. The buying and other decision-making responsibilities were handled by the company's partners, Jackie Andrews and Carrie Michaels. As the shipments arrived in the store, the boxes were opened on the selling floor where the merchandise was examined by either of the partners. They checked for quality and to make certain that invoices reflected what was ordered and that the quantities were properly charged on the invoices. The salespeople would tag the merchandise according to the partners' orders and prepare it for inclusion in the inventory. The system for handling incoming merchandise was simple and satisfactory for the store's needs.

Every few years, the company reinvested its profits and opened additional units. Today, they operate six stores that are all within a 50-mile radius. Each store receives merchandise directly from the vendors, and handling procedures are dealt with by the individual stores. At the present time, Claudette Fashions is considering an expansion that would bring its store total to ten and expand its trading area to a radius of approximately 120 miles. Along with the plans for expansion has come a need to examine its past practices. One of the store's functions that needs attention is merchandise handling. Both partners agree that individual shipments to each unit are inappropriate now that the company has expanded. In fact, discussions with vendors have indicated that a centralized approach to receiving would significantly reduce shipping expenses. With all of the merchandise delivered to a central warehouse, merchandise handling costs could be minimized.

Although Jackie and Carrie are ready to acquire a distribution center for merchandise receiving, checking, and marking, they have not yet been convinced that the new arrangement would be as good as the one they have used in the past. Their concerns involve the accuracy of the shipments received in terms of quantity and quality checking and the costs involved in the operation of the new facility.

Questions

1. Will the new facility reduce or increase the overall personnel expenses attributed to merchandise handling? Why?

2. Which system of quantity checking will be best to guarantee proper attention to the shipments? Why?

3. How can quality checking be successfully achieved if the buyers are not in attendance at the warehouse?

The combination of exquisite merchandise and sophisticated shoppers has made Boulevard one of southern Florida's most prestigious fashion empires. With three shops in the region's most exclusive shopping environments, Boulevard is the place to buy the latest in fashion-forward merchandise and for customers to receive the most personal attention. Discerning customers come from very distant places to satisfy their fashion needs.

Along with success has come the problem of shoplifting. While some of the highest-priced fashions are stored in stockrooms and brought out to be shown to customers, other items are featured on the selling floor with easy shopper accessibility. Such garments as leather apparel are featured unattended and have fallen victim to shoplifters. One such theft each day could cause profits to erode considerably.

Boulevard's management recognizes the need to alleviate the problem, but has not been able to determine how to minimize shoplifting. Such deterrents as chaining the merchandise to the racks or the use of uniformed guards are out of the question because of the image it would project to the customers.

Faced with an ever-increasing problem, the store is still trying to address the situation. Their only concern is not to change the store's image with the use of unsightly, offensive deterrents and controls.

Question

1. What suggestions would you make to Boulevard, keeping in mind the store's image?

Exercises

1. Write to a company that specializes in receiving equipment for retailers and request information on computerized systems. The names and addresses are available from advertisements placed in such trade periodicals as *Stores Magazine* and *Chain Store Age*. Prepare an oral report to describe the systems available and how they are used by retailers.

2. Visit a major fashion retailer to determine the various types of shoplifting deterrents and controls in use. A written report should then be prepared to illustrate your findings.

Accounting Procedures and Operational Controls

Learning Objectives

After reading this chapter, the student should be able to:

1. Discuss the accounting procedures that are used in retailing.
2. Describe the use of balance sheets and income statements.
3. List the reasons why the retail method of estimating inventory is used.
4. Differentiate between the LIFO and FIFO cost methods of determining inventory.
5. Explain the various aspects of inventory control used by retail organizations.
6. Define unit control and its advantages to the retailer.
7. Discuss the importance of stock turnover and how it is determined.
8. Describe several types of expenses and their impact on profit.

In most discussions about retailing among students and those who hope to eventually enter the field, attention is generally focused upon inventory sourcing, buying procedures, department and store management, visual merchandising, and promotion. These, the more glamorous aspects of the retail environment, provide immediate interest. Only on occasion do those who aspire to become participants become inquisitive about the financial procedures and operational controls utilized by the industry.

Those who are retailing practitioners, on the other hand, understand the importance of the accounting role and the controls that concern inventories and expenses. The major organizations maintain in-house accounting staffs that are chosen with the same care as their other employees. Many sometimes utilize the services of private accounting firms in addition to their own people when special situations need attention. Smaller retailers rarely have an accountant on staff, but use the services of outside specialists who periodically visit the store to prepare financial statements and offer accounting assistance where needed.

Specifically, whether the accounting role is played by an in-house team or a consultant, the functions that are performed are identical. The accountant supervises the recording of information into accounting books, sorts the particular information into specific categories, and prepares financial reports that address every transaction made by the store and its impact on profit and loss. In statements such as balance sheets and income statements (sometimes referred to as profit and loss statements) they depict the company's overall status. In addition to these typical functions, accountants assist the retailer with future planning. Through careful analysis of current information coupled with the store's past performance, the financial expert is able to make predictions and forecasts for purposes such as expansion, inventory considerations, and expense controls. Oftentimes merchants are too closely tied to policies that they themselves have introduced to the company. Accountants are equipped to examine the store's figures and ascertain the impact of those policies on profitability. If the expense generated through the use of extravagant visual presentation is too costly in terms of sales, for example, the accountant will be able to objectively discuss the cost with management and help them to understand its impact on profits.

The purpose of any retail business is to maximize profits. In order to do so, a great deal of attention is centered on such inventory considerations as dollar control, unit control, stock turnover, sales per square foot, and physical inventory, all of which will be explored later in this chapter along with the various expenses that are incurred in the running of a retail business.

Financial Statements

Accountants are called upon to prepare financial statements for the retailer. Two of the most commonly used are the **balance sheet** and the **income statement**.

In order to be able to read these statements, it is necessary to become familiar with specific accounting terminology.

Accounts payable—The amount that the retailer owes to its merchandise vendors and other creditors.

Accounts receivable—The monies that are owed to the retailer from credit card sales.

Merchandise inventory—How much money the retailer has invested in inventory.

Notes payable—The amount the retailer owes for equipment, fixtures, and other items acquired with loans.

Supplies—How much the retailer has on hand in terms of items such as paper bags and boxes, cleaning compounds, light bulbs, billing materials, and sewing thread for alterations.

Salaries payable—The amount the retailer owes for services rendered by the staff.

Balance Sheet

This financial report contains the company's assets—that which it owns such as merchandise inventory; liabilities—that which it owes such as accounts payable—(the monies owed to vendors); and its net worth. By subtracting the liabilities from the assets, the net worth or equity is determined.

The formula used in a balance sheet is:

$$\text{Assets} - \text{Liabilities} = \text{Equity (or Capital)}$$

Thus, if a company's assets are $75,000 and its liabilities are $25,000, its net worth or capital is $50,000.

$$\$75,000 - \$25,000 = \$50,000.$$

A simplified balance sheet, typical of a small fashion retailer may look something like this:

<div align="center">

THE FASHION BOUTIQUE
BALANCE SHEET
DECEMBER 31, 19__

</div>

Current assets

Cash	$15,000	
Merchandise inventory	25,000	
Accounts receivable	10,000	
Total current assets		$ 50,000

Fixed assets

Fixtures	$22,000	
Building	95,000	
Total fixed assets		$117,000
Total assets		$167,000

Current liabilities

Accounts payable	$12,000	
Salaries payable	1,000	

Current liabilities	$ 13,000

Fixed liabilities

Notes payable	$ 75,000
Total liabilities	$ 88,000
Net worth (capital)	$ 79,000
Total liabilities and net worth	$167,000

Some accountants prepare balance sheets that list last year's figures as well as the current ones so that comparisons can be made.

Income Statement

An income statement, or profit and loss statement as it is sometimes called, reveals whether the retailer has realized a profit or loss for the period. When a store's revenue from sales exceeds its expenses, it has made a profit. On the other hand, if expenses exceed revenue, the result is a loss.

An income statement for a small independent fashion retailer would be similar to this one.

<div align="center">

AVANT-GARDE FASHIONS
INCOME STATEMENT
FOR THE YEAR ENDED DECEMBER 31, 19__

</div>

Sales		$175,000
Cost of goods sold		
Inventory, Jan.1	$ 32,000	
Add: Purchases	84,000	
Goods available for sale	116,000	
Less: inventory Dec.31	28,000	
Cost of goods sold	88,000	
Gross profit		87,000
Operating expenses		
Salaries	$ 31,000	
Rent	12,000	
Utilities	7,000	
Insurance	2,000	
Total expenses		$ 52,000
Net profit for year		$ 35,000

In the above example, Avant-Garde Fashions achieved a profit of $35,000 for the year (gross profit − expenses = net profit). The term "gross margin" is sometimes used by retailers in place of "gross profit."

Retail Method of Estimating Inventory

The income statement, as we have seen, is a very important tool needed by management to get a picture of the operation's success. One of the figures that is required to prepare the statement is the store's inventory. Such information may be made available by taking a physical count of the merchandise. While this is possible, retailers rarely take physical inventories more than twice a year because the procedure is costly and time consuming. If income statements are required by stores more frequently, it is more appropriate to use another method. With most merchants keeping records of their inventories at the retail price, it becomes necessary for use in the income statement to convert the numbers to the cost.

The retail method of estimating inventory at cost is used by the vast majority of retailers and is illustrated in the following example.

Inventory, September 1, at cost......................................$ 20,000
Inventory, September 1, at retail 40,000
Purchases for September, at cost................................... 25,000
Purchases for September, at retail..................................50,000

Step 1. Determine the goods available for sale at cost and retail.

	Cost	Retail
Inventory, Sept. 1	$20,000	$40,000
Purchases.................................	25,000	50,000
Merchandise available..............	$45,000	$90,000

Step 2. Determine the percent of the cost of the merchandise to the retail price.

$$\frac{cost}{retail} \quad \frac{\$45,000}{\$90,000} = 50\%$$

For September, the cost of the merchandise that was available for sale was 50% of the retail.

Step 3. Determine the inventory at retail.

If sales for the month of September were, for example, $60,000, and the goods available for sale for the month were worth $90,000 (from step 1), the inventory at retail is $30,000.

Merchandise available at retail ..$90,000
Less: sales... 60,000
Inventory at retail ...$30,000

Step 4. The inventory at retail is converted to cost.

Inventory at retail ...$30,000
Percent of cost to retail .. × .50
Estimated inventory at cost..$15,000

It should be remembered that the 50 percent, or .50, was determined in step 2. Stores are afforded many advantages when they use the retail method of inventory.

1. Most important, as already stressed, is the ability to generate as many financial statements as necessary, without the need to take a physical inventory.

2. When physical inventories are required, it is easier to manage the operation since the merchandise is already marked with the retail price. This helps to reduce the number of clerical errors that could be made if the items were individually figured at cost.

3. Management may assess inventory shortages by comparing the actual numbers generated by the physical inventory with the estimates determined by the retail method.

4. In situations where merchandise has been destroyed or damaged, the retailer must file a claim with the insurance carrier. The retail method can be quickly utilized to estimate the losses and used for the claim. The cost of insurance coverage is comparatively expensive and is based in part on the size of the inventory. Since inventories change according to the seasons and selling periods, retailers regularly adjust their insurance needs. The retail method can produce the information needed by the retailer to determine how much insurance is needed for a particular time. By making these adjustments, monies can be saved on premiums.

While the retail method offers considerable advantage, there are some disadvantages.

1. The cost of using the system is high. With all of the changes necessitated by additional markups, markdowns, and customer returns, a great deal of clerical expense is encountered.

2. Since this is an averaging technique, the retailer might have a distorted picture of the store's inventory. When numerous departments are involved and different markups and markdowns are utilized, an inaccuracy might occur. In some cases, retailers with many different merchandise classifications use separate figures for each department.

Cost Methods of Determining Inventory

As we have just discussed, most retailers use the retail method of inventory. Some, however, utilize the cost method for determining the value of their stocks because of the lower record-keeping costs associated with the technique. The cost method

of determining inventory requires physical inventory taking and identifying the cost of each item. In order to determine the value of the inventory, most retailers use one of two methods, FIFO and LIFO, both of which will be fully explored. It is important to have accurate inventory figures so that profits are accurately stated and appropriate taxes are paid. Misstatement of these figures can lead to the overpayment of taxes.

FIFO is the abbreviation for *first in, first out.* The assumption made when using this method is that the merchandise that is bought first is sold first.

LIFO stands for *last in, first out.* This system is the opposite of FIFO and assumes that the last items that were purchased were the first to be sold.

While the FIFO method seems most appropriate for fashion merchandise with its seasonal and style characteristics and its perishability factor, most retailers use the LIFO method because it values inventory at a lower rate (especially during inflationary periods) and helps the retailer offset taxes.

The LIFO method became available for use in 1947 as a result of a ruling by the Internal Revenue Service (IRS). It should be understood that while the choice is up to the retailer, the IRS requires that they always use the same system.

The following illustration shows how the two methods work.

Problem

During the course of a year, Fabulous Hosiery made the following purchases of argyle socks.

Jan. 8...120 pairs @ $6
April 15...150 pairs @ $8
Sept. 10...300 pairs @ $8
Dec. 10 ...100 pairs @ $9

At the time of the physical inventory on December 31, there were 180 pairs of socks on hand. Since each pair of socks is not specifically marked at cost, it is difficult to determine the actual cost of each remaining pair.

Calculate the value of the argyle socks inventory using both FIFO and LIFO.

FIFO

Under this method, the assumption is that the first socks purchased were the first socks sold. Therefore, the remaining socks were those purchased last.

100 pairs of socks@ $9 = $ 900
80 pairs of socks@ $8 = 640
Total cost..$1540

LIFO

Using this method, we assume that the last socks purchased were the first to be sold. In this case, the socks remaining were purchased first.

120 pairs of socks ..@ $ 6 = $ 720
60 pairs of socks ..@ $8 = 480
Total cost..$1200

When we compare the figures that resulted from both techniques, the second affords the retailer a lower valuing of the inventory and a lower profit on which taxes are paid. It should be understood that this example merely touches upon the principles of LIFO and FIFO. For more complete examination of the two practices, an introductory accounting textbook would be advisable.

Inventory Control

While retailers have significant investments in their store's fixtures and equipment, the merchandise carried represents the major portion of its capital. In order to produce a profit for the company, there must be a sufficient amount of merchandise on hand to satisfy customer needs.

Careful planning of how much merchandise is needed and what the assortment should be in terms of prices, sizes, colors, and styles is imperative to the success of the business. This information, coupled with the time it takes to sell the merchandise, helps the retailer to stock the shelves with salable merchandise.

In the next two chapters, "Buying Principles and Procedures" and "Inventory Pricing," attention will focus on how the assortments are determined by the buyers and merchandisers and how the retail prices are determined. At this point, the focus will be on the various inventory controls and measurements management utilizes to maximize the store's profits.

Before they are explored, it is important to understand the necessity for their incorporation in a retail operation.

The Need for Inventory Controls and Measurements

Small retailers often rely upon "eyeballing" their inventories to determine the need for additional merchandise. If the shelves or racks look sparse, it might signal the need for replenishment. No matter how small the operation, scanning the inventory does not give insight into specific needs. It will not indicate which colors sold best, which sizes account for the greatest number of sales, and which prices generate the most business. A variety of techniques is necessary to take the guesswork out of planning; the following are some of the reasons why.

1. Even in the most ideal situations there are items that do not catch the customer's attention. In order to sell some of the slower-moving merchandise, a reduction of the selling price, or markdown, is often necessary. If too many items require markdowns, the company may not achieve its anticipated profit. Through the analysis of sales, management is able to assess every item in the store. By paying attention to the information reports generated by specific control systems, popular types of merchandise can be reordered and slow sellers can be eliminated.

2. It might seem that carrying a vast assortment to satisfy everyone's needs is the key to a successful retail operation. Seasoned merchants are quick to report that not everyone can be satisfied in a single store. It should also be understood that there are numerous expenses tied to the sale of merchandise such as rental expenses, employee costs, insurance, and the cost of fixtures to feature the goods. If the assortment is more abundant than necessary to meet the customer's needs and the expenses are increased to offer the assortment, the store's profits will be affected. Again, with the application of controls, there will be a more realistic relationship between the size of the inventory and sales.

3. One of the most serious problems faced by retailers today is inventory shortage as discussed in the previous chapter, "Merchandise Handling and Protection." With shoplifting and internal theft reaching alarming proportions in many of the nation's retail organizations, it is imperative to discover the areas that are responsible for the shortages. With a good system of control, the problem could be addressed and often corrected.

4. Overbuying might seem like a harmless act. In fact, when more merchandise is purchased than necessary to meet customer demand, the store's monies are tied up in unnecessary inventory. This could lead to the inability to pay for the merchandise on time, causing credit problems for the store's future purchases.

Inventory Control Systems and Measurements

In order to provide management with the soundest advice, a variety of systems are employed. They include dollar and unit control, stock turnover, sales per square foot analysis, and the taking of a physical inventory.

Dollar Control

In the **dollar control** system, most retailers use the selling price for their calculations. The inventory is thus stated in retail dollars. Those who wish to determine their dollar inventories at cost may do so by means of simple calculations that convert the retail dollars to cost.

Dollar control is used to show the store's sales, purchases, markdowns, and inventories. Inventory levels in terms of quantity are revealed through the unit control system that is explored in the next section.

The dollar control system may be applied to an entire store's inventory or individually to specific departments. Specialty stores that concentrate on one merchandise classification such as shirts would be satisfied with an overall picture. On the other hand, department stores carry a large assortment of hard goods and soft goods and would not be satisfied with a general dollar figure. In those cases the transactions are classified according to the individual departments, giving management specific insights into each one. Thus, the management team can assess each department on its own merits and make adjustments where needed.

Two methods are used to keep dollar control of inventories, the **perpetual inventory method** and **periodic inventory system**. The former is an ongoing or continual method that reveals the value of an inventory at any time. The latter provides the value of an inventory at a specific time and requires the physical counting of the merchandise.

Perpetual inventory method. As we have discussed, inventory control can be used to measure an entire store's stock, individual department's inventories, or specific items. Whichever is needed, the procedure followed is the same.

The information must be carefully recorded to produce accurate figures. Smaller retailers tend to hand record information on inventory pages for their stores' purchases and sales while their large-store counterparts utilize the computer to record the transactions. The latter merely speeds up the process, enabling employees to perform other tasks.

The following example illustrates a day's activities for a small men's wear retailer. It should be understood that the figures represent an estimate of the merchandise picture since such factors as shoplifting and employee theft are not considered.

INVENTORY CONTROL
JASON HABERDASHERY
JANUARY 25

Opening inventory	$65,000
Merchandise received	4,000
Sales	3,000
Closing inventory	66,000

To the inventory that was on hand the morning of Jan. 25 (opening inventory), $65,000, we add the $4,000 purchases that were received that day, for a total of $69,000. From that figure we subtract the sales for the day, $3,000, to determine the amount of inventory on hand (closing inventory) at the day's end, $66,000.

While this was one day's transactions, the procedure may be used for periods up to one year. Each store's management determines the frequency for such figures. Stores that have computer programs for the task can, in a matter of moments, determine dollar control.

As with most systems, dollar control has advantages as well as disadvantages. The biggest advantage is that it can quickly alert the retailer to the store's inventory situation with a minimum of effort. On the negative side, it should be understood that this is merely an estimate of the figures. In order to determine the true picture, the periodic inventory system is used.

Periodic inventory method. In the perpetual inventory system, the closing inventory was determined through arithmetic calculation. The periodic technique requires taking a physical count. Such a system is very time consuming and expensive for the retailer and is therefore infrequently employed. Most retailers limit the procedure to twice a year, generally at times when the inventory is at the lowest levels. Fashion retailers, for example, usually count their inventories at the end of January or the beginning of February, and sometime at the middle or end of July. Since these time spans fall between seasons, the merchandise is often at low levels and easier to count.

Since the task must be performed carefully to guarantee that the right numbers have been recorded, most retailers close their doors while the inventory is being taken. Smaller retailers generally rely upon writing each bit of information while the larger companies usually have computerized systems that are used to record the numbers. Through the use of a scanner (a device that automatically reads the information from merchandise tags such as price, department classification, and style) the system is faster and more accurate.

The following example illustrates the employment of the numbers used in the periodic inventory system taken by the same store as in the previous illustration.

INVENTORY CONTROL
JASON HABERDASHERY
JANUARY 25

Opening inventory ..$62,500
Merchandise received.. 4,000
Sales ... 3,000
Closing inventory ... 63,500

A comparison of the two methods, taken at the same point in time, reveals that there is a discrepancy. The real figure, a closing inventory of $63,500, indicates merchandise shortages that might have been caused by pilferage, returns to vendors that were not recorded, or some other reason. The comparison of the two dollar control methods indicates to the retailer, among other things, how much shrinkage (merchandise loss) is plaguing the company.

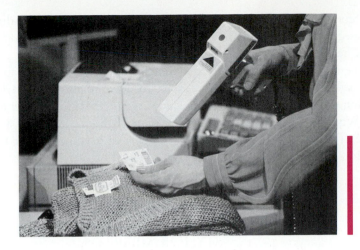

Figure 9-1. Scanner automatically records information used for unit control. (Courtesy of International Business Machines Corp.)

Unit Control

In addition to keeping records in dollars, retailers also use a system that involves quantities. Unit control, as it is known, reports the number of individual units or items sold.

The importance of such a system can be best understood when some of its advantages are explored.

1. When buyers are planning their purchases, as discussed in the next chapter, "Buying Principles and Procedures," it is important that they know about the specifics of their past sales. Through a unit control system they can assess each vendor in terms of which styles sold best, returns made by customers, markups maintained, and markdowns needed to dispose of merchandise.

2. We have seen that the periodic inventory system used for dollar control reveals dollar losses from pilferage. The unit control system also helps the retailer to discover which types of items are being lost to shoplifting and which areas of the store are subject to such theft.

3. In a good unit control system the store keeps records of the merchandise's date of arrival. When this is coupled with the time it took for specific units to sell, the merchant can determine which items move faster and might warrant reorders and which might sell so slowly that they might be eliminated from future buying plans.

4. Two key elements of an appropriate fashion inventory are size and color. Unit control systems indicate which sizes sell better and which colors are preferred by the customers. By paying attention to this information the buyer will be better prepared to develop a model stock (the right assortment of merchandise in terms of size, color, style, and prices to satisfy the customer's needs).

Stores maintain unit control systems using either hand recording or computer-based recording. Even many small fashion retailers are utilizing electronic systems because accurate merchandise information is needed to plan purchases. Unlike the retailer who sells staple goods (items such as small appliances, foods products, and men's hosiery) and does not have to deal with style changes, the fashion merchant must be able to evaluate the inventory and react to changes.

Whether the system is automated or not, the records kept are basically the same. The example that follows illustrates a unit control sheet for a particular vendor's style.

BUTTON-DOWN SHIRT
POWDER BLUE
VENDOR NUMBER: 615
STYLE NUMBER: 325

DATE	RECEIVED	SOLD	ON HAND
March 5	—	—	15
10	12	5	22
19	—	8	14
27	20	9	25

Analysis of style 325 indicates that it regularly sells and that it should be continuously reordered until sales decline. While this information gives the buyer some basic information, it might be appropriate to examine sales in terms of sizes. If this is deemed necessary, another column could be added to the report that offers those figures.

Stock Turnover

An important measurement for retailers to use is **stock turnover**. The technique indicates the number of times a store's average inventory is sold in a year. To better understand the concept, it might be appropriate to examine two different product classifications, milk and precious jewelry. The former often sells out completely every day that the store is open. If the milk merchant is open 365 days a year and in fact sells out the entire inventory every day, the stock turnover is 365. On the other hand, the nature of precious jewelry limits the frequency of its sales. Let's assume that a jewelry shop sells out its average inventory every three months. If this is the case, the store produces four annual stock turnovers. The following example illustrates the concept and the mathematical computation needed for its solution.

The men's sweater department at Judson's produced the following figures for the past year.

Opening inventory (Jan. 1)..$220,000
Closing inventory (Dec. 31) .. 180,000
Sales for the year.. 800,000

The formula for stock turnover is

$$\frac{\text{net sales}}{\text{average inventory at retail}} = \text{stock turnover}$$

First we must find the average inventory.

$$\frac{\$220,000 + \$180,000}{2} = \$200,000$$

Then

$$\frac{\$800,000}{\$200,000} = 4$$

The department's inventory turned over four times during the year.

In order to assess the significance of the numbers, the retailer should first try to determine the average turnover for the various departments in the store. Knowing this can help the store to recognize how well the department is performing in comparison to what is being achieved in the industry. If the rate is below the industry standard or that which the company deems appropriate for the merchandise classification, further investigation might be necessary to correct the problem.

The following are some of the causes of low stock turnovers.

1. The buyer has not successfully met the needs of the customer. The styles might be too fashion-forward for the clientele, the colors and fabrics were not appropriate for their needs, the merchandise was not properly stocked in terms of size requirements, and so forth.

2. The prices might have been too high. Competition of other area retailers, such as off-price operations, could have eroded customer confidence.

3. Unreliable vendors might have delivered the merchandise too late, causing the need for markdowns.

4. Sales personnel may be experienced.

5. Advertising, promotion, and visual merchandising may have been unimaginative.

By addressing all of these problems, the retailer should be able to determine the causes of the lower than anticipated turnover rate. Perhaps adjusting prices, eliminating certain vendors, introducing new lines, improving in promotional endeavors, and better training of the sales staff could improve the situation.

It is the improvement of the turnover rate that usually leads to a more profitable picture.

Sales per Square Foot

More and more retailers are using the **sales per square foot** measurement to evaluate the relationship between sales and the space the merchandise occupies. Different types of locations, merchandise classifications, and retail philosophies play a part in the amount of business that is transacted in a particular selling area. The new power centers report that sales per square foot often reach the level of $1,000, far above the amount realized by department stores and specialty chains located in malls. Off-pricers and discounters lead the traditional merchants when it comes to sales per square foot.

Managers in retail organizations that feature a host of different types of merchandise are extremely interested in this control method. Not only does it tell them if their departments are achieving the desired dollar figures but it enables them to make comparisons among the various departments. Merchants are inclined to alter their merchandise mixes when there are indications that one department is not profitable or another department's sales warrant expansion.

The merchandising trend in department store retailing today points to a rethinking of the store's model stocks. Once the proponents of one-stop shopping and featuring a wide assortment of hard goods and soft goods, these merchants are moving decidedly away from housewares and appliances and replacing those areas with additional fashion items. With the business of microwave ovens, television sets, vacuum cleaners, and furniture moving to the discounters and specialty chains, department stores are finding that such items are not bringing significant profit to the store. Stores like J.C. Penney have abandoned their hard-goods merchandise and expanded their fashion areas. The examination of the sales per square foot figures dictated that change.

The formula for finding sales per square is simple. Sales are divided by the number of square feet in a space. Some stores opt for a variation of the method and choose to determine profits per square foot. If this is the case, profits are substituted for sales in the formula.

When each of these inventory controls is carefully applied, the retailer is able to take a more scientific approach to managing the business and ultimately to maximize profits.

Expense Controls

One of the problems that faces the retail industry today is the constant spiraling of expenses. Whether it is salaries, advertising, rent, insurance, or any other category, the costs of doing business are increasing. It is quite clear that if expenses are curtailed, profits will be greater. This, however, is a simplistic approach to the problem. The inexperienced might suggest that with the elimination of sales per-

sonnel and the substitution of self-selection, enormous monies would be saved and profits would soar. Of course, such a radical decision would probably substantially affect the store's sales volume and profits would decline.

The concept of expense control does not suggest the reduction of expenses. The system analyzes expenses and adjusts them to levels that will bring the store a greater profit.

Expense Classification

There are a host of expenses necessary for running a retail operation. Among the most costly are payroll, advertising and promotion, visual merchandising, supplies, travel, heating and ventilation, telephone, insurance, taxes, pensions, equipment, service contracts, delivery, depreciation, and rent.

After the expense classifications have been identified, a system must be set up to evaluate them in terms of sales or profits. In either case each expense is allocated to the department that receives its benefits. For example, advertising should be allocated to each department that uses it, as should payroll, travel, and everything else. In this way, each department's expenses can be analyzed individually and studied by management to see where adjustments may be made. If the advertising budget for children's wear is 6 percent of sales and that for shoes is 3 percent, and both have virtually the same sales figures, it might be a signal for management to consider the curtailment of the children's wear advertising expenditure.

Expense Budgeting

In order to control expenses, retailers prepare an expense budget for the store that addresses past expenses and sales and planned expenses and sales. By doing so it offers numerous advantages to the company.

1. By projecting future expenses, management will be prepared for them when the needs arise.

2. When sales are projected and specific expenses are earmarked for that sales level, a planned net profit will be easier to achieve.

3. After a six-month or yearly period, the actual expenses incurred can be compared to the budgeted figures. In this way management will be able to readdress those figures that showed a discrepancy.

4. Specific employees who are responsible for particular expenses can be held accountable if the expenditures are greater than budgeted.

Computerized Accounting and Inventory Control

Large retail organizations, as well as some smaller operations, use the computer for their accounting and inventory control functions. The speed and accuracy of the equipment enables merchants to receive daily reports on which decisions can be made. Prior to the use of electronics, retailers had to write sales checks and other documents by hand, which then necessitated the manual transfer of the information onto forms that were eventually used to produce financial statements and other reports.

The sophistication of the hardware (a term used to describe the computer equipment) and the availability of scores of software programs (the instructions that perform the various functions) make every financial requirement easier to come by.

Some of the smaller operations rely upon outside services for their computer needs. Customer billing, processing merchandise information, and other tasks are taken over by these companies and are delivered to the retailers for their use.

While there are numerous programs to choose from for accounting procedures, there are considerably fewer for use in controlling fashion inventories. ACI (Advanced Cybernetics Inc.), a business partner of IBM, is a leader in fashion-oriented inventory control software. Their Retail Express package features just about every program needed by fashion merchants to carry out their merchandising tasks.

Department/Vendor Ranking By Retail Sales

```
CO. ID: THE RETAIL CO.                          DATE 12/18/90   TIME 16:04:05
*********************** VENDOR RETAIL SALES INQUIRY *******************MV3015
                                                 * * * ASSISTANCE * * *
Department- 001   OUTERWEAR                       F6=Top 10/20 Vendors
Year      - 90                                    F12=Previous
Acct.Per. - 03

VENDOR      VENDOR        RETAIL $   COST  $  GROSS    RECEIPTS $ RECEIPTS $
NUMBER      NAME          SALES      SALES    MARGIN%  RETAIL     COST
000000002 SPORTS MFG CO.   12410      7215    41.86     13735      9660
000000003 U.S.A. SPORTS     1873      1000    46.60      3746      1500
000000011 RETEX COMPANY      151       106    29.80       182       106
000000012 THE MFG CO.        145        66    54.48       218       103
000000001 THE VENDOR COMPANY 127       106    16.54       136     11363
000000021 AMERICAN PROD.     121        54    55.37       152       118
000000025 ABC MFG            121        78    35.54       121        79
000000004 SPORTS INC         109        27    75.23       106        30
000000007 OCEANSIDE INC       90        30    66.67       136        45
000000017 FLEET STREET        90       121    34.44-      152       109
000000010 THE SPORTS LOOK     84        48    42.86       115        61
000000008 PANTS PLUS          60        36    40.00        91        55
```

Figure 9-2. Computer printout ranking vendors by retail sales (Courtesy of ACI, Inc.)

Vendor Ranking By Gross Margin

```
CO. ID: THE RETAIL CO.                           DATE 12/18/90   TIME  8:41:44
*************************  VENDOR GROSS MARGIN RANKING  ***************** MV3038
                                                    * * * ASSISTANCE * * *
                                                    F6= Top 10/20 Vendors
                                                    F12=Previous

            VNDR NAME   G/M%   SALES COST  SALES  RETAIL SELL OFF%
  VENDOR      RANK      MMU%   RCPTS COST  RCPTS  RETAIL    M/D$       RTV$
000000020 AMERICAN MF  61.78       7166           18747  58.61                 0
        1             57.75      13512           31984              0
000000004 ABC SPORTS   57.51       9371           22052  92.71                 0
        2             38.26      14687           23787            549
000000021 S.S. SPORT   55.02       4961           11029  80.00                 0
        3             22.00      10754           13787           1101
000000023 FASHION IN   47.24        210             398  83.79                 0
        4             40.63        282             475             78
000000022 AM MFG       47.15      10198           19296  57.36                 0
        5             50.00      16820           33640           1378
000000024 MADE IN US   45.51         97             178  56.87                 0
        6             31.63        214             313             18
000000007 CLOTHES IN   42.86      11028           19300  58.33                 0
        7             68.33      10478           33089          12406           +
```

Figure 9-3. Computer printout ranking vendors by gross margin (Courtesy of ACI, Inc.)

As we have already seen, vendor analysis is important so that the buyer can make purchasing decisions based on past performance. Figures 9-2 and 9-3 feature two of the informational reports generated by the computer with the Retail Express program. The first ranks vendors by retail sales and the second by gross margin.

Chapter 10 spotlights ACI and the programs of Retail Express and features a variety of computer-generated reports used by buyers and merchandising managers.

Small Store Applications

Small retailers rely upon accounting firms to prepare their financial statements. As with the larger companies, many reports and instruments must be provided for use in management decision making and for tax purposes. While much of the information needed for the preparation of the reports is simple to collect and is generally accomplished by an owner or manager who records the data in a set of "books," the accountant offers other services that are invaluable to any company.

Retailers must make a number of decisions for which they have very little experience. The types of credit to offer, sales forecasting, inventory levels, potential expansion, service costs, and insurance needs are just some that need attention. The experienced accountant can provide counseling on these topics as well as perform the bookkeeping chores. All too often, it is the latter function that accountants are asked to attend to. By failing to call upon the accountant for expert advice on financial matters, many small retailers fail.

In order to make sound merchandising decisions, even the smallest retailer must utilize inventory control systems. In the fast-paced world of fashion merchandise, the requirements are even more important. It should be understood that tasks such as unit control and estimating inventories can be manually accomplished. With the proper system in place, every retailer can keep track of the inventory and make decisions based upon the data.

Since the cost of purchasing a computer is no longer prohibitive, it is appropriate for every fashion merchant to buy one. With the availability of numerous programs at modest cost, the entrepreneur can have access to the same types of reports used by the giants.

The list of expenses incurred by the small merchant to carry out the business is similar to those of the larger companies. No matter how small the store, expense budgets must be carefully prepared and controlled so that profits will be maximized.

Highlights of the Chapter

1. Accountants supervise the recording of information into accounting books, sort it into different categories, and prepare financial statements that address every one of the store's transactions.

2. Two of the most commonly used financial documents prepared by accountants are balance sheets and income or profit and loss statements. The former lists the company's assets, liabilities, and net worth; the latter shows how much of a profit or loss was achieved.

3. In order to prepare the income statement, it is necessary to first determine the size of the inventory. Instead of taking a physical inventory, stores use the retail method of estimating inventory.

4. The two most frequently used cost methods of determining inventory are FIFO and LIFO. The application of FIFO assumes that the merchandise bought by the store first is sold first. LIFO makes the assumption that the last items purchased were the first to be sold.

5. Retailers use a number of inventory controls and measurements for numerous purposes, including the analysis of each of the store's merchandise items, to determine whether the size of the inventory is appropriate to maximize sales and to evaluate inventory shortages.

6. Two of the controls that management utilizes in order to make future purchasing decisions involve dollars and units. Dollar control addresses the store's sales, purchases, markdowns, and inventories. Unit control keeps records of the individual items that are sold by the store.

7. Two methods are used to keep dollar control of inventories, the perpetual and the periodic systems. The perpetual system is ongoing and is merely an estimate of the figures while the periodic technique is more accurate in that it requires the physical counting of the merchandise.

8. An important measurement device that is used to determine the relationship of sales to space is known as sales per square foot. It enables the retailer to learn how well his company is performing in comparison to industry standards and which departments in his own store are the winners and losers.

9. In order to run a business, retailers incur a great deal of expense. Expense controls are used to curtail expenses wherever possible so that a greater profit will be achieved.

10. In order to control expenses, retailers prepare expense budgets for their stores that consider past and planned expenses and sales.

11. The use of the computer for accounting and inventory control provides information more quickly and more accurately than when manual systems are employed.

For Discussion

1. Discuss some of the functions performed by the accountant for the retailer.
2. List five of the accounting terms that are found on financial statements.
3. Explain the importance of a balance sheet and identify its three component parts.
4. What purpose does an income statement serve for the retailer?
5. Discuss the most important reason for the use of the retail method of estimating inventory.
6. Differentiate between the FIFO and LIFO cost methods of determining inventory.
7. What are some of the reasons needed for inventory controls and measurements?
8. Discuss the concept of dollar control and the advantages it affords the retailer.
9. How does the perpetual inventory method differ from the periodic system?
10. What is the significance of unit control?
11. Explain the importance of stock turnover.
12. Does the sales per square foot measurement serve any purpose for the store?
13. Are expense control and expense elimination one and the same thing?

14. List several of the typical expenses incurred by retailers in running their businesses.

15. How has the computer helped to benefit the functions of accounting?

Originally established as a small specialty store in 1938, Marsh & Company has grown to become one of the Midwest's most important department store chains. At their first location, they featured women's clothing and accessories and ultimately added men's wear when the space doubled in size. Through the acquisition of adjacent buildings they expanded their selling floors as well as their merchandise mix. By the end of 1950 Marsh & Company offered a wide assortment of both hard and soft goods.

Business was so profitable that they ultimately opened eight branches that were all within a 150-mile radius of their flagship, the original store. Each branch featured a complete inventory of fashions for men, women, and children, as well as housewares, furniture, appliances, cosmetics, and hosiery. Every year since the company was founded a profit has been achieved.

The store's policy has always been to involve the buyers and merchandisers in future planning. At semi-annual seminars, each buyer and merchandise manager is asked to deliver a plan for the improvement of his or her department. In that way management is able to get an impression of which merchandise direction the store might take for the future.

At the most recent meeting, Alex Forbes and Maryanne McGovern, the respective buyers of men's clothing and large-size women's apparel, suggested that the store rethink its merchandise offering. The proposal was to expand the space allocated to their areas and to phase out the sale of appliances and hardware. By doing so, they would be able to assume the space vacated by those areas and offer a greater variety of their products. The rationale for the suggestion was based upon the premise that hard-goods retailing was becoming specialized and no longer profitable in department stores.

The heads of the departments that would be eliminated if the Forbes and McGovern plan came to fruition strenuously objected. They felt their departments were sufficiently profitable and that their demise would alter the image of Marsh & Company. It would no longer serve as a one-stop shopping environment as it had for so many years.

While top management is eager to improve profits, it is not certain that such a radical change would be beneficial.

Questions

1. Which measurement tool would help to assess the value of the departments in question?

2. What is the formula used for the test?

3. How might management assess the true value of the departments with outside sources?

Paul Philips has worked for many years as a branch manager at Edwards & Barnes, a 300-unit chain that specializes in children's clothing. He has been with the company for 15 years, beginning as an executive trainee in company headquarters. He presently is responsible for the organization's most profitable unit.

Last month Paul decided to try his hand at his own business. After a very successful career in retailing he believed he was capable of starting his own children's wear company. He had saved a sufficient amount of money for a good part of the investment and felt that financing the rest would enable him to be self-employed.

Although he is still employed by Edwards & Barnes, he has looked into a variety of locations for possible use. He has tentatively decided on a small building on Main Street, about 10 miles from the unit he manages, and is ready to sign the lease.

While he has had considerable experience in the children's wear business, it was for a giant in the field, somewhat different from his small-store ambition.

Totally familiar with the wholesale market, Philips is confident buying would not be a problem. His main concern is the expense that it would take to operate a small store. Although some of the expenses would be along the lines with which he was familiar at Edwards & Barnes, the running of a small company is different.

He is aware that unless expenses are identified and controlled a profitable venture might be impossible to achieve.

Questions

1. Which expense classifications should Paul address before he starts his new operation?

2. Are there any expenses that he might not have to incur in contrast to the company that he worked for?

Exercises

1. Make an appointment to meet with a financial officer of a major department store to discuss the methods used to take a physical inventory. Make certain you ask about computerized systems, input devices such as scanners, or any other technological information about their inventory taking. Using the

information obtained during the interview, deliver an oral report highlighting the system's main features.

2. Visit a fashion operation in your area and try to assess from your observation the various expense classifications of the company. Make a list of these assessments and ask to speak to a management representative to determine if your judgments are correct.

section

4

Merchandising Fashion

Buying Principles and Procedures

Learning Objectives

After reading this chapter, the student should be able to:

1. List the duties and responsibilities of those responsible for the buying function.

2. Discuss the various sources of information the store buyer assesses before the season's purchases are made.

3. Define the term "model stock" and how it is developed by the store buyer.

4. Describe the four elements that must be considered prior to placing orders for a new season.

5. Differentiate between domestic and offshore purchasing.

6. Calculate "open-to-buy."

7. List the various elements included in "landed cost" and how it is calculated.

8. Describe the various types of resident buying offices and how they serve the fashion retailing organizations.

Every piece of merchandise that is found in a store has been purchased by a buyer who works for the store or a resident buyer who represents the store. In large stores the buying tasks are performed by specialists who have acquired specific knowledge in preparation for the buying challenge. In small stores the buying function might be one of many carried out by the company's owner. Whatever the size of the business, it is the purchasing of fashion merchandise, more than any other merchandising classification, that provides the greatest challenges. Unlike other goods that are considered to be staples—that is, they are in demand for extended periods of time and not subject to rapid design changes—fashion items are available in a wealth of styles and have a life expectancy that is relatively brief. Those in the fashion buying field are regularly called upon to make decisions that could result in success or failure for the store. Will the customer prefer

short skirts to long styles, or will she opt for pants? Will the gentlemen prefer button-down shirts to spread collars? Will red be the fashion color that will motivate purchasing or will that color be passed over and eventually head for the markdown table? There is little room for error in the purchase of fashion goods, and those who do not carry out their roles responsibly could be looking for new employment.

There are two specific buying careers available to those who wish to enter the field of fashion merchandising. Each provides different challenges, but both require dedication, expertise, product knowledge, and discipline in order to achieve success. **Store buyers** are the individuals who determine the merchandise needs of their departments, or sometimes entire stores, and ultimately make the purchases. The merchandising decisions they make help determine their stores' eventual profits or losses. **Resident buyers** generally perform advisory tasks and assist the store buyers by providing them with a significant number of services. Merchandise is generally not purchased by resident buyers unless they have store authorization to do so. On occasion, however, some retailers have been known to use resident buying offices for all purchases.

The duties and responsibilities of each store or resident buyer depends upon the organizations for which they work, the type of merchandise featured, and the size of their respective companies.

Since their jobs are considerably different from each other's, fashion retail buyers and resident buyers will be discussed separately.

Fashion Retail Buyers

The store buyer performs a great number of tasks. They include purchasing merchandise, pricing, assigning specific floor space for items and how they are to be featured, selecting merchandise for visual presentations and advertisements, and managing the people in their areas.

In addition to these duties and responsibilities, which will be discussed in the following section, attention will focus upon how the buyer prepares for his or her purchases, how model stocks are determined, the four elements that comprise fashion purchasing, and the various aspects of writing a merchandise order.

Buyer Duties and Responsibilities

While each store utilizes its fashion buyers in a manner that best suits its individual needs, the following duties and responsibilities reflect some that are typically performed.

Figure 10-1. Buyers purchasing a collection (Courtesy of AETEC)

Purchasing

The most important task performed by the store buyers is merchandise selection. Such responsibility includes determining which goods are needed, the size of the purchases, from whom goods should be bought, when they must be ordered for prompt delivery, and negotiating the prices and terms of the sale.

Pricing

In order to bring a profit to the store, buyers must determine at what prices the goods should be marked. Several factors are generally considered before pricing decisions are made, such as the degree of competition in the trading area, the cost of protecting the merchandise, how quickly it should turn over, the probable "perishability" of the goods and the buyers' judgment of the value of the individual items.

Assignment of Selling Space

In some retail organizations, the manner in which merchandise is featured on the selling floor and where it is actually placed is left to the buyer's discretion. The actual placement and how it is featured can hinder or improve sales. The buyer's expertise and understanding of visual presentation makes him or her most qualified to decide where something should be featured.

Selecting Merchandise for Promotions

Many retailers have large promotional budgets to make their prospective customers aware of the store's merchandise. The decision on what to feature in a par-

ACI (Advanced Cybernetics, Inc.), a leader in retail computer system innovation, was founded in 1969. By 1974 it was providing the retail industry with sorely needed merchandise processing systems. Until ACI's entry in the field, few companies addressed the needs of merchandisers in their quest for record-keeping systems, and even fewer paid attention to the computer needs of the smaller merchants.

In a partnership with IBM, which supplies the computer hardware (the machinery), ACI offers a wide range of software (computer programs) that address all of the merchandising needs of retailers. Such record keeping as sales, inventory, markdowns, shortages, initial markup, gross margin, additional markup, markup cancellations, and open-to-buy is simple for any size organization. Whether it is a full scale computer installation or a midrange or personal computer, software is readily available. For those with specific needs, custom software applications can be developed.

ACI has developed a software package for major retailer use called Retail Express that focuses upon all of the possible needs of fashion buyers and merchandisers. This program generates reports such as vendor, brand, and style analyses, all of which are vital to careful purchase plans. Among the better-known international retailers that utilize the package are Harrods and Selfridges of Great Britain and Dillard's and Hartmarx Specialty Stores, Inc., in the United States.

Figure 10-2 summarizes all of the aspects of Retail Express and the various information that buyers evaluate to better perform their merchandising duties and responsibilities.

ticular window display, advertisement, or fashion show is the buyer's. While buyers are not necessarily versed in the technical aspects of promotion—these are left to the experts in the advertising, display, and promotion departments—they are the most knowledgeable in assessing what will whet the customer's appetite.

Department Management

Some retailers call upon the buyers to manage the departments for which they purchase merchandise. Although this responsibility has become less and less important to some organizations as the buyers' purchasing responsibilities have increased, some still utilize the buyers as department heads. Not only do they perform the buying function but they arrange employee schedules, handle customer complaints, and sell during peak periods. Those who still involve the buyers in department management are generally small retail operations. In the larger com-

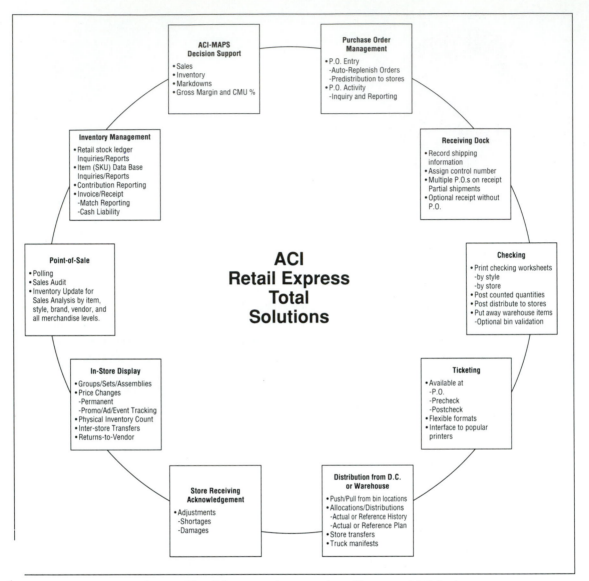

ACI-MAPS Decision Support
- Sales
- Inventory
- Markdowns
- Gross Margin and CMU %

Purchase Order Management
- P.O. Entry
 - Auto-Replenish Orders
 - Predistribution to stores
- P.O. Activity
 - Inquiry and Reporting

Inventory Management
- Retail stock ledger Inquiries/Reports
- Item (SKU) Data Base Inquiries/Reports
- Contribution Reporting
- Invoice/Receipt
 - Match Reporting
 - Cash Liability

Receiving Dock
- Record shipping information
- Assign control number
- Multiple P.O.s on receipt Partial shipments
- Optional receipt without P.O.

ACI Retail Express Total Solutions

Point-of-Sale
- Polling
- Sales Audit
- Inventory Update for Sales Analysis by item, style, brand, vendor, and all merchandise levels.

Checking
- Print checking worksheets
 - by style
 - by store
- Post counted quantities
- Post distribute to stores
- Put away warehouse items
 - Optional bin validation

In-Store Display
- Groups/Sets/Assemblies
- Price Changes
 - Permanent
 - Promo/Ad/Event Tracking
- Physical Inventory Count
- Inter-store Transfers
- Returns-to-Vendor

Ticketing
- Available at
 - P.O.
 - Precheck
 - Postcheck
- Flexible formats
- Interface to popular printers

Store Receiving Acknowledgement
- Adjustments
 - Shortages
 - Damages

Distribution from D.C. or Warehouse
- Push/Pull from bin locations
- Allocations/Distributions
 - Actual or Reference History
 - Actual or Reference Plan
- Store transfers
- Truck manifests

Figure 10-2. The various facets of Retail Express software package (Courtesy of ACI, Inc.)

panies, as noted in chapter 2, "Organizational Structures," the management duties have been assigned to other specialists in the store.

Planning the Store's Purchases

The major fashion chains and department stores generally take a careful approach in assessing their merchandise needs for each season. That is, they use a variety of

sources within their own companies and numerous outside informational sources to direct them to fashion items and resources that will result in profits for their organizations. Internally, they investigate past sales records that are available through computers, use surveys that involve questionnaires and observations, and hold a host of sessions with department managers, sales associates, and fashion directors for their input. Coupled with this internal information gathering, they employ outside companies such as resident buying offices, fashion forecasters, and reporting services and thoroughly study the trade and consumer periodicals that focus attention on their industries to learn about potential trends and consumer preferences. Small, independent fashion retailers generally spend less time planning their purchases. Rather than making a careful analysis of past sales as do their large-store counterparts, the buyers for small stores rely upon their close customer contact for purchasing direction. A blending of informal customer research, information garnered from such trade papers as *Women's Wear Daily*, an unscientific look at the inventory and what went unsold, and intuition perhaps best describes the small store approach.

Many of the smaller fashion retailers are either fearful of computers or believe the costs outweigh the benefits. With very little time and a modest dollar investment the smallest entrepreneurs can take a better approach to fashion buying. By coupling computer-generated reports with their traditional approaches to purchase planning, these fashion buyers will be more likely to provide their customers with a more appropriate assortment and render their companies more profitable.

Figure 10-3. Brand analysis of past sales (Courtesy of ACI, Inc.)

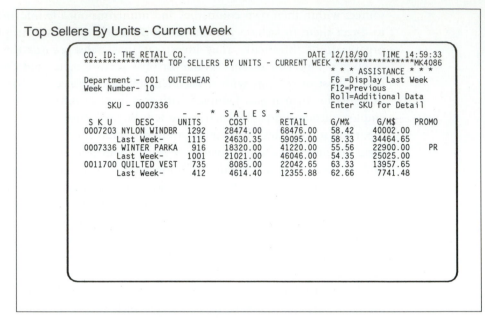

Top Sellers By Units - Current Week

```
CO. ID: THE RETAIL CO.                      DATE 12/18/90  TIME 14:59:33
**************** TOP SELLERS BY UNITS - CURRENT WEEK ****************MK4086
                                            * * * ASSISTANCE * * *
Department - 001  OUTERWEAR                 F6 =Display Last Week
Week Number- 10                             F12=Previous
                                            Roll=Additional Data
     SKU - 0007336                          Enter SKU for Detail
                 - - * S A L E S * - -
  S K U    DESC    UNITS     COST     RETAIL     G/M%      G/M$    PROMO
0007203 NYLON WINDBR 1292  28474.00  68476.00   58.42    40002.00
        Last Week-   1115  24630.35  59095.00   58.33    34464.65
0007336 WINTER PARKA  916  18320.00  41220.00   55.56    22900.00    PR
        Last Week-   1001  21021.00  46046.00   54.35    25025.00
0011700 QUILTED VEST  735   8085.00  22042.65   63.33    13957.65
        Last Week-    412   4614.40  12355.88   62.66     7741.48
```

Figure 10-4. Analysis of top sellers by units (Courtesy of ACI, Inc.)

Internal Preparation

By investigating past sales records, the buyer is able to analyze the success or failure of each vendor, style, color, price point, size allocation, and so forth. Past sales are recorded either manually, as in the case of many small fashion retailers, or automatically with the use of the computer. The major retailers have long utilized the computer for such record keeping and have regularly upgraded their systems to incorporate the latest data processing systems for inventory analysis. Whether it is the old-fashioned hand-recorded system or the computerized systems, the records kept are similar.

After the merchandise reaches the store, it is unpacked, sorted, tagged, and entered into the system. Every time an item is sold, such factors as style number, color, vendor name, size, and price are recorded. Any time the buyer wishes to obtain information to decide upon reorders or to formulate buying plans for a new season, the sales records are reviewed. In this way a determination can be made to assess such factors as a particular brand, top sellers, and customer color preferences. If the system employed requires hand-generated reports, the task might require considerable time. In the case of computerized reporting, the needed information is made available in a matter of minutes.

The information from past sales can be used on a weekly basis to adjust inventories or can go back several years to determine possible trends in customer merchandise preferences.

Some fashion retailers subscribe to various survey methods to assist in the development of purchase plans. By determining customer fashion preferences through observations such as fashion counts or direct questioning via the personal interview or questionnaire technique, the buyer is able to incorporate customer needs and wants into the buying plans. A complete discussion of such methodology was explored in chapter 4, "Problem Solving: The Role of Retailing Research."

Employee input is still another internal source that seasoned buyers employ in the decision-making process. Many staff members can provide valuable information because of their close involvement with the customers or by virtue of the specialized fashion roles they play in the store. What better person is there than the sales associate to discuss customer likes and dislikes? While computers and other records signal what has been purchased, they fall short in terms of reporting customer requests that could not be satisfied. Perhaps it is a particular designer label that is being sought or a price point that does not fall within present merchandise availability. By involving the salesperson, the buyer is gaining information that has come directly from the shopper. Department managers are also excellent sources of information. Many routinely meet with their staffs to elicit ideas about how to improve sales and satisfy customer needs. Such information may then be turned over to the buyer for possible use in purchase preparation for the new season. Most major retailers employ fashion directors or coordinators who perform a host of tasks for the merchandising division. They regularly prescout the market prior to the buyer's visits to learn about trends in terms of

Color/Size Matrix

```
CO. ID: THE RETAIL CO.                          DATE 12/18/90  TIME  8:36:27
**********************      SKU ENTRY COLOR/SIZE  **********************  MK2070
                                                    * * * Assistance * * *
Class/SKU- 00002 0007302     Attributes -           Enter Y/N Display
Style    - FL SW SUIT        Manufact ID- ABC MFG CO   ?=Window
Color    - RED   Size- XS    Compare At -      42.99 F4 =Accept Entry
Ticket Cd- A  Description- FLEECE SWEAT SUIT          F12=Previous
                                                     F20=Scroll Right

COST  Unit- EA  Case Pack-      Cost -      12.00   Markup%- 74.99
RETAIL Unit- EA  Min Sell -      Retail-    39.99   Edit for Lng SKU- Y (Y/N)
SIZE                       COLOR   CODES                 Window 1 of 3
CODES     GREN     WHIT    BLCK     BLUE    YELW
XS        Y        Y       Y        Y       Y
 S        Y        Y       Y        Y       Y
 M        Y        Y       Y        Y       Y
 L        Y        Y       Y        Y       Y
XL        Y        Y       Y        Y       Y
```

Figure 10-5. Analysis of colors and sizes (Courtesy of ACI, Inc.)

color, fabrication, and style and to locate and evaluate new merchandise resources. While these individuals are not the decision makers in terms of actual purchasing, they provide a great deal of insight that the buyers can incorporate into their fashion purchase plans.

External Assistance

Once the buyer has carefully studied the store's internal sources of information, the next step is to make use of the many available external sources. Those that fashion buyers make considerable use of are resident buying offices, fashion forecasting and reporting services, trade publications, and consumer periodicals. All of these give insights into what is happening in the marketplace and what potential trends the buyer should consider in the purchase plans.

FASHION WATCH IS A 3-PART SERVICE CONSISTING OF:

THE FASHION WATCH
Weekly Newsletter

This 16 page weekly report keeps you up-to-date with the best sellers and reorders, the hot items and the best buys, the new resources and the best lines.

Our staff of fashion authorities shop the market every week, selecting and recommending resources and items that you should keep an eye on.

Invaluable information for buyers who shop the market throughout the year, and especially for those who shop close to the season.

THE FASHION WATCH
Market Preview Report

Published five times a year just before each market opening, this 72 page bound report takes you into the manufacturer's showrooms so you can **pre-shop** the market.

This unique report provides an in-depth analysis of the fashion trends...colors, fabrics, patterns, silhouettes and items that are important for the coming season. In addition, for each merchandise classification, our fashion experts highlight the noteworthy looks and provide sketches of actual merchandise. Each sketch is accompanied by complete specifications; fabrics, colors, price points, style no., delivery dates and reps in regional markets.

Timely advance market information to help you make better buying decisions.

THE FASHION WATCH
Toll-Free Market Hotline

A quick easy way to get answers to any of your retail related market questions. Call us to track down an address, find a resource you can't locate, recommend a resource for a specific item, check out a line, give an opinion...

Whatever your needs, our staff of seasoned fashion specialists are at your disposal. We're here to help with personal, professional attention.

Figure 10-6. *Fashion Watch* is published weekly to provide buyers with information for future purchases. (Courtesy of Retail News Bureau, Division of Retail Reporting Corp.)

A large number of fashion retailers employ the services of a **resident buying office**. These companies play a major role in assisting the stores with their fashion purchases. A separate section, later in the chapter, will be devoted to the different classifications of these offices and how they serve the retailer's needs.

Fashion forecasters are companies that scout markets all over the world prior to the time the buyer is ready to begin the purchasing process. They visit textile mills, trimmings manufacturers, design studios, and trade associations so that they can determine what fashion trends in terms of fabrication, color, and style will probably reach the marketplace. Some of these internationally based forecasting firms such as Promostyl and Nigel French, through intensive market investigation, are able to supply their clients with information pertinent to buying plans about one year in advance of the season. Promostyl offers "trend books" for textiles, women's wear, accessories, men's clothing, and children's fashions. Complete with a host of photographs and forecasting predictions, the buyers find these publications valuable sources of merchandise information.

Most major retailers subscribe to **reporting services** that provide them with up-to-the-minute information on a weekly basis. Through the distribution of brochures and pamphlets that feature which items are the hot sellers, which stores are successfully selling particular fashions, the names of the resources where the "headliners" in the fashion industry are available, what is being reordered and suggestions for inventory replenishment, fashion retailers are able to quickly adjust their inventories to reflect what is making news in fashion. One of the major reporting services that covers the fashion industry is the Retail Reporting Bureau based in New York City. One of its most important informational reports, *Fashion Watch*, is published weekly with major supplements published at the beginning of each fashion season. The weekly publications feature that period's best sellers, reorders, reprints of advertisements that feature the market's hottest items, and an editorial overview of the week. The seasonal supplements explore merchandising themes for the upcoming seasons complete with style, fabric, and color stories and the names of the resources where the latest designs can be ordered. During slow selling periods, buyers are constantly searching the market for fashions that might become winners and turn a quiet time into one that is more profitable. With the addition of just a few new fast-selling numbers, a lackluster season may be turned around. The information brochures offered by the reporting services are excellent tools to quickly address merchandise needs at any time.

Each segment of the fashion industry has at least one **trade publication** that explores a particular fashion merchandise classification. The leading publisher for the industry is Fairchild Publications, which produces such internationally acclaimed papers as *WWD* (*Women's Wear Daily*), which researches everything pertaining to women's fashion on a daily basis, and *DNR* (*Daily News Record*), the most important of the men's wear trade papers. Fashion merchants of every size and merchandise philosophy subscribe to these periodicals to learn more about

trends, price changes, color forecasts, new designers, recommended styles, fabric innovation, and anything else that is newsworthy in the world of fashion. By reading these and other trade publications religiously, the fashion buyers, for a very small investment, can feel the pulse of their markets without leaving their stores.

There are numerous consumer periodicals that provide insights into the world of fashion for buyers. Daily newspapers such as *The New York Times*, and magazines such as *Harper's Bazaar*, *Vogue*, and *Esquire* make buyers aware of what kinds of fashion information their potential customers are being fed. Since many consumers are motivated to buy what their favorite newspaper and magazine fashion editorial staffs are touting, it is important for this information to be in the minds of the professional buyers when they are preparing for new merchandise purchases.

In addition to these sources, buyers might familiarize themselves with fashions to which their potential customers are being exposed. MTV, for example, features performing artists in costumes that are often headed for mass design. Since the audience is so large and often influenced by what is worn, the buyer can easily learn something about the latest in fashion. By viewing street fashion, too, a great deal of pertinent information can be incorporated into the buying plan.

Model Stock Development

A **model stock** is an inventory that includes an appropriate assortment of merchandise in terms of price points, styles, size ranges, colors, and fabrics. The fashion buyer has a much more complicated task in the development of a model stock than his buying counterparts who purchase hard goods and staple items. Since fashion items are almost always seasonal in nature, the model stock is constantly changing. The merchandising of nonseasonal or nonfashion goods does not require continuous change since their salability lasts for extended periods of time.

The scope of the model stock is determined by those who decide which merchandise classifications should be considered for inclusion and the amount of money that will be expended. In small fashion operations, this decision is made by the company owner with, perhaps, consultation with a manager. In larger organizations where formal organizational models are in place, such as those discussed in chapter 2, "Organizational Structures," the dollar merchandise allocation is determined by the merchandising division. The general merchandise manager apportions the budget among the various divisions. Each division's manager then determines how much each buyer, for whom he or she is responsible, is to receive for purchases. Each buyer then sets out to develop a model stock that must stay within the budgetary limitations.

The model stock of a designer sportswear department, for example, must reflect needs such as which designers will be featured, the depth and breadth of

each merchandise category, the number of tops needed for the number of bottoms to be carried, the concentration on particular sizes, the price points that must be emphasized, etc. With the information gathered from such internal sources as past sales and external sources as resident buying offices and fashion forecasters, the buyer develops the model stock. The initial plan is generally a preliminary program that could easily change once the buyer visits the marketplace and examines the offerings of the vendors.

Elements of Fashion Buying

In order to construct a realistic model stock, the buyer must address four specific areas that are known as the **elements of buying**. They are the qualitative and quantitative considerations, the fashion merchandise resources, and the timing of the purchase.

Qualitative Considerations

Internal and external sources give the buyer an indication of the nature of the goods necessary to satisfy the customer's needs. The scope of fashion merchandise is so broad that it is available at every price level and quality in styles that range from conservative to extremely fashion forward.

Each store has developed a character and image that must be considered before even the simplest task for the buyer may be performed since there is less risk involved with conservative merchandise than the inventory wanted by the upscale, fashion-forward enthusiast. Buyers charged with the responsibility of merchandising a conservative collection will immediately know the types of styles preferred by the customers, whether man-made or natural fibers are desired, the length of the skirt that most would wear, the preference of basic colors to those that are new, and the ratio in which the bottoms should be divided between pants and skirts. Qualitative considerations such as these for the more conservative shopper are generally predictable and are usually an extension of what has happened in the past.

While size allocations and price points are generally simple to ascertain for the fashion extreme audience, style and color considerations are more difficult to determine. If the fashion editors of *WWD* are championing the micro-miniskirts, is it a safe bet to invest large sums in inventory if last season's styles centered around the midi look? If wide, billowy pants are being heralded as the potential winners of the next season, should the buyer cram the inventory with such designs or should fashion safety be considered? Should an investment be made in an upcoming designer's collection in favor of those that have been steady winners in the past? These decisions are but a few of those that must be considered before any orders are placed.

Quantitative Considerations

One of the most important planning aspects is how much money is available at any given time for new merchandise. By knowing this figure, the buyer will not exceed the dollars allocated for his or her department. The established limits are based upon sales forecasts for each department. The forecasts take into account past sales, economic conditions, and the store's assessment of each department's relative worth to the entire organization.

When a department is given a dollar amount for merchandise, it is understood that this is not solely for new purchases for the coming season, but must include the size of the present inventory. Since sales are constantly being made in the department, new merchandise is arriving, and customer returns are adding to the inventory, the budget ceiling must be constantly examined to make certain that it has not exceeded its limits. If a buyer was able to clear out every piece of merchandise from the previous season and start fresh for the next, the job would be much easier. Since this is impossible for the vast majority of fashion retailers, it is necessary to determine the total worth of the inventory at any given time. It is standard practice for buyers to use a formula called **open-to-buy** to determine how much they have available for new merchandise. The following example depicts the numerous figures considered in the open-to-buy calculation.

Problem. On June 1 the handbag buyer wanted to know how much she still had in her present budget to purchase additional merchandise for the period ending June 30. On this day, the following figures reflected her department's situation: merchandise on hand, $72,000; merchandise on order, $18,000; inventory planned for the end of the month, $90,000; planned sales, $36,000; and planned markdowns, $3,000.

What was the handbag buyer's open-to-buy on June 1?

The formula for open-to-buy is:

$$\text{Merchandise needed} - \text{Merchandise available} = \text{Open-to-buy}$$

Solution to the Problem

Merchandise needed for June		
planned end-of-month inventory	$ 90,000	
planned sales	36,000	
planned markdowns	3,000	
Merchandise needed		$129,000
Merchandise available, June 1		
merchandise on hand	$ 72,000	
merchandise on order	18,000	
Merchandise available		$ 90,000
Open-to-buy ($129,000–90,000)		$ 39,000

With the use of a few additional figures such as actual sales and actual mark-downs, the buyer can determine open-to-buy at any time.

Today, there are many computer programs that automatically figure the buyer's open-to-buy. Whether the store is a major retail operation using a sophisticated computer installation or a small independent company, a variety of software are available to satisfy everyone's needs.

Resource Selection

Buyers of fashion merchandise have a host of domestic and foreign **resources** from which to purchase. The vast majority of these resources are manufacturers who produce and distribute their own collections. Unlike other merchants who buy from wholesalers as well as manufacturers, those involved in the area of fashion generally restrict their purchasing to manufacturers. The principal reason for this approach is that fashion items have short lives and must reach the retailers as quickly as possible. The nature of wholesaling, on the other hand, is to have the goods warehoused until they are needed by the retail market. Products such as appliances are purchased from wholesalers who store them until they are needed. Since such goods have long lives, there is little chance for them to become obsolete before they are sold.

Although the rule is to buy from manufacturers, a small number of wholesalers of fashion merchandise are in existence. They serve the needs of some very small merchants who are unable to buy directly from the manufacturer because of certain imposed restrictions. For example, many producers have minimum order requirements and stringent credit policies that might make some retailers ineligible for purchasing from the manufacturers. Another situation is the acquisition of imports. Foreign purchases often require large commitments, visits to offshore districts, commitment to purchases many months before the typical buying period, or reliance on commissionaires who are foreign resident buyers who act in behalf of American buyers. These and other factors might be too restrictive for those with limited financial ability or whose merchandise needs do not warrant the risks involved.

With the seemingly limitless number of available resources for every classification of fashion merchandise, the buyer must evaluate those companies from whom purchases were made in the past and investigate the possibility of adding other vendors to the store's roster of suppliers.

Evaluation of currently used resources requires careful inspection of the store's past sales records. Computer-generated reports such as the brand analysis detail illustrated earlier in the chapter in the internal preparation section give the buyer an idea of how successful the store was with each supplier. For smaller stores that rely upon hand-recorded inventory and sales records, similar statistical analyses can be developed. Whichever format is used, it is imperative to examine each vendor in terms of maintained markup (how much the store was able to achieve over

the cost of the merchandise), the number of customer returns, the average time it took to sell the items, reliability of shipments (whether the orders were received on time and in the same quality as the samples), fit, and anything else that might make the resource a valuable one or a poor risk for another season.

Attention should always be paid to the external sources where new resources might be discovered. Often a new designer is on the horizon or a new line might become hot in the industry and evaluation of their offerings could result in new, exciting merchandise. The trade papers, resident buying offices, fashion forecasters, and reporting services are in business to discover and recommend the industry's latest winners and their choices should be considered.

One area that needs careful attention in resource selection is the geographic location of the companies. Today, more and more fashion merchandise is being produced out of the country. Better quality merchandise is often available from foreign producers at lower prices and the use of the word imported conjures up a sense of more exciting design, but purchases from abroad may bring unfavorable results. For example, deliveries are often less reliable, fit might not be perfect for the American figure, delivered merchandise might not be identical to the samples from which orders were placed, and the landed cost (the actual cost of the goods after many additional charges were added to the original prices) might render the merchandise too costly for the store's consumption.

The landed cost must be determined to evaluate what the product will actually cost the store after such additional expenses as duty (an amount that runs as high as 100 percent of the cost of the item); commission charges paid to an intermediary or commissionaire who seeks out merchandise for the customer; shipping costs, which can be very high especially if time is of the essence to receive the goods and air freight is used; and packing and storage charges. In addition to these costs, the value of the dollar must be considered whenever purchases from abroad are made. The dollar continuously fluctuates and can cause merchandise to cost more than anticipated. In 1985, for example, the British pound sterling was worth approximately $1.08, compared to the pound at today's writing, which is around $2.00. In times of a very weak dollar, the cost of foreign merchandise might prohibit such offshore purchases.

With a great deal of sentiment "for made in the USA," more and more stores are finding customer resistance to imports. That is not to say that every bit of fashion merchandise from overseas should be bypassed in favor of American made. It is practical for a buyer to know his or her customers' preference in terms of imported merchandise before starting out on a buying venture. Such information can be attained through the use of a formal survey, discussions with sales associates to discover if preferences exist, and examination of sales of imported goods to determine how well they sell in comparison to domestically produced fashions.

After all of these considerations have been examined, the buyer should develop a list of merchandise resources that should be reviewed when purchasing is to begin.

Timing the Purchase

There are traditional purchase periods in the fashion market when buyers begin to make selections for the next season. The time when the major stores send their buyers to the fashion industry to visit the resources is called **market week**. The number of such market weeks varies in the fashion industry according to the merchandise classifications. The apparel and sportswear industry has four market weeks while the children's industry has only two. During this time, the buyers face a whirlwind challenge that requires the attendance at a host of collection openings. Those retailers that purchase during market weeks do so to be guaranteed of the fastest possible delivery for the next season. If the store is one that has the image of being "fashion first," early ordering is essential. Some fashion-oriented stores choose to avoid the opening of the new lines in favor of waiting for the collections to be streamlined before they commit to ordering. Since most lines are reduced to those items that merit the greatest attention during market week, those who wait might find it easier to pick the winners. Many small retailers opt for this later viewing and are satisfied with slightly later delivery dates.

Merchandise that is made in the United States often requires as much as six months before delivery can be expected. Goods produced offshore need even earlier commitment to make certain orders will be received on time. The seasoned buyer is fully aware of the problems associated with the timely receiving of merchandise and must make certain that orders are placed sufficiently early for their needs. Considerations such as catalog preparation and advertising and promo-

Figure 10-7. Buyers shop the lines at a trade show during Market Week. (Courtesy of AETEC)

Figure 10-8. Buyer purchasing line in New York City showroom. (Courtesy of AETEC)

tional plans must be examined to make certain that the inventory will have the merchandise being promoted.

Sometimes buyers purchase far in advance of a season and are often rewarded with seasonal discounts from the vendors. Not only does this approach give them a head start on competition, but it enables them to test the items with smaller quantities before the major selling period arrives. In this way, they can eliminate the slower sellers and invest heavily in the better styles.

Figure 10-9. Buyers registering for New York Prêt, a women's apparel, sportswear, and accessories trade show. (Courtesy of AETEC)

Purchasing in the Marketplace

Fashion buyers have many options available to them in terms of where to make their purchases. Some smaller stores that are far away from their markets and have restrictive travel budgets rarely get to the fashion centers to place their orders. They might make the trip once or twice a year for major purchases, but rely upon sales representatives to visit them with the company's lines for the remainder of their purchasing needs. This arrangement severely restricts the buyer who must rely upon those vendors with traveling sales personnel for their merchandise. It should be understood that many smaller manufacturers with extremely desirable lines do not have "road" staffs to visit the stores.

For those who do have the opportunity to go to the marketplace, they might visit individual showrooms or trade shows to see the collections.

The major designers and manufacturers generally operate permanent showrooms in centralized fashion districts. New York City's Seventh Avenue garment center is the nation's largest, with other smaller regional districts found in such cities as Los Angeles, San Francisco, Dallas, and Chicago. Store buyers and resident buyers regularly visit these sales facilities to attend collection openings, see fashion show presentations, write orders, and check upon the status of their current orders. The showrooms are clustered within a radius of several blocks or within a major structure such as the Chicago Apparel Center.

In addition to these permanent facilities, there is an abundance of **trade shows** throughout the world that feature the offerings of fashion producers for short periods of time. These shows specialize in a particular fashion segment. Some of the better-attended exhibitions are the New York Prêt, which is held semi-annually in New York City and features internationally designed collections of upscale women's wear, accessories, shoes, and leather goods; NAMSB, the major men's wear entry; MAGIC, for men's sportswear in California; and the International Kids' Show that features children's fashions from around the world.

Whatever approach buyers take to examine the market's offerings, it must be done on a regular basis to make certain that they are always aware of what is current in fashion merchandising.

Writing the Order

Seasoned buyers rarely ever commit themselves to specific merchandise the first time they see the lines. They merely take notes on what they have seen at each showing so that they can evaluate each item in terms of what they have seen at all of their resources. Once they have examined everything that is available for that time period, they are able to choose those fashions that are best suited for their stores.

Figure 10-10. Materials furnished to buyers (Courtesy of Chicago Apparel Mart)

At this point they are ready to write the orders. Purchase orders are contracts between the buyer and the seller and must be carefully executed to prevent any misunderstandings.

The major fashion retailers have their own company order forms that are tailored to their specific needs. Smaller retailers utilize order forms supplied by the manufacturers. Manufacturers with extensive collections often produce seasonal order forms that list every item in the line and require only that the buyers fill in the desired amounts for each.

Whether the purchase order is company generated or one that is supplied by the vendor, there are various elements that must be completed by the buyer. Some of these matters are standard, such as the trade discount offered in the industry. In the apparel market, for example, there is a standard 8 percent discount that all stores receive. Other details leave some room for negotiation. The buyer's expertise as a negotiator is important and may result in the store's achieving an advantage. Among the various areas that require negotiation other than price—which is often standard under the terms of the Robinson Patman Act, enacted to limit price discrimination—are shipping costs and who will pay them, delivery dates, extra discounts for early acceptance of merchandise before the peak selling period, advertising and promotional allowances, cash discounts, and "anticipation," which is an extra discount if the invoice is paid prior to the time it is due for payment.

A good buyer must be a good negotiator. He or she must understand that there is a certain amount of give and take during the process, and must be willing to forego certain demands in return for others that are more favorable.

Resident Buying Offices

Many fashion retailers consider resident buying offices their most important means of feeling the pulse of the market without having to leave their own stores. Located within the wholesale markets in the major fashion centers in the United States and abroad, these organizations provide a variety of assistance to store buyers. It should be understood that unless a store directs a resident buying office to make specific purchases, they do not do so. The nature of the job is primarily advisory and service oriented, although there is some movement for these companies to buy certain types of goods for the stores they represent.

Buyer Duties and Responsibilities

As in the case of retailing, different companies have different tasks for their buyers to perform. Some of the more typical duties and responsibilities include locating new resources, previewing collections, following up open orders, communicating

Tickle Me!
29-10 THOMSON AVENUE
LONG ISLAND CITY, N.Y. 11101

CRUISE/EARLY SPRING 1990

*** FOR COMPUTER DEPT. ONLY ***

Acct. No. _____
STORE _____
BATES _____

Date _____

SOLD TO: _____ SHIP TO: _____

_____ Zip Code _____

Telephone No. _____

Cust. Order No. _____
Dept. No. _____
Start Date _____
Comp. Date _____
Priority _____
Salesman _____

DEL. TO START **AS READY**	COMPLETION DATE **JAN. 15**	TERMS NET 30	SALESMAN	COMPANY POLICY: ALL FIRST ORDERS **C.O.D.**
PLACE ADDRESS LABEL HERE		F.O.B. Long Island City, N.Y.		Customer Approved

TICKLE ME!

Style	Description	Color	Size	Qty.	Price	Ext.
CAPRI SET						
1110C01	Yellow Daisy	Yel/Wht Check	12-24		23.50	
2110C01	Yellow Daisy	Yel/Wht Check	2-4		24.50	
1110C02	Pink Lace	Pk w/lace legging	12-24		24.00	
2110C02	Pink Lace	Pk w/lace legging	2-4		25.00	
1110C04	Boat w/ruffle	Brights	12-24		25.50	
2110C04	Boat w/ruffle	Brights	2-4		26.50	
2110C08	Dancing Flowers	Brights	2-4		28.50	
4110C08	Dancing Flowers	Brights	4-6X		30.50	
2110C09	By the Sea	Nautical R,W,B	2-4		25.50	
4110C09	By the Sea	Nautical R,W,B	4-6X		27.50	
2110C12	Little Painters	Paint Splash	2-4		24.50	
4110C12	Little Painters	Paint Splash	4-6X		26.50	
2110C13	Fruit Chicks	Brights	2-4		26.50	
4110C13	Fruit Chicks	Brights	4-6X		28.50	
4110C16	Floral	Pastel Blue	4-6X		21.00	
7110C16	Floral	Pastel Blue	7-14		23.00	
4110C19	Katie	Blue/Brights	4-6X		26.00	
7110C19	Katie	Blue/Brights	7-14		28.00	
4110C20	Sailor Girls	Pastels	4-6X		26.00	
7110C20	Sailor Girls	Pastels	7-14		28.00	
4110C21	Rockin & Jamin	Blk/Wht	4-6X		22.50	
7110C21	Rockin & Jamin	Blk/Wht	7-14		24.50	
BIKE PANTS						
2120C25	Arf!	Blk/Wht	2-4		20.00	
4120C25	Arf!	Blk/Wht	4-6X		22.00	
2120C26	Ice Cream Cones	Bright/Pink	2-4		20.50	
4120C26	Ice Cream Cones	Bright/Pink	4-6X		22.50	
1120C27	Le Moo!!	B/W Polka Dot	Inf.		20.50	
2120C27	Le Moo!!	B/W Polka Dot	2-4		21.50	
4120C27	LeMoo!!	B/W Polka Dot	4-6X		26.50	
2120C28	Mermaids	Wht/Turq	2-4		24.50	
4120C28	Mermaids	Wht/Turq	4-6X		26.50	
4120C29	Fruit Frosty	Multi Brights	4-6X		27.00	
7120C29	Fruit Frosty	Multi Brights	7-14		29.00	
4120C31	Reggae Band	Blk/Org & Grn	4-6X		22.00	
7120C31	Reggae Band	Blk/Org & Grn	7-14		24.50	
4120C32	Bandana Girl	Blk/Wht	4-6X		28.50	
7120C32	Bandana Girl	Blk/Wht	7-14		30.50	
1120C33	Beach Pail	Multi Brights	12-24		20.50	
2120C33	Beach Pail	Multi Brights	2-4		22.50	
4120C34	Geometrics	Multi Brights	4-6X		25.00	
7120C34	Geometrics	Multi Brights	7-14		27.00	
BUBBLE SHORT SET						
1140C44	Cherries Jubilee	Blk/Wht	12-24		21.00	
2140C44	Cherries Jubilee	Blk/Wht	2-4		22.00	
1140C45	Balloons	Red/Wht/Blue	12-24		20.00	
2140C45	Balloons	Red/Wht/Blue	2-4		21.00	
TRI COLOR PANT SET*						
1200C46	Caterpillar	Pastels	12-24		20.00	
2200C46	Caterpillar	Pastels	2-4		21.00	
1200C47	Tri-Hearts	Brights	12-24		20.00	
2200C47	Tri-Hearts	Brights	2-4		21.00	
1200C48	Whale	Red/White/Blue	12-24		20.00	
2200C48	Whale	Red/White/Blue	2-4		21.00	
SUPLEX JACKET PANT SET						
2221C49	Time To Ride	Pastels	2-4		31.00	
4221C49	Time To Ride	Pastels	4-6X		33.00	
7221C49	Time To Ride	Pastels	7-14		35.00	
2221C50	Stainglass	Brights/Blk	2-4		31.00	
4221C50	Stainglass	Brights/Blk	4-6X		33.00	
7221C50	Stainglass	Brights/Blk	7-14		35.00	
TRIPLE RUFFLE DRESS W/KNEE BIKE PANT						
2150C51	Stars	Blk/Wht	2-4		26.00	
4150C51	Stars	Blk/Wht	4-6X		28.00	
2150C52	Sailboat	Red/Wht/Blue	2-4		26.00	
4150C52	Sailboat	Red/Wht/Blue	4-6X		28.00	
TANK DRESS W/BIKE PANT						
4170C58	Color Block Fish	Blk/Brights	4-6X		24.00	
7170C58	Color Block Fish	Blk/Brights	7-14		26.00	
2170C59	Flashy Fish	Red/Wht/Blue	2-4		23.50	
4170C59	Flashy Fish	Red/Wht/Blue	4-6X		25.50	
2170C60	Oops Again	Wht/Pastels	2-4		22.00	
4170C60	Oops Again	Wht/Pastels	4-6X		24.00	
2170C61	Confetti	Pink Multi	2-4		26.50	
4170C61	Confetti	Pink Multi	4-6X		28.50	
7170C61	Confetti	Pink Multi	7-14		30.50	
4170C62	Butterflies	Purple/Grn/Blue	4-6X		23.50	
7170C62	Butterflies	Purple/Grn/Blue	7-14		25.50	
4170C63	Flowers	Blk w/Multi Brts	4-6X		25.00	
7170C63	Flowers	Blk w/Multi Brts	7-14		27.00	

TACKLE ME!

Style	Description	Color	Size	Qty.	Price	Ext.
3 PANEL PANT SET						
1220CA1	Ship Ahoy	Red, Wht, Blue	12-24		21.00	
3220CA1	Ship Ahoy	Red, Wht, Blue	2-4		22.00	
1220CA2	Pro Diver	Turq, Black	12-24		22.50	
3220CA2	Pro Diver	Turq, Black	2-4		23.50	
1220CA3	Trucks	Blk, Turq, Org	12-24		20.00	
3220CA3	Trucks	Blk, Turq, Org	2-4		21.00	
SHORT SET						
1260CB1	S.O.S.	Red, Wht, Blue	12-24		16.00	
3260CB1	S.O.S.	Red, Wht, Blue	2-4		17.00	
1240CB2	Sea Friends	Blk, White	12-24		15.00	
3240CB2	Sea Friends	Blk, White	2-4		16.00	
1240CB3	Keep on Trucking	Blk, Turq, Org	12-24		13.00	
3240CB3	Keep on Trucking	Blk, Turq, Org	2-4		14.00	
3PC JACKET SET						
1500CD1	Sailboat	Red, Wht, Blue	12-24		32.00	
3500CD1	Sailboat	Red, Wht, Blue	2-4		33.00	
1500CD2	Diving Buddies	Black, White	12-24		28.00	
3500CD2	Diving Buddies	Black, White	2-4		31.00	
1500CD3	Convoy	Org, Blue, Blk	12-24		28.00	
3500CD3	Convoy	Org, Blue, Blk	2-4		31.00	
SKID SET						
3250CC1	Surf Saurus	Blk, Wht, Multi	2-4		18.00	
5250CC1	Surf Saurus	Blk, Wht, Multi	4-7		20.00	
3250CC2	Volleyball Beach	Blk/Brights	2-4		18.00	
5250CC2	Volleyball Beach	Blk/Brights	4-7		19.00	
3290CC3	Funny Surfers	Gray/Orange	2-4		18.00	
5290CC3	Funny Surfers	Gray/Orange	4-7		20.00	
BEACH PANT (VELCRO) SET						
5310CF1	Spike!	Blk/Gry/Neon Red	4-7		18.00	
8310CF1	Spike!	Blk/Gry/Neon Red	8-12		20.00	
5310CF2	Roller Blade	Royal/Lime	4-7		18.00	
8310CF2	Roller Blade	Royal/Lime	8-12		20.00	
5310CF3	Batik Wave	Blue Batik	4-7		21.00	
8310CF3	Batik Wave	Blue Batik	8-12		23.00	
KNEE BUSTERS						
5390CH1	Leaping Lizards	Blk/Green	4-7		20.00	
8390CH1	Leaping Lizards	Blk/Green	8-12		22.00	
5390CH2	Pirannas	Blk/Neons	4-7		18.00	
8390CH2	Pirannas	Blk/Neons	8-12		20.00	
5390CH3	Coast to Coast	Blk/Multi	4-7		20.00	
8390CH3	Coast to Coast	Blk/Multi	8-12		22.00	
5390CH4	Surf Boys	Org/Navy	4-7		20.00	
8390CH4	Surf Boys	Org/Navy	8-12		22.00	
5390CH5	Silly Surfer	Gray/Org	4-7		15.00	
8390CH5	Silly Surfer	Gray/Org	8-12		17.00	
SHORT SET W/BIKE PANT						
3300CE1	Skate	Gray/Blk/Org	2-4		18.50	
5300CE1	Skate	Gray/Blk/Org	4-7		20.50	
3300CE2	Surf Beach	Neons	2-4		19.00	
5300CE2	Surf Beach	Neons	4-7		21.00	
SUPLEX JACKET SETS						
3360CG1	Cycling	Grn, Purple, Blk	2-4		29.00	
5360CG1	Cycling	Grn, Purple, Blk	4-7		31.00	
8360CG1	Cycling	Grn, Purple, Blk	8-12		33.00	
3360CG2	Kahuna	Org, Blue, Turq	2-4		29.00	
5360CG2	Kahuna	Org, Blue, Turq	4-7		31.00	
8360CG2	Kahuna	Org, Blue, Turq	8-12		33.00	
SHORT/BATHING SETS						
3370CJ1	Race Team	Grn, Purple, Blk	2-4		19.50	
5370CJ1	Race Team	Grn, Purple, Blk	4-7		21.50	
8370CJ1	Race Team	Grn, Purple, Blk	8-12		23.50	
3370CJ2	Pro Surfer	Org, Blue, Turq	2-4		19.50	
5370CJ2	Pro Surfer	Org, Blue, Turq	4-7		21.50	
8370CJ2	Pro Surfer	Org, Blue, Turq	8-12		23.50	

TICKLE ME!
SWIMWEAR

Style	Description	Color	Size	Qty.	Price	Ext.
TANK BATHING SUITS						
1850C85	Watermelon	White, Raspberry	12-24		14.00	
2850C85	Watermelon	White, Raspberry	2-4		15.00	
4850C85	Watermelon	White, Raspberry	4-6X		16.00	
1850C86	Cats	Multi Brights	12-24		14.50	
2850C86	Cats	Multi Brights	2-4		15.50	
4850C86	Cats	Multi Brights	4-6X		16.50	
1850C87	Arf!!	Black, Wht	12-24		15.50	
2850C87	Arf!!	Black, Wht	2-4		15.50	
4850C87	Arf!!	Black, Wht	4-6X		16.50	
1950C88	Ballerinas	White/Pastels	12-24		13.50	
2950C88	Ballerinas	White/Pastels	2-4		14.50	
4950C88	Ballerinas	White/Pastels	4-6X		15.50	
2850C69	Whale	Red/Blk/Wht	2-4		14.50	
4850C69	Whale	Red/Blk/Wht	4-6X		15.50	
2850C70	Ric Rac Flower	Tangerine/Aqua	2-4		14.50	
4850C70	Ric Rac Flower	Tangerine/Aqua	4-6X		15.50	
1860C71	Hearts	Pastels	12-24		15.00	
2860C71	Hearts	Pastels	2-4		16.00	
4860C71	Hearts	Pastels	4-6X		17.00	
2850C72	Sequin Rosebud	Pastels	2-4		22.50	
4850C72	Sequin Rosebud	White	4-6X		23.50	
2850C73	Sequin Bows	Hot Pink	2-4		20.50	
4850C73	Sequin Bows	Hot Pink	4-6X		21.50	
2950C74	Bandana Girl	White	2-4		16.50	
7950C74	Bandana Girl	White	7-14		17.50	
4950C75	Op Art Girl	Multi	4-6X		14.00	
7950C75	Op Art Girl	Multi	7-14		15.00	
4950C76	Hawaiian Flowers	Tie Dye	4-6X		17.50	
7950C76	Hawaiian Flowers	Tie Dye	7-14		18.50	
COLOR BLOCK TANK BATHING SUITS						
4850C77	Stars	Black/White	4-6X		16.00	
7850C77	Stars	Black/White	7-14		17.00	
4850C78	Multi	Multi Brights	4-6X		13.00	
7850C78	Multi	Multi Brights	7-14		14.00	
4850C79	Ruffles	Green/Black	4-6X		16.00	
7850C79	Ruffles	Green/Black	7-14		17.00	
ONE SHOULDER BATHING SUITS						
4950C80	Geometric Fish	Black/Brts	4-6X		19.50	
7950C80	Geometric Fish	Black/Brts	7-14		20.50	
2950C81	Rainbow Spray	Black Tie Dye	2-4		18.00	
4950C81	Rainbow Spray	Black Tie Dye	4-6X		19.00	
7950C81	Rainbow Spray	Black Tie Dye	7-14		20.00	
2950C82	Bows	Pink Tie Dye	2-4		19.00	
4950C82	Bows	Pink Tie Dye	4-6X		20.00	
2950C83	Flower Bloom	Hot Pink	2-4		18.00	
4950C83	Flower Bloom	Hot Pink	4-6X		19.00	
7950C83	Flower Bloom	Hot Pink	7-14		20.00	
4950C84	Op Art	Black/White	4-6X		15.00	
7950C84	Op Art	Black/White	7-14		16.00	
4950C85	Multi Wave	Multi Stripe	4-6X		13.00	
7950C85	Multi Wave	Multi Stripe	7-14		14.00	
2 PIECE WITH SKIRT BATHING SUITS						
4650C90	Embroidered Flower	Pink Ombre	4-6X		21.00	
7650C90	Embroidered Flower	Pink Ombre	7-14		22.00	
4650C91	Roses	Pink/Turq	4-6X		14.50	
7650C91	Roses	Pink/Turq	7-14		15.50	
4650C92	Ribbon Flower	Tangerine	4-6X		16.00	
7650C92	Ribbon Flower	Tangerine	7-14		17.00	
4650C93	Bows	Black/Yellow	4-6X		15.00	
7650C93	Bows	Black/Yellow	7-14		16.00	
2 PIECE BATHING SUITS						
4750C96	Ruffles	Black/Pink	4-6X		14.00	
7750C96	Ruffles	Black/Pink	7-14		15.00	
4750C96	Stripes	Black	4-6X		15.00	
7750C96	Stripes	Black	7-14		16.00	
4750C97	Rainbow	Multi	4-6X		14.50	
7750C97	Rainbow	Multi	7-14		15.50	

TOTAL DOLLARS	TOTAL UNITS

Buyer's Signature _____

Figure 10-11. Manufacturer's purchase order form (Courtesy of Tickle Me! Tackle Me!)

with store buyers, purchasing, preparing for market week visits, arranging vendor adjustments, and analyzing market conditions.

Locating New Resources

Store buyers are constantly looking for new lines for their stores. Since most of the store purchasing representatives have many in-house responsibilities and are located too far from the fashion market centers, it is unlikely that they will have the time to discover new fashion manufacturers and designers. With their presence in the wholesale markets and their importance in the ultimate purchase of fashion items, the resident buyers are constantly being contacted by those who wish to have their collections recommended to the stores. Many of the new resources are housed in less than prime locations, making their visibility minimal, and without resident buyer support would be unable to make store connections. In this area, it is the resident buyer who generally makes the marriage between the new resource and the retailer.

Previewing Collections

When the store buyer comes to market to purchase for the next season, the time allocated for such a task is often limited. Resident buyers save the store representatives time and effort by previewing the lines and analyzing each in terms of the store's needs. In this way some lines can be passed over by the store buyer and others can be considered. By having a close working relationship with each store, the resident buyer is able to satisfactorily assess the importance of each collection.

Following Up Orders

Although purchase requisitions have been placed by the store buyer, oftentimes merchandise does not arrive in the store according to the instructions on the order form. It is the responsibility of the resident buyer or assistant to visit the vendors and try to determine if a problem exists. Many resident offices recruit "follow-up" people for these chores.

Communicating with Store Buyers

The only way in which resident buyers can effectively service the needs of their accounts is through continuous communication. They may reach their clients in a variety of ways that include the use of pamphlets and brochures that feature information on the latest in hot items and new resources, letters, and direct telephone contact.

Purchasing

Purchasing is generally restricted to special orders, reorders or new merchandise that the store buyer asks the resident buyer to purchase. A reorder, merchandise that sells well and needs replenishment, can be placed by the store buyer. There are times, however, when some reorders need special attention so that they can be received as quickly as possible. In such cases, ordering through the resident office usually brings better results. With the clout of the resident office, established because of their importance to vendors, such orders often get preferential treatment. Special orders, or merchandise that is needed in a particular color or size, are often left to the resident buyer. Off-price merchandise is sometimes needed by a store so that it may be averaged in with the existing goods that were purchased at full price. Through direct vendor contact, immediate access to the market, and knowledge of market conditions, the resident buyer is able to obtain quality merchandise at lower prices. Sometimes in the middle of a season the retailer finds that the inventory is stale and needs some freshening to improve business. In such a case, the resident office is directed by the store to scout the market and purchase whatever they think is appropriate.

Market Week Preparation

Several weeks before the buyers come to town for market week, the resident buyers are at their busiest. A great deal of planning must be undertaken to make the store buyer's trip a success. The resident buyer is busy previewing the new season's collections, obtaining sample merchandise to show to the store buyer, participating in the planning of in-house fashion shows, preparing written materials that include suggestions for the coming sales period, and all other details that would be beneficial to their clients.

Arranging Adjustments

No matter how much attention the store buyer pays to purchasing, some merchandise received is problematical. For example, the fit might be imperfect, the construction could be shoddy, the fabrics might not be exactly as promised by the samples, or perhaps the merchandise just does not seem to motivate the consumer to buy. Under such circumstances the store often tries to return the goods to the vendor. If the attempts are futile, the store sometimes calls upon the buying office representative to act as mediator. The resident buyer might arrange for the goods to be returned or to have the store receive an allowance that could be used to discount the current invoices. Since the resident office is in a better position than the individual store, adjustment arrangements often fall upon their shoulders.

VBW associates 512 SEVENTH AVENUE • NEW YORK, N.Y. 10018 • (212) 944-0810 • FAX (212) 764-8678

P.O. #
9032

S H I P T O

NAME:
ADDRESS:
CITY: STATE: ZIP:

B I L L T O

NAME:
ADDRESS:
CITY: STATE: ZIP:

VENDOR: _____
ADDRESS: _____ PHONE # _____
CITY & STATE: _____ ZIP _____

STORE ORDER NO.: _____
DATE: _____ DEPT.: _____
TERMS: _____ F.O.B.: _____
SHIP VIA: _____
DELIVERY START: _____ COMPLETE: _____

All merchandise on this order must conform to specifications and sample. Acceptance of any merchandise after due date is at purchaser's option. Return of merchandise for failure to conform to specifications, or for a failure to deliver on time is to be at seller's expense.

CANCELLATION. This order automatically cancelled as of above specified date of delivery.

STORE BUYER: _____ PHONE # _____

STYLE	QUAN.	DESCRIPTION	COLOR						COST	UNIT RETAIL

• NO MERCHANDISE TO BE CHARGED TO VAN BUREN/BURNS WINKLER.
• DEPARTMENT NO. AND PURCHASE ORDER NO. MUST APPEAR ON ALL INVOICES AND CARTONS.
• ALL LABELS, HANGTAGS AND CARE INSTRUCTIONS MUST REMAIN IN GARMENT.
• NO SUBSTITUTIONS OR BACKORDERS, SHIP A STYLE COMPLETE.
• **THIS ORDER IS SUBJECT TO THE TERMS AND CONDITIONS AS SET FORTH ON BOTH SIDES OF THIS ORDER.**

TOTAL

VAN BUREN/BURNS WINKLER

BUYER _____

VENDOR

SFI STANDARD FORMS INC. 212-685-6300

Figure 10-12. Resident buying office purchase order form (Courtesy of VBW Associates)

Analysis of Market Conditions

Resident buying offices are familiar with the state of the market because of their continuous involvement with designers, manufacturers, fashion forecasters, reporting services, trade publications, and trade associations. Through these contacts they are able to assess the conditions of the market and apprise their member stores of any changes or trends that might affect their businesses. This assistance allows the stores to be better able to adjust their future purchasing plans.

In addition to these duties and responsibilities, others that are performed at some offices are product development for use in private label merchandise, pooling of smaller orders to qualify for purchases from certain vendors with large-order minimum requirements, assistance with promotional campaigns, and inventory management.

Classifications

The vast majority of the resident buying offices are independent. That is, they have no affiliation with any specific company or group of companies but represent retailers who are willing to affiliate with them and pay for their services. Stores sign a contract with the independent offices guaranteeing a flat fee for their services and a percentage of the cost of the merchandise ordered by the resident buyers. Some of the better-known independent offices are Henry Doneger Associates, Independent Associated Distributors, and Men's Fashion Guild.

The opposite of the independent office is the type that is privately owned by a retailer. It should be understood that such ownership is practical only for retailers with very large organizations and where exclusive attention to their own needs is imperative to the success of the company. Stores like Neiman Marcus, with their unique merchandising requirements, and Sears, with its enormous holdings, own their own offices. In addition to the assistance they provide for their company's store buyers, the private resident buyers play a major role in developing private label merchandise and scouting foreign markets to discover merchandise that would be for the exclusive use of their stores in the United States.

Somewhere in the middle of these two diverse groups are the cooperative offices that represent groups of stores under one corporate ownership. Companies such as Campeau (with the Federated and Allied stores under its umbrella) and the May Company (with ownership of such groups as May department stores and Lord & Taylor) utilize the cooperative office arrangement. Their buyers perform similarly to those in the private organizations.

While the two jobs are different, close relationships between the store buyer and the resident buyer counterpart will help make the store's fashion inventory one that better meets the needs of the consumer.

Since its inception in 1946, Henry Doneger Associates has helped retailers generate greater sales, increase profits, gain market share, and realize their full potential. They have endeared themselves to the industry by always meeting the challenge of retail growth and change. This independent operation has strengthened its position more than ever before through acquisitions and mergers.

The company has absorbed other resident buying offices that once were mainstays of the industry such as Jerry Bernstein, Gordon/Horowitz, Hilda Bridals, Steinberg-Kass, and The Buying Connection prior to its merger with Independent Retailers Syndicate. Its most recent affiliation has been with VBW

Associates. Doneger Associates' ability to stay at the top of its field has been unheralded. It is even more impressive since the industry has gone through a shakeout that witnessed the demise of such legendary resident buying offices as Felix Lilienthal & Company and Mutual Buying Syndicate.

One of the key ingredients in the company's success is its highly specialized divisions. In addition to the typical resident buying segments such as better sportswear, juniors, and men's wear, Doneger features divisions such as Price Point Buying, which specializes in off-price merchandise, and Thompson/Auer, a reporting and directory service for women's specialty retailers in con-

temporary, better, bridge, and designer markets. The inclusion of the Thompson/Auer service enables fashion retailers to keep up with the latest industry news without having to subscribe to a separate reporting organization. This saves additional expense for member stores.

Henry Doneger Associates' forte is service and opportunity for its member stores. They offer product development, private label programming, planning and research, analysis of market trends, reservation and travel assistance for visiting buyers and merchandisers, direct mail catalog participation, and modern office facilities in the heart of the New York Garment Center that defy comparison.

Small Store Applications

Those individuals who own small retail operations generally are responsible for purchasing. In some situations, they may utilize the services of a manager to assist with the purchases or even hire someone whose major responsibility is buying. Whatever the approach, it is imperative that as much planning takes place in these small enterprises as in their large retail counterparts.

Planning, in terms of what types of merchandise to buy, how much to spend for inventory, which resources to consider for replenishment, and when the goods should be bought, must be undertaken no matter how small the operation.

Small retailers often rely more upon whim and instinct than on a more technical approach in carrying out the store's purchases. Such an approach often leads to buying more than was actually needed for a selling period, neglecting some price points, buying from the same vendors in the past without considering what is new in the marketplace and other mistakes that could seriously hamper profits.

Planning should follow those that are utilized by the major stores. Past sales should be carefully examined, sales associates should be questioned, trade papers should be regularly read, and, if possible, the services of a resident buying office should be used.

It should be understood that the lifeblood of even the smallest store is the merchandise it carries, and every effort should be made to make certain the assortment is appropriate to motivate customer purchasing.

Highlights of the Chapter

1. There are two different types of buyers that are used by retailers. One is the store buyer who has the responsibility for determining the store's needs and developing a plan to satisfy those requirements. The other is the resident buyer whose job it is to assist the store buyer with purchasing plans primarily through advice and sometimes through actual purchasing.

2. Among the more important duties and responsibilities of store buyers are purchasing, pricing, assignment of selling space, and department management.

3. In planning purchases, the store buyer should investigate both internal and external sources to make certain that the plans contain everything necessary to make knowledgeable merchandising judgments.

4. A model stock is developed by buyers that represents the merchandise assortment that will be purchased in terms of quality, quantities, prices, sizes, styles, and colors.

5. There are four major elements that constitute the fashion buying plan. They are the qualitative and quantitative considerations, resource selection, and purchase timing.

6. The actual purchases may be accomplished in the store with road salespeople who carry the lines to the retailer, in manufacturer's and designer's showrooms, and at trade shows.

7. When the time comes to write the orders, buyers must be prepared to negotiate such aspects as discounts, freight payment responsibility, cooperative advertising and promotion allowances, delivery dates, and additional price reductions for early payment and acceptance of the merchandise prior to the traditional selling period.

8. Resident buyers serve their affiliated stores in a number of ways. They preview new collections, follow up open orders, communicate with the store buyers, make purchases according to the instructions of the retailer, prepare for market week arrival of their members, arrange adjustments between the store and the vendors, and make their customers aware of conditions in the marketplace.

9. There are three major resident buying office classifications. The largest are the independents. The others are the privately owned and cooperative offices.

For Discussion

1. Briefly discuss the primary difference in the roles played by the store and resident buyers.

2. Do some buyers also function as department managers? Discuss your answer.

3. What is the most important internal source of information for the buyer in terms of purchasing planning, and what are some merchandise areas that are considered in the examination of this source?

4. Which survey techniques do some retailers use to provide purchase planning information for their buyers?

5. Which external sources do many buyers regularly utilize in order to gain information on market conditions?

6. Discuss the difference between fashion forecasting services and retail reporting agencies.

7. Define the term "model stock" and discuss its importance to the store's merchandising success.

8. What are some of the qualitative considerations the fashion buyer should address before purchases are made for the next season?

9. Discuss the concept of "open-to-buy" and its importance to inventory replenishment.

10. In addition to the stated price of merchandise available in foreign markets, what other costs must the buyer consider to reach the true cost of the merchandise?

11. What is the term used for the actual cost of merchandise bought abroad?

12. Are there any advantages for buyers to attend trade shows when purchasing for a new season?

13. While price is often set and may not be a negotiable item, what aspects of ordering merchandise can be negotiated by the buyer?

14. List and describe five duties and responsibilities of resident buyers.

15. What are the three types of resident buying offices and how do their operations differ?

Ellen Sherman has been employed in fashion retailing for the past 12 years. After majoring in college in fashion buying and merchandising and successfully completing an internship with Conway, Inc., a full-line department store, she accepted a position with that company after graduation.

For approximately nine months she participated in Conway's executive development program, rotating throughout the store in a number of merchandising and management roles. She was involved in a combination of formal classroom instruction and on-the-job training. After nine months, the company decided Ellen was ready for her first full-time assignment, assistant buyer for men's furnishings.

After about five years, showing considerable strength as an assistant buyer, Ellen was promoted to become a buyer of moderately priced men's sportswear. She met the challenge of the job admirably, and enthusiastically carried out a successful career for another seven years.

A few months ago, Ellen was approached by a head hunter who specialized in fashion retailing and offered to arrange an interview for her with a major upscale fashion retail organization. Although she was satisfied at Conway's, the temptation of working for such an important fashion leader motivated her to be interviewed and ultimately accept the new position.

Ellen Sherman became the buyer for the men's designer collections at John Stevens, the Midwest's most highly regarded fashion retail empire. Her new job was very different from the one she left at Conway's. The merchandise for which she was now responsible was at the highest price points and was most fashion forward. Although she was a seasoned buyer, this new venture was totally different from her previous experience.

At the time of her employment with John Stevens, the company was preparing their purchasing plans for the fall season. With approximately six weeks before the industry's collection openings, Ellen had to develop a model stock for her department and address the four elements of fashion buying. Since the new position was completely different from the last in terms of merchandise classification and customer base, she had a considerable challenge ahead of her.

Questions

1. Which information source should Ellen first investigate in initiating her buying plan? Discuss the various aspects of the source with which she should become familiar.

2. In trying to quickly familiarize herself with this merchandise classification, which external sources of information should she utilize?

3. From which people on the store's staff could she seek advice and counsel in order to help develop a sensible buying plan?

As the proprietor of a small fashion boutique, Maggie MacNamara performs just about every task in the store. She buys, sells, schedules her small staff, arranges for such promotions as fashion shows, and changes the window displays. The business, which began as a lark for Maggie after her children were grown, has taken off and developed into a successful operation. In just three years her space doubled, as did her sales volume. Today her store's annual sales are approximately $700,000.

The merchandise mix offered in the store includes designer ready-to-wear, custom-made clothing, and accessories. Her merchandise resources include designers from the United States and abroad. She buys at manufacturer's showrooms during market weeks, at trade shows, and occasionally from sales representatives who visit her store. Her only advice on buying has been from her sales staff and from paying attention to trade publications such as *WWD* and consumer periodicals. She has no resident buying office affiliation or any connection with fashion forecasters.

Prompted by many of her customers to open a men's shop in the vacant building that is adjacent to her store, Maggie has signed a lease for that purpose. It seemed to her that with her loyal women's clientele, their spouses would favorably embrace the new shop. The only problem is with the merchandise. Maggie has no experience in men's wear other than she has impeccable taste. She is unfamiliar with the market and would need some assistance in merchandise procurement. She would like to have the overall responsibility for the purchase of the new classification, and would be willing to delegate her other responsibilities to people presently employed in the women's boutique.

At the present time she is listening to a host of ideas that are being generated by her staff and industry professionals to find a solution to the new purchasing problem.

Questions

1. Now that Maggie has committed herself to the new operation, do you believe she is capable of purchasing the needed merchandise? Defend your answer with sound reasoning.

2. What types of assistance might she employ to help her with the purchase of men's wear?

3. If you were in her position, what approach to merchandising the new facility would you take?

Exercises

1. Obtain three issues of a fashion industry trade publication such as *Women's Wear Daily* and *DNR* and examine each for articles that would be of interest to buyers who are planning the upcoming season's purchases. In an oral presentation, briefly discuss each article in terms of how it will help the buyer with his or her plans.

2. Make arrangements to interview a store's fashion buyer to determine how he or she develops a model stock. Prepare your questions in advance of the meeting so that you will be prepared for the interview. Emphasis should be placed upon the various elements that go into fashion buying. Once you have gained the necessary information, prepare a report that describes the particular buyer's approach to model stock development. In addition to the written material, include photographs or drawings that are typical of the buyer's merchandise classification.

3. Write to a resident buying office and ask for materials they send to prospective clients. Prepare a report that highlights the office's services, costs of membership, and the flyers used by the company to communicate with the buyers.

Inventory Pricing

Learning Objectives

After reading this chapter, the student should be able to:

1. Discuss the various factors that fashion retailers consider in pricing their merchandise.

2. Evaluate the importance of competition to retailers in determining their prices.

3. Explain the concept of "markup" and perform its calculation.

4. Identify the three different markup philosophies that retailers use in pricing their inventories.

5. List several reasons for markdowns and how they are calculated.

After the merchandise has been purchased, it is the responsibility of the buyers to determine the individual price that will be charged for each item. Retailers of all sizes and structures develop pricing philosophies and guidelines that they hope will bring a profit to their companies.

There are many factors that must be considered by the retailer before such policies are formulated, including the composition of the consumer market, the image that the store wishes to project, the amount of competition with which it must deal, and other factors that are peculiar to specific merchandise.

Once these items have been addressed and a philosophical approach has been determined, the buyers must apply their markups based upon the guidelines provided by management. Some retailers subscribe to a policy of uniform markups while others take a completely opposite approach and determine individual markups for each item. Others use approaches that fall somewhere between the two.

Although significant planning generally goes into each store's strategy, even the best plans will need some adjustments. While some merchandise will be on target and warrant reordering, others will fall short of expected sales and will require the taking of markdowns. When to reduce the prices of the slow sellers and how much the items should be marked down are just two of the problems that buyers must handle.

All retailers face a number of hurdles in merchandise pricing, but it is the fashion merchants who usually have the greatest challenges to confront. The nature of fashion goods makes them more difficult to merchandise than any other inventory classification. With such considerations as customer acceptance of radical styling and the perishability factor, pricing often affords the buyer an enormous challenge.

Pricing Considerations

Before the buyer can decide upon the appropriate price for each piece of merchandise, a number of factors must be considered. Fashion merchants focus their attention on such areas as the amount of competition they face, the life expectancy of the item, riskiness, overhead, the type of promotional endeavors needed to bring attention to the product, the image their company wishes to project, the type of customer patronage they seek, special requirements needed in the sale of the merchandise, and its vulnerability to pilferage.

Competition

Today's fashion retailer faces greater pricing challenges than those experienced in the past. In addition to the traditional competition that comes from the conventional retailing community, there is an ever-growing number of off-price merchants who sell fashion at less than the regular retail prices and an enormous number of specialty fashion businesses which bring merchandise directly to the home through a host of catalogs. Not only do they provide additional competition, but the prices they feature often are considerably lower than those found at the conventional fashion retail organizations.

Off-price merchants like Burlington Coat Factory and Marshall's, which sell men's, women's, and children's clothing, and NBO, which specializes in clothing and furnishings for men, are generally able to offer the same goods as their traditional counterparts at prices well below the normal selling price. This entry into retailing has caused considerable difficulty for the typical department store and specialty chain whose operational overheads continue to spiral upward. While it is apparent that higher prices could cover these operating costs, the visibility of the off-pricers makes higher prices an unlikely approach to solving their problems.

Direct retailers who sell fashion via their catalogs, such as Speigel, are also able to price their items lower than those found in stores. Without the need for high-rent districts, attractive surroundings, and sales personnel, the prices they charge are difficult for the store operator to match.

Outlet malls such as Sawgrass Mills in Ft. Lauderdale, Florida, and Franklin Mills in suburban Philadelphia, Pennsylvania. feature nationally advertised merchandise

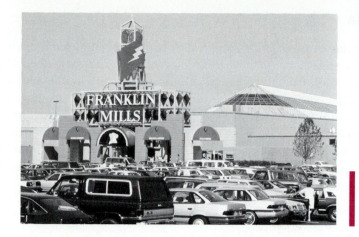

Figure 11-1. Franklin Mills, an outlet mall (Courtesy of Western Development Corp.)

at a fraction of its regular selling prices. Their accessibility to automobile traffic has made such retail environments regular stops for fashion shopping. Retailers like the upscale Ann Taylor and Tahari for women's wear and Aca Joe for men's sportswear are just some of those that have set up shop in these outlet centers.

Whether it is appropriate to meet the challenges brought by these competitors with lower prices or other methods, it is imperative for the fashion retailers to know the extent of their competition and price their merchandise accordingly.

Merchandise Characteristics

To a large extent, fashion merchandise has a limited life expectancy. Not only do seasonal changes affect the salability of the goods, but fashions that are considered to be trendy or fadlike often fade from desirability soon after they reach the selling floor. In these cases, prices must be sufficiently high to cover the losses attributed to their sudden demise.

Some items are delicate or fragile and subject to damage. Whites or pastel colors often require markdowns when they become soiled after careless handling, and sheer, chiffon-like materials might be damaged after the numbers of times they are tried on by customers. These perishable characteristics necessitate higher than typical markups to offset the losses that their damages cost the store.

Swimsuits and furs, because of their seasonal nature, are generally marked up more than other items to make certain that those that do sell early in the season bring sufficient profit to cover the losses of the items that are left over.

Small items such as fashion jewelry require storage in cases and therefore necessitate additional sales personnel. This tends to increase overhead expenses, thus warranting an additional markup.

Company Image

Many fashion retailers enjoy prestigious images that enable them to price their merchandise higher than what is typical for their industry. The additional markup is never high enough to have an adverse affect on sales. A markup of just a few additional percentage points is safe since it will rarely discourage customers from purchasing. Companies like Neiman Marcus, Saks Fifth Avenue, Henri Bendel, and Bergdorf Goodman are typical of those who charge higher prices for their merchandise. It should be understood that price is not a factor for every customer. Many get sufficient pleasure from patronizing these companies and are willing to pay a little extra for the "privilege."

Customer Profile

In chapter 3, "The Fashion Consumer," a great deal of attention was focused on different types of consumers and how their fashion needs are satisfied. All retailers should recognize the composition of their markets and how price affects their purchases. As we learned, some classes of people are cost conscious and only shop in stores that feature price advantage, while others such as the upper-upper class are more concerned with service and quality and pay little attention to price. Factors such as income, life-style, and psychographics indicate to what degree price is an object and should be considered by the merchant before a pricing philosophy is established.

Stock Turnover

A very important concern to retailers is the number of times a year the average inventory is sold. The more often an inventory turns over, the less need there is for a high markup. Conversely, the lower the number of "stockturns," the higher the markup to make a profit.

Off-price merchants and discounters are able to turn profits with lower markups (the amount added to the cost to arrive at the retail) because they expect greater turnover rates. Traditional fashion retailers who charge higher prices than the off-pricers and discounters expect fewer stockturns. In men's wear, where purchasing is less frequent than in women's wear, the men's items are usually marked higher.

In chapter 9, "Accounting Procedures and Operational Controls," the mathematical concept of stock turnover was described and should be reviewed at this time for better comprehension.

Promotional Endeavors

Fashion retailers participate in a variety of promotional activities to attract shoppers to their stores. The promotional involvement depends upon the size of the company, its method of operation, its budget, and its target market. Promotional dollars spent on advertising, special events such as fashion shows, and visual merchandising may significantly contribute to the store's overhead expenses. While these funds are intended to encourage more purchasing, they often necessitate higher prices. A complete discussion of promotional activities will be explored in Chapters 13 and 14, "Advertising and Promoting Fashion," and "Visual Merchandising."

Services

Many of America's better-known fashion emporiums offer a host of services to their clienteles. Many of these are free, including "At Your Service," which offers personal shopping at Bloomingdale's, a putting green for golf enthusiasts at Bergdorf Goodman's men's store, free fashion consultation, foreign language assistance for non-English speaking customers like the interpreters program at Macy's, corporate gift service, bridal registry, and alterations. While there isn't any extra cost to the customers for these services, the expenses incurred by offering them require consideration when merchandise is being priced. Unlike their off-price counterparts who subscribe to a bare-bones service philosophy, these merchants must include such "free" services as expenses.

Vulnerability to Shoplifting

The attention paid to shoplifting in Chapter 8, "Merchandise Handling and Protection," underscores the severity of the problem and the losses sustained by the fashion retailer. Some stores are plagued by the problem more than others and must address the seriousness of the problem when determining price. Not only must the losses be considered but so must the cost attributed to the protection of the merchandise. In the case of furs, for example, where sophisticated surveillance systems must be in place to protect the merchandise and where the protection of the garments requires additional sales associates on the floor, the cost of doing business increases. Departments that are located near store entrances, such as men's wear departments, and provide the shoplifter with greater accessibility to the merchandise might price their goods higher than the other departments in the store. Many merchants are reporting that the pilferage factor has indeed necessitated higher prices.

Buyer Knowledge

Typically buyers uniformly apply the same markup to all of the items in their departments. Occasionally, however, some styles may be priced higher or lower based upon the buyer's judgment. In cases where a particular business suit, for example, seems in the buyer's opinion to appear more costly than it actually is, the buyer might elect to add a few extra dollars to the price. Conversely, another suit might seem too expensive when the traditional markup is applied. The knowledgeable buyer might elect to price that one lower to encourage purchasing. This juggling of markups makes each item in the inventory more appropriate for the customer's needs. Of course, it is imperative that the buyer be fully aware of the competition to make certain that this price adjusting will not place the store at a competitive disadvantage.

Exclusive Merchandise Resources

Some fashion retailers are able to charge prices that are higher for some styles because of their exclusive rights to the merchandise in their trading area. The exclusivity comes as a result of the store's ability to purchase in large quantities, its location, or its ability to produce its own merchandise. These conditions enable the buyer to mark up the merchandise at a higher than usual percentage.

Private Label Collections

Most of the fashion empires such as The Limited, Neiman Marcus, Bloomingdale's, Macy's, and Lord & Taylor employ designers or product developers to create collections for their respective stores' exclusive use. Others make arrangements with manufacturers to produce lines for their exclusive use. One such major men's wear manufacturer who specializes in private label goods is Schoenemann, who produces separate collections for many major fashion retailers all across the United States. In these situations the items may be priced higher because of the shopper's inability to compare the prices in the other stores. It should be understood that the private label offerings must be sufficiently attractive to motivate the customer and must still be at price points that will make them compatible with the store's other merchandise.

Geographic Exclusivity

On occasion some fashion retailers are able to gain the exclusive rights to a particular line within a specific geographic radius. Since most potential customers come from a well-defined trading area and the store is the only one to feature the collection, it will be able to charge higher prices. Some fashion resources are willing to offer

this benefit to established stores because they often find that by limiting distribution in an area, more effort will be concentrated on promoting the line. The end result is often a benefit to both the vendor and the buyer in the form of greater sales volume.

Large Quantity Purchases

By guaranteeing significant ordering, some buyers are able to gain the right to exclusivity. Caution should be exercised by the retailer before making commitments to large orders because it might prevent them from featuring a merchandise mix that includes a host of vendors.

The factors upon which a store bases its prices are unlikely to remain constant. Changes in the store's method of doing business might require pricing adjustments. Economic conditions might also warrant new pricing policies. The educated fashion retailer must always be aware of factors that might necessitate price changes and should be ready to address them at any time.

Mathematical Concepts of Pricing

Once top management has analyzed all of the factors that make up the cost of their operation, they must determine how much must be added to the cost of the merchandise to bring a profit to the store. The amount that is added to the wholesale cost of each item, or the difference between the cost and the retail price, is called **markup**. Not every item sells at the original markup and might have to be reduced to motivate purchasing. The amount of the reduction is known as the **markdown**.

Markup

The concept of markup is examined arithmetically:

$$\text{Retail} - \text{Cost} = \text{Markup}$$

For example, if a pair of men's trousers costs $80 and it is priced to retail at $150, the markup is $70.

$$\$150 \text{ (R)} - \$80 \text{ (C)} = \$70 \text{ (MU)}$$

In this case, the buyer purchased the pair of trousers from the manufacturer for $80, priced it at $150, and sold it. This situation is the best possible for the retailer, but in reality not every item sells at its original or **initial markup**. Using the above illustration, let's assume that the trousers were marked down to $120 and then sold. The actual markup achieved by the store was $40.

$120 (price after markdown) − $80 (C) = $40 (MU)

The markup actually achieved by the store after the markdown was applied is called the **maintained markup**.

One of the factors that retailers often build into their initial prices is an estimation of how great the eventual markdowns will have to be before the goods are sold.

Few retailers are sufficiently satisfied with dollar markup as it has been described here. They prefer to express markup as percents. Markup percent may be figured on cost or retail. Fashion retailers generally use markup based on retail.

To determine the markup percent based on retail, dollar markup is divided by the retail price. Before the percent can be determined, it is necessary to first find the dollar markup. For example, if a sweater costs $40 and it retails for $80, the markup on retail is 50 percent.

$$\text{Retail} - \text{Cost} = \text{Markup}$$

$$\$80 - \$40 = \$40$$

$$\frac{\text{Markup}}{\text{Retail}} = \text{Markup percent on retail}$$

$$\frac{\$40}{\$80} = 50\%$$

Markdowns

No matter how carefully costs are determined and markups are applied, the reality of markdowns must be faced by every retailer. There are numerous reasons why prices must be adjusted. Some are attributable to retailer error and others to uncontrollable outside forces. In addition to exploring the reasons for marking down merchandise, attention will focus upon the size of the reduction and when markdowns should be taken.

Reasons for Markdowns

The various circumstances that cause merchandise to be marked down include errors committed by the buyers, management errors, poor attention by the sales force, and situations that are not controlled by the store.

Buying errors. Although most buyers carefully plan their purchases, they nonetheless are apt to make mistakes. They might place too much emphasis on a potential fashion trend only to find that the customer has not greeted the new styles with enthusiasm. Overbuying a particular silhouette or choosing the wrong color palette might also require markdowns to entice purchasing. Incorrectly

determining the proportion of private label goods to designer brands, inaccurately timing the arrival of the merchandise, and placing too much emphasis on an unheralded designer are other errors that are the sole responsibility of the buyer. Fashion buyers are more prone to such errors than any of their purchasing counterparts because of the unpredictable nature of the industry and must take the markdown route to right their wrongs.

Management errors. Although the buyer is given the purchasing responsibility, he or she is guided by the decisions that have been made by management. The markup percent, for example, on which the buyer figures the selling prices is determined by the store's merchandising managers. Some stores follow the "markup by classification" philosophy, which mandates a specific markup percent for each department. Without giving the buyer the flexibility to adjust the prescribed price, the selling price might be too high to motivate purchasing. The end result might be a reduction in the selling price.

Promotion and visual merchandising, which will be explored in chapters 13 and 14, are often the vehicles used to whet the customers' appetites. Where management fails to significantly promote particular merchandise, the outcome could be an adjusted price.

Inadequate sales staff. Every one of us has experienced situations where salespeople have discouraged us from making a purchase. Whether it is laziness or the lack of employee motivation that causes the complacency, the products available for sale are never shown to the shoppers.

Stores such as Nordstrom, Bloomingdale's, and Neiman Marcus have taken the initiative to motivate their sales associates by offering commission incentives. Instead of taking the traditional straight salary route, which provides no direct correlation between sales and employee income, these stores have instituted remuneration programs that require 100 percent attention to selling. Under such circumstances the customer is afforded better service. The result has been increased sales and fewer markdowns.

Many retailers are negligent when it comes to training their sales associates. A few days of rigorous training helps to improve the salesperson's efforts.

External factors. The very best merchandise mix that is carefully advertised, promoted, displayed, and presented to the shopper by enthusiastic, knowledgeable salespeople does not always provide the store with the profits it has envisioned.

Adverse weather conditions can be neither predicted nor avoided. An unusually warm September or October might discourage shoppers from buying snowsuits for their children or other cold weather fashions. A rainy, cool summer will not provide the necessary stimulation for the purchase of swimsuits. Since the merchandise affected by these unforeseen conditions is seasonal in nature, each

passing day provides less opportunity for selling. Markdowns are often necessitated to induce merchandise turnover.

A poor or declining economy also plays a significant role in the sale of fashion merchandise. While food items and other essentials are not as seriously affected, consumers generally pay less attention to fashion-oriented items during those times.

In order to minimize the effects of these uncontrollable situations, attention must be paid by everyone in the organization to reduce the errors within their jurisdictions.

When to Take Markdowns

The seasonal nature of fashion and its unpredictability in terms of customer acceptance make it a merchandise classification that is more complicated to manage than any other. While it is understood that many factors necessitate price reductions in order to turn the inventory, timing the markdown is critical to providing ample time for its disposal. Product classifications that are not as perishable may be kept in the inventory for longer periods in order to try different techniques that might help them sell. Those who merchandise fashion do not have the time for such luxury.

Given that the goods must be sold sometime during the season, retailers take different approaches to timing their markdowns. Not too many years ago the vast majority of fashion merchants subscribed to the semi-annual markdown philosophy. Typically the periods following Christmas and July 4th were traditional for marking down unsold merchandise. Today more and more fashion retailers are opting for earlier markdown periods. The following are some of the reasons for this approach.

- Fashion items that are held too long will find that the market for such goods is severely reduced.

- If merchandise is held too long its sale will require more significant markdowns.

- By quickly disposing of less desirable goods the store's rate of turnover will improve and enable the buyers to purchase fresher items.

- There will be less room on the selling floor to display the new season's offerings, thus delaying the sale of the fully marked-up goods.

Although most fashion merchants abide by these principles, some still play by the old rules. They argue that:

- Too many "sale" periods put customers on notice to wait for price reductions.

- Sometimes a hasty decision to lower prices is unnecessary and a matter of a few more weeks will bring a better profit to the store.

- During periods of markdowns more people crowd the store, resulting in a reduction of customer service.

Filene's is a well-known traditional department store based in Boston. Like most other full-line department stores, Filene's expanded its operation with the opening of branch stores. Featuring a fine selection of hard goods and soft goods and offering a great deal of customer service, the company enjoyed significant success as a Boston institution. Unlike its department store counterparts throughout the country, Filene's initiated a merchandising philosophy that brought large profits to the organization.

In 1909 Edward Filene announced that he was going to transform the lower level of the flagship store into a bargain basement. While bargain basements were not unusual to department stores, this venture was quite unique. It did not merely house the store's lowest priced goods as was the case in most operations but it served as a clearing center that would guarantee the disposal of merchandise within 30 days as well.

Every piece of merchandise is tagged with five different prices. The highest price is held intact for the first 12 selling days. Any items that are unsold after that time are automatically reduced 25 percent and are sold at the second price. Items remaining for another 6 days are reduced an additional 25 percent, and a further discount of 25 percent is offered after the next 6 days. If after a final 6 days any merchandise remains in the inventory, it is given away to charity.

Originally intended to quickly dispose of the store's slowest sellers, the concept was soon expanded to help manufacturers sell off their unsold fashions. Filene did not believe that this would be profitable but would serve the fashion industry and save some of its producers from going out of business. Not only did it enormously help those suppliers in distress but it also added to the store's overall profit. Buying merchandise from resources at bargain prices enabled the company to offer bargain prices to the consumer.

A third aspect of the operation, in terms of merchandise acquisition, involves purchasing end-of-season inventories from well-known fashion merchants. Dramatically announcing the acquisition of high-fashion merchandise from a prestigious retailer, Filene's sent a twelve-truck caravan across the country proclaiming in large, bold letters: "Neiman Marcus to Filene's Basement."

Today, the basement operation is no longer a division of Filene's, but a separate organization that was purchased by management. In its Boston facility it still functions on the automatic markdown philosophy. Its list of resources has grown significantly, featuring fashion labels that are world famous.

Deciding the Size of the Markdown

In order to make goods sell faster, the price must be sufficiently reduced. Few shoppers would be motivated to buy a dress that originally retailed for $120 and is now being offered for $110. The markdown must demonstrate a significant savings for the potential customer.

The size of the markdown percent is usually dependent upon how far it is into the selling season. When a buyer, for example, wants to motivate coat shoppers in early October, the discount could be much lower than if it were the middle of January when the season has virtually ended. This early markdown decision not only affords the buyer a lower markdown percent but also allows for a higher markdown later in the season.

Early markdowns usually reflect a savings of 20 percent, with end of the season sales producing markdowns of as much as 50 percent. Less than 20 percent rarely entices the shopper to buy.

Arithmetically, retailers calculate markdowns as percentages of the new selling price. For example, a dress originally priced at $100 has been marked down $30 to retail for $70. In order to determine the markdown percent, the following formula is used.

$$\frac{\text{Markdown}}{\text{New retail}} = \text{markdown percent}$$

$$\frac{\$30}{\$70} = 37.5\%$$

Pricing Policies

Fashion merchants subscribe to three major pricing policies in terms of how they apply their markups. These are markup by store, classification or individual items.

Storewide Markup

Very few retailers apply a universal markup to each item in the store's inventory. The exception to the rule could be when the merchant is an off-pricer or a discounter. In these organizations, the inventory as a whole is marked up at a specific percentage without any attention being paid to such factors as those previously discussed in the section on pricing considerations. The retailer determines the costs of running the operation and applies a markup that covers these expenses with enough left over for profit.

Markup by Classification

Department stores generally employ a system that involves different markups for each of its merchandise classifications. Since each category requires different attention and costs in bringing the goods to the customers, separate markups are sought for each. For example, precious jewelry and furs necessitate better security systems, and furniture requires more costly warehousing. Fashion merchandise is often short lived and must bring higher prices to make up for the lower markups of highly competitive electronics. If stores that carried a full complement of hard goods and soft goods used the storewide markup philosophy, some items would be profitable and others would represent losses to the company.

In order for such stores to turn a profit, they must first assess the overall markup needed to be profitable. Once all pricing factors have been considered, a specific markup is assigned to each merchandise classification. Averaging these markup percentages should result in the appropriate overall markup needed by the store.

Traditionally, fashion merchandise is marked up higher than most of the store's other offerings. The following represents typical department store markups by classification.

Markup Classification	Markup Percent
Jewelry	70%
Apparel	60%
Accessories	65%
Children's Clothing	40%
Electronics	35%
Shoes	65%
Men's Wear	50%
Home Furnishings	55%

Markup by Item

More and more fashion buyers are given the opportunity to apply individual markups to their inventories. They must, however, consider the markup percent mandated by their merchandise managers. By using this pricing approach, buyers are able to price certain lines such as private label fashions higher than they normally would and price more competitive styles lower. As in the case of markup by classification, where averaging is a factor, this system also requires averaging. The only difference is that the average markup is achieved within the department.

Let's consider a junior sportswear department that features a large variety of items such as sweaters, dress pants, jeans, skirts, and sweats. Some of the items are more competitive than others and might require lower markups. To offset the

lower prices, other items within the department will carry greater markups. The following might be indicative of how such a buyer must mark the goods in his or her department in order to generate the greatest sales volume.

Junior Sportswear	Markup Percent
Sweaters	55%
Dress pants	60%
Jeans	40%
Skirts	55%
Sweats	40%

In the example above, the buyer is confronted with competition generated by flea markets that often specialize in such items as jeans and sweats and price them lower than the traditional department store does. In order to be able to feature such items, the store must remain competitive. By using the averaging technique, the less competitive items are priced higher, resulting in the overall desired markup percent.

Price Points

No store is able to feature fashion merchandise at every conceivable price. With couture designs at the top of the price scale and budget fashions at the bottom, there is an enormous range of merchandise available for sale. Retailers select particular price ranges or price points for their inventories for a number of reasons, among which are the following.

- Stores are too small to feature every price point.

- Higher priced fashions are merchandised differently from their lower priced counterparts.

- Different levels of customer service must be delivered for each price range.

- Different price points denote different store images.

- Fashion merchandise is available in similar styles at many prices and the featuring of many price points would tend to confuse the customer.

- Too many price points would reduce the overall assortment.

Today, more than ever before, stores are becoming more restrictive in their merchandise price ranges. Macy's, for example, once carried a broad variety of prices ranging from upscale to budget. In the early 1980s they began to trade up and narrow their price points. By doing so they were able to project a more defined image of their store and tailor the services needed to satisfy their customers. Narrower price points are also beneficial to consumers, enabling them to immediately determine if a particular store meets their price requirements.

Small Store Applications

Many small fashion retailers are finding that the competition generated by the major department and specialty stores is often overwhelming. Few can feature the breadth of services offered by the giants in the field or are able to be as price competitive. The large fashion retailers often have the pricing edge because of their buying potential. Manufacturers are quick to offer deep discounts to the department stores and specialty chains, enabling them to feature lower prices. How could the small fashion merchant compete in such an environment?

Some attack the pricing problem by cutting their expenses, which enables them to sell for less. A less costly store location or the elimination of charge accounts and other services might be the answer. Another approach would be to maintain their markup strategies and appeal to the customers on a different basis. They might become more service oriented, warranting the higher markup. Custom alterations that are free of charge might induce fashion-conscious women to patronize a smaller store. The costs of garment alterations at the most exclusive stores often carry additional charges that significantly increase the price of the purchase. By featuring such a service without customer expense, the small retailer could attract additional shoppers to the store. Although such a service will incur an additional cost of doing business, it will be offset by achieving higher markups.

Small fashion merchants must be creative to meet the competitive challenge of the giants. They might contact charitable organizations for the purpose of sponsoring fashion shows and contributing a small percent of the profits to the charity. Many people have favorite charities and would find it beneficial to patronize the store that participates in such events. Appointments might be offered to customers, guaranteeing uninterrupted attention at a desirable time. This might appeal to the shopper with time limitations.

Whatever the approach, a plan must be put in place to make certain that the prices charged by the small retailer will result in a profit.

Highlights of the Chapter

1. Before the fashion retailer can make any pricing decisions, he or she must consider many factors.

2. Pricing considerations that need exploration include the level of competition faced by the organization, the image it is trying to portray, the services it deems necessary to maintain customer satisfaction, and its vulnerability to shoplifting.

3. Sometimes the store's ability to offer merchandise exclusively in its trading area enables it to mark the goods at a rate higher than usual.

4. After the costs of running the operation have been determined, the retailer decides upon the appropriate markup to cover these expenses and bring a profit to the company.

5. Markup is the difference between the retail price and the cost of the merchandise.

6. Fashion items are marked up higher than most other merchandise classifications due to their perishability.

7. Even when all prices have been carefully determined, some items will not sell at the original prices. These goods are then reduced or marked down to improve their sales potential.

8. Markdowns may be needed because of errors that are attributed to the buyer, sellers, or management, or for reasons such as adverse weather conditions or economic slowdowns.

9. There are three major markup philosophies utilized by retailers in regard to their pricing policies. These are storewide markup, markup by classification, and markup by individual item.

For Discussion

1. Why is it more difficult to merchandise fashion items than any other classification of consumer products?

2. Briefly describe two types of nontraditional fashion retail operations that pose considerable competition for the conventional retail organizations.

3. Explain the effect of the prestigious image on pricing.

4. What is meant by the concept of stock turnover?

5. While it is obvious that knowledgeable buying often improves the store's merchandise mix, does it in any way affect the prices charged by the store?

6. List three factors that constitute exclusive merchandise resourcing.

7. If a dress costs the retailer $65 and it is retailed for $125, what is the dollar markup?

8. What is the difference between initial and maintained markup?

9. What is the markup percent on retail for a sweater that costs $30 and retails for $50?

10. Discuss some of the errors attributed to management that might cause merchandise markdowns.

11. Why are an increasing number of fashion retailers opting for earlier markdowns?

12. Describe the concept of automatic markdowns.

13. If a coat that was initially priced to retail for $225 was marked down to $210, would it generally sell at a faster pace?

14. Differentiate between storewide markup and markup by merchandise classification.

15. Why do most department stores use the markup by classification approach when pricing their merchandise?

Langham's is a traditional full-service department store that has been in business for 60 years. In its downtown flagship and twelve branches it features a wide assortment of hard goods and soft goods. It has always offered many services to its customers who, for the most part, are considered to be loyal to the company. For all of its years of operation, Langham's has been the primary source for family needs in all of its locations.

Unlike most of Langham's department store counterparts throughout the United States, which have abandoned some of their hard goods lines, the company continues to feature major appliances. It is company policy that they provide one-stop shopping for their market. While this policy has afforded customer convenience, it has worked against the store's profit picture.

For the last three years, the sales volume in the appliance department has declined. The problem seems directly related to the opening of a discount appliance center in the Langham's flagship trading area and others in or near some of its branches. In order to combat profit decline, several suggestions have been made by members of the management team. Among them are:

1. Eliminate the appliances department and expand the store's fashion areas.

2. Restructure the store as a specialty department store, closing all of its hard-goods departments.

3. Retain its hard goods and soft goods philosophy, but adjust its pricing policies.

It should be noted that Langham's has always subscribed to the storewide markup policy.

Questions

1. Which management suggestion is most appropriate to solve Langham's problem?

2. Using your answer to question 1, how would you specifically make the store a more viable retail institution?

When Kensington Fashions opened its doors five years ago, it never anticipated the success it would soon achieve. Located in a fashionable suburban strip center, it features designer labels such as Liz Claiborne, Anne Klein, Calvin Klein, Jones New York, and Perry Ellis.

The store's reputation is not due solely to its merchandise assortment but to the various services and conveniences it affords its customers. In addition to custom alterations, personal shopping, and wardrobe consultation, it enjoys a reputation that defies competition. A downstairs hair salon and cosmetics counter, as well as a small dining facility where lunch is served and informal modeling of the store's fashions is held, have made Kensington more than just another retail operation.

In order to offer such unusual surroundings and services, Kensington marks up its merchandise at a rate that is higher than that typically found in specialty stores. Its success indicates that customers are willing to pay a little extra for the pleasures they derive from the company.

The impending opening of a branch of an off-price fashion outlet has caused great concern for Kensington. Exeter, Inc., has six units, each featuring many of the same labels as Kensington. Although most of the Exeter goods are parts of closeouts or job lots, they do bear similarity to Kensington's merchandise assortment. With the bare essential services offered, Exeter is able to sell its goods below that of any traditional retailer. With such competition, it is difficult for full-price stores to compete favorably.

Questions

1. Should Kensington abandon its method of operation and compete with Exter on price?
2. What suggestions would you make to Kensington so that they can successfully continue their business?

Exercises

1. Visit two different types of fashion retailers for the purposes of comparing the various considerations they address when determining prices. Through your own observations, examine such factors as the store's promotional endeavors, image, services offered to customers, and anything else that you could observe. Use a form similar to the one featured below to record your observations.

| DEPARTMENT STORE | OFF-PRICE STORE |

Image

Store design

Services

2. Write to a company like Filene's Basement or Syms and ask for information regarding their automatic markdown system. Write a report on the chosen store emphasizing the store's merchandise assortment and the specifics of the markdown system.

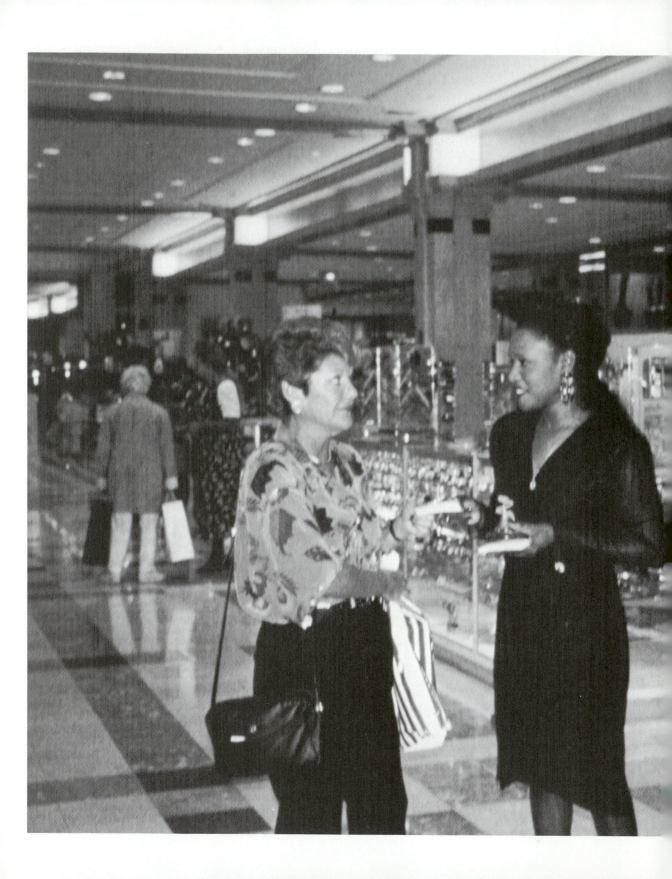

Communicating
with
and
Servicing
the
Fashion
Clientele

chapter **12**

Advertising and Promoting Fashion

Learning Objectives

After reading this chapter, the student should be able to:

1. Define the term "advertising."

2. Classify the types of fashion retailing advertisements.

3. Evaluate the advertising media in terms of their importance to the fashion retailing organizations.

4. Discuss the concept of cooperative advertising and how it aids the fashion retailer.

5. Describe the various special events undertaken to promote fashion merchandise.

6. Explain the different types of fashion shows utilized by the retail industry.

7. Identify and discuss several techniques that fashion retailers employ to promote their stores and merchandise.

8. Discuss how the small fashion retailer with limited resources can make use of advertising and promotion.

Once management has made numerous decisions concerning store location and design, human resources selection, and merchandise procurement, it is essential to make the potential customers aware of the store's existence and its merchandise assortment. The primary manner in which they achieve such recognition is through advertising. The wealth of print and broadcast advertising that is directed towards the fashion consumer is immediately obvious through the scanning of newspapers, magazines, catalogs, and direct mail brochures and through the ever-increasing advertisements that we see on television and hear on the radio.

In such a highly competitive market as fashion retailing, it is imperative that merchants establish specific images and alert the shoppers to their stores so that the consumers' fashion needs can be satisfied. If advertising is not utilized, how else can the word be spread?

Advertising as defined by the American Marketing Association is "any paid-for form of nonpersonal presentation of the facts about goods, services, or ideas to a group." These "facts" are illustrated with the use of copy (the written message) and/or artwork that includes photographs and drawings. It is impersonal in nature in that it is directed to a group rather than to a specific individual as in personal selling.

While advertising accounts for the greatest proportion of the dollars spent on promotion, it is not the only avenue taken by fashion retailers to reach their target markets. Fashion shows, demonstrations, in-house video programming, special campaigns and celebrations, personal appearances by designers and celebrities, and institutional events such as charity functions are also utilized in getting the fashion message to the public. Along with their advertising and promotional endeavors, fashion retailers make extensive use of visual presentation in their stores. The magnitude of this attention-getting medium is so significant that it will be discussed separately in the next chapter, "Visual Merchandising."

Management of the Advertising and Promotion Functions

The size of the organization and the scope of its advertising and promotional activities determine the responsibility for managing the functions. Most major fashion retailers, whether they are department stores, specialty operations, or direct sellers, employ internal staffs to manage and develop the promotional campaigns. Smaller businesses rely upon outside companies or free-lancers to create and direct their advertising and promotional involvement because the costs attributed to in-house staffs are prohibitive for such companies. Although store size plays the major role in deciding which approach to take, it should be understood that advertising and promotion are imperative to the success of any fashion venture.

The initial publicity planning in terms of direction, budget allocation, and media selection is management's task. In major fashion retail enterprises, the buyers interface with a promotional division that carries the technical tasks of placing ads and creating promotions. In small stores, the proprietor makes the publicity decisions and passes the responsibility for carrying out the function to one or more outside creative sources.

The Internal Structure

As was noted in chapter 2, "Organizational Structures," the larger retail organizations have separate promotional divisions that are solely responsible for such functions. The names of the divisions vary from company to company but generally

include such nomenclature as Sales Promotion Division, Publicity Division, or Division of Advertising and Sales Promotion. Whatever the names, their roles are the same. They are in charge of advertising, visual merchandising, promotional campaigns, special events, and publicity. Typical of such structures is the one that is illustrated in figure 12-1 below.

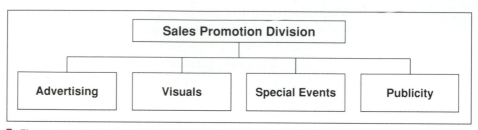

Figure 12-1. A typical department store sales promotion division

Each of the departments within the division is responsible for a specific aspect of the store's sales promotion program. Specialists are employed in each department to perform specific tasks such as writing copy, photography, arranging layouts, planning story boards (the pictorial outlines for television commercials), signage preparation, and so forth.

While the role of this department is to provide the technical knowledge necessary for producing advertisements and promotions, the store's merchandising division sets the plans in motion. First, the merchandising manager allocates promotional budgets to each buyer for a specific time period, usually six months. Then, each buyer decides when to spend the money to best suit the department's needs, which media and promotional tools should be used to gain the most customer attention, and which specific merchandise should be featured in each campaign. When the two divisions interact favorably, the chances for success vastly improve.

External Sources

On occasion, even the largest retail organizations with staffs of their own utilize outside companies. At Christmastime, fashion giants such as Lord & Taylor and Saks Fifth Avenue employ Spaeth Design, a company noted for creating animated displays, for their promotions. While these stores are expert at delivering the traditional advertising and promotional messages to their customers, they do not have the resources to create and design the animated promotions that they use during this brief selling period. Some of the typical outside organizations employed by both large and small fashion retailers are advertising agencies, free-lance designers, merchandise resources, and the media.

Advertising Agencies

Whether it is a complete campaign that is needed to announce the opening of a new branch store or an individual advertisement that is needed to recognize the accomplishments of a charitable organization in the community, advertising agencies are called upon to provide their creative talents. The money that the agency receives for its work is based upon a commission for the print space or broadcast time utilized for the advertisements. The standard rate of 15 percent is paid to the agency by the medium in which the advertisement was featured. For example, a newspaper advertisement that costs $10,000 will return $1,500 to the agency from the periodical in which the ad appeared.

Freelance Designers

When a retailer wishes to feature a unique advertising or promotional campaign, it might be appropriate to employ the services of a specialist. Even when the store has its own staff, an outside designer might be used to develop the concept. Not only do freelancers provide creative ideas to be used in a program, they also oversee the entire advertising process, which might include providing the copy and artwork.

Merchandise Resources

The designers and producers of fashion merchandise toil in an industry that is highly competitive. Not only must they regularly turn out collections that will be accepted by the store buyers and merchandisers but they are keenly aware of the need to help motivate the consumers to buy their lines. In order to assist the retailers in their quest for customers, many fashion resources prepare a variety of aids that can help stimulate sales. Some prepare direct-mail flyers that feature specific items and offer them to their accounts without cost. The flyers might then be sent along with the customer's monthly charge account statements. Others occasionally produce "advertising mats" or photostats of camera-ready advertisements that feature specific styles and are used by the stores for their print advertisements. Many fashion designers and manufacturers participate in cooperative advertising programs to help their retail organizations. This concept will be fully explored later in this chapter.

The Media

Fashion retailers use newspapers, magazines, television, and other media to whet the appetites of their potential customers. In order to assist customers with their advertising needs, the media generally supplies a variety of services concerning advertising preparation. They will help create the entire advertisement including writing the copy, preparing the layout, and providing information on demographics

and direction in terms of where the ads might be most appropriately placed. These are free services to the clients who pay only for the space that their ads will occupy.

Types of Fashion Advertisements

There are two distinct types of advertisements that retailers use to attract the attention of their markets. These are promotional and institutional advertisements.

Promotional Advertising

When a store wishes to sell a specific item or alert the shopper to a style that has been marked down, the store utilizes promotional advertising. These ads are employed to provide immediate sales results for the store. For example, if a hot item is advertised, the effectiveness of the ad should be measured in the sales volume of that particular item immediately after the advertisement has run. The majority of retail advertising is promotional.

Institutional Advertising

Rather than promoting a specific style, the institutional advertisement is used to create an image for the store. Fashion retailers, in particular, are proponents of this technique. Many believe that is the way in which to separate themselves from their competitors.

Ads of this nature concentrate on services offered by the store, their attitudes in regard to customer relations, and the store's recognition of areas of interest to the customer. In the latter case, an institutional ad might recognize the valor of our armed forces in battle or the problems associated with the environment. While the effectiveness of these ads cannot be immediately measured because there is no specific product being offered, the results are long-term. Those who favor this form of advertising believe that efforts will provide customer loyalty in the long run.

Combination Advertising

The best of both possible worlds is the advertisement that features both promotional and institutional elements. In such a format the retailer might choose to alert customers to the store's dedication to fashion and at the same time feature a particular fashion item. In this way the store's fashion image is stressed alongside a

GOD BLESS AMERICA,
THE LAND THAT WE LOVE.

AnnTaylor.

Figure 12-2. Institutional advertisement commemorating national pride (Courtesy of AnnTaylor)

"I've always wanted one!"

Buffalo Bill's aim was legendary, but we suspect his gifts weren't always on target. He would have loved us—because a gift from Neiman Marcus always hits the mark. We've rounded up the finest, most imaginative merchandise for our new Cherry Creek store: fashion from blue jeans to black tie, plus irresistible accessories, dazzling jewels, and collectible items for the home. And our expert sales associates will steer you in the right direction, so you won't have to scout around for the items that fit your lifestyle. On August 17, discover Denver's very own Neiman Marcus. The best has come to the West.

Neiman Marcus

Neiman Marcus opens Friday, August 17, at Cherry Creek.

3030 East First Avenue, Denver, (303) 329-2600

Figure 12-3. Institutional advertisement announcing a Neiman Marcus branch opening (Courtesy of Neiman Marcus)

It's time to unleash your personal style.
At NM, we make it easy. You'll find an array of collections
by designers who consistently take the lead
in fashion innovation. Come in soon to see the new breed.
Sculpted suit by Claude Montana.
Designer Sportswear.

To do today:
Join us for a
special presentation
of the fall collection
by Claude Montana,
with informal
modeling from
noon to 4, in
Designer Sportswear.

NorthPark
Open Labor Day 10 to 6.
(214)363-8311
Call store for more information,
or call 1-800-634-6267.

In addition to the Neiman Marcus
Charge Card, we welcome the
American Express® Card.

Neiman Marcus

Figure 12-4. Combination advertisement showing store's dedication to fashion along with a specific designer creation (Courtesy of Neiman Marcus)

specific style. The institutional portion of the piece is used to stress the store's fashion concept, while the featured item is used to bring immediate sales to the company.

Mackie's In Town

Tuesday, Wednesday & Thursday, January 29th to 31st.
Join us at Kleinfeld to preview Bob Mackie's Boutique Collection of Spring and Summer evening gowns and cocktail dresses. And just in time for spring weddings, bar mitzvahs and other special occasions. No appointment required.

Call for directions (718) 833-1100, I. Kleinfeld & Son, 5th Ave. at 82nd St., Brooklyn, N.Y. 11209 Tues & Thurs 11-9, Wed & Fri 11-6, Sat 10-6. Closed Sun & Mon.

Figure 12-5. Cooperative advertisement between I. Kleinfeld & Son, a fashion retailer, and designer Bob Mackie (Courtesy of I. Kleinfeld & Son)

Cooperative Advertising

Few fashion retailers have unlimited funds to be used for advertising. Oftentimes there is a greater need to inform the store's customers of newly arrived merchandise, personal appearances of designers, or special promotions than the budget allows. Although seasoned merchants usually agree that properly funded advertising brings positive results to the store, there are occasions when the promotional budgets are reduced. Whether it is the necessity to stretch a minimal advertising budget during lean times, or a desire for more advertising than the budget allows, **cooperative advertising** is the solution for many retailers.

Cooperative advertising is a joint effort between the manufacturer or designer and the retailer. The expense of these advertisements is shared by both parties. The value to each participant is quite obvious when such an ad is examined. Featured are the names of both the supplier of the merchandise and the retailer. Since the merchandise resource is responsible for paying for a portion of the ad, it has the right to examine its contents and layout before the ad goes into production.

Under the rules of the Robinson-Patman Act, cooperative advertising allowances must be uniformly offered to all customers. Companies that offer such monetary compensation must do so by using a formula that is fair and equitable to both its largest and smallest accounts. Typically such arrangements are predicated on the amount of the retailer's purchases, with a percentage of sales usually used as the basis of the allowance. The following example demonstrates how the cooperative arrangement may be applied.

Beaumont Fashions purchases $300,000 worth of coats from Coleridge, Inc. The manufacturer offers an allowance of 5 percent for all of its customers to use in cooperative advertising and pays up to 50 percent of the cost of the ad.

$$\$300,000 \times .05 = \$15,000$$

If Beaumont chooses to run an advertisement for $30,000, Coleridge will pay $15,000 or 50 percent of the cost.

The Exeter Boutique also purchases coats from Coleridge, Inc., but the amount of the sale is only $5,000. Using the same arrangement as provided to all of Coleridge's accounts, Exeter is allowed a total of $250.

$$\$5,000 \times .05 = \$250.$$

Exeter might now be able to run an ad for $500, with each party paying $250 towards its cost.

Although the amounts of money contributed by Coleridge, Inc., to each customer are different, the same percentage allocation was used in the determination, a concept mandated under the provisions of the Robinson-Patman Act.

The Media

Print Media

The fashion retailers' advertising needs are best served by the print media. Whether it is the newspapers, magazines, direct mail catalogs, or shopping publications, the print media play a greater role in bringing attention to the industry than the broadcast and miscellaneous media.

Newspapers

Throughout the United States, readers of such newspapers as *The New York Times*, *Washington Post*, *Miami Herald*, and *The Los Angeles Times* are made aware of newsworthy items as well as what their favorite stores are featuring. While these giant consumer periodicals get the lion's share of retailer attention, smaller, localized publications also serve the needs of merchants.

Most full-line and fashion-specialized department stores spend the greatest proportion of their budgets on newspaper advertising. The reasons for such unparalleled use include the following.

- The timeliness of the newspaper is important to the fashion retailer. With its seven-day schedule, advertisers are able to quickly address their audiences with the latest styles and fashion innovations.

- Unlike magazines, which require a significant amount of lead time for advertisement placement, newspaper ads can be inserted almost up to press time.

- The appeal of the paper is not limited to one family member as are some magazines. Columns and features are directed to every member of the family, giving the advertiser the ability to reach more than just one segment of the population.

- The newspaper automatically reaches large numbers of households as a result of subscriptions. This guarantees the retail community a large number of daily readers.

- When compared with other media, the newspaper affords the advertiser lower cost per prospective customer.

- The newspaper's life, while not as long as that of the magazine, is much greater than radio or television. The Sunday paper, where significant advertising is positioned, often has a life expectancy until the next week's edition is published. With its numerous parts, families often read the Sunday periodical throughout the week, making it an excellent investment for the advertiser.

What's hot, saucy, and Italian?

Our shoes! Italy is as famous for beautiful footwear as we are for cutting-edge design. So Neiman Marcus has scores of shoes from Italy by designers such as Donna Karan, Walter Steiger, Casadei, Y.D.W., Pancaldi, Bottega Veneta, Petra, Bruno Magli, Salvatore Ferragamo, and Anne Klein. From metallic pumps and ballerina flats to T-strap sandals and suede pumps in an array of vivid colors, our collection has international appeal. These Italian-made, Italian suede mules are a perfect example. Visit the Shoe Salon soon, and add a little Italian flavor to your dressing.

Monday through Wednesday, February 4–6
Carolyne Roehm trunk show. The Spring '91 collection reflects this designer's innate understanding of the modern woman's busy but elegant lifestyle. Informal modeling from 11 to 3. Couture Salon. NM Galleria Post Oak.

Tuesday and Wednesday, February 5 and 6
David Hayes for Spring/Summer '91. His collection of daytime suitings and jacket-dresses of luxurious silk and French cotton command attention in unusual color combinations and bright prints. Informal modeling from 11 to 3. Couture Salon. NM Town & Country.

Thursday and Friday, February 7 and 8
Oscar de la Renta trunk show. This American designer's tradition of romantic, feminine style is beautifully exhibited in his Spring/Summer '91 collection. Informal modeling from 11 to 3. Couture Salon. NM Town & Country.

EVENTS IN STORE AT NM

Thursday and Friday, February 7 and 8
Scaasi trunk show. Not for shrinking violets, this gregarious designer's new collection underscores his affinity for high color and high drama in cocktail dresses and evening gowns. Informal modeling from 11 to 3. Couture Salon. NM Galleria Post Oak.

Saturday, February 9
Introducing Kors: a new approach to accessible style. Combining high-spirited American design and high-quality Italian workmanship, this collection from Michael Kors is a fresh, easy, uncomplicated approach to '90s dressing. His versatile fabrics and clean silhouettes strike a perfect balance between comfort and sophistication. Informal modeling from 11 to 3. Sport Shop. NM Galleria Post Oak.

Galleria Post Oak
2600 Post Oak Boulevard, (713)621-7100
Town & Country
10615 Town & Country Way, (713)984-2100
Town & Country store closed Sunday.
Call stores for more information, or call 1-800-825-8000.

In addition to the Neiman Marcus Charge Card, we welcome the American Express Card.

Neiman Marcus

Figure 12-6. Newspaper advertisement featuring Italian shoes and store events (Courtesy of Neiman Marcus)

- The major newspapers usually incorporate full-color supplements in their Sunday editions. These sections utilize high quality stock (paper) which provides the fashion merchant the opportunity to feature merchandise in a more exciting format. Some readers retain such supplements after the rest of the newspaper has been discarded, giving the advertiser the advantage of extended periods of customer awareness.

- Specific markets can be reached since each newspaper targets a different consumer segment. Through assistance provided by advertising agencies and the media themselves, retailers are able to assess which newspaper is most appropriate for their merchandise assortments.

- Since newspapers concentrate on narrow geographic areas, it is easier to confine advertising to those within the reach of the store. Many newspapers have regional editions that narrow the population even more carefully, giving a more exacting exposure to retailers.

Magazines

A trip to the newsstand immediately reveals that the fashion magazine has reached new heights in print publishing. Added to the list of such household standards as *Harper's Bazaar*, *Vogue*, *Glamour*, and *Mademoiselle* are names like *Elle*, *Mirabella*, *Town and Country*, *Linea Italiana*, *L'Officiel-USA*, *Italian Vogue*, and numerous others that are published all over the world.

While the advertising focus of these periodicals is oriented toward designers and manufacturers, more and more fashion retailers are using magazines to deliver their advertising messages. The reluctance in the past toward widespread use of this medium stemmed from the fact that such usage had significant drawbacks. Specifically, many thought the trading area was too broad for retailer use since only a limited number of shoppers were actually within reach of the store, the lead time necessary to place an ad made it difficult for fashion shops to determine which styles would be timely once the ad was run, and the costs were often prohibitive.

Although the importance of the magazine to the fashion retailer does not compare with that of the newspaper, the use of such periodicals has certain advantages.

- The quality of the stock enables the fashion retailers to put their best feet forward. Excellent paper coupled with high-quality color reproduction enables every design to achieve the best possible exposure.

- Magazines, unlike newspapers, have extremely long lives. Many subscribers retain copies for extended periods of time and often pass them on to others. In this way the advertisement has the potential to be viewed over and over again.

- Many fashion retailers have branch stores that are located throughout the country. In such cases organizations like Saks Fifth Avenue, Lord & Taylor, Neiman Marcus, The Limited, The Gap, and others are able to reach a very wide audience with one advertisement. With the regional nature of newspapers, such widespread exposure would require numerous individual advertisements.

- Since magazines are retained for long periods of time, and fashion is so perishable, advertisers often use this medium to promote their images. That is, their advertisements might be more institutionally oriented than those placed in newspapers.

- With the vast numbers of women working today, many resort to mail and telephone ordering for their fashion needs. The magazines' ability to show fashion to its fullest makes them appropriate vehicles for such ordering.

- Even though the magazines have broad geographic distributions, making them inappropriate for some companies, many publish regional editions that make them viable choices for more stores.

Unlike the typical fashion magazines, which feature scores of advertisements among various articles and regular columns, Neiman Marcus publishes a periodical that features the store's fashion merchandise exclusively. Not to be confused with direct mail catalogs, which Neiman Marcus does utilize, it produces a magazine called *NM Edits*. Developed in 1987, the company highlights styles that are available only in the stores. The purpose of this "slick magazine," as *WWD* refers to it, is to bring traffic to the store. Its cost has been anywhere from $120,000 to $300,000 and has been paid for cooperatively by manufacturers and the store. In order to evaluate the effectiveness of *NM Edits*, the company uses a computer program that calculates the impact it makes on each department and the store's overall sales volume.

Direct Mail

Originally utilized as a means of bringing business to the store from people who were too far away to make in-store visits or to enable those with little time for shopping to make their selections in the home, direct-mail advertising was born. As retailers expanded their businesses with new branches or units, the need for such selling became less important. How many shoppers would prefer to shop at home if there was a store within easy reach?

Whether it was the "women's movement" or merely a necessity caused by inflation, a significant number of women joined the workforce. With less time to shop in stores and the need for fashion merchandise growing because of their new roles, many chose to satisfy their clothing and accessories needs through direct-mail purchasing.

More and more merchants began to allocate additional funds for flyers, pamphlets, brochures, and catalogs, which they mailed to their charge account customers and to individuals whose names were supplied by marketing research companies. The following are among the advantages afforded those fashion retailers who invest in direct mail advertising.

Figure 12-7. NM Edits, a Neiman Marcus direct mail catalog (Courtesy of Neiman Marcus)

• Merchandise offerings may be directed to specific groups that appear to have the right characteristics for the store's merchandise assortment.

Since it opened its doors, Neiman Marcus has always followed the policy of offering the finest fashion merchandise to its customers. The company received national attention from fashion critics and consumers alike because its assortment was unique and often unlike anything else that was readily available. To reach a broader market than its general trading area, Neiman Marcus made extensive use of direct-mail pieces and catalogs. The Christmas Book, the company's major direct marketing effort, began as a Christmas card used to invite customers to the store to do their shopping. The earliest catalog that is still in existence was a six-page offering that was sent to customers in 1915. Abandoned until 1926, when they published a 16-page booklet that featured gift suggestions, French handbags, perfumes, and furs, the store established a philosophy that it would showcase "the unusual, the unexpected, the

humorous, and the beautiful."

Along with their regular high-quality product mix, Neiman Marcus became known for its unorthodox publicity techniques and unusual items. In 1959 the Marcus's developed the concept of an extraordinary gift for that year's catalog: A Black Angus steer could be ordered "on the hoof" or as a package of individual steaks. The response from both the press and the public was so overwhelming that the company regularly has offered amusing and unusual gifts ever since.

Beginning with the 1960 Christmas Book, the unique gifts were featured as "His and Her Christmas Gifts." The products were sold as pairs, with the first being his and her airplanes. Although the gifts seem impractical to the typical fashion consumer, many sell each and every year. His and her ermine bathrobes in 1961, camels in 1967, mummy cases in 1971, ostriches in 1980, Shar-pei puppies in 1983,

diamonds (his a natural yellow 56-carat stone and hers a 21-carat mate valued at more than $1,000,000) in 1985, and "chairpersons" (chairs created as portraits by artist Philip Grace) are just some that have been offered and sold.

The acceptance of these products was astounding. Eight orders for Chinese junks were sold through the Book in 1962, and hundreds of chocolate monopoly sets retailed for $400 were sold through another Christmas Book.

It should be noted that a good deal of the merchandise featured in the publication is high quality, top-of-the-line fashion items. While the unique his and her offerings bring the company a great deal of attention, the profit comes primarily from the sale of the more traditional fashion assortment.

The Christmas Book has a circulation of 3.2 million worldwide.

- Small direct mail pieces may be inserted with end-of-the-month statements, thus avoiding the additional expense of separate mailings.

- Since each advertisement is viewed individually, it gets the attention of the reader. Newspaper advertising, on the other hand, vies for the reader's attention because the papers are full of advertisements.

- Individuals can examine the mailings at their leisure and can order when time permits them to do so.

It should be noted that one of the drawbacks for some direct-mail pieces is that they may be perceived as junk mail and not even opened.

Stores like Macy's, Bloomingdale's, Carson Pirie Scott, Marshall Field, and Lord & Taylor have long subscribed to this form of promotion and have delivered a variety of mailed matter to consumers. Few have rivaled the innovativeness of Neiman Marcus, which has embraced the direct mail medium since 1909.

Shopping Publications

The nature of the shopping publication is to provide the readers with a host of advertisements that are surrounded by a minimum of regular columns. These periodicals serve the needs of small communities and the stores within them. The costs of advertising are considerably lower than the expense involved in using the other print media. Since the monetary outlay is relatively small, the shopping publication attracts the small merchant with a limited budget.

Most of these papers are published weekly, are either delivered to the consumer's home as part of a "promotional package" consisting of supermarket flyers, coupon enclosures, etc., or mailed, and are made available free of charge.

Flyers

Some small merchants make use of flyers for the purpose of announcing a sale, a special promotion, or the opening of a new store in a community. They are inexpensively produced and, like shopping publications, are delivered to the consumer's residence.

Broadcast Media

Once considered impractical for most fashion retailers, radio and television have become important outlets for some. The users are those merchants with significantly large trading areas and the budgetary resources needed to use the media.

Radio

Of the two broadcast communication outlets, radio is less frequently used than television by fashion retailers. Although the costs involved are much less than those required for television advertising, the appeal of the radio is quite limited. Fashion merchandise is best understood when it can be seen. Verbal descriptions often leave much to be desired for the listening audience. In addition to this shortcoming, the market is somewhat restricted to a narrow segment: the teenager or young adult who often turns the dial when the commercials take place. Those who listen to the radio do so primarily in their automobiles. This seriously reduces the time for commercials to the peak commuting periods.

With all of these negatives some fashion retailers find that radio is a good tool for announcing sales and special promotions. It would be wasteful to advertise a specific design or fashion item on the radio since it is difficult to satisfactorily whet the listener's appetite without the use of visuals.

Television

Television has started to come of age for fashion advertising. An increasing number of merchants have found that the dollars expended have paid off with increased sales. What other medium has the combination of action, color, and excitement in providing fashion to the marketplace?

Since the costs are relatively high, it is rare to find a retailer who has the capital necessary to sponsor a program. Only the very largest of consumer products manufacturers—those who produce automobiles, foods, household cleaners, toothpaste, and so forth—have sufficiently large markets to warrant the expenditures.

Those fashion merchants who have found the need to use television have done so on a more restrictive basis. They utilize spot announcements in limited geographic areas to sell their wares. For example, for the period of time after a program concludes and another is to begin, the network sells spots to local advertisers. In this way Bloomingdale's might purchase the time slot for the New York viewing area, Marshall Field for Chicago, and Woodward & Lothrop for Washington, D.C. The store then reaches that market that is able to patronize it.

Fashion retailers generally approach television advertising in a number of ways. A & S, a division of the Campeau empire, regularly reaches its New York market through television announcements when it is running a sale. Annie Sez, an off-price fashion chain, concentrates on the institutional approach by underscoring its bargain price structure. Barney's, a high-fashion retailer that features an extensive collection of designer imports, utilizes foreign environments and foreign language supplemented by English titles to spread its fashion image. Bloomingdale's usually uses the combination of promotional and institutional advertising when it tells the consumer about special sales and signs off with its image-making slogan, "Bloomingdale's: it's like no other store in the world!"

Miscellaneous Media

Though insignificant in terms of the other media, some local fashion merchants make use of billboards and car cards or transit advertising for their promotions. The former might be placed on roadsides to advertise their stores to automobile occupants and on railroad platforms to alert the waiting passengers to their presence in a community. The latter are used on trains and buses to attract the attention of the commuters.

The Costs of Advertising

Prior to the decisions concerning the types of advertisement to use and the media to employ, retailers must consider the amounts they wish to spend and the costs of the advertisements.

Development of the Budget

Budgets are derived in a number of ways. The most typical are the **percentage of sales**, **objective and task**, and **the unit of sales** methods.

Percentage of Sales Method

Most retailers who have been in business for a number of years choose this technique to determine how much they will invest in advertising. Analysis of past sales is essential for this plan so that the retailer can try to determine what the sales figures might be for the next period. Once these figures have been determined, other considerations such as the store's plans for expansion, changes in merchandising philosophy, and the state of the economy are factored in and carefully examined. Then, the retailer applies a percent of anticipated sales to arrive at a budget.

Objective and Task Method

A more sophisticated approach involves analysis of the store's objectives and the tasks that must be performed to achieve these goals. Such factors as the opening of branch stores, development and promotion of new private labels, expansion of customer services, and so forth are analyzed in terms of how much advertising expense would be necessary to reach these objectives.

Unit of Sales Method

In addition to being concerned with dollar volume, most retailers keep records on the number of units sold in their stores. Using this technique for advertisement

budgeting, the retailer tries to assess how much must be spent on advertising to sell each unit. In large stores with numerous departments and different merchandise classifications, each product type requires a different advertising investment. For example, furs will certainly necessitate greater per-unit expenditures than shoes because of the differences in price and units sold. It is therefore necessary to examine just how much advertising might cost for each merchandise category. Once this has been estimated, the numbers of units that are expected to sell are multiplied by the factor that has been assigned to them.

Advertising Costs

In order to properly utilize the prescribed budgets, those responsible for advertising must investigate the costs involved for each advertisement. In order to gain an insight into the comparative costs of the media and their relative worth to the advertiser, many merchants consult the directories produced by the Standard Rate and Data Service (SRDS). These directories provide the most up-to-date information on newspapers, magazines, radio and television spots, network radio and television, and transit advertising that includes billboards and car cards.

The actual costs of the ad vary according to the space or length of time required, its position in a newspaper, the hour of the day it will be aired on radio and television, and other factors. Familiarization with the following formula and placement considerations can help the advertiser to maximize the benefits of the expenditure.

Milline Rate

Newspaper space is sold on the basis of the "agate line" rate. That is, each line (one column in width) costs a certain amount of money. The number of agate lines multiplied by the rate per line determines the cost of the ad. While this gives the retailer the price, it does not give any indication of the relative worth of the advertisement. For example, if one newspaper's rate is $.90 per line and another charges $1.25, the second certainly costs more. However, the size of the circulation of the second might be significantly greater than the first, giving more value to the second paper's advertisement. In order to assess the value of the ads, the milline rate formula is applied.

$$\frac{\text{Rate per agate line} \times 1,000,000}{\text{Circulation}}$$

Applying this formula, if the agate line rate is $.95 and the circulation is 950,000, the milline rate is $1.

$$\frac{.95 \times 1,000,000 = \$1}{950,000}$$

If the store is considering several newspapers for their ads, the milline rate formula can be applied to the actual cost of each to determine the cost in terms of readership.

Placement Considerations

By placing in the newspaper, the retailer only gets the guarantee that the ad will be printed. Specific placement of advertising will sometimes bring better results in terms of sales. A knowledge of the various technical placement terminology will aid the retailer in considering the available options.

Run of Press

This the basic cost of newspaper space. Being the least expensive rate, it does not guarantee a specific location in the paper. Placement is left to the discretion of the publisher. **Run of press**, or ROP as it is commonly called, might result in an ad being printed in an undesirable location.

Preferred Position

In order to guarantee the location of an advertisement in a particular place, many merchants pay a premium rate. Fashion retailers who want to get maximum exposure are often willing to pay extra for an ad that might be placed near a fashion column or as close to the first page as possible where more readers are likely to see it.

Regular Position

Some stores subscribe to the theory that if their advertisements always occupy the same position, their customers will be able to find them quickly. An additional charge is levied for an ad to occupy the same position.

Evaluation of the Advertisement

The purpose of advertising is to increase sales and profits. In order to make certain that advertising is fulfilling its purpose and warrants the expense involved, it is necessary to evaluate its effectiveness.

Small fashion merchants, because of their involvement with customers, often get verbal acknowledgements of the ads that were presented. This is certainly not a scientific approach to advertising evaluation.

Larger stores that invest heavily in promotional endeavors must know if their costs were worth the investment. Most of the major stores with in-house research departments measure sales prior to the advertisement and immediately after it has been published. If there was an increase in sales for the advertised merchandise, it can be assumed that the promotion brought in the additional revenues. In addition to the increase in sales, some retailers determine if the additional sales brought enough business to the store to cover the cost of the ad and delivered a profit.

Some of the research tools discussed in chapter 4, "Problem Solving: The Role of Retailing Research," are used in the evaluation of advertising's effectiveness.

Promotional Programs

Whether it is to attract new customers to their stores, make the consumers aware of their images, promote the collections of international designers, herald the arrival of a new season or call attention to store-sponsored charities, fashion merchants are constantly developing promotional programs. While the more extravagant and ambitious endeavors take place in the major organizations, numerous devices and tools are used with considerable success by their small-store counterparts. It is not always the seemingly limitless budget that brings customer attention to the sales floors but oftentimes the creative promotions that are equally successful with small monetary investments.

Special events and regular store programs are planned by specialists in the major stores. Under the direction of a divisional manager, the promotional efforts are usually part and parcel of a plan that includes advertising and visual merchandising. With proper coordination the advertising captures the consumers' attention and brings them to the stores, and the visual presentations enhance the promotions. The smaller operations usually rely upon the talents of their owners or managers to develop the fashion formats and tools that will draw customers to their shops.

Fashion Shows

What better way is there for the retailer to dramatically present the latest styles to their customers than the fashion show? While other devices may bring excitement to the retail arena, few incorporate the store's merchandise in the presentation as well as fashion shows. Ranging from formal events that demand the attention afforded professional theater and significant budgets to the fashion parades that merely employ simple runways and recorded music, fashion shows may be produced for every store's budget and audience.

Formal Productions

Complete with themes, live music, and commentary, formal shows are the most costly. The settings are usually theaters that have been leased for the occasion or ballrooms that have been transformed to stage the events. Professional models dance, march, frolic, or even skate through the various scenes of these shows. Sometimes the backgrounds and props rival the fashions that are being displayed.

Stores such as Bloomingdale's and Neiman Marcus subscribe to these extravaganzas and often present them in conjunction with charitable causes. Tickets are usually sold for these special events with the proceeds going to the charities. The retailers involved might get free publicity from the media that covers such events, such as *Women's Wear Daily*, recognition from the public for their participation in worthy causes, and ultimately business from the sale of the fashions featured in the production.

Runway Parades

The more typical fashion show is presented runway style, generally in the store. The staging area might be a department that has been cleared of its merchandise for the event and refitted with chairs that are placed on either side of the runway, an in-store restaurant where the patrons may watch the show after finishing a meal, or in shopping centers and mall areas.

Easy to organize and modest in cost, such parades concentrate on specific collections or store departments. It might be the introduction of resort wear or perhaps, a "trunk show" that features a designer's collection that has been brought in for the purpose of taking special orders. Trunk shows are very popular with many high-fashion merchants and equally favored by their clienteles. They not only feature the collection but also the designer or company representative to deliver the commentary and answer questions at the show's end.

Where the magnitude of the formal show requires considerable professional participation and salaries that are commensurate with their talents, the less-structured fashion parades can be offered without incurring as many costs. College students, charity workers, or store employees could be used in place of the professional models. These substitutes often make the presentation more fun for the observers. Instead of a paid professional band or pianist, a school's music department could be contacted for use of their musicians. A small donation to the educational institution often results in their cooperation. Prerecorded music could certainly be used at very little expense.

Whatever the size of the company and its budgetary limits, fashion shows can be presented that will bring both publicity and profits.

Special Campaigns and Celebrations

The major fashion-oriented department stores are proponents of special campaigns and celebrations to attract customer attention. Companies like Neiman Marcus and Bloomingdale's in this country and Harrods in London periodically transform their selling floors into arenas that overflow with special merchandise for these events.

Bloomingdale's has long been a devotee of the events that acknowledge fashion from all over the world. Every year or so a major presentation features the designs and merchandise from a particular country. These spectaculars have paid homage to China, France, Italy, Spain, Portugal, and other fashion centers. During the promotions, which run for approximately six weeks, every piece of merchandise featured in the event either comes from the nation being saluted or

Figure 12-9. Storewide celebration featuring merchandise from Spain (Courtesy of Bloomingdale's, North Michigan Avenue)

is created especially for the show. For example, in addition to the goods imported from China for the "Year of the Dragon" celebration, a separate collection inspired by China was designed by Norma Kamali. Each selling area was redesigned to enhance the merchandise and included pagoda telephone booths, cooking stations that prepared special cuisine, and artwork that was suggestive of China. The men's department on the main floor was circled by a three-dimensional replica of the Great Wall of China which magnificently set the tone for the temporary environment.

Neiman Marcus has long provided the Dallas community with its fabulous annual event, the "Fortnight." Held at the end of October, the presentation honors a specific foreign country. The celebration focuses attention on fashion and accessories from faraway places and is enhanced with the appearance of dignitaries from those lands. During one Fortnight, whose theme was "Britain: Then & Now," members of the British royal family, including Princess Margaret, the

Queen's sister, were on hand to participate in the festivities. Not only do the Fortnights bring business to Neiman Marcus but they also deliver significant contributions to selected charities. Other Fortnights have been designed to honor such countries as Greece, France, Italy, Switzerland, and Germany and have included personal appearances by the late Princess Grace of Monaco, the Queen of Thailand, and others.

Harrods also regularly utilizes such celebrations to recognize the fashion brilliance of particular countries. One event, "Buongiorno Italia" exhibited fashion, foods, and furnishings from all parts of Italy. Window displays and interior presentations that utilized craftspeople and artists augmented the merchandise that was offered for sale. It was one of Harrods' most ambitious and successful of these endeavors.

Institutional Events

Some stores draw attention to themselves by featuring events that are not specifically merchandise oriented but are intended to bring the shopper to the store. Once the shopper is inside the intention is to motivate purchasing. These promotions run the gamut of themes from physical fitness orientations to flower shows.

The Macy's annual flower show literally transforms the main floor of the New York flagship into a botanical garden overflowing with flowers. The show heralds the arrival of spring and has been a well-received promotion since 1975. The windows feature merchandise abundantly surrounded with flowers, the awnings are changed to incorporate the theme, and interior displays utilize flowers throughout the departments. The success of the show is measured by the attendance of huge crowds and the increase in store sales during that time.

Bloomingdale's, in its Chicago flagship, regularly features fashion shows that are expressly held to bring donations to charitable organizations. Although the end result of such a presentation can be the sale of merchandise featured in the event, the purpose is institutional in nature in that it brings to the customer's attention the store's awareness of causes that are not profit oriented.

Designer and Celebrity Appearances

The announcement that Calvin Klein is going to appear at a store to discuss his latest collection or that Elizabeth Taylor will make a personal appearance to promote her perfume line guarantees enormous crowds of shoppers. Some of these celebrities do little more than show up, while others act as narrators or hosts during the presentation of fashion shows that emphasize their collections. If the individual has "star power," it assures the store a great deal of attention.

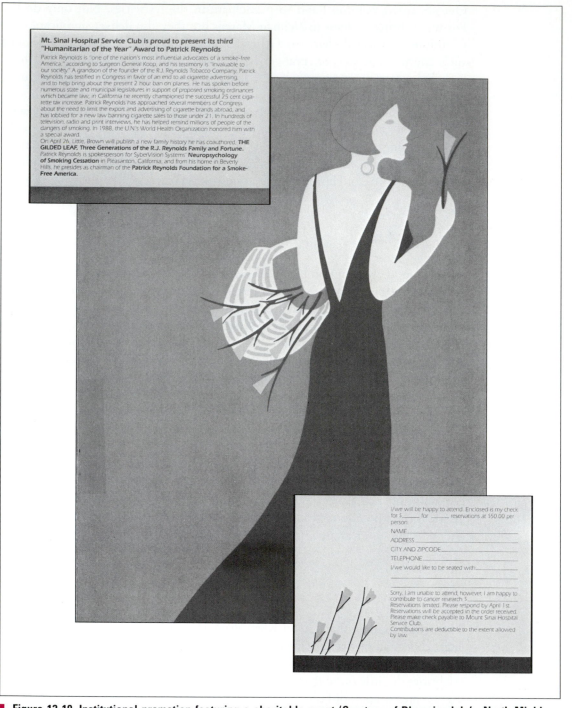

Mt. Sinai Hospital Service Club is proud to present its third "Humanitarian of the Year" Award to Patrick Reynolds

Patrick Reynolds is "one of the nation's most influential advocates of a smoke-free America," according to Surgeon General Koop, and his testimony is "invaluable to our society." A grandson of the founder of the R.J. Reynolds Tobacco Company, Patrick Reynolds has testified in Congress in favor of an end to all cigarette advertising, and to help bring about the present 2 hour ban on planes. He has spoken before numerous state and municipal legislatures in support of proposed smoking ordinances which became law; in California he recently championed the successful 25 cent cigarette tax increase. Patrick Reynolds has approached several members of Congress about the need to limit the export and advertising of cigarette brands abroad, and has lobbied for a new law banning cigarette sales to those under 21. In hundreds of television, radio and print interviews, he has helped remind millions of people of the dangers of smoking. In 1988, the U.N.'s World Health Organization honored him with a special award.

On April 26, Little, Brown will publish a new family history he has coauthored, **THE GILDED LEAF, Three Generations of the R.J. Reynolds Family and Fortune.** Patrick Reynolds is spokesperson for SyberVision Systems' **Neuropsychology of Smoking Cessation** in Pleasanton, California, and from his home in Beverly Hills, he presides as chairman of the **Patrick Reynolds Foundation for a Smoke-Free America.**

I/we will be happy to attend. Enclosed is my check for $_____ for _____ reservations at $50.00 per person.

NAME _____
ADDRESS _____
CITY AND ZIPCODE _____
TELEPHONE _____
I/we would like to be seated with _____

Sorry, I am unable to attend, however, I am happy to contribute to cancer research $_____
Reservations limited. Please respond by April 1st. Reservations will be accepted in the order received. Please make check payable to Mount Sinai Hospital Service Club.
Contributions are deductible to the extent allowed by law.

Figure 12-10. Institutional promotion featuring a charitable event (Courtesy of Bloomingdale's, North Michigan Avenue)

The importance of this type of event is demonstrated by an appearance at a store by Priscilla Presley to promote her scent. She took the time to pose for a photograph with a group of merchandising students on a field trip. Each student bought the Presley product whether he or she really liked it or not!

The purpose, of course, is to get the people to visit the store. Once inside, and if properly motivated through appealing displays and unique merchandise offerings, the shoppers will become buyers.

In-house Video

Initially introduced by designer Norma Kamali in her retail shop windows, video has become an excellent tool to promote fashion. Some of the tapes are supplied by designers and manufacturers to promote their new lines, while others are the creation of the particular retailer to inform the moving audiences about such topics as store services. Whatever the use, shoppers always seem to be willing to stop and take a look.

A designer of scarfs scored heavily for himself and the stores that merchandised his line by developing a video that demonstrated numerous ways in which to use scarfs. Strategically placed on the counter that housed the merchandise, the demonstrator shows the versatility of scarfs. Standing close by, a salesperson answers further questions and assists in the sale of the items.

Some designers create extensive collections that are too costly for the store to purchase outright. While the retailer might find it worthwhile to buy a representation of the line, a video featuring every style could show interested parties what else is available. A particular number could then be special ordered for the customer, saving the retailer from the initial investment of inventory stocking.

Stores like Saks Fifth Avenue, Jordan Marsh, Macy's, Lord & Taylor, and Burdine's make significant use of the medium.

Demonstrations

The manipulation of a scarf, as promoted with the use of in-house video, can also be accomplished by a demonstrator. The major fashion products that rely substantially upon demonstration for sales are cosmetics and fragrances. A quick walk through any store's cosmetics department will immediately reveal a host of "artists" eagerly waiting to begin the application of their products. Very often crowds gather around the volunteers and, upon seeing the results, quickly purchase many of the items that were demonstrated.

Sampling

Another way the cosmetic and fragrance segment of the fashion industry promotes its wares is through the use of samples. The prime time for such sampling is at Christmastime when the store is at its busiest. The concept, originated by Estée Lauder, involves offering a free item or a full selection of items at a bargain price when a product is purchased at the regular price. This technique introduces the customer to the company's latest offerings in the hopes that future business will be forthcoming. The cosmetics industry has become so fashion oriented that the product lines change with the same frequency as the apparel and accessories collections.

Publicity

Every major fashion retailer has a public relations department. The purpose of such operations is to gain as much favorable publicity for the store as possible.

Publicity, sometimes referred to as free publicity, comes as a result of something that the retailer is involved in and is considered newsworthy. It is technically free because it (the derived publicity) is not paid for. The Macy's flower show, for example, costs the store a great deal of money. In order to notify the public of such an event, the store's publicity director might prepare a press release to be issued to the media. If a newspaper or television news show covers the event, and reports it in its communication outlets, there will be no extra costs to the store.

Publicity is achieved through the use of press releases and press kits. The former is usually a letter or announcement that is sent to the media in the hope that they will publicize the promotion. The latter is more elaborate and might include a statement about the event, photographs, and, where applicable, invitations.

With the wealth of competition in fashion retailing, it is the efforts of the publicity departments that often help the store to achieve greater traffic and greater profits.

Small Store Applications

Small retailers often believe that the expenses attributed to advertising and promotion are simply too high for their participation. Those who do not involve their companies are likely to be less profitable than those who do.

Promoting a business through the use of advertisements and promotional devices need not be costly if certain approaches to the problem are addressed.

One way in which to stretch the budget is by considering cooperative advertising. With the expenses shared by the manufacturer and the retailer and inexpensive

local print media employed, such as the independent shopping publications, even the smallest merchant can participate.

Fashion boutiques and other small operations attract attention with modest investments by producing fashion shows. As was discussed in this chapter, students and customers can be substituted for paid models, meeting rooms of charities can be transformed into stages for the event (and donations can be made to offset the cost of rental space), commentary if deemed necessary can be written and read by the store's owner or manager, and recorded music can be used.

While major advertising campaigns and extravagant promotions are out of reach for these businesses, there is no reason to abstain totally.

Highlights of the Chapter

1. Those responsible for the management of the advertising and promotion functions in large fashion companies are specialists. They limit their duties to the store's promotional plans. In small stores, the responsibility is at the hands of the owner, who also performs a host of other duties.

2. Advertising is either institutional or promotional, with some ads combining the characteristics of both.

3. Some designers and manufacturers are willing to share the expense of advertising and enter into cooperative arrangements with their customers. By dividing the cost, the store can make better use of its budget, and the manufacturer has the opportunity to make certain that his line is being featured by the store.

4. The most important medium for fashion retailing is the newspaper. It requires little lead time for publication, can be placed to reach a defined market, and is relatively inexpensive in terms of the numbers reached.

5. Television is used sparingly by the fashion retailer. Aside from its cost, it generally appeals to too wide an audience, many of whom are too far from the store to make purchases. When it is used, it is generally to announce sales.

6. The fashion show is one of the more important promotional devices used by the industry. The events may be extravagant productions or parades that feature models on a runway.

7. Companies like Bloomingdale's and Neiman Marcus regularly use storewide campaigns and celebrations to promote themselves. Both of them have programs that salute foreign countries and their merchandise.

8. In order to get their names in print and on the air, the larger fashion retailers have public relations departments that prepare press releases and press kits for publicity purposes.

For Discussion

1. Which departments are part of a major store's promotion division?
2. Describe the operation of the advertising agency and how it receives its income.
3. In addition to the ad agencies, what other external sources are used by the retailer to promote his or her organization?
4. How does a promotional advertisement differ from one that is institutional?
5. Give an example of an advertisement that combines promotional and institutional concepts.
6. Is it possible for a retailer to place ads that cost double the store's budgetary allowance? How?
7. Define the terms "ROP" and "preferred position."
8. What benefit does the advertiser get from utilizing the milline rate formula?
9. How does SRDS serve the retailer?
10. In what way is the formal fashion show different from the fashion parade?
11. For what purposes do fashion retailers use in-house video?
12. Why are designers willing to take time from their busy schedules to make personal appearances in stores?
13. Discuss the use of demonstrations in fashion retailing.
14. Describe Neiman Marcus's Fortnight celebrations.
15. What is an institutional promotional event?
16. Is "free" publicity really free?

The Kensington Kloset is a modest size boutique that specializes in upscale fashion. The majority of its merchandise is custom designed by its owner, Jim Sanders. Using talents that were honed by attending a well-known fashion school and working as an apprentice for a clothing designer, Jim has achieved moderate success in his own shop.

The shop is located off the beaten path and out of sight of a potentially large market. Customer recommendations are the basis of his business.

With little money to spend on advertising and promotion, the company's potential is quite limited. Some of his friends who work for major organizations have suggested that he use the cooperative advertising route. Since most of the items are his own creations, there is not enough business with one manufacturer to make this a viable approach. The major newspapers are out of the question

because of cost, and magazine and television advertising is impractical for his operation.

Questions

1. Should Jim be satisfied with his success and forget about promotion?
2. What would you suggest, in terms of advertising and promotional devices, that would be within his reach?

Langham and Dover is a traditional department store that has been in business for 52 years. Since its inception it has regularly examined its merchandising philosophy and has made changes where necessary. In the beginning it featured an equal assortment of hard goods and soft goods, but has gradually shifted away from furniture and appliances to concentrate on the more profitable soft goods categories. While the merchandise mix has drastically changed, the store's approach to advertising has not.

Many of those in management positions in the promotion division have been with the company for as long as 40 years. While they are technically trained specialists who have served the company well, their creativity seems to have stagnated. The traditional approaches to advertising are still employed, and little excitement has been obvious in their campaigns. Change might not have been as crucial if the merchandise assortment was still heavily concentrated on hard goods, since there is little change in those offerings. Now, however, with the emphasis on fashion, a more contemporary approach to advertising is imperative.

Top management has considered replacing those responsible for the ad programs, but their longevity in the company does not make this possible.

In approximately six months Langham and Dover will be opening a new branch. Its design was created by one of the best architectural teams in the business, the location promises to be a winner and the market to be served is fashionable and affluent. Management does not have enough confidence in the department to risk having the "regulars" prepare the campaign to announce the new store.

Questions

1. Would you alter the internal staff in any way?
2. What other suggestions might you make that would help solve the company's problem?

Exercises

1. Collect 10 retail fashion advertisements from newspapers and magazines and categorize each according to its type. The three classifications to use are promotional, institutional, and combination. Each ad should be mounted and then discussed as to why it fits into the specific category.

2. Using the Standard Rate and Data Service, available at most libraries, look up the advertising rates for three newspapers. Prepare a chart that shows the line rates for run of press (ROP), preferred position, and regular position placement for each publication, and the circulation of each. Using the appropriate information, prepare each newspaper's milline rate.

3. For an end of the semester activity, the class should develop a runway fashion show to raise money for a charity. Many stores will gladly provide the clothing for such a purpose if they receive the proper publicity. The class should be divided into groups with each handling a different aspect of the production such as development of the concept, model selection, acquisition of props, writing commentary, publicity, store liaison, and so forth.

 The production could take place on the campus or in the store. Tickets could be sold with the proceeds going to a specific charitable organization.

Visual Merchandising

Learning Objectives

After reading this chapter, the student should be able to:

1. Define the term "visual merchandising."

2. Discuss three major means by which retailers carry out their visual merchandising plans.

3. Differentiate between window displays and interior presentations.

4. List and briefly explain the various elements that are incorporated into visual presentations.

5. Explain the design principles that are incorporated into the displaying of merchandise.

6. Tell about the use of themes in display.

When shoppers look at the windows of Barney's, New York, Henri Bendel, Lord & Taylor, or Neiman Marcus, they are immediately treated to a visual delight. The originality and excitement generated by such creative displays promptly motivates the observer to enter the premises. What else can better whet the appetites of those seeking fashion than distinctively styled visual presentations? The sameness of merchandise offerings, customer services, and fixturing often make one store indistinguishable from the others, but with imaginative visual focusing retailers can lift themselves out of the pack and make the customer aware that there is something special about their store.

The spell cast by fabulous window displays should be continued inside of the store, and wherever the shoppers visit they should be greeted with an environment that enhances the merchandise offered for sale. It is the visual merchandising team that is charged with the responsibility to take the reins and present the store and its product mix in the best possible light.

In retailing's past, the display personnel's responsibility was generally limited to the installation of formal window displays, dressing mannequins in the windows and store interiors, preparing signs and price tags, and selecting props and materials that would be used in the presentations. Today the scope of the "trimmers" or display persons' activities has been significantly broadened. While a great deal of their time is still occupied with decisions concerning formal window and interior displays, additional attention is focused on designing the store interior and windows, selecting of merchandise fixtures that will be used to house the fashions, and planning how the store's fashion image will be projected to its audience.

Display departments have been replaced by visual merchandising departments that are often headed by people at the level of vice president, which indicates the importance of the function to the store.

The manner in which the visual merchandising function is carried out in fashion retailing depends upon the size of the company and its budget. Each approach will be discussed along with such areas as window and interior presentations, the elements that comprise each of the displays, how the principles of design are applied to visual merchandising, and the various types of themes that are employed to present the merchandise in the best possible settings.

Responsibility for the Visual Merchandising Function

Fashion retailers are generally more dedicated to visual presentation than are any of their counterparts such as supermarkets and appliance stores. Visits to large and small fashion retailers alike reveal that large sums are often expended to capture the shopper's attention. Whether it is at Christmastime, when the largest dollar amounts are expended, the introduction of a new season, or at such times as Mother's Day, it is quite obvious that visual merchandising and display is considered essential to generate business.

The accomplishment of the store's visual tasks is generally achieved by one of three means. Full-line and specialized department stores usually employ in-house staffs for their programs, chains generally subscribe to the centralized management of the visual function, and the small entrepreneurs often rely upon freelancers for their needs.

In-house Staffing: The Department Store Approach

The major department store organizations such as Marshall Field, Macy's, Dayton Hudson, Bloomingdale's, Nordstrom, Saks Fifth Avenue, and Carson Pirie Scott have full-time staffs that develop and execute their visual merchandising pro-

grams. A visit to any of these stores immediately reveals the scope of their involvement. With the advent of a new season or the beginning of a special holiday selling period, these visual teams transform their environments almost overnight from one theme to another. In early March Macy's, in its New York City flagship store at Herald Square, sheds its lackluster pallor of the winter sales period and refreshes itself into a gardenlike habitat bursting with fresh flowers and plants. The doldrums of early November, a typical downtime for fashion selling, are replaced with excitement at every major department store with the lavishness of

FASHION RETAILING SPOTLIGHTS

MR. GENE MOORE

Tiffany & Co., which enjoys a unique position in retailing, has an equally unique display director heading its visual department. With magnificent, elegant, original jewelry designs central to its merchandising mix and a clientele that is affluent as well as sophisticated, the approach to display cannot be mundane or that which is acceptable at most other stores.

After spending many years at illustrious stores like I. Miller, New York, Bergdorf Goodman, and Bonwit Teller, Gene Moore joined Tiffany & Co. as its display manager and divisional vice president in 1955. Born in Birmingham, Alabama, in 1910, his reign as a display director is unparalleled in the fashion retailing industry.

His displays of silver, jewelry, china, and crystal for Tiffany's are known for their dramatic effects through the use of scale change, lighting, and the juxtaposition of opposing elements. His windows include commentary on current events, the fine arts, and social phenomena. He is noted for his ability to interpret his themes with wit and irony. An Easter window that featured real, artistically cracked eggshells, a simple straw basket that served as the home of an emerging silver snake belt, and a ball of twine that was used as the resting place for a diamond brooch are all displays that typically show his genius.

Not only does Mr. Moore continue to head the display team at Tiffany's at age 81 as of this writing, but his marks in visual design and accomplishments are without equal. Among his many accomplishments are the design of unique Christmas tree displays for the Seagram Building in New York City, design of the party decor for President Kennedy's honoring of the president of Pakistan, exhibition designs for the American Museum of Natural History, sets and costume designs for the London and American stage, posters and costumes for the Paul Taylor Dance Company, and photographs of numerous celebrities. For his accomplishments Mr. Moore has had more honors bestowed upon him than any other visual merchandiser.

As the "dean" of visual merchandising, he is regularly hailed as the one of the world's greatest design geniuses in trade publications and such books as *The Art of Gene Moore*, *The American Store Window*, and *Show Windows*.

gold ornamentation, twinkling lights, and tinsel, all heralding the coming of Christmas.

Headed by a visual merchandising director or vice president, in-house staffs prepare for their assignments with the same dedication as fashion designers who are preparing for their latest collections. Teams of prop builders, signmakers, painters, carpenters, photographers, and trimmers work diligently to make each presentation equal to or better than the one that preceded it. Armed with the

brightest talent in the visual merchandising field and fortified with greater budgets than any other classification of retailing, the in-house staffs are responsible for putting the store's best foot forward and distinguishing it from all of the other retail operations in the trading area. So distinctive are the workings of these in-house staffs that many have recognizable "signatures" similar to those of the fine art community. The work of Gene Moore, the display director for Tiffany & Co., for example, is immediately recognized by the professionals in the field.

Centralized Management: The Chain Store Approach

The size of chain organizations ranges from a two-unit company to those that have well over 1000 stores. The approach they take to visual merchandising is unlike that of the department stores.

Small chains often utilize one or two individuals who go from store to store installing window displays and making interior merchandise changes in counters, showcases, vitrenes (glass display cases used for small, formal presentations), and other fixtures. Their efforts generally center upon changing the merchandise displays rather than drastically transforming the store to depict different seasons.

Larger chain organizations often subscribe to the practice of centralized visual merchandising. The concept involves a very small professional display staff that operates from the company's headquarters. A team headed by a visual merchandising director plans each window and interior presentation. After the designs

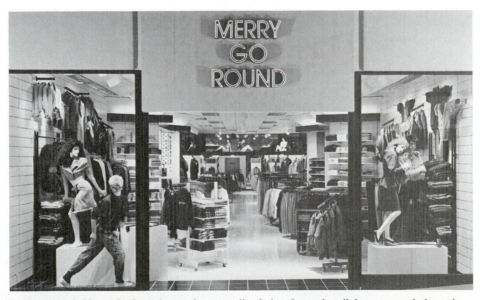

Figure 13-2. Merry Go Round uses the centralized visual merchandising approach throughout its organization (Courtesy of Merry Go Round)

have been executed in "sample" windows and interior spaces, they are photographed. The photographs, accompanied by some props, materials, and instructions, are then forwarded to the individual units of the chain for use in the installation of the displays. So carefully executed are these visual merchandising plans that they are easily installed by the store manager or assistant.

This route is utilized for a number of reasons. First, it saves a considerable amount of money with the elimination of professional trimmers. Second, the practice guarantees the uniformity of visual presentation throughout the organization. Third, it allows the central office to quickly make changes throughout the company without sending trained professionals to each store. Stores such as Casual Corner and The Gap rely upon centralized visual merchandising for their stores.

Free-lancing: The Small Store Approach

Some of the smaller fashion retailers prefer to make their own visual changes. A creative entrepreneur may learn about visual merchandising through trial and error or might acquire some technical knowledge through classroom instruction. Many of these small businesses have such a small amount of space for visual presentation that the use of a professional would be unwarranted.

Many of these merchants, however, prefer to use the services of professional free-lancers. These are individuals who provide the props, make merchandise changes, and alter the store's fashion image through effective visual programs. They are paid on a fee basis and usually contract with individual stores for one-year periods.

The Environments of Visual Presentation

Visual merchandisers function in two separate store environments: the windows and the interiors. Each is used to capture the attention of the shoppers and motivate them to purchase merchandise.

Windows

As we learned in chapter 6, "Designing and Fixturing the Fashion Facility," retailers have a host of window structures available to them for the display of their goods. Whichever models are chosen, the function of each is the same: to show passers-by the store's merchandise in the most motivating settings.

Small stores have one or two window spaces to feature formal displays while the largest fashion retailers in their downtown flagships have as many as 100 or

more. Whether it is the small retailer or its giant counterpart, planning the use of these windows is imperative to the success of the store's visual program.

Every major retailer prepares window schedules that indicate the dates of each display, the merchandise classification to be featured, the nature of the background props and materials, the length of time of the installations, and the exact location of each window or display case. Many develop window schedules for six-month periods.

By carefully addressing the scheduling, buyers are able to plan the arrival of merchandise that is to be featured in the displays to coincide with the allocated time as indicated in the window schedule agenda. Since the visual team only has the responsibility of enhancing the merchandise, it must work closely with the buyers to make certain which fashions will be featured and how they can best present them to the shoppers.

The most extravagant window displays are those that adorn the major fashion department store flagships. Usually located in busy downtown areas where pedestrians continuously pass the windows, management allocates significant money for these displays. They bring the image of the store to the passers-by and hope that they will be sufficiently motivated to come inside for a closer look. Windows of this type are generally changed weekly so that a different merchandise classification can be presented to the public.

Figure 13-3. Lord & Taylor's Christmas window created by Spaeth Design (Courtesy of Spaeth Design)

When fashion retailers such as Lord & Taylor, Saks Fifth Avenue, Marshall Field, Jordan Marsh, Nordstrom, and G. Fox want to make an impact on the public with imaginative displays, they head immediately for Spaeth Design. In business since 1945, the company has long been considered one of the top firms in the creation of exciting visual decor for the leading retailers. One look at the moving mechanical figures dressed in period costumes reflecting fashion from other eras in Lord & Taylor's Christmas window tells why Spaeth commands such attention. These are not the typical installations that are constantly turned out by visual teams but works of art that draw crowds wherever they are featured. In New York City, the Lord & Taylor and Saks Fifth Avenue Christmas windows, created by Spaeth, receive attention similar to that of the famous Christmas tree in Rockefeller Center. With a staff of the most creative and innovative designers, artisans, and craftsmen, they regularly execute visual presentations of distinction.

The founders of Spaeth Design

are Walter Spaeth, a man well into his seventies at the time of this writing, and his wife Dorothy. Rounding out this "mom and pop" operation is their son David. Although they specialize in animated displays, seasonal trims and decor, and store planning, the company's forte is the Christmas period.

Not long after the remains of winter and the preceding Christmas have faded, it is time to begin again for the next Christmas period. With about 90 percent of the company's business realized from Christmas promotions, the Spaeths are ready to greet the retail industry's major visual merchandising proponents in the early spring so that their plans can be incorporated into new themes that will be ready for installation around Thanksgiving.

Around the beginning of July, after continuous planning sessions between Spaeth designers and store visual planners, the ideas are usually finalized. The themes run the gamut from the traditional to those that are high-tech, with the dominant feature in most being the miniature mechanical figures. Since the development

and creation of the various displays are the combined efforts of the store's planners and the Spaeth team, the results are totally different for each store. The actual installation of these displays requires the hands-on efforts of the store and Spaeth.

By November about thirty carpenters, painters, and welders are working diligently to meet their deadlines. At the very last moments Spaeth employs many unskilled workers to put the finishes of sparkle dust and other coverings on the displays. Just before Thanksgiving teams of Spaeth designers depart for Chicago, Kansas City, San Francisco, and wherever else the orders came from to install their creations. Just before Christmas Day the Spaeths close up shop and inspect the stores close to home such as Lord & Taylor and Saks Fifth Avenue to check their work.

One look at their magnificent presentations indicates how creative Spaeth Design is. The continuous increase in their business indicates the company's success.

Many fashion giants such as Neiman Marcus, Nordstrom, Saks Fifth Avenue, Lord & Taylor, Macy's, and Bloomingdale's spare little expense when they are designing their major window presentations. Whether it is a merchandise presentation that features specific fashions or an institutional endeavor that concentrates on image, the planning is as painstaking as many theatrical presentations. Spaeth Design is a visual company that creates unique displays for such windows all over the United States.

Stores in malls usually have less formality in their window presentations. The windows are smaller and sometimes are just enormous glass partitions that separate the shoppers from the store's interior. Much less attention and expense go into this type of window display. It might merely be the use of a few mannequins that are regularly changed and the incorporation of some props that are indicative of a theme or season.

Interiors

For many years retailers have disproportionately allocated the monies for window and interior visual programs. The drawing power of the window as the merchant's silent seller was reason enough for those showcases to receive the lion's share of the visual budget. Today, however, with less and less space allotted for formal window structures and their importance being diminished because many shoppers come directly from parking fields into stores that are void of showcase windows, the interior spaces have taken on new importance.

Interior visual merchandising goes far beyond the installation of carefully executed displays. While much of this is still significant in many of fashion's leading shops, a great deal of attention has been focused upon the effective presentation of merchandise that beckons the customer.

The Gap has decidedly transformed its operation from one of moderate success to one that is enormously profitable due, in part, to its visual merchandising approach. The merchandise is carefully folded, neatly stacked in abundant quantities that are color coordinated, and featured on three-tiered, diamond-shaped, self-service fixtures. The merchandise is regularly rotated with new styles replacing the older ones that have been moved further back into the store. This type of visual merchandising always presents the latest to the shopper in an exciting manner. The entire store is a full-color picture, with each style having its own place on the selling floor.

Another direction for interior visual merchandising is the **environmental** concept. Stores like Banana Republic and Aeropostale use such an approach. Instead of relying upon seasons or changing themes for their stores, these companies build their units with specific themes in mind. Banana Republic, for example, creates an atmosphere that immediately transforms the selling floor into a travel

and safari environment. Since the merchandise carried by the company is virtually all travel and safari oriented, the surroundings are used to enhance the fashions. Thus the merchandise and the arena that houses it become one theatrical setting. Aeropostale, borrowing from the environmental idea that was initiated by Banana Republic, builds selling units that immediately give the shopper the impression of early air travel. Replete with replicas of old flying machines and other aviation memorabilia, the merchandise that is oriented toward that period is greatly enhanced by its background. The use of the environmental concept eliminates the need for constant change of props and materials and thus significantly reduces the monies that the stores spend on display.

Although the approaches embraced by The Gap, Banana Republic, and Aeropostale serve their needs very well, they are not necessarily appropriate for all retailers. Most companies have constantly changing merchandise mixes that require different types of visual presentation. Depending upon the season, a selling space could be used to feature swimsuits only to be used at another time for winter outerwear. In such cases, the visual teams are called upon to provide the appropriate settings for the merchandise of the time.

Some retailers make enormous investments in the props and materials used for storewide promotions. Bloomingdale's regularly presents extravagant storewide celebrations that feature the merchandise from different countries. In order to enhance these fashions, visual merchandisers spend countless hours transforming their selling floors from routine environments into places that recall the country being featured in the promotion.

Whatever the approach or the size of the company, more and more fashion merchants are realizing that visual merchandising can provide a sales arena that distinguishes their stores from the others.

Elements of the Visual Presentation

Whether it is a formal window display, the creation of interior environments for a major fashion promotion, or the featuring of a specific style in a department on a mannequin, many elements must be properly coordinated to maximize the visual effect. These elements include the merchandise, materials and props, lighting, color, signage, and graphics.

The Merchandise

First and foremost in any visual presentation is the merchandise that is being offered to the shopper. Too often those responsible for display forget that they are supposed to present merchandise in the best possible way and proceed to develop

concepts and themes that overpower the fashions. The store is trying to sell merchandise, not props and background materials.

The best approach is for the visual planner to meet with the buyer or, in the case of the small retailer, the free-lancer should pay a visit to the store before deciding upon the next season's window background. In this way the specific items can be examined and the proper vehicle for their promotion can be created. A display cannot be considered appropriate if the shopper cannot immediately determine what is being sold.

Most of the major fashion retailers have forms that are filled out by the buyers that accompany the merchandise to the visual merchandising department. These forms require information about the items such as material, construction, price, or whatever else might play a part in the display. If the actual merchandise is not available, and the presentation is one that will require a substantial amount of time to prepare, photographs, drawings, and discussions are appropriate substitutes.

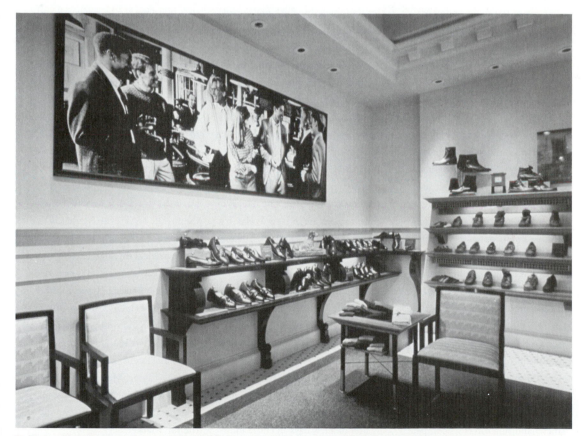

▌ Figure 13-4. Ordinary props, when used in an unusual way as in this Macy's display, take on an exciting look.

Materials and Props

Once the merchandise has been examined, it is time for the visual team to determine how best to show the items to the shoppers. Some budgets are sufficiently large to enable the staff to purchase the most sophisticated and costly props.

The major trade association for visual merchandising is the National Association of the Display Industry, better known as NADI. It is an organization whose membership is composed of the most important and influential companies in the field of display throughout the world.

In addition to sponsoring semi-annual shows around the globe in which vendors feature their lines of mannequins, fixtures, lighting systems, computerized sign-making equipment, supplies, and materials, NADI is the group that brings attention to the latest innovations of visual merchandising and bestows awards to the field's most notable participants. Separate awards are presented for distinctive achievement in full-line department store and chain displays, large specialty stores, specialty chains, store planning, and industrial retail management. Visual merchandising directors compete

for these awards, which are considered to be this industry's equivalents to the Oscars, Tonys, and Emmys.

While the accomplishments of the deserving are recognized with such awards, the emphasis of the shows that NADI sponsors is on presenting display-oriented products to retailers. Hundreds of manufacturers prepare magnificent exhibits that are observed by thousands of retailers of every size. The largest of these exhibits are in New York City. The spring show features Christmas materials and supplies, with the December convocation offering the latest in display merchandise for spring and summer.

By attending these unique display shows, visual merchandisers are able to compare the various lines in much the same way as the buyers in their stores who purchase merchandise at the garment trade shows. In a matter of a few days an entire indus-

try's offerings can be evaluated and easily purchased.

Those who are already engaged in the field or students who wish to pursue visual careers make use of two services offered by NADI. A resume exchange service is available to receive resumes from job seekers or written requests from merchants wishing to hire new employees. NADI then sends the resumes to all of the stores that have requested them. The NADI Job Market is another service that is offered at the major regional meetings and exhibits. The program is free and is designed to bring potential employers together with those seeking positions in visual merchandising. Such major fashion retailers as Nordstrom, Rich's, Neiman Marcus, The Limited, Lord & Taylor, Merry-Go-Round, and Casual Corner often seek visual merchandisers by participating in the Job Market.

While these display pieces are often elaborate and functional, they are not always the ones that generate the most excitement. Household objects, antiques, and items pulled from the junkpile might be effectively used to enhance merchandise. It is the knowledgeable and creative visual team that knows what is best suited for a particular display.

Most larger retailers with their own visual merchandising staffs prepare budgets for six-month periods. A significant part of the money is earmarked for materials and props. Sometimes the giants in the industry build their own pieces, while other times it is the prop manufacturer that is visited to purchase various elements.

In order to learn about what industry has to offer, most retailers send representatives to display trade shows such as NADI, the National Association of the Display Industry.

Mannequins

A visit to such fashion emporiums as Henri Bendel, Neiman Marcus, Bloomingdale's, Bergdorf Goodman, I. Magnin, and Bullock's immediately reveals the diversity of mannequins being utilized by visual merchandisers. The plain, expressionless models that once satisfied the needs of the display world have been replaced by forms that are true works of art.

Just as there are different fashion directions taken by apparel designers and merchants, there is the same diversity in mannequin design. While the traditional models are still the most extensively used, stylized versions are readily available to fit the most unique requirement.

Those responsible for the purchase of mannequins often approach their task with the same enthusiasm and care that is exercised by the store's buyers. They

Figure 13-5. Diversity in mannequin design provides additional options for visual merchandisers. (Courtesy of Adele Rootstein)

Figure 13-6. An alternative to a regular mannequin (Courtesy of Neiman Marcus)

must work within the framework of a budget, consider the image of the store that they represent, examine the offerings of the marketplace, evaluate what is available in terms of quality, durability and flexibility, and make certain that final choices meet the store's merchandise needs. For example, while athletically built male models are quite fashionable, their presence in the window of a conservative men's shop would not foster the store's image and properly feature the merchandise.

The best way to purchase mannequins is through market visits. Although photographs give the purchaser an indication of appearance, they do not provide enough information to make a meaningful purchase. Careful physical examination of forms will give insight into the moveable parts that are necessary to facilitate

merchandise changes, the weight of the forms, the quality of their cosmetic applications and wigs, and so forth. If the retailer is not conveniently located near the regional display markets, they might wait until a NADI show or other trade presentation is offered so that many vendor's products could be quickly evaluated in one place. Those who choose their forms via the mail order route will rarely do service to their companies.

Lighting

That narrow, intensive beam of light that settles on a fashionably dressed mannequin accentuates and dramatizes it as nothing else can. The tiny, sparkling bulbs that grace the majestic Christmas trees at holiday time in store windows and interiors transform the most mundane models into enchanting presentations. The exciting dimension attained with the use of artistically crafted neon designs turn interior spaces into lively sales arenas. With comparatively little expense, lighting has been successfully used by visual merchandisers to enhance an otherwise unexciting display.

In order to achieve the best lighting results, it is imperative to have full knowledge of what the field has to offer and how to utilize these tools to their best advantage. For example, will the use of the latest generation of fluorescent lamps and their advantage as energy savers satisfactorily illuminate a general area with the same results achieved by the use of incandescents? Will colored bulbs or the use of colored gels over white lights intensify the merchandise's coloration or radically change it? Can lighting fixtures be adapted to accommodate patterned templates? Without the complete technical comprehension of lighting and light sources, the desired effects will not be accomplished.

Color

The use of a single red dress in the midst of an all-white window will generate excitement and help focus the viewer's attention on the colored merchandise. The striking contrast of reds and greens will intensify both colors in a manner that cannot easily be achieved by any other means. The feeling of warmth that is imparted by a swimsuit department's interior that utilizes amber in its color scheme quickly creates a suitable mood for the shopper.

These are but a few simple examples of how visual merchandisers with the proper color utilization can quickly and inexpensively create moods and capture the customer's attention. The appropriate use of color affords those responsible for visual merchandising an easy way to make their windows and interiors attractive and distinguishable from the competition.

The visual merchandiser's cue for color selection must first come from the merchandise. Oftentimes prints or patterns inspire the trimmer to select a particular scheme. Seasons too might reveal the color approach that could be taken. When planning an autumn display, the rusts, oranges, and yellows of the turning leaves immediately provide nature's color scheme on which a display might be based. The colors of the American flag quickly supply the colors that can be utilized in a nautical setting. Sometimes, the selection of colors is not so obvious and necessitates the use of technical theories to provide schemes that are attractive and correct.

The theory of color and appropriate selection is based upon a number of different methods. The most widely used involves the color wheel. When the wheel's three primary colors—yellow, red, and blue—and secondary colors—orange, violet, and green—or variations of them are used in particular arrangements known as schemes, the results are pleasing to the eye. Most seasoned display personnel are so familiar with the standard approaches that the wheel has to offer that they automatically proceed to make their color selections without constant references to the wheel. For the novice, however, attention to the wheel and an understanding of the color guidelines will help to create color harmonies of distinction.

The "Rules" of Color

There is a host of color schemes or arrangements that are simple to extract from the color wheel. Each scheme is based upon a specific color or set of colors and their placement on the wheel.

The simplest to use is the **monochromatic** arrangement. Employing only one color or "hue" the technical name for a color, the visual merchandiser might plan a window that features only red. While this might seem to be a sure way to create monotony, various tones of reds may be incorporated to provide variation and interest. Whites and blacks, technically considered to be neutrals, can also be added for variety, while still producing a monochromatic effect.

Analogous colors are those that are adjacent to each other on the wheel. This scheme enables the trimmer to develop a presentation that has more than one color. Fashion designers often use analogous arrangements in their fabric designs, making it easy for the display person to carry out the color story in a visual setting. As with the monochromatic harmonies, variations of the colors along with whites and blacks can be added for interest.

The use of two colors that are directly opposite each other on the wheel results in a **complementary** color scheme. When reds and greens are placed next to each other in a setting, the colors intensify. When intensity is the goal, no other scheme can accomplish this.

Other arrangements include split complementaries, using one color and two others that are on either side of its complement; double complementaries, involving two sets of complementary colors; and triads, schemes that use three colors that are equidistant from each other on the wheel.

One rule that should always be remembered when applying color to a display or interior is that the merchandise is the most important element and that color should only be used in a manner that makes it an enhancement rather than a distraction.

Signage and Graphics

In any fashion premises, attention is quickly captured by a wealth of signage and graphics. They are used to direct the shopper to a particular area of the store, alert the observer that a special designer's collection is featured, announce the celebration of a special event, call attention to a cosmetics demonstration, make individuals aware of special sales, or merely call attention to merchandise prices. Whatever the reason, today's fashion retailers are making more use of these devices than ever before.

Figure 13-7. Signage used to feature a designer name in a display (Courtesy of Marshall Field)

The types of signs and graphics are numerous and are available from many different sources. Some of those that are currently favored by fashion merchants are **backlit transparencies** that incorporate photographic transparencies and lighting to produce a striking vibrancy; banners, made of fabrics or plastics for permanency or paper for brief usage; wall signs comprised of metals and woods that delineate departments; valance signs that conceal light fixtures; glass signage that is used directly on the store's windows; and pennants that are inexpensively constructed from felt, plastic, or paper.

The major retailers usually have in-house sign shops which regularly produce a variety of signs. The types of products created in these shops range from the paper variety, which are used for short periods of time, to the more extravagant glass, wooden, metallic, or plastic variety. The production of almost any type of signage has been made possible through the use of computers. The installation of such equipment inside of the store's visual department has reduced the expense of outside acquisition and has decreased the amount of lead time necessary for outside sign production.

For smaller fashion merchants sign acquisition is best achieved through utilization of the professional sign shop or from merchandise vendors who often provide a variety of signage for their own products.

Whatever the route taken to sign procurement, the visual merchandiser should be aware of the technical elements incorporated in these tools. Layout, letter style, artwork types, and so forth should be carefully selected so that the store's image and messages will be properly delivered to the shoppers.

The Principles of Design

Once the display's environments have been targeted for specific events and promotions and the various elements that are to be used in the presentations have been selected, it is time for the installation to take place. Whether the task is to prepare a setting for the smallest interior niche or one that is as monumental as a Christmas window display, the principles of design must be carefully coordinated.

Visual merchandisers address the same design principles such as balance, emphasis, proportion, rhythm, and harmony as do interior and apparel designers. The satisfactory execution of these principles, coupled with imagination and the creative use of props and merchandise, will result in presentations of distinction.

Balance

The concept of balance is one that involves the eye to get the impression of the equal distribution of weight. Visual merchandisers are less concerned with

absolute balance, which scientifically assigns exact weight to two sides as in the case of a balanced scale. The effect that they are striving to achieve is one that gives the illusion of equal distribution.

In order to assess the balance of a display, an imaginary line may be drawn down its center. The pieces on one side should give the impression of "weighing" the same as those on the other. A formal approach to balance, and one that is simpler to achieve, is called symmetrical balance. It involves the use of identical pieces on either side of the display's central point. A mannequin on one side, in such situations, is balanced by another on the other side. The end result is satisfactory in terms of perfect execution, however, such usage often tends to produce lackluster, unimaginative results.

The more exciting, creative method employs asymmetrical or informal balance. While the design still demands concentration on weight distribution, the

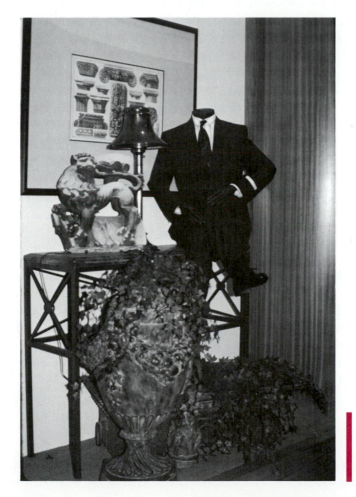

**Figure 13-8.
Merchandise and props asymmetrically balanced (Courtesy of Neiman Marcus)**

pieces in the display do not mirror each other on the two sides of the imaginary line. It is this artistic use of merchandise and props that brings interest to the window or display fixture.

Emphasis

Every installation requires an area of interest to which the shopper's eye will be drawn. Keeping in mind that the retailer is first and foremost in business to sell merchandise, the professional visual merchandiser must make certain that this area of emphasis, or focal point, must be something that is being offered for sale. While some props are excellent attention getters, they should never steal the thunder of the merchandise.

Emphasis can be achieved in a number of ways including the use of a contrasting color for one item, spotlighting a mannequin while the rest of the window is dimly lit, or presenting an abundance of a particular item as The Gap does in their interior displays.

Proportion

The size of the elements in any presentation should be in proportion to the space in which it is being featured. Very tall human forms should not be incorporated into low windows, for example, and small jewelry pieces should not be shown in oversized spaces. The eye can quickly detect when the proportion is inappropriate and this may cause the shopper to misjudge the merchandise.

Rhythm

If the observer concentrates on only one portion of a window or interior display, failing to examine everything that is being featured, the presentation has not achieved its goal. In order to encourage the eye to move from one object to the other until the total offering has been examined, a sense of rhythm must pervade the display. Rhythm can be achieved by numerous means including the use of a linear element such as a garland that passes through the merchandise, stacking many of the same items, or alternating two contrasting colors.

Harmony

If all of the other design principles have been carefully executed, then the visual offering will achieve a harmonious effect. That is, the merchandise will be featured

Figure 13-9. Shirts, ties, and braces create rhythm in display. (Courtesy of Neiman Marcus)

in a setting that addresses balance, emphasis, proportion, and rhythm and will be enhanced through appropriate lighting, fixturing, signage, and other visual elements.

While many of the design principles are easy to master and functional displays not difficult to install, it is the creative talents of those involved that break the rules and produce effects that sell the merchandise.

Maximizing the Visual Program's Success

It would seem logical to conclude that when large sums of money have been budgeted for visual merchandising and significant planning has preceded the use of the funds, then the end result would be installations of distinction. This is not always the case. If the visual merchandise manager in the largest company or the entrepreneur in the smallest boutique does not pay strict attention to details, the visual program will not deliver what it is potentially capable of doing.

In order for a program to achieve maximum success, a checklist outlining basic visual rules and regulations should be developed and religiously adhered to. The areas of concern that follow include some of those that are most often mishandled or ignored.

Maintenance of Display's Component Parts

A chipped mannequin, burned-out spotlight, unkempt wig, or other unsightly element of a display can cause a distraction and minimize the effectiveness of the entire presentation. Before any display is installed it is essential that the fixtures and props are repaired and freshened, lighting is checked to make certain that it is functioning properly, merchandise is carefully pressed, and every part of the display is cleaned. It is sinful and wasteful to take the latest fashions and present them in settings that do not provide them with the proper surrounding enhancements.

Prompt Removal of Displays

If you have ever looked into a store window the day after Mother's Day that still features fashions for that event or have noticed interiors that still have the Christmas look long after the holiday has passed, then you have come upon retailers who are guilty of doing a disservice to their visual program. While the day after Christmas might not give the retailer ample time to install another display, two weeks with the display of the season or holiday passed is just too long.

Fashion retailers are always moving from one season to the next and must use every day to alert their customers to the next event. While the days leading up to Valentine's Day are big-volume periods for some stores, once the day has passed displays featuring that type of goods are of no importance.

Signage used for brief promotions should be removed once the event has passed. When a store is offering a three-day sale and prices are reduced 25 percent for that event, leaving up such signs after the promotion could cause problems for the merchant. The excuse of "That sale is over" is a poor way to cement good customer relations and might result in selling the merchandise at the lower prices past the sale period.

Displays must be timely to bring maximum profits to the store.

The Daily Walkthrough

Most fashion merchants use interior displays to attract the customers' attention once they have entered the store. Some use mannequins right on the selling floor or counter displays that are within easy reach of the shoppers. At the end of the day, most of these installations have been touched by passersby.

Stores that use these point-of-purchase displays must make certain they are readjusted each day. By establishing a walkthrough schedule, trimmers can evaluate each presentation and make the adjustments necessary for restoring the display to its original freshness. If this is not attended to each and every day, the featured merchandise will no longer be appealing.

Maintenance of Self-selection Merchandise

More and more retailers are subscribing to the use of merchandise fixtures that invite the shoppers to handle the items that are featured on them. When the goods are meticulously stacked and color coordinated, they have enormous visual appeal. Stores like The Gap and The Limited utilize this approach in all of their stores. In order to keep these areas attractive and tempting, they must be adjusted regularly. The Gap, in particular, pays strict attention to such merchandise presentation. Employees on the selling floor are constantly refolding sweaters and tee shirts and aligning them according to color. If this maintenance concept is not strictly adhered to, the stores would become a jumble of merchandise and the visual effect would be lost.

Rotation of Merchandise

It is very important that every piece of merchandise is within reach and view of the passing customer. Since some locations in the department are better than others, it is important to rotate the inventory so that each item can for a short period of time have the best location. One approach might be to place the newest arrivals at the entrance to the department, within easy customer accessibility. Whenever new merchandise comes onto the selling floor, it can be featured in the best spot, replacing what has been there for a week or so. By doing this the department is always putting its best foot forward and telling the customer that it is constantly updating its inventory.

It is the attention to such details that makes one visual team more effective than the other and the store's premises and merchandise more appealing.

Small Store Applications

While it is quite obvious that the small retailer has neither the financial resources nor the creative visual specialists that are found in the larger organizations, it does not mean that distinctive displays and merchandising presentations are out of their reach. Even the smallest fashion merchant can afford the expenses associated with superior visual merchandising if they carefully prepare themselves for the task.

If cost is a factor, then the visual merchandising and display function should be attempted by the store's owner, manager, or someone else who serves the store in another capacity. Preparation for such an endeavor may best be served by participating in a visual merchandising course. All of the elements concerning interior and window installations such as color selection, use of lighting, use of the design principles, and so forth can be mastered in such a course. The lessons learned can then be adapted to fit the individual's store.

Once the installation techniques have been acquired, additional expense could also be reduced or completely eliminated through the use of borrowed props or those reclaimed from the junkpile. Antique stores, for example, are wonderful places from which distinctive props can be loaned. With an agreement to give the antique store credit for the props in the store window, the deal is usually consummated. Old picture frames, sporting equipment, trunks, and other treasures are often found in attics or second-hand shops and are available at little cost. With a bit of cleaning or repainting, the oldest articles can be transformed into distinctive props. Many fashion merchants have a flair for transforming commonplace objects into outstanding display pieces.

A great number of small fashion retailers choose the route of hiring free-lancers to install their displays. These individuals will not only perform the trimming function but will also provide the props and other background materials necessary for the installations. If such people are hired, their work should be assessed through inspection of portfolios, examination of windows and interiors that they have created, or discussion with other clients. In this way the retailer can determine if the trimmer's approach is appropriate for his or her store. Like visual merchandisers in major companies and designers of clothing, the free-lancers have specific "signatures" which might or might not be right for each store.

Whichever approach is taken by the small merchant, care should be exercised to make certain that the displays are timely, the merchandise chosen for each is carefully selected, and the backgrounds that are used in the presentations are enhancements that do not overshadow the merchandise.

Highlights of the Chapter

1. The visual merchandising task is generally approached in three ways. The major fashion-oriented department stores utilize in-house staffs for their stores, chains often subscribe to the centralized approach, and small fashion merchants usually resort to the use of free-lance trimmers.

2. The use of centralized visual merchandising provides the chain organization with a program that guarantees uniform display work throughout the organization without incurring enormous expense.

3. Visual presentations are utilized in two store environments: windows and interiors. The former motivates shoppers to enter the store by providing merchandise in settings that enhance the store's image, while the latter serves as the enticement to convince the shopper to take a closer look at the goods at the point of purchase.

4. In order for a visual presentation to produce satisfactory sales results, all of the elements of the display must be carefully coordinated. It should always be kept

in mind that the merchandise is the display's most important element and all of the other items are merely there to make the merchandise more exciting.

5. Color and lighting are two elements that, when soundly used, can make even the most mundane setting come to life.

6. The professionals in the visual field execute their window and interior installations with care, always bearing in mind the principles of design such as balance, rhythm, emphasis, proportion, and harmony. In this way the end results always meet the standards established for effective display.

7. A visual program's success can be maximized by making certain that the display's component parts are in good order, presentations that are no longer timely are removed, interior settings that are easily handled by customers are regularly adjusted, and self-selection areas are always being refreshed.

8. Visual merchandising is available at little cost to the small retailer who might otherwise shy away from it because of insufficient money. With the use of borrowed props and refinishing items pulled from the junkpile, the smallest store, without much expense, can create distinctive displays.

For Discussion

1. How has the display person's role been broadened in today's retail environment?
2. Which type of retailer uses in-house staffing for their visual merchandising function?
3. What are some of the areas of responsibility for the in-house visual team?
4. Define the term "centralized visual merchandising," and describe how it is employed by fashion retailers.
5. If the smaller retailer wants to utilize a professional trimmer but is unable to afford someone to work exclusively for the store, what approach is taken?
6. Why has there been a decrease in the use of window displays by department stores and other retail operations that have units in regional malls?
7. Describe the environmental concept that some fashion merchants are subscribing to, and name two companies that use the approach totally.
8. List all of the elements of a visual presentation and briefly discuss the importance of each to the overall success of the display.
9. Identify the most important element in a display and explain its importance.
10. How can the fashion retailer get an overview of the display market and satisfy his or her needs with one-stop shopping?
11. Briefly discuss the rules of color.

12. What is meant by the term "backlit transparency."

13. List the display's component parts and tell how they must be maintained to be effective.

14. Describe the walkthrough of the store's trimmer and its purpose.

Oxford and Pembroke is a large fashion chain that has 450 units throughout the United States. They have been in business for 58 years specializing in moderate- to better-priced missy and junior sportswear. Most of their stores are located in the country's major regional malls.

The company's success has been due in part to the fashion-forward merchandise mix they provide for their customers and the manner in which they feature it in their windows and interiors. Most of the stores in the organization are built to "formula." That is, each is a clone of the others with approximately the same general square footage and window configuration. The oldest stores in the company have been refurbished to bring them up-to-date with the newer stores.

O & P, as it is often referred to, has been a family enterprise since it opened its first unit. General management of the company has recently been assumed by one of the founder's sons, Jonathan Pembroke. With Don Oxford and the senior Mr. Pembroke now retired, the company's future is in Jonathan's hands.

Although the store has maintained a healthy profit for all of its years, the new general manager believes that some changes could be made to improve the organization's profit picture. Among the areas where there is a belief that savings could be realized is in visual merchandising. Up to this point the company has employed a number of regional visual teams to install window and interior displays. Each team, comprised of two individuals, is responsible for approximately 10 stores which they visit every week to make the necessary changes. The number of people on the display staff totals 90. While they perform satisfactorily, their cost to the store is significant. Expense is not the only problem. There is no direction that is offered by the company in terms of visual approach, and each team is left to its own judgment and expertise in deciding how to trim the stores.

Mr. Pembroke would like to see a more uniform approach adopted by the company, one that would also provide a savings.

Questions

1. Should management tamper with the company's success by changing its approach to visual merchandising?

2. If a new method is instituted, what direction should it take? Bear in mind that uniformity of design and budgetary savings are essential ingredients of the plan.

3. Are there advantages to keeping the present policy?

Amanda Norfolk has decided to open a fashion boutique with the money that she has just inherited. She is well versed in the fashion field in areas such as buying and merchandising, having spent eight years as a buyer with Dover Fashions, a small specialty chain.

Her previous experience, coupled with her formal education as a fashion major in a community college, has prepared her for most of the tasks she will have to perform personally. Her one weakness is in the area of visual presentation. Having never taken a course in display or participated in her previous employer's visual program, she is not sure of how to approach the situation.

Ms. Norfolk has made the decision to utilize a free-lancer to perform the typical window changes, believing that professionalism is necessary to bring the best results. Although this has been settled, she wants to make certain that the fixturing, props, lighting, and other elements of display reflect her own personal tastes. She does not want these items to be purchased by the free-lancer but feels that such decisions should be her own.

The problem at this point is time. With all of the details yet to be worked out such as staffing, buying, and so forth, she has little time in which to properly scan every corner of the market for her visual merchandising needs. She has agreed to let the contracted visual merchandiser assist her with the selections, but neither has sufficient free time to do a good job. With the need to choose mannequins, display forms, and other elements, it seems to be a problem that is difficult to solve.

Questions

1. How might Amanda Norfolk quickly assess the market and satisfy her needs in a brief period of time?

2. If the free-lancer cannot accommodate her, should she pursue the effort alone?

Exercises

1. Visit a downtown shopping area or mall to photograph fashion-oriented window displays. Select five of the most interesting visual presentations, take pictures, and mount them on a piece of construction paper. Alongside each window write an evaluation of its elements.

2. In groups of three or four, visit local fashion merchants to discuss with them an offer to trim a window or install an interior display. In exchange for the project, the class might encourage the merchant to provide discounts for the participants.

3. On an 8" × 10" piece of construction paper, prepare four "thumbnail" sketches (3" × 3" rough drawings) of a copy card that could be used in a display window. Each of the four presentations should concentrate on the same theme. After consultation with the instructor, the best one should be selected for completion as a copy card. Paste-on or transfer letters may be obtained at any art supply shop and may be used for the project. Those with more artistic capability might try to hand letter the signage.

4. Visit a department store or specialty shop and photograph the different types of mannequins used for the visual presentations. Evaluate each mannequin type in terms of its appropriateness to the merchandise it features.

Selling: In the Store and in the Home

Learning Objectives

After reading this chapter, the student should be able to:

1. Define the role of the salesperson in the fashion retail organization.

2. Describe the characteristics necessary for a successful career in retail sales.

3. List and explain the major steps in a professional fashion retail sales presentation.

4. Explain the various techniques that fashion retailers use to train their sales associates.

5. Prepare a sales demonstration using the five steps necessary to satisfy the customer's needs.

6. Discuss the reasons why many fashion retailers have adopted the catalog method of appealing to the consumer.

7. Distinguish between catalog merchants and retailer catalogs.

8. Discuss how those who use catalogs acquire their mailing lists.

When the salesperson at Neiman Marcus sends a note to the customer just served showing appreciation for the sale or the associate at Nordstrom offers a refreshment to the shopper who needs time to come to a decision, the quintessence of professional selling has been demonstrated. All too often, however, consumers are totally ignored when they enter many stores or are merely greeted with the typical, routine question, "May I help you?" If the response to the question is negative, there is little chance to recapture the customer's attention and make the sale.

The salesperson's indifference in satisfying the needs of the consumer is a problem that plagues a very large number of retail organizations. While selling is not required in self-service stores such as supermarkets or businesses that are oriented toward discount or off-price selling, individual attention is essential for fashion boutiques, specialty shops, and department stores. By demonstrating a will-

ingness to answer questions and make suggestions and by showing enthusiasm for the store and its merchandise, the salesperson can make the store a more profitable venture.

Excellence in selling is not an automatic occurrence. Those retailers who have the finest sales staffs painstakingly prepare their employees before they step onto the selling floor. They provide the proper training and motivation necessary for success while others offer little preparation and incentives to their people and wonder why sales goals are not reached.

Today's retail environment is quite different from that of past decades. Stores are not the hustling and bustling arenas as they once were where many women spent countless hours shopping. More and more women have joined the work force and have little time to spend full days in the stores. With the decrease in customer traffic, retailers must learn to serve those that do enter the store with courtesy, efficiency, and enthusiasm. A carefully developed sales program is a prerequisite for success.

Even when shopping in a store is a pleasurable experience, there are times when a trip downtown or to the mall is inconvenient. To reach those who are unable to shop in person, many retailers have expanded their direct mail efforts to reach the market. Stores that sparingly used catalogs and other brochures at Christmas and for seasonal sales have now intensified their efforts and use as many as thirty mailings a year to reach the customer in the home. Companies like Spiegel that enjoyed a large share of the consumer market without the benefit of stores have found that they have significant competition from new direct mail merchants. The J. Peterman Company, Smith & Hawken, and Harvest Almanac all develop exquisite catalogs bursting with fashion for the entire household.

Whether it is through in-store visits or in-home purchasing, professionalism in selling is the necessary ingredient for a retailer's success.

Selling in the Store

Once the consumer enters the store, it is up to the salesperson to provide all of the assistance necessary to transform shoppers into satisfied customers. Selling, however, is not the only responsibility of the sales associate. While the sale is the primary responsibility, others include the provision of service to make the shopper comfortable, promotion of the store's image, and discovering the consumer's needs so that this information can be passed along to the store's buyers and merchandisers.

Before these roles can be efficiently played, it is imperative that those chosen to do so are equipped with certain characteristics that will make the tasks simpler to perform. Although many qualities are important to successful selling, none is more vital than proper dress and grooming, the ability to communicate effectively, possession of practical and technical knowledge, and the devotion to the company.

Cognizant of the roles employees are called upon to play and the characteristics and qualities needed to render service to the store and the customers, managers must deliver satisfactory training to foster excellence in each sales representative. Armed with all of the necessary background information, the seller is ready to meet and greet the arriving shoppers.

The Role of the Fashion Retailing Salesperson

Only the ill-prepared or less knowledgeable sales associate believes that selling exactly what the shopper asks for is his or her sole responsibility. Those with that mind set need merely to "shadow" the true retail sales associate for a full day to learn what professionalism in the field is all about. Performance of the expected as well as the unexpected duties make up each and every day in the life of a salesperson. A brief survey of the more typical roles played are presented to underscore how vital the seller's part is in the success of a retail operation.

Selling

What is the difference between a sales clerk and a professional retail salesperson? The former simply assists the shopper with selections by directing them to the try-on room, retrieving unwanted merchandise and replacing it on the racks or in shelves, and performing cashiering and wrapping services for goods that the customer has chosen. The latter is a different player in the game. He or she tries to determine the needs of the consumer through specific questioning techniques, suggests merchandise that might meet the individual's requirements, solves problems when the need arises, coordinates and accessorizes outfits to show how they might be enhanced while at the same time increasing the size of the purchase and cementing a relationship that will bring future business to the store.

Customer Service

The services offered by fashion retailers range from very little in the stores that feature price as their forte to an abundance found at the traditionally oriented companies. Many of the services are handled by specialists in the store, and those will be explored in the next chapter. There are, however, numerous ways in which the salesperson can service the customer to make shopping a pleasurable experience and to motivate him or her to become a loyal patron.

Simple courtesies such as providing a chair for a husband to use while his wife is trying on clothing, taking a shopper's coat and storing it until she has finished making her selections, tending to small children when a visit to the try-on room is a necessity, ringing up merchandise from other departments so that

numerous trips to different register stations may be eliminated, and assisting the customer to his or her car if the packages are too cumbersome to handle make customers feel special. Not one of these services is difficult to offer, yet the benefit derived from each could result in customer loyalty.

Promoting the Store's Image

How many times have you heard people say, "I dislike that store, I'll never shop there again"? It is not often the store to which they are referring but the salespeople who are employed there. Many retailers try very hard to project a positive image through the assemblage of an appropriate merchandise mix, creative advertising and promotion, and visual presentations that present the store in an exciting manner. While all of these enhancements are necessary to project a good image, the lack of sales associate initiative and caring could ruin any store's image. Poor dress and grooming habits, discourteous attention to the shopper or the avoidance of contact, inability to properly address customer needs, and tactless outbursts can cause any retailer's image to be shattered. Customer contact is with the selling staff and not the upper level of management by whom the store's mission is developed. Management sets the rules that will promote a specific image, but the sales associates will either promote it properly or destroy it by their actions.

Intermediary between Customer and Buyer

In chapter 10, "Buying Principles and Procedures," we learned how the store's merchandising personnel researches the market, develops a buying plan, and proceeds to purchase the goods that seem most appropriate for the company. While scores of informational reports are generated by the computer that give direction to the buyers on future purchasing, and many external sources such as resident buying offices and reporting services are engaged for additional input, not one source interfaces regularly with the consumer as does the salesperson.

Computers can tell you which styles sold best, which colors outdistanced all of the rest, which price points brought the greatest profits, which sizes remained for markdowns, and which silhouettes were preferred. They cannot provide information on what was requested by the customer that the store did not stock and why sales were lost. The salesperson is the intermediary between the shopper and the buyer. They hear about the likes and dislikes, the merchandise wants and needs, and anything else that is on the consumer's mind.

Buyers who are knowledgeable understand the vital role played by sales personnel in terms of merchandising and regularly approach these individuals to learn what other sources of information cannot provide about the customer.

Characteristics of the Professional Seller

Specific qualities and characteristics separate the average salesperson from the outstanding performer. Some people believe that the best of the lot have natural ability and are born salesmen. While some people may in fact have a natural affinity for selling, others can learn to refine their craft by investing time and effort to acquire those characteristics that are obvious in the most successful sellers. The consummate professional sales associate possesses many significant attributes that enable him or her to produce revenue for the store.

Appearance

Each of us has an individual philosophy about how we want to look. This individuality is what makes us different from the next person. Although this freedom to express ourselves, in terms of appearance, is appropriate for social engagements and after-hour activities, there are certain rules to which we must adhere in the workplace. Most of the major retailers have established dress codes that mandate a certain appearance. These are not formulated to foster the impression of cloning but to make certain that the store's image is favorably advanced.

The first impression that the salesperson makes is not with motivational greetings or through the display of technical knowledge. What we see as we are approached by a salesperson is his or her clothing and grooming. If the individual's appearance is offensive, the customer might be dissuaded from making a purchase.

Fashion retailers in particular are very concerned with the manner in which the staff dresses. Since fashion is the essence of their business, they must insist on proper wardrobes and grooming that will enhance their merchandise offerings and make the customer feel comfortable. Although there are certain standards for acceptable dress in fashion-oriented stores, there are variations on the standard theme. A conservative store might require more rigidity in terms of outfitting and hair styling, while the upscale, avant-garde organization might allow for a more contemporary approach. The popularity of beards and longer-length hair has caused many merchants to adjust their philosophies on appearance and permit the once-taboo styles as appropriate dress. If, however, the store's typical customer is a staid, traditional individual, such freedom of dress expression will be frowned upon.

Some fashion merchants encourage their sales associates to wear the store's merchandise by allowing them a significant discount. Ralph Lauren, in his flagship store on New York City's fashionable Madison Avenue, goes one step further to motivate the staff to purchase and wear Lauren-designed apparel and accessories in the store. Each employee is given a monthly dollar allowance towards the purchase of anything that could be worn to work. Not only does wearing the store's clothing provide a safety net for proper appearance, it shows the prospective purchaser how the merchandise looks on the figure. Shoppers will often ask

where the salesperson bought his or her outfit. If it is in stock, an easier sale can be accomplished.

Communication Excellence

Those people who have the ability to communicate properly have a distinct advantage when it comes to selling. They make their points succinctly using appropriate language that will help to gain the shopper's confidence. When the spoken word is effectively utilized, the seller's image is quickly enhanced.

Not everyone possesses a natural ability to communicate effectively. Some speak in colorful slang that has little place in the business world while others lack the knowledge of proper grammar usage. Since selling is a communicative task, the refining of one's language tools is essential.

There are many ways in which to improve communication skills. Colleges offer various courses that range from learning the basic skills to persuasive speaking. Courses are given at language centers that help people with a variety of communication problems such as heavy accents. For those with little time for formal instruction, a wealth of audio and video tapes is on the market that addresses every aspect of proper voice and speech.

Knowledge

While proper appearance and communication excellence are essential characteristics with which to successfully approach the shopper, the salesperson must possess sufficient knowledge about the product, the store, and the customer to make selling easier. Armed with such information, the seller can immediately answer questions, handle customer objections, and successfully close the sale.

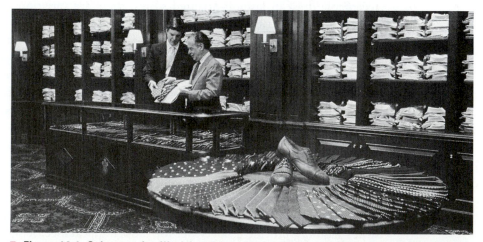

Figure 14-1. Salesmen familiarizing themselves with tie and shirt coordination to better assist customers and generate more sales (Courtesy of Neiman Marcus)

Consumer knowledge is imperative so that the salesperson can be prepared to properly motivate the individual. By fully understanding the many theories that focus on consumer behavior, better assessment of needs is more easily accomplished. Chapter 3, "The Fashion Consumer," explored all of the theoretical approaches to understanding the consumer's actions.

Knowledge of the store's philosophies in terms of fashion, pricing, and services is are essential so that they can be used during the selling process. Such questions concerning special orders, delivery, credit, merchandise returns, alterations, prices, and special customer services should be quickly and satisfactorily addressed. The sales associate who must stop to learn the answers to such questions without having them at his or her fingertips is apt to lose the customer's confidence. All of this knowledge is easily obtainable through a number of sources. Such information is usually disseminated during new employee orientation sessions, through the use of store handbooks and manuals, and through discussions with management.

At the core of any sale is product knowledge. While the articulate saleperson can use language to encourage purchasing, a lack of merchandise information can be the cause of failure to close the sale. Bluffing and misrepresentation might convince the customer to buy, but it might also result in merchandise returns and loss of customer loyalty.

The acquisition of product knowledge may come from a variety of sources. Designers of fashion merchandise sometimes provide store sales personnel with information about their collections on video tapes that feature runway shows or fashion parades. Usually complete with commentary that centers upon style description, fabrication, and price, the presentation makes the seller aware of what to use when selling the items. By being able to replay the tapes until the concepts are fully appreciated, the salespeople can avail themselves of the information whenever time allows.

Some manufacturers provide pamphlets, videos, and brochures that offer advice to the store's sales staff on their lines. Swimsuit manufacturers, for example, have supplied stores with literature that describes the proper techniques used to assess the various body shapes and problems and which styles would be appropriate to satisfy specific needs.

Some colleges offer product information courses that provide the technical insights of such fashion merchandise as shoes, apparel, gloves, jewelry, and other accessories. Not only is style addressed in these classes but so are the methods of manufacturing and the key benefits of each to the consumer. On a less formal basis, seminars are often conducted in the store by fashion directors who bring the latest in fashion news to the store.

A simple way in which to gain an insight into various product classifications is to examine both consumer and trade publications. Such magazines as *Harper's Bazaar, Glamour, Elle,* and *Vogue* regularly feature the latest and "hottest" trends along with commentaries by knowledgeable editorial staffs. Since these periodicals

are earmarked for the consumer, the salesperson can learn what the customer is being tempted to buy and can be prepared with information on the styles that are being featured by the press. Trade publications such as *Women's Wear Daily* and the *Daily News Record* feature future news on women's and men's fashion. Since the information provided is more technically oriented than that found in the consumer magazines, the salesperson can learn all about fabrication, color trends, fashion innovation, and other items that will help prepare for professional selling.

Being able to discuss why one shoe manufacturing process is better than another, which fabrics will withstand creasing and perform more effectively for travel, how garments should be cared for, why 14-karat gold is more costly than gold plate, and which product will provide more comfort for the wearer will make selling a simpler task.

Company Loyalty

All too often sales associates are either unfamiliar with their store's mission or are too disinterested to find out about it. The individual who demonstrates a sense of loyalty to the company and carries out its message is the one who is most likely to succeed. A sense of integrity is necessary to perform satisfactorily. The seller who jumps from company to company just because of small salary increases or better hours is not a loyal employee. By the time the individual learns about one store he or she is ready to move on to the next challenge. The person who establishes longevity with a merchant and capably spreads the store's image to the customer will prove to be an asset.

Sales Training Methodology

One of the criticisms of most retail organizations is that the people on the selling floors are ill prepared for their tasks. Too often the time devoted to training ranges from a mere few hours to a couple of days. In that time most attention is paid to store policy and procedures and little to selling preparation. If the store is primarily self-service where salespeople generally function as cashiers and wrappers, then minimal training is adequate. When the key to success for a fashion merchant depends upon working with individual customers to motivate purchasing, then more attention to selling is a requirement. Proper sales training involves a number of approaches including the use of role playing, video cassettes, on-the-job methodology and vestibule training.

Role Playing

The training that most parallels selling on the floor is role playing. Under the watchful eyes of a human resources specialist or a seasoned salesperson and an

audience that is usually composed of other sales trainees, individuals assume the roles of customer and seller. They are given a situation involving the sale of a specific item and proceed through the various stages necessary to close the sale. At the conclusion of each demonstration the "salesperson's" performance is evaluated. Areas such as appearance, language usage, greeting the customer, displaying the merchandise, handling objections, and attempting to close are critiqued by both the trainer and the audience. The audience is called upon to make suggestions and give constructive criticism under the direction of the seasoned expert. Not only does the role player learn about the positive and negative aspects of the presentation but those who are to follow with their own "sales" gain significant knowledge to apply for their own use.

Many companies use evaluation forms for such training. The forms are completed by the observing novices as well as the sales trainer. These are then given to the individual who was evaluated to keep for further reference.

Some merchants utilize video recording, which permits specific analysis of each stage of the demonstration. After the tape has been reviewed and discussed in terms of strengths and weaknesses, it may be retained by the participant for future review.

Video Cassettes

Professional video cassettes are readily available from a variety of companies. They provide all of the information necessary to make a sale beginning with appropriate dress and culminating with the customer's purchase of the merchandise. Fashion retailers may choose tapes that fit their store's image and selling philosophy. The following are some of the reasons for the use of such materials.

1. The expense is relatively modest.

2. Individuals can replay the tapes as often as deemed necessary for refinement of the selling task.

3. It is unnecessary to assemble a group for a seminar on selling.

4. Employees may take the cassettes off the premises to use at home.

5. The expense of sales trainers may be reduced.

On-the-job Training

While the aforementioned techniques might prepare the beginner for the task, there is no substitute for the selling floor. Some merchants assign their new employees to mentors who work with them in real situations, evaluating their performances, assisting them with problems, and providing direction when the need arises. Learning from the experienced seller can provide an invaluable experi-

ence for the less-seasoned worker. The choice of those who will act as trainers, however, must be made with care. A dedicated, professional salesperson will be a good role model. Those who take their jobs less seriously and utilize shortcuts in servicing the customer might teach unfavorable practices to the newer employee.

It is important for those who are selected to perform the mentor function to remember that their responsibility is to train and not to become involved in the sale. This could result in a decrease in the trainee's morale and might cause discomfort to the customer. An important part of these programs is the use of written evaluations. Those being trained might use them for honing their skills while management might utilize them to assess progress.

Vestibule Training

Selling at the retail level involves more than just making the sale. Tasks that include completing sales receipts, using computerized point-of-sale registers, placing special orders, holding merchandise on layaway, preparing forms for merchandise that is to be delivered to the customer's home, and properly packing garments are practiced every day. Small stores do not have the facilities to teach these routines anywhere but on the selling floor, but their large-store counterparts generally have facilities that simulate the real thing. Vestibules are areas that house counters, computerized registers, and any other equipment that will be used in the store. By making use of these facilities, new employees can be trained without interfering with the selling environment.

No matter which training techniques are used, it is vital for proper teaching to take place. It will instill confidence and eliminate some of the dangers of sending the ill-prepared individual onto the selling floor.

The Sales Presentation

The situation in which the customer approaches the salesperson with merchandise in hand ready for it to be purchased without anyone's assistance is one that retailers hope for. This, however, is not typical of fashion selling except for companies that promote a discount or off-price policy. While some purchases are made without any sales help in the traditional store, this is the exception rather than the rule.

Fashion retailers who operate service-oriented, full-price, traditional businesses rely upon the sales staff to make the register ring. The approaches used by the most successful of the sellers involve several steps or stages before the customer is satisfied. Before these various steps are attempted, the seller should have an understanding of the importance of rapport with the customer.

Rapport is accomplished through the use of a three-pronged approach. By carefully using key words, distinct voice quality, and appropriate physiology

including gestures, facial expressions, and eye contact, the transition from one part of the sales presentation to the next should be easier to accomplish.

The typical steps of any selling situation include approaching the shopper, determining needs, presenting the merchandise, overcoming objections, and closing the sale. It should be understood that not every sale requires attention to each step. There will be no need to overcome objections, for example, if none arise. Another point to remember is that there are times when no amount of professional selling will bring a sale to fruition.

Approaching the Shopper

The timeworn opening of "May I help you?" may bring a negative response, leaving the sales associate little room for additional conversation. In certain situations where the customer shows a need for assistance, however, the approach is appropriate. For the customer who has examined the shoes in a display and, holding one, sits down waiting for a salesperson to retrieve the right size, such an approach is appropriate.

More successful approaches begin with, "Good morning, sir," or "What a lovely day it is." These merely help gain the shopper's attention and could open up a dialogue concerning his or her merchandise needs.

Determining Needs

If the shopper asks for a specific item, then needs assessment requires no additional investigation. There are times, however, when some questions are necessary to uncover the customer's wants. Brief questions or statements might produce results. For example, if the department is one in which designer labels are featured, the seller might talk about the focal points of the best-known designer collections. This might elicit a response from the shopper that could be used to carry on the conversation. Another might concentrate on asking the individual about the purpose of the proposed purchase. "Will you need something for a particular occasion, or is it just to freshen your wardrobe?" This type of questioning requires an answer. After spending a great deal of time on the selling floor, sales associates individualize their needs assessment and use questions or other techniques that become second nature to them.

Presenting the Merchandise

When showing particular styles and models to prospective customers it is important to discuss their features or selling points. This might include talking about the newest fashion trends and how this item is at the center of the concept. Attention might be focused on the item's color and how it is being featured in

Figure 14-2. Sales associate showing merchandise to customer (Courtesy of Neiman Marcus)

fashion magazines such as *Harper's Bazaar, Glamour* or any other that might catch the shopper's attention. If the shopper's concern involves purchasing something for travel, its ease in care and wrinkle resistance should be stressed. If the price has been reduced, attention should be called to the value of the garment.

An attempt should be made to convince the shopper to try on the merchandise if that is appropriate. Once the shopper is in the fitting room, other styles could be brought to him or her that might motivate purchasing. In such circumstances professional sellers are often able to suggest additional items, resulting in a larger sale.

It is important to involve the shopper whenever possible. "Feel the quality of this blouse. Doesn't it feel like silk?" This is yet another way in which to bring the sale closer to completion.

Overcoming Objections

After spending considerable time with a salesperson, looking at the merchandise and asking questions, many people are simply not ready to commit themselves to a purchase. Reasons given for the negative attitude might be excuses not to purchase or they may be real, such as the price being higher than the individual is willing to spend. Whatever the situation, the seller must attempt to handle the objections and satisfy those that are real.

There are several methods used to bring the sale closer to a conclusion when objections have been raised. The **yes, but method** involves agreeing with the cus-

tomer's objection but offering selling points that might turn the objection into a selling point. If the price seems higher than the individual expected to pay, the seller might say, "Yes, it is a little higher priced than you might have anticipated, but the quality and the versatility of the garment will serve you in many different ways. The dress could be used to go to the office and, when properly accessorized, it could be used for social occasions." Other comments using this type of objection intervention might include:

1. You are right, the style is very basic but jewelry and scarfs could be used as enhancements.

2. The cost of the gown might be more than you intended to spend, but the style lends itself to altering for street wear, giving it a longer life.

3. The delivery date for the color you want might require a longer wait than you anticipated, but it will be smashing in that color.

Some salespeople prefer to handle objections by asking questions such as, "Why isn't the color right for the party?" "Which types of fabrics do you prefer to the ones I've shown to you?" and "How much would you consider your limit for a pair of shoes?"

Occasionally there is no basis for the shopper's objection. In such cases the objection might be denied by the seller. It is important to remember to use this technique only when there is absolute certainty that the shopper is incorrect. Examples are "No, we do not charge more for the same items that are carried at the Petite Woman," or "No, the dress will not need pressing, it is constructed with a wrinkle-resistant fabric."

The handling of objections should be delivered in a positive manner and not in one that is offensive to the customer. Some objections simply cannot be overcome, and the door should always be left open for future business.

Closing the Sale

After the natural progression of the stages has been satisfied, the seller should attempt to make the sale. Closes that are attempted before they might seem perfect are known as trial closes. Sometimes the attempt is successful, other times more selling is necessary. While shoppers sometimes close the sales themselves, this is not always the case.

All during the selling process the salesperson should listen for signals that indicate a willingness to buy. They might be:

1. May I leave a deposit on the shoes and pick them up another time?

2. Can it be ordered in my size?

3. Will there be a charge for delivery?

4. Can this be exchanged for another item?

5. Can I get my money back if I change my mind?

Each of these is an indication of real interest and should signal that the shopper is ready to become a customer.

Many times the closing signals are not obvious. In such cases the professional seller uses an assortment of questions or statements, such as the following, to determine if purchasing could be accomplished at this time.

1. Would you like to pay cash or can I put it on your charge account?

2. Could I give you a card to enclose with the gift?

3. How much time do we have to dye the shoes to match your dress?

4. Would you like the black or navy blue skirt?

5. This new ivory shade would be perfect with the ensemble!

Even when many closing attempts have been made, the sale might never come to fruition. Sometimes the individual simply cannot be satisfied. Other times, when additional attempts to close have been tried, the approach could be to involve a department manager or store buyer. This is known as the turnover method. By involving a store representative who has more authority, the customer might feel that special attention has been paid and the sale could be made then.

The most experienced sales associate will tell you that not every sale can be completed no matter how many selling techniques are employed. If this is the case, the shopper should still be handled in a courteous manner to encourage future business.

Essentials of a Successful Sales Program

In order to attract the most talented individuals to join the store's sales staff and to motivate company loyalty, the retailer should consider some of the essentials for a successful program.

Incentives are often the key to success. They might include commission remuneration that motivates the individual to try harder, promotion from within as a reward for satisfactory service, discounts on purchases, recognition seminars that feature prizes for the most accomplished salespeople, and a pat on the back to show that there is appreciation of the sales effort.

Proper training, as previously discussed, is another essential. It gives the seller the feeling of self-confidence that can translate to bigger sales.

Periodic evaluations are a necessity to help the sales associate learn about his positive as well as negative characteristics. A good evaluation program can help build morale and foster employee longevity.

Selling to the Customer in the Home

Reaching the customer in the home is nothing new. In order to attract those who were unable to come to the store to purchase, Sears developed an extensive catalog at the turn of the twentieth century that attracted considerable attention. People who were out of the store's general trading area and those who were unable to leave their homes patronized the company for many of their needs. Today Sears has been joined by many merchants who seek to capture a share of the direct retailing market. The diversity of the mailed materials that regularly enter the home is enormous. Fashion retailers make up a large portion of this ever-growing industry that features merchandise at every price and taste level.

Unlike personal selling, which involves interaction between the seller and the shopper, the sale is made without the benefit of spoken word to answer questions. In order to capture the shopper's attention and satisfactorily address any buyer apprehension associated with this type of purchasing, the direct retailer must painstakingly prepare catalogs that anticipate questions. In addition to showing fashion items in the most exciting manner, answers to questions such as those about delivery, returns, payment methods, and quality must be presented in narrative form to allay any of the fears that might be associated with this type of buying.

Stores that engage in catalog offerings generally develop divisions for these purposes that are separate from their traditional retail operations. The tasks involved in this type of selling include selecting merchandise that will have visual appeal, determining the size and scope of the market to be serviced, establishing an image and style for the catalog, preparing simple instructions for ordering, and providing assurances for guaranteed satisfaction.

Reasons for Direct Catalog Selling

With a major mall, power center, downtown area, strip center, or freestanding store within easy reach of most Americans, accessibility is no longer the motivation to shop by mail. Some of the reasons for the success of merchants selling to customers in their homes include convenience, no-cost ordering, specialized merchandise mixes, special price considerations, courteous servicing, and inadequate availability of in-store shopping.

Convenience

Without leaving the comfort of home, just about any fashion item from a jogging suit to a sophisticated business dress can be ordered quickly. The housewife-turned-business-executive can now simply put her feet up and order anything from a piece of jewelry to an exciting dress by merely using the telephone and the

busy corporate lawyer can purchase a ski outfit from his or her company's headquarters. While shopping was once considered a happy pastime for many people in pursuit of their fashion wardrobes, the problems associated with visiting the

AnnTaylor.

To order your Summer Collection
Call Toll Free **1-800-825-6250**

Name _____

Address _____

Apt. _____ City _____

State _____ Zip _____

Just in case we have questions about your order we request:

Daytime telephone no.

(Home) _____

(Business) _____

☐ Check or money order enclosed.
Indicate amount in U.S. funds.
Please make payable to AnnTaylor. $_____

☐ Please send me an application for an AnnTaylor charge account.

☐ AnnTaylor charge number

☐ American Express

☐ Visa ☐ MasterCard

Exp. date _____

Signature _____

No C.O.D. (Required for all charge orders)

***Please indicate item(s) to be shipped to separate address(es) below.

Name _____ Address _____

City _____ State _____ Zip _____

Item number(s) _____ Your card message _____

Name _____ Address _____

City _____ State _____ Zip _____

Item number(s) _____ Your card message _____

Item No.	Qty.	For A.T. Use	Description	Color 1st Choice / 2nd Choice	Size	Price	Gift Wrap	Total

*Shipping and handling: $5.00 for the first item ordered plus .75 for each additional item. New York residents are required by law to pay sales tax on the total of merchandise and shipping and handling. Residents of all other states please calculate tax based on the merchandise amount.
**The law requires sales tax must be paid on orders being sent to any of the United States listed below.
***There is a $5.00 charge for each additional address you ship to other than your own.

Total Item Cost	
Shpg. & Hdlg.*	
Tax**	
Addl.*** Shpg. Costs	
Total Amt. Due	

States where AnnTaylor stores are located:
Alabama • Arizona • Arkansas • California • Colorado • Connecticut • Florida • Georgia
Hawaii • Illinois • Indiana • Kentucky • Louisiana • Maryland • Massachusetts • Michigan
Minnesota • Mississippi • Missouri • Nebraska • New Hampshire • New Jersey • New Mexico
New York • North Carolina • Ohio • Oklahoma • Oregon • Pennsylvania • Rhode Island
South Carolina • Tennessee • Texas • Virginia • Washington • Washington, D.C. • Wisconsin
If you would like more specific store information, call
1-800-825-6250
We welcome the AnnTaylor Card and the American Express® Card.

Figure 14-3. Catalog order form featuring "no-cost" 800 telephone number (Courtesy of AnnTaylor)

stores are significant. The hassles encountered in trying to get to the store, finding a parking spot, and getting quick attention from the salesperson has made catalog purchasing pleasurable for increasing numbers of consumers.

No-cost Ordering

While all direct retailers offer order forms for their customers to complete, most provide 800-number telephone service for their customers. The 800 number affords the customer immediate access to a store representative at no cost for the telephone call. The elimination of the expense of a long distance call, coupled with the convenience of such ordering, has increased the amount of business that comes from the home and office.

Specialized Merchandise Mixes

Some stores such as Sears continue to feature the department store approach to direct selling. Even Sears, however, recognizes the need to offer specialty catalogs to specific market segments. For example, they distribute a special catalog that features only Western wear. Most direct retail merchants follow the philosophy of the specialty store and limit their offerings to a narrow classification of items. By doing this they can target a narrower market and achieve better sales results. AnnTaylor seeks out the sophisticated female with a busy life-style and offers an assortment of clothing and accessories for work and play. Neiman Marcus, By Mail, as their catalog is known, concentrates on traditional fashion merchandise at a price point that is lower than what is found in their stores, and Patagonia concentrates on active wear with a fashionable flair for the sports enthusiasts.

Special Price Considerations

In order to make shopping at home more tempting, some merchants offer incentives for buying from the catalog and ordering during a particular time period. In a 1991 catalog for Victoria's Secret, the company tried to motivate purchasing by placing the following announcement on their catalog cover:

LIMITED TIME OFFER
Place an order from
this issue by April 19, 1991,
and receive an additional
50% savings on the special
savings certificate inside.

Others offer varying discounts based upon the size of the order, lower prices for multiple purchases of the same item, or special prices on specific merchandise.

Courteous Servicing

Ordering by phone is generally a pleasant experience. Courteous order takers are able to answer any questions about the merchandise, the time it will take to receive the goods, company return policies, and anything else that would motivate purchasing. Some companies provide their telephone order takers with lists that offer special discounts that are not in the catalog, which often increase the size of the sale. Some even train their sellers on how to accessorize the items that have been ordered, also contributing to increased volume.

Inadequate In-store Shopping

The size of many department stores, coupled with inadequate sales staffs, discourages many would-be store shoppers from making the trip. When time is of the essence for so many people, simply finding the merchandise in a brief amount of time presents a challenge. More and more consumers are voicing dissatisfaction with shopping in the store. While some companies pride themselves on customer service, this is the exception rather than the rule.

Types of Catalog Organizations

There are two major classifications of catalog organizations: retailers who operate direct-mail businesses in addition to their stores and companies that opt to sell to the consumers in their homes.

Retailers with Catalog Divisions

Merchants who operate stores develop catalog facilities for numerous reasons. It might be as a means of encouraging business through that medium or a method for motivating satisfied catalog users to visit the store. Some use this route to attract the customer who normally is too busy to visit the store or to recapture the market that once patronized the company's stores but no longer does so. Still others utilize the catalog to offer merchandise that is not sold in their retail outlets.

Victoria's Secret, a division of The Limited, Inc., features a unique approach to capturing a segment of the market. In their stores they concentrate on lingerie and sleepwear and present the various items in a ladies' boudoir setting. In their catalog, however, the lingerie is only part of the story. Along with frilly nightgowns and other intimate apparel, an assortment of sportswear, work clothing, and evening wear complements the nightgowns, pajamas, and undergarments. While such a merchandise mix is not unusual, Victoria's Secret limits their collection in their stores to the intimate classification. Their at-home selling concept is based upon the fact that those who are familiar with their store assortment might be in the market for other types of fashion merchandise.

Today every major department store such as Woodward & Lothrop, Macy's, Marshall Field, Carson Pirie Scott, and Bloomingdale's sends direct merchandise mailings to their customers, and most specialty chains like Ann Taylor and Eddie Bauer do the same.

Direct Retailing Companies

Organizations like Spiegel and Horchow pursue their customers strictly via the direct-retailing route. They have operated successfully in this manner, offering the finest in fashion items long before retailers started to provide them with competition. Spiegel's enormous volume permits them to carry merchandise not available from any other resource. Famous labels like Liz Claiborne, Perry Ellis, and others are found through the merchandise mix but, unlike items with the same names found in stores throughout the country, these offerings are designed exclusively for the catalog. In this way the customer cannot comparison shop in terms of price and is guaranteed a certain degree of exclusivity when making such purchases.

Finding the Right Customer

Merchants who specialize in catalog selling cannot motivate shoppers to buy from them in the same manner as that used by the stores. Retailers use advertising to capture the potential customer's attention and hope to stimulate a positive response by this means. Once the customer is drawn to the store, the salesperson does the rest.

Catalog companies make extensive use of lists reach their target markets. The lists are either internally drawn or externally acquired.

Internal Lists

Organizations that operate retail outlets have a distinct advantage over those that are solely catalog oriented. If the merchandise is charged to the store, there is an immediate record of the individual's name and address that could be used for direct merchandise mailings. Many stores enlarge their own lists by taking the names and addresses of customers who have purchased there for later catalog selling.

Catalog companies often keep records of the past purchases made by customers. They use this information to direct specialized catalogs to customers whose purchasing records indicate a need for some particular merchandise. For example, if a customer orders a petite size from a general catalog, her name would be placed on a customer list of those ordering in this category so that she will receive future mailings of specialized catalogs of petite clothing.

External Lists

Most companies are not satisfied with the lists that have been generated internally and use other means to increase their customer base. Commercial list houses or marketing research organizations are excellent resources from which to acquire lists.

Since names and addresses alone provide little information about prospective customers, those in the business of selling lists have many available that feature specific customer characteristics. The upscale, fashion-forward, direct-mail company would prefer to have lists whose occupants' earnings are within a particular range, whose academic background falls within certain guidelines, whose employment or life-style is compatible with the merchandise to be offered, and whose interests are specifically geared to the merchandise mix. While this seems like a tall order to fill, the professional list houses are able to provide such information.

Some catalog businesses acquire names and addresses through other means. The Ann Taylor booklet regularly offers a $5 incentive for any names supplied by people placing orders. Another means of acquiring an appropriate list is to purchase it from a company that sells compatible merchandise. This is one of the reasons why so many unsolicited catalogs come into the home. Ann Taylor clearly indicates a place on their order form to be completed if the customer does not want her name to be used by other companies. In this way the customer reserves the right to receive any other mailings or not.

Miscellaneous Methods for Reaching the Home

Some sellers reach their markets with the use of cable television and telephone solicitation. While the scope of these activities is nowhere as significant as catalog usage, they nonetheless serve the purposes of some companies.

Cable Television

The leaders in the field are The Home Shopping Network and QVC, which stands for quality, value, and convenience. They are available to viewing audiences 24 hours a day. As a method to motivate individuals they feature games that bring prizes for the correct responses. A few wins give the participant points that may be accumulated towards the selection of a gift. The main purpose of the programs is to sell a variety of merchandise to the television audience. A host of items is sold each and every day at prices that are supposed to be lower than those found in stores or catalogs.

For fashion-minded consumers, QVC offers hourly segments known as "Fashion Coordinates." Jewelry, accessories, and apparel are displayed and featured on live models. Sometimes special prices are used to build greater sales volume.

Although this approach to selling is currently popular with these two pro-

FASHION RETAILING SPOTLIGHTS

THE PATAGONIA CATALOG

If style and artistic individuality are the ingredients necessary to capture the attention of the catalog shopper, then Patagonia has met that challenge. Not only does this selling device feature the most extraordinary merchandise in its classification, it does so in a manner that defies competition.

Patagonia is a company that operates retail shops as well as a catalog division. They sell active sportswear of the highest quality for men, women, and children. It is the catalog and its unique presentation that immediately enhance the merchandise offered inside.

The size of the mailer and the stock used for the pages are both atypical of that which is found in the industry: a 10-by-13-inch format composed of rough-textured recycled paper and graced with a cover that is reminiscent of museum-quality artwork. The recipient is quickly motivated to look inside!

Throughout the booklet an assortment of the company's product line is featured in a range of jewel-tone colors, the Patagonia signature. Each category of merchandise is accompanied by a narrative piece either in poetry form or some sort of format that centers upon an aspect of nature or the seasons for which the items will be worn. The photography not only features the individual items but presents them in nature's most beautiful settings.

The customer is treated to a host of other features such as those that explore the advantages of particular materials, methods of packing for travel, or themes that range from places to visit to how accessories can be used to enhance the merchandise.

While this is unlike anything else in the marketplace of direct selling, the offering is first and foremost a sales tool. It carefully addresses how to determine appropriate sizes with a measurement chart; how to place an order by mail; telephone, or fax; gift wrapping services; return policies; gift certificates; and the availability of international ordering.

To make examination easier, the catalog utilizes a table of contents that immediately delivers the reader to a specific page.

grams, its continued success is questionable. Many of the shows that were on the air are no longer operational. Some, such as those utilized by Kmart and Dayton-Hudson, have ceased their operations. Proponents of this selling methodology point to the fact that more and more families are becoming cable subscribers, broadening the consumer market base.

Telephone Selling

Although their numbers are comparatively small, some retailers use the telephone to sell their products. When fashion merchandise is the product mix, the use of

this method is limited. Not too many items lend themselves to this type of selling. Small stores sometimes use this approach to notify regular customers of specific merchandise that is available. The call might be to inform people of a promotional sale or the arrival of an item that seems appropriate for a specific customer. Sales associates at stores like Loehmann's, a chain of approximately 100 off-price specialty units, regularly telephone selected customers to notify them of the arrival of certain collections.

Large fashion retailers generally shy away from such usage as it is impractical for them to be participants. Some, however, through their personal shopping services use the telephone to inform their very best customers about fashions of interest. The telephone is the perfect vehicle for personal shoppers to contact regular customers. Since files are maintained that keep records of the customer's size, color, and style preferences, price-point requirements, and other pertinent information, such selling could provide positive results.

Fashion retailers must explore every avenue of customer satisfaction to gain their share of the market. Whether it is personal selling or other methods that involve coming into the home, they must choose the ones that best satisfy their methods of operation.

Small Store Applications

When it comes to personal selling, most industry experts and consumers agree that the small store does it best. Unlike the giants in the industry where customer attention leaves much to be desired, the small retailer's forte is personalized service. At the heart of many of these operations is the store's proprietor. He or she oversees the entire operation and is generally on the selling floor for most of the day. In that way, observation concerning the salesperson's approach to the shopper is usually possible, which helps in making an assessment of each sales call.

Training in the small store is usually accomplished on the job and overseen by the owner or manager. Using this approach, the newcomer to sales can learn from those who run the store. Greetings can be experienced firsthand and duplicated when the newcomer's time has come to sell. Merchandise inventories of small stores are narrower than those found in the larger companies and easier to learn.

Many small businesses have the pleasure of servicing regular customers. This enables the seller to learn about the preferences of the returnees, more easily anticipating and satisfying their needs.

Few smaller merchants participate in catalog selling. Their limited volumes and merchandise depth prevents them from becoming participants. Some reach their customers via the telephone. The call might announce a private sale or the arrival of a style that would suit a specific customer's needs. The telephone is a good vehicle for friendly reminders.

Highlights of the Chapter

1. The retail salesperson plays a vital role in the organization, and in addition to selling, helps to establish the store's image and acts as the intermediary between the customer and the buyer.

2. In order to catch the attention of the prospective customer, the sales staff must pay strict attention to proper grooming and dress.

3. Armed with knowledge about the merchandise, the store, and the customer, the seller should be able to answer all customer questions and overcome any objections that might arise during the sale.

4. Training techniques used by retailers include role playing, the use of video cassettes, on-the-job training and vestibule training.

5. A carefully organized sales presentation that addresses all of the stages from approaching the shopper to closing the sale will help the seller conclude more sales.

6. The shrinking market of people who come to the store to shop has caused many merchants to approach their customers via direct selling methods.

7. Catalogs are utilized by stores and direct retailing companies as the most important method to reach their customers in the home.

8. Although not as extensively used as the catalog, some retailers sell to the consumer with the use of cable television and telephone solicitation.

For Discussion

1. Why are many merchants experiencing a decrease in in-store traffic?

2. In addition to selling, what other roles do salespeople play?

3. What very important function does the seller perform for the store's buyers and merchandisers?

4. Describe the importance of appearance and communication ability for the professional sales associate.

5. In what ways can the retailer provide the sales staff with the information necessary for the successful close of sales?

6. Discuss the term "role-playing" and describe how the technique is used to improve selling.

7. Why are video cassettes receiving so much attention in sales training?

8. List the five major steps in a sales presentation.

9. How might the saleperson overcome customer objections? Discuss three techniques that are used for this purpose.

10. Explain some of the reasons why an increasing number of retailers are using direct catalog selling.

11. Differentiate between internal and external lists. Which approach is less costly for the retailer to use?

12. What is meant by the term "direct retailing company"? In what way are they different from the traditional retailer who utilizes catalogs to reach customers?

13. Describe how cable television is used to sell merchandise to people in the viewing audience.

14. How important is telephone solicitation to the fashion merchant?

The Glenmere organization is a small specialty chain that began its operation as a one-unit business. Eighteen years ago, Tom Rogers and Steve Morgan formed a partnership for the purpose of specializing in upscale men's clothing and furnishings. They offered merchandise that might be described as fashion forward, featuring designer collections not found in traditional men's shops.

Both men had selling experience in the field. Tom was the men's wear department manager at a small Northeastern store and Steve sold clothing at Boston's leading haberdasher for eight years. They were both ambitious, knowledgeable, and extremely capable as salespeople.

Since the operation was very small in its formative years, the partners engaged in every aspect of the business. When they were not buying, they spent their time on the selling floor. They employed one other full-time salesman and two part-timers during peak periods. Their day-to-day involvement enabled them to train their salespeople on the job. With two such successful teachers, the employees soon became experts.

After three years, Tom and Steve opened a second store. Each managed one unit, training salespeople the same way they had in their first shop. Again, success was obvious by the volume they achieved. Customers were especially loyal in both stores, and repeat business was always a factor in their success.

By the time they expanded to their present-day situation—owners and operators of six units—the level of personalized customer attention had diminished. The partners were no longer able to spend time at all of the stores and sales professionalism faltered. Some of the sellers were excellent, while others performed less effectively.

Tom and Steve recently realized that their inability to train the salespeople personally, as they had in their earlier days, has impacted negatively on the com-

pany. They would like to return the level of selling to the place that it once held. The size of the business does not warrant a special training program, but something must be done.

Questions

1. Which two techniques might the partners employ to improve selling?
2. Where could such training take place to guarantee uniformity of instruction?

Caroline Fredericks is a small fashion boutique that specializes in apparel for "that special occasion." Brides, members of the bridal party, and invited guests to such affairs comprise the major portion of the store's market. Many of the garments are especially designed and created on the premises while others are offerings from prestigious designer collections.

The success of the store has been based upon the uniqueness of the merchandise, excellent individual attention to the customer, and fine service. Since the store is located off the beaten path, business is generated through word of mouth. Satisfied customers send their friends and relatives whenever the occasion of a wedding arises. Business has been brisk since the store opened five years ago, but Caroline believes it could improve if steps were taken to promote the store.

Caroline believes that a catalog that features some of her merchandise could be used to sell to those who might not have the time to shop in person. She is prepared to call upon a specialist to prepare such an approach to increasing sales volume.

Questions

1. Does Caroline's operation lend itself to the use of a catalog? Defend your answer with logical reasoning.
2. What tool might she employ to reach people in their homes?

Exercises

1. Plan a role-playing demonstration for a salesperson and a shopper in a designer shop. Each participant should assume a part and prepare for it as though it were a real situation. Preparation for the seller should include selection of proper attire, familiarization with the department's product line and services of the store, and anything else that is essential to professional sales. The cus-

tomer should be prepared to ask questions as he or she would when purchasing from that type of retailer.

Once all of the plans have been completed, students should play the roles and have the event recorded on video tape for the class to critique.

2. Write to five direct retailers requesting their catalogs. After carefully examining each one, prepare a report indicating the methods they use to make catalog shopping easier.

3. Visit three stores in your area that have catalog divisions. Select one department in each store and compare the merchandise on hand with that available through the catalog. In an oral report discuss the differences, if any, between the merchandise assortments in the stores and those offered by mail.

15

Customer Services and Credit

Learning Objectives

After reading this chapter, the student should be able to:

1. Explain the reasons why retailers offer services to their customers.
2. List several types of services that fashion retailers provide and which, if any, might bring direct profit to the store.
3. Discuss the reasons for growth in personal shopping services such as Macy's MBA program.
4. Describe various methods of credit offered by retailers.
5. Discuss the advantages of credit card utilization to the retailer and the consumer.

When Henri Bendel, founder of the famous fashion institution that bears his name, personally greeted customers at the door and directed each one to a sales specialist who would satisfy their needs, the epitome of customer service was displayed. Saks Fifth Avenue's dedication to service is evident when members of their prestigious Fifth Avenue Club can call upon personal store representatives to bring merchandise to the home for inspection and possible purchase. Macy's, not to be outdone by the other major fashion empires, provides interpreters for non-English speaking customers. While these seem to be above and beyond the typical ways in which customers are served, the stores that provide such assistance and comfort believe that these are some of the approaches necessary to preserve their images and bring profits to their respective companies.

Throughout the text, many references have been made to the highly competitive nature of fashion retailing and the sameness of the merchandise carried throughout the industry. Attention has focused upon some of the ways in which retailers attempt to separate themselves from the rest of the pack, including the design of elegant surroundings, innovative and imaginative visual merchandising,

MACY'S BY APPOINTMENT

Meeting at 9 . . . plane at 11 . . . no time to shop! Let Linda Lee and her staff of fashion consultants help you. Whatever you need—the perfect gift, one unforgettable dress, even an entire new wardrobe. Macy's By Appointment is a completely complimentary service. Corporate accounts are welcome. Third Floor, Broadway Building. Telephone 560-4181.

CORPORATE GIFT SERVICE

Our expert consultants will help you select client gifts, incentive offerings and service or retirement awards for your company. Just open a Macy's Corporate Account . . . volume purchase incentives and all service amenities are available. Call 560-3620.

BRIDAL REGISTRY

Macy's gift to the bride—a personal bridal coordinator and a computerized, constantly updated record of gifts. A complimentary service. Eighth Floor, Broadway Building. Call 560-4700.

INTERIOR DESIGN STUDIO

The New York apartment is often 5,000 sq. ft. of living squeezed into 500 sq. ft. of space. At Macy's, we can help. Whatever your design problems or goals, we can help you plan and furnish a room or your whole house. Ninth Floor, Broadway Building. Call 560-4153.

AMERICAN EXPRESS TRAVEL SERVICE

Traveler's Aid—at Macy's. Expert travel advice, worldwide booking, and a full range of financial services—personal check cashing, foreign money exchange. We'll arrange for fast replacement of lost or stolen American Express Cards and Traveler's Cheques. 35th Street Balcony.

POST OFFICE

Send postcards home right from Macy's. We have our own full-service Post Office, open weekdays until 5:30p.m. Ninth Floor, Broadway Building.

THE OLD APOTHECARY SHOP

Macy's own country drug store—stocked with vitamins, natural nutritional supplements, natural hair dyes and conditioners. There's even a Caswell Massey corner. And we'll fill your prescription for you while you shop. The Cellar. 560-4567.

GLEMBY HAIR SALON

Expert haircutting, perming, coloring, frosting and manicuring—a bit of luxury, for both men and women. Fourth Floor, Broadway Building. Call 695-4624.

SPECTACULAR SPECTACLES

Fashion for your eyes. Designer frames for men and women—plus dependable optical care. Third Floor, Seventh Avenue Building. 564-5830.

FILM DEVELOPING

Take lots of pictures—then bring them to Macy's! We offer next business-day service, and a full range of supplies: films, flashbulbs, batteries, even videotapes. Main Floor, Seventh Avenue Building.

JEWELRY BROKERAGE

A complete jewelry service—appraisal, brokerage, purchase, consultation and repairs. Ninth Floor, Broadway Building. Monday to Saturday 9:45a.m. to 5:30p.m., Thursday 9:45a.m. to 7:30p.m. 560-3840.

Figure 15-1. Macy's offers a host of services to its customers. (Courtesy of Macy's)

creative advertising and promotion, and professional and dedicated selling. While each of these helps to distinguish the stores from each other, none is more effective than specialized service.

Being able to dine comfortably during a shopping spree without having to leave the premises, having merchandise accessorized with the assistance of a trained fashion coordinator, being able to have alterations completed on short notice when the need arises, and having special hours in which to shop when other stores are not yet open, all make shopping more pleasurable and appealing. These, and many others, are the reasons why some customers can be counted on as loyal followers, regularly returning whenever the need arises.

The one service that is more widely offered than any other is customer credit. While retailers would prefer to receive cash at the time of purchase and avoid some of the problems that accompany the service, its availability encourages people to shop more regularly and often spend more than what was originally planned.

An overview of credit practices will be presented later in this chapter, along with a host of other services featured by fashion retailers.

Customized Services

Fashion retailers in particular often provide customized services for their clienteles. It might be the price points in which they deal, the types of merchandise they offer, the segment of the market they serve, or their geographic location. Whatever the reason, some of the more service-oriented companies develop programs and plans outside the realm of those typically available.

The Special Shop

Because of its proximity to the corporate offices of many companies in downtown Chicago, Carson Pirie Scott initiated a special store within their flagship location that caters to the needs of executives and management-type individuals. The shop, called Corporate Level, not only sells merchandise that is appropriate to this particular group but also offers many services to make the goods more accessible. Fitted with a separate entrance, Corporate Level opens two and one-half hours earlier than the rest of the store and remains open one and one-half hours longer. In this way, the very busy shopper who has the financial resources necessary to buy at the store, as well as the need for such specialized clothing and accessories, can do so at a time that is compatible with his or her schedule. In addition to the extra hours offered, the customer is able to enroll in the "Corporate Level Club," which for a $50 annual fee offers free one-day alteration service, wardrobe consultations at the home or office, a free hairstyling or cosmetic makeover, a garment bag, refreshments at no extra charge while shopping in the department, use of space to conduct meetings, and notification of special sales before others are contacted.

The success of this special shop has prompted Carson Pirie Scott to open spinoffs of the flagship's Corporate Level in locations that are surrounded by major businesses and government agencies.

Personal Shoppers

With less time to spend shopping and little success using catalogs for their purchases, a small segment of the population needs to be satisfied in another manner for their fashion requirements. The answer for many retailers has been to institute a personal shopping service. Typically, customers can call ahead for a store appointment and, at no extra cost, be accompanied by a fashion specialist to help make their selections. There is neither an obligation to buy nor a price level at which purchases must be made.

Macy's MBA program, which stands for Macy's By Appointment, takes the concept one step further. Because for many of their customers time is of the essence when shopping, the personal shopper saves time by preselecting items before the customer arrives at the store. That is, when an individual calls the store and arranges for an appointment, the consultant will discuss personal preferences in terms of style, color, price, size requirements, purpose of the purchase, need for any accessories, and anything else that will be pertinent to the sale. Before the customer comes to the store, the shopper makes a "selection trip" throughout the store, choosing items that seem to fit the customer's request. All of the items are brought to the MBA office where fitting rooms and consultation areas are available for ease in shopping. The need to go from department to department has been eliminated and the customer receives the special attention of a professional. At Macy's the service is for both men and women.

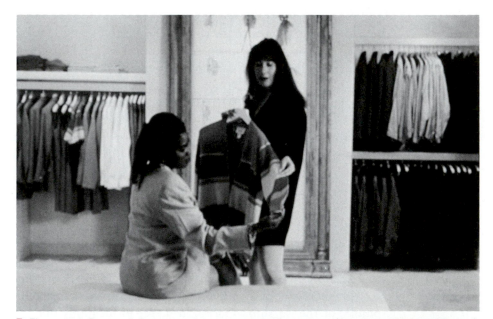

▌ **Figure 15-2. Personal shopper assists customer with purchase (Courtesy of Neiman Marcus)**

Saks Fifth Avenue also features a program that surpasses the traditional personal shopping service. In their Fifth Avenue Club, members are treated to the same courtesies as those afforded by Macy's. However, specialists will assemble merchandise and deliver it to the customer's home for that extra convenience.

Interpreters

Some fashion merchants have the advantage of being located in areas that are regularly visited by tourists. In London, Harrods provides interpreters who speak just about any language. In Macy's flagship store at Herald Square in New York City, a similar program is in place. Without charge, individuals with fluency in many languages will accompany shoppers throughout the store. They will help make immediate alterations available, assist the customer with currency exchanges, and provide anything else that will serve their needs. Macy's interpreters report that this market segment spends more than the average shopper and purchases in a minimum amount of time.

Fitting Specialists

Certain merchandise classifications require special attention to fitting customers. When merchants make an effort to custom fit shoppers who are in the market for swimsuits and undergarments, sales soar. More and more retailers are conducting clinics to train their salespeople on the fine points of proper foundation fitting. Stores like Woodward & Lothrop, Maison Blanche, and Jacobson's report that when fit sessions for bras and other undergarments are held, sales volume increases significantly.

Jacobson's runs full page ads in the newspapers to make the public aware of their staff of trained shape wear consultants. Customers may call ahead for appointments for the service. Instead of customers having to rummage through racks and racks of bras without having an understanding of what is appropriate, the specialists quickly are able to satisfy their needs. The training used by the store involves periodic visits from the various vendors and videotapes that manufacturers have supplied.

Woodward & Lothrop holds "fit weeks." Each season trained vendor representatives visit the store and assist with the fitting of customers. The company reports that this service increases the sale of bras enormously.

Maison Blanche runs these sessions once a month. A manufacturer's representative trains the store's staff and awards those people who have passed a test with certificates. It is these individuals who ultimately offer the service to the customer. Maison Blanche reports that the events are so successful that oftentimes customers stand in line for the specialized service.

Henri Bendel was founded in 1896 as a millinery store on East Ninth Street in New York City. Raised in the French culture of southern Louisiana, Mr. Bendel had an innate sense of style and a deep understanding of the importance of personal service. These qualities quickly allowed him to expand his business, first into furs and then into made-to-order dresses. In 1912, the Bendel store became one of the first commercial establishments to move uptown to the then exclusively residential area of Fifth Avenue and 57th Street.

In its grand fashion emporium, Henri Bendel featured Parisian merchandise that he acquired on trips to Paris several times each year. The world's leading fashion designer collections were introduced at lavish in-house fashion shows that became social events attended by the city's smart set, including women from the New York "Four Hundred" (society's most prominent families) as well as famous singers and actresses.

Throughout its history, unique merchandising methods and attention to service have separated the company from other high-fashion empires. One of its most innovative concepts was the Street of Shops, a series of intimate first-floor boutiques that spilled out onto a main corridor.

This was the prototype for many of the boutique operations that grace retailing today.

Service at Bendel's is a combination of the traditional and the highly customized. It is the unusual efforts that began under the direction of Henri Bendel and continue today that make the store a place for customers to buy exquisite, tasteful fashion while being afforded the luxuries of special service.

In the store's early days, each customer was addressed by name and the sales staff remembered their preferences from past purchases. Unusual custom orders for a customer were commonplace. One client returning from an African safari, where she had bought a cape from an African chieftain, had Bendel's make it into a pillow for her boudoir. A famous opera singer, Geraldine Farrar, had her own dressing room in the store that was decorated with pictures of herself in her most popular roles. The store's cold storage vaults that were primarily used for furs stored the winter outfits of presidents Teddy Roosevelt and Franklin Delano Roosevelt, as well as the wardrobes of the Duke and Duchess of Windsor.

Today's clientele is made up of the famous as well as the regular shopper who seeks fashion-forward merchandise. The services offered

in their flagship—which in 1991 moved into the Coty Building with its magnificent Lalique art-glass windows on Fifth Avenue—are also offered in the other units in Chicago, Columbus, and Boston. They are among the reasons for maintaining a loyal following.

The only American branch of the French spa, the Institut Jeanne Gatineau, is located inside of Bendel's where customers can sample a natural beautifying treatment. The concierge is in her office, available at a moment's notice to arrange for a customer's every whim, be it faxing a sketch of an ensemble to a husband for his comments, or arranging for overnight delivery of the perfect wedding present. Stylists rather than salespeople rove the entire store with customers helping to find the perfect outfits. The doorman will make arrangements for the car to be parked or to hail a taxicab. For the hungry, or those who merely want to rest during shopping, the partaking of Bendel sweets by Guy Pascal at Le Salon de Thé is yet another special service.

A division of The Limited, Inc., since 1985, the store is more than ever committed to excellence in fashion merchandising and service.

The Executive Retreat

Stores that cater to the busiest and most highly paid executives find that it is not the merchandise alone or the everyday services that entice these players to patronize their stores. Bergdorf Goodman's separate men's fashion emporium is a good example of what it takes to lure their customers out of the office and into the store. A special "retreat" provides one of the most complete facilities to service the male clientele. A staff of secretaries is available for dictation, as are fax machines. Food is also served in this area and, for those who wish to sharpen their golfing skills, a putting green is available for use.

Since the majority of men finding shopping to be a chore that interferes with their everyday lives, some stores offer these pleasures and services as an inducement to shop.

Child Care

When parents are accompanied by children to the store, either the amount of time spent for shopping is considerably reduced or efforts are hampered by offspring disturbances. As a means to afford the customer undivided attention, some merchants have organized play areas or baby-sitting services.

The most unique service of this kind in the United States today is the one initiated by IKEA. The Swedish-based company, with several American branches, sells a large selection of fashion furniture and housewares in huge, warehouselike settings. Furniture shopping takes considerable time and concentration and the presence of children during the decision-making process can cause many interferences. IKEA addresses the problem with its Ballroom facility. A large area with its floor covered with thousands of colorful plastic balls and a variety of challenging equipment is set aside for the use of children. The area is guarded by trained personnel who are responsible for the welfare and safety of the children while their parents shop leisurely. Each child is marked with a special tag for identification and is only returned to the parents when matching identification is shown.

Many department stores are also making it easier for parents to shop with their children by building changing areas. With this service, the shopping day can be extended.

Traditional Services

Gift Wrapping

Except for those who operate a discount or off-price business, fashion retailers generally offer gift wrapping services for their customers. The service is sometimes offered free, but oftentimes it is one that generates considerable income for the store.

When the major department stores package the customer's gift purchases with paper that bears the store name, logo, or insignia, the service comes without cost. However, most retailers have gift wrap departments that also provide fancy packaging at the customer's expense. It is this type of usage that often brings considerable revenue to the store.

The stores that wish to generate income from their gift wrapping service often spend considerable effort in the design of papers and ribbons for their packages. Displays featuring these unique wrappings are displayed on the department's walls in order to motivate the customer to use them.

All is not lost if the paper chosen bears the store's own motif. Recipients of these packages immediately know the source of the merchandise and might be sufficiently impressed to patronize the store.

Alterations

The key to the success of many small fashion shops is the availability of alterations. A good percentage of customers require adjustments of the merchandise purchased and expert in-store services motivate them to buy. While these stores are often at a disadvantage when trying to compete with the larger companies, the offer of alterations makes them better able to compete.

Men in particular require alterations for their suits, sportscoats, and pants. Whether it is just a need for shortening trousers or the total adjustment of a suit, men prefer to shop where the service is available.

Some stores charge their customers for tailoring while others offer it as a free service. Some companies, in fact, make a distinction in terms of cost for alterations based upon who is making the purchase. In the very same store, men's alterations are often included in the price of the garment while ladies' apparel adjustments require additional expense.

Delivery

Although most retailers encourage their customers to take their purchases home with them, some people require delivery services. The merchandise might be too cumbersome for transporting it on public transportation or the package might be a gift that must be sent to another person. Whatever the case, large and small stores generally offer the service.

At one time the major retailers in the United States had their own fleets of trucks. Today, however, the cost of such an operation is prohibitive and the use of outside delivery companies has replaced the in-house variety. Companies like

United Parcel Service (UPS) make regular stops at the major stores to pick up packages. The smallest retailer also takes advantage of UPS. Arrangements to pick up packages for delivery can be made by telephone.

Small retailers who do not have the facilities or resources necessary to wrap packages for shipping sometimes use the services of the many small packaging services that are flourishing all across the country. These people pack the goods and select an appropriate delivery organization to handle the shipping. The cost of the service is generally charged to the customer.

With the expense attributed to delivery, even the largest retailers who once offered the service without customer cost have started to pass the expense along to them. Stores like Macy's, Lord & Taylor, and Bloomingdale's regularly charge for delivery.

Eating Facilities

Whether it is the fashionable Le Train Bleu in Bloomingdale's in New York City, where an exquisite meal may be eaten, or in the same store, the less formal Will's Place, where casual dining is emphasized, eating facilities are commonplace in the major companies. While this service is offered to the customers as means of extending the shopping day, many of the facilities are profitable.

The major retailers provide a variety of eating establishments to meet the various needs of their shoppers. Snack bars, expresso dispensaries, dessert counters, and self-service facilities, in addition to full-scale dining rooms, give the customers a choice.

Miscellaneous Offerings

More and more services are being offered to customers. Some of the others that are being featured by the full-service fashion merchants include corporate buying programs where large companies may call the store and have a variety of products such as perfumes, small leather accessories, or other items sent to their customers at holiday times, special shopping hours for the handicapped who need more space to maneuver through the aisles, community centers for charities and other nonprofit groups, use of strollers for children, beauty consultation, and travel services.

Credit is one of the most important of the services offered by both the small and larger companies. Since the service is so complex, it will be discussed in a separate section to follow.

Credit

The use of "plastic" for retail purchases continues to grow each year. In decades past charge accounts were primarily for the affluent, with the vast majority of American customers using cash when buying. Today the picture has changed drastically. Except for some stores that work on extremely low markups, everyone in the retailing game accepts at least one type of credit card. They may be of the proprietary type or the multiuse variety such as MasterCard, Visa, Discover Card, or American Express.

While retailers would prefer to do business on a cash basis, card purchases are generally higher than those with dollar bills. According to a report by the Clarion News Service, a New Jersey-based news gathering organization, there are differences in the amount of each sale based upon the cards that are used. They report that "proprietary card holders spend 212 percent more than bank card customers." A General Electric Capital study uncovered a variety of meaningful statistical data for retailers to consider. In comparing the use of the retail card (the one that bears the store name) for store purchases to the bank, entertainment, and travel cards, the following was reported:

- Average shopping trips per year, per shopper, were about 12, compared to 7.5 for a 58 percent difference.

- Average purchase trips per year were almost 9 versus 4.2, a difference of 113 percent. Apparel shops as a group had an even greater difference with 222 percent.

Although these statistics reveal pertinent information for the retailing environment, other factors must be considered before a determination is made as to the nature and scope of the credit programs to be used.

Why Retailers Offer Credit

We have already learned that one type of card brings greater volume to the stores than others. What is also important for the retailer is that the use of any type of credit generates higher average sales than those made with cash. In addition to this very important aspect of credit card usage, other reasons account for the retailer's involvement.

The store-generated card gives the company regular access to each customer once a month, at the time of billing. Along with the statement that indicates the amount of money owed, the retailer can insert a variety of mailers and advertising pieces that generate additional business. It might be a special hosiery sale for charge customers, the announcement of a private sale, or the introduction of a new designer collection.

The display of a credit card is an immediate signal to the seller that suggestion selling is possible. Customers who are not limited by the amount of cash they have on hand might be shown shoes, a handbag, or other accessory to enhance the ensemble.

Proprietary credit card holders often show loyalty to the stores in which they have accounts. They tend to spend more time in these stores, read the advertisements more religiously, and come to the promotions more frequently.

Why Consumers Use Credit Cards

The reasons why consumers use credit cards are both rational and emotional. Some are based upon logical reasoning while others might provide an image-building motivation.

Safety has become a very real factor for carrying credit cards. There has been an enormous increase in the number of violent crimes that are committed throughout the United States. Shoppers have had their pockets picked and purses snatched, costing them cash that was earmarked for purchases. The use of the credit card enables the individual to shop more freely.

Customers who have store charge accounts tend to be treated better than those who do not. When exchanges or adjustments are sought, the cardholder usually finds the transaction easier to accomplish.

With the use of credit cards, a great deal of direct mail information is generated that might bring special offers to the member. Stores often announce special sales for charge customers only and multiuse cards such as American Express regularly make special merchandise available to their accounts.

When cash is in short supply and purchasing is a necessity, there is nothing like the convenience of the credit card to satisfy the customer. By postponing the payment, merchandise is available even when cash is not. Many companies pay their employees on a bimonthly or monthly basis, which often results in a cash flow problem. The card enables shopping to take place between pay periods.

In order to make a major purchase, such as an automobile or a home, it is generally necessary to finance it. Lending institutions carefully examine the borrower's record before any loan is made. Those who have charge accounts and pay their bills promptly have credit backgrounds that receive favorable recognition at the time the loan is applied for.

Some people are emotionally motivated to obtain credit cards for prestige. The display of an American Express platinum card, or a Neiman Marcus charge card sometimes brings personal satisfaction to those who have them and better attention from those who request pieces of identification.

Better record keeping may be at the heart of some card usage. American Express gold card members receive an annual detailed record of their purchases.

They are listed as totals for each month and cross referenced according to category. Merchandise purchases, for example, are shown as a separate classification. In this way, the user can quickly examine the year's purchases and will have records that might be needed in the future.

Types of Retail Credit

For many years, the only game in town for retail credit was the **proprietary card**. Merchants, both large and small, instituted their own programs and extended credit to those who were considered worthy. In the 1950s the bank cards became the rage. Retailers could either eliminate their own plans, as many small businesses opted to do, or accept the new cards in addition to their own. Some merchants also embraced the travel and entertainment cards bearing such names as American Express and Diner's Club. Today all of these avenues are used to increase sales.

Proprietary Cards

Larger retail organizations, particularly the department stores, offer their own cards to their clientele. Most offer a number of different credit approaches.

"Regular" charge accounts have been a feature of retailers for many years. The customer is able to charge purchases up to a certain prescribed line of credit or credit limit that was established prior to issuing the card. At the end of the billing period, usually thirty days, the store sends the bill to the customer who must pay it in its entirety. For this service, there is no additional finance or service charge.

Revolving credit accounts are extremely popular with consumers and retailers. Unlike the traditional charge account, which requires total payment each month, this arrangement provides the customer with alternative methods of payment. When the statement is received, it indicates the balance due or a minimum that must be payed. If the customer opts for the latter payment plan, there is an interest charge on the unpaid balance. The amount due keeps revolving whenever payments and additional purchases are made. The interest rates are established under individual state guidelines, with the highest hovering around an annual figure of 20 percent. Both retailers and consumers share enthusiasm for revolving credit since it enables those who cannot pay their bills in full each month additional time to do so. The retailer is served by allowing the consumer to continuously buy from the store.

Installment credit is another method by which payments can be made over a long period of time. Reserved for major purchases, such as furs and precious jewelry, consumers enter into an agreement that is separate and apart from other accounts they may have with the store. An item that costs $3,500, for example, must be

paid in a prescribed number of payments. Installment purchases might require a down payment in addition to interest charges. By using this type of credit, consumers still have their charge accounts or revolving credit for other purchases.

Third Party, Multiuse Cards

The popularity of these cards in retailing was first established with smaller stores and with merchants who did not choose to operate their own programs. Since self-run credit is complicated and costly to deliver, third party credit was a natural for these stores. The popularity of the multiuse cards motivated many giants in the industry to accept them along with their own. Among the reasons for their willingness to accept cards other than their own proprietary ones are that some customers prefer to use one card for all of their purchases, and tourists and people from other geographical areas will probably not hold cards offered by stores outside of their regular trading environment.

Travel and entertainment cards were initially intended for use in hotels and resorts. They were soon embraced by retailers who determined the advantage of such cards. With the rigid rules associated with the acquisition of such cards (many people are denied membership), retailers find that these customers often are the purchasers of higher-priced quality items. One of the disadvantages of the acceptance of these cards for payment is the high rate the stores are charged for their use. At the present time the typical charge to the merchant for an American Express purchase is approximately 4 percent, or double the amount required by the bank cards. Other travel and entertainment cards include Diner's Club and Carte Blanche.

Bank cards continue to account for more and more retail business each year. Many major department stores that were once reluctant to accept this credit have joined the fold. Specialty chains are enormous users of bank card credit since few offer proprietary arrangements. MasterCard and VISA, the giants in the field, are companies that engage banks to issue the cards. A consumer applies to a bank for such a card and is either granted or denied its use based upon financial information. Cards that are offered bear the name of the issuing bank. When a purchase is made in a store, the merchant sends the invoice to MasterCard or VISA, and the customer's responsibility for payment is to the bank in which he opened the account. While the retailer pays a charge for the service, as do the consumers, they receive payment promptly and avoid some of the hassles associated with unpaid balances.

Cash reward cards are the most recent entries into third party credit. Similar to the benefits of the bank cards, there is one major distinction that is afforded the consumer. Discover Card, the brainchild of Sears, awards consumers a return of a portion of the money spent with the card.

With all of the advantages associated with bank cards, not every major retailer is convinced of their value. After a two-year test started in 1988, Sears has decided not

to accept them. According to a company spokesperson, "We have a complete, comprehensive credit plan and after a fair trial we found no reason to add other cards. The incremental sales were not enough to offset the cost of accepting bank cards."

At the present time, other retailers are investigating the possibility of adding the bank card as an alternative method of extending credit. Palais Royal and Beall's, Texas-based companies, are testing the need to accept bank instruments. As of this writing the decision of whether to move in that direction has not been made.

Many merchants continue to assess their credit needs and make adjustments when necessary.

Credit Department Responsibilities

Stores that operate their own credit departments are involved in a variety of tasks. They include opening new accounts, authorizing purchases, billing customers, and handling collections.

Opening New Accounts

People who seek store-generated credit cards may visit the store or request that an application be sent to their homes. When retailers are anxious to enlist new card customers, they often send solicitors onto the selling floor. These representatives of the credit departments rove throughout the store trying to motivate shoppers to become cardholders. As a means of motivating individuals to request credit, the stores sometimes offer discounts for the first purchase made with the new card or premiums as incentives.

No matter which route is taken to open new accounts, the prospective candidate must satisfy certain minimum requirements. The application form requests both personal and financial information on which a decision must be made. In addition, stores sometimes conduct interviews with prospects to determine if they have the capacity to pay. Such topics as employment, family income, and residency frequently are pursued at the interview.

If all of the areas of credit concern are satisfied, a credit card is issued. Some retailers, such as Lord & Taylor, offer on-the-spot credit to customers who have other credit cards. The premise is that if a credit card has already been issued, the customer's references have already been checked.

Sometimes stores contact bureaus that keep records of consumer activity in terms of purchasing and reliability of payment. TRW, one of the country's leading agencies for credit analysis, quickly responds to requests from users of the service concerning the candidate's record.

In addition to determining whether or not a card should be issued to the customer, the store must establish a **line of credit** or **credit limit** for each account.

Credit lines are based upon income, assets, and the individual's payment practices. All retailers and bank card organizations set customer credit limits. American Express, however, gives an open line of credit to all of their subscribers.

Once the card has been delivered to the customer, he or she is free to use it up to the predetermined limitations set by the store.

Purchase Authorization

In order to keep tight controls on spending with credit cards, credit departments are called upon to make authorization decisions on purchases. The shopper must present his or her card, which bears the individual's name and account number. When the sale is being recorded and charged to the account, the card is used to verify if credit may be extended. Sometimes credit is denied if the limit has been reached or payment has been slow.

Checking is done in a number of ways. Less sophisticated procedures involve manually checking each account in a book that is periodically issued or calling the credit department when the sale is greater than a prescribed maximum amount. Most major retailers use scanners that automatically determine the shopper's credit position.

When records indicate problems with the account, the shoppers are directed to the credit department for intervention.

This step is very important to any credit program. If it is not properly handled, shoppers who might not have clean records could purchase merchandise that might result in a loss to the store for nonpayment.

It should be noted that in cases where authorization has been denied, the customer must still be handled courteously and tactfully. Sometimes a customer explanation could solve the problem or it might have been an error that caused the problem. Improper attention to customers in these times could result in the loss of customer loyalty to the store.

Billing

Each month the accounts are billed for their purchases. Different methods are used by retailers to collect monies owed.

Smaller retailers who operate their own systems generally bill all of their customers at the same time. With the enormous credit volume transacted by the larger companies a uniform billing time is eliminated in favor of a system known as **cycle billing**. The technique involves dividing all of the store's accounts into groups and billing each at a different time of the month. Customers are generally required to pay 10 days after receipt of the invoice.

Some stores engage in the practice of **country club billing.** Users of this method send a copy of each customer transaction along with the total due. This saves time in that it eliminates the necessity to post each customer transaction to the account.

Descriptive billing procedures are used by most of the major merchants. Computers automatically print customer statements that indicate purchases, balances owed, minimum payments due, merchandise returns, payments received, and anything else considered pertinent to the store and the customer.

Collections

Even the most carefully organized and managed credit systems have customers that do not pay for the merchandise at the time payment is due. Sometimes the customers are slow in sending their checks while other situations indicate refusal to pay. Whatever the case, the credit department is responsible to begin the procedure to collect the monies owed them.

Credit departments establish collections procedures to handle slow or non-payment. Although the store has every right to collect from their customers, courtesy and discretion is the essence of every good plan.

Stickers attached to bills and reminder notices are usually utilized during the first stage in a collection procedure. Appeals are made on the basis of reminding the customer of the bill and suggesting that if it has already been paid, to "please disregard the notice." This usually is sent to the customers when the accounts are approximately 30 days in arrears.

When additional time passes, perhaps 60 days, the appeal is generally a little stronger. Customers are asked to contact the store to discuss reasons for nonpayment. If no response is received in about 90 days, customers are usually notified that their accounts are being closed and are given strong warnings to pay their bills. The use of professional collection agencies and notification of credit bureaus are also mentioned in these appeals.

When accounts are delinquent for longer periods, telephone calls are often the last resort before further action is taken. If there is no success at this point, the files are turned over to the collection agencies or attorneys for legal action.

Governmental Legislation

Prior to the passage of specific credit legislation, consumers were often unprotected when they financed their purchases. In an effort to afford the consumer protection, both the federal and state governments enacted laws that deal with interest rates, guidelines on installment and charge purchase, women's rights to credit, and the handling of inaccurate billing.

Federal Legislation

The most important piece of legislation enacted by the federal government is the **Truth-in-Lending Law**. Passed in 1968, it requires that lenders provide a signifi-

cant amount of information to those making charge and installment purchases. Disclosure must include the annual interest rate, which, before the law, was often omitted from the customer's charge contract. The monthly rate was indicated, but many consumers did not realize that the number had to be multiplied by 12 to achieve the real rate of interest. Thus, interest shown as 1.75 percent was actually costing the customer 21 percent annually. Also included on the bill must be the actual amount of interest for the purchase and how much time is allocated for payment before the interest charge must be paid.

Other federal laws to protect the public include the **Equal Credit Opportunity Act**, which prohibits merchants from denying credit based solely on sex, marital status, race, or religion. It also protects against the discrimination against divorced and widowed women who did not have a credit history because the account was in their spouse's name. The **Fair Credit Reporting Act** enables credit applicants to examine their files for accuracy, and the **Fair Credit Billing Act** deals with customers' rights in reporting billing mistakes and the time allocated for both the customer and the retailer to make the necessary adjustments to the bill.

State Legislation

The federal government does not address the important issue of finance charges. Each state has the right to enact legislation that sets interest rates, and many have laws that do so. Some states also provide the consumer with the right to cancel a signed contract within a specified period of time.

Small Store Applications

While the larger retail organizations hold the edge over their smaller counterparts in such areas as quantity discounts, location supremacy, and credit facilities, entrepreneurs can often make their marks with personalized service.

Fashion merchants in particular can offer the customer many extras that make their businesses flourish. The expert tailor or seamstress is often sufficient reason to maintain a loyal following. While the giants in the industry provide alterations for their customers, the attention is rarely personalized and continuity from one individual is generally unobtainable. Many men and women feel comfortable with their purchases if they have been satisfied with quality alterations for past purchases.

Small stores often keep records of their customers' purchases, which sometimes may alleviate certain fears when buying a special item. A fashion merchant in Princeton, New Jersey, for example, keeps careful records of evening wear sales so that women going to the same social function will not buy the same dress. Such a simple service reduces the potential for two friends to purchase the same dress for the same function.

The telephone can be used by the smaller merchant to notify customers of the arrival of certain lines. By knowing customer preferences, the regular patron can be served personally with a simple call.

While smaller retailers offer credit, very few feature their own financing or charge arrangements. Some entrepreneurs, however, offer house accounts which are finance free and often result in cementing long-lasting relationships with the store.

The best credit arrangements for the smaller retailer are bank cards and travel and entertainment programs.

Highlights of the Chapter

1. It is with the use of special services that retailers can distinguish their companies from the competition.

2. Personal shopping has become an important service in most of the major fashion department stores. Some not only have personnel who accompany the customers throughout the store but establish special areas where merchandise is assembled for customer fitting.

3. In locations where tourists account for significant sales volume, stores sometimes provide interpreters. Shopping is simplified and needs are more easily satisfied when customers are addressed in their own language.

4. Some upscale fashion merchants have set aside areas in the store where their customers can avail themselves of such services as faxing and secretarial assistance. When executives are away from the office, the ability to conduct emergency business could enable the busiest executive to shop in a more relaxed manner.

5. In addition to the customized services that some retailers employ, those that are more traditional are gift wrapping, alterations, and delivery.

6. The advantage of a dining facility provides not only a place for the shoppers to nourish themselves but it also helps to extend the amount of time spent in the store.

7. Credit is a very important service offered by the vast majority of fashion retailers. It fosters customer loyalty, increases the size of the average sale, and helps to develop a mailing list for direct-mail selling.

8. The major fashion merchants provide credit in two ways. They offer propriety cards and accept multiuse cards from third party companies.

9. Credit departments perform a number of functions including the opening of new accounts, authorization of purchases, customer billing, and collections.

10. In order to protect the consumer, both the federal and state governments have enacted credit legislation.

For Discussion

1. Why do many fashion retailers develop customized service programs in addition to those that are traditionally offered?
2. Describe the term "special shop" as it relates to customer services.
3. In what way have stores like Macy's improved upon the personal shopping service?
4. How does the delivery of customized fitting translate into greater sales volume?
5. Discuss the term "executive retreat" in retailing and explain some of the services a major retailer might offer in one.
6. How can the use of in-store child care improve sales?
7. Is gift wrapping merely an overhead expense in most fashion operations?
8. Why do retailers set aside dining facilities for their customers?
9. What are the "traditional" services offered by the vast majority of large department stores?
10. Discuss some of the reasons why retailers offer credit purchasing.
11. Why do so many consumers opt for credit card purchases?
12. Differentiate between proprietary and multiuse credit cards.
13. In what way is the bank card different from travel and entertainment cards?
14. List the functions of a store's credit department.
15. Why has the government enacted financing legislation?

Since 1973 Fashion Values, Inc., has operated stores throughout the East that feature fashion merchandise at prices that are lower than usual. In addition to purchasing a significant amount of merchandise off-price, the store works on a low markup to bring the best value to their customers.

Since it first opened its doors, the company has operated on the basis of "cash only" and has restricted its services to the bare essentials. This philosophy has enabled the company to return a profit to its owners regularly.

During the last few years Fashion Values has witnessed the opening of other off-price stores in their trading areas. While the competition operates on lower prices, they offer some customer services that include the acceptance of third party credit cards. While business has not significantly declined, there are some indications that leaner times might be ahead. More and more customers are asking to charge their purchases, some are asking for liberal return privileges, and many are requesting alterations.

Paul Lindsay, the founder of the business, and his son Jonathan are the general partners. The younger Lindsay joined the company five years ago after finishing college. The two have generally agreed on most of the store's policies, accepting change whenever both felt it would benefit the store. At this time there is a disagreement concerning the handling of the company's competition. The elder partner believes a status quo approach is best, and that the customers who have patronized the store in past will continue to do so. Jonathan feels that a more radical approach is now necessary to meet the competitive practices of the other stores.

"Service will cause prices to rise and will dissuade Fashion Value customers from buying," says Paul. His son is firmly convinced that slightly higher prices will enable them to offer some services and that business would improve.

Questions

1. With whom do you agree? Why?
2. Would additional services necessarily result in higher prices?

The Carriage Trade is a fashionable men's and ladies' specialty store that is located on Chicago's most fashionable street. It enjoys a clientele that is among the area's most affluent and influential. Its customers are primarily business executives, bankers, entertainers, lawyers, doctors, and other professionals. The market served is downtown Chicago and all of its surrounding suburban areas.

Like most upscale companies the bulk of the Carriage Trade business comes as a result of credit card transactions. They operate their own credit department and utilize only two types of proprietary instruments, the regular charge plate and the revolving credit card.

While business has always been profitable, the recently hired chief financial officer (CFO) believes that Carriage Trade is making a grave credit error. He believes that third party credit cards such as American Express and Diner's Club as well as the bank cards will bring additional revenue to the company. The company's principals are reluctant to alter their traditional approach. They feel that the proprietary customer is loyal, likes the prestige of the store's own cards, and that more business is generated in this manner. The CFO argues that the acceptance of multiuse cards will generate additional business.

Questions

1. With whom do you agree? Why?
2. How might the acceptance of additional cards improve business?

Exercises

1. Pretend you are planning to open a high-fashion men's wear store in the city's financial center. The potential customers are affluent executives with little time to spend away from their offices. Although they are preoccupied with their careers, they must dress properly. Make a list of services that you think your store must provide to make the shopping experience pleasurable and appropriate so that they may comfortably leave their offices.

2. Collect five applications for credit cards and assess each one in terms of finance charges, annual costs of membership, and complexity of the forms. Prepare a report that lists in order the cards that you believe are most beneficial to consumer needs, along with the reasons for your conclusions.

Appendix A

Careers in Fashion Retailing

Few careers offer as much excitement and reward as those that are in the fashion retailing environment. Not only does the industry provide a host of varied and interesting positions, but because of the international nature of the field, there are opportunities all over the globe.

Those determined to pursue such careers will be able to find success in both large and small retail organizations as well as in companion industries that service the retailers, such as resident buying offices, fashion forecasters, and reporting agencies. Even those fascinated with the possibility of entrepreneurship may become owners of specialty stores, boutiques, and flea market operations.

Although the smaller fashion retailer provides some opportunity for employment, it is in the larger store, with its enormous sales potential, where most career-minded individuals will achieve success.

Before deciding upon a starting place or a particular job, it is best to explore all of the levels of fashion retailing and the various types of positions available in them.

Small Store Opportunity

While the small store might offer someone a chance to learn about the field by working closely with the store owner, such an environment generally provides little opportunity for advancement. In the vast majority of these operations, the owner is a combination buyer, merchandiser, manager, and promotion planner. He or she is a jack of all trades who makes most of the decisions. The employees who work in these places are usually salespeople. Often, to make matters worse, when and if the owner feels it is time to relinquish the reins, a member of the family is waiting in the wings to take over. If selling is all that the prospective employee is seeking as a career, then this level of retailing might be appropriate.

Entrepreneurship

Many people dream of the time when they can be masters of their own companies. While the thought is exciting, the opening of a small specialty store or boutique most often results in little success. The capital requirements associated with ownership, along with the expertise needed to deal with competition, often turn the most ambitious venture into a failure.

Today's entrepreneur requires significant sums of money to establish a business. The cost of merchandise, coupled with expenditures for fixtures, visual props, construction materials, advertising and promotion, and other initial investments, is considerable. In addition to these expenses, a good location is difficult to find. The better sites are reserved for the giants in the industry because of their superior financial positions. Rarely, if ever, would a mall developer accept an independent as a tenant if a chain operator wanted the same location.

Although the outlook for self-employment in fashion retailing is bleak, there are some opportunities for those still willing to take the risk.

Franchises and licenses are available for those who wish to own their own businesses. While there is some degree of self-employment in franchised and licensed companies, it should be understood that there is little room for creativity for the franchisees or licensees. These stores are "clones" that have been established by a retailer who has had some success in business and wishes to expand by offering specific units to individuals. Company philosophy, merchandising practices, image, methods of operation, and other details are decided upon by the franchisor or licensor. The unit owners merely follow predetermined rules and regulations and keep whatever profits are made by the stores they have purchased. Anyone with the desire to start a business from the bottom up would not be satisfied with the restrictiveness mandated by such retail operations.

With little capital, however, a beginning could be made in a flea market. With modest daily expense, an individual could begin a small retail operation. Some who started this way eventually have opened additional stalls in other markets and become the owners of chain operations. The combination of the right merchandise and low prices are the necessary ingredients for success in the flea market. Those with access to manufacturer's lines find that such ownership is profitable.

Large Store Opportunity

Without question, the greatest potential for career advancement is in the department store and to a lesser extent the fashion specialty chain. The size of these businesses, their geographical scope, and the number of specialists needed to perform their functions make them ideal ventures for people who seek success. The differences in their methods of operation necessitate that, in terms of career opportunity, they be discussed individually.

Department Stores

With their enormous flagships and host of branches and spinoff stores, they are the industry's largest employers of top- and middle-level managers.

The route to these upper-level positions generally begins with acceptance into an executive development program. A combination of classroom instruction and on-the-job training quickly leads to a management assignment. These positions are most likely to be in the area of merchandising or management, or in such jobs as visual merchandising, advertising and promotion, and control. Some who complete the formal program are placed as fashion directors or coordinators. The salaries paid by the department store groups are usually at the top of the retail scale.

Fashion Chains

Companies like Merry Go Round, The Gap, The Limited, and Casual Corner are also excellent arenas for the retailing enthusiast. With some companies operating hundreds of units across the country, the opportunities provide a chance for quick advancement and an opportunity to work in many geographical locations.

The nature of the chain organization, with its centralized management concept, provides an opportunity that is somewhat different from department store employment. Potential for a merchandising career is restricted since there are fewer buyers needed to supply the vast number of stores in the group. One buyer of moderate-priced sweaters, for example, is all that is needed to purchase knit-wear for as many as 1000 units.

It is in store management where the jobs are plentiful and relatively easy to obtain. Each unit in a chain organization requires a manager, assistant manager, and individual department heads. With the rapid growth of companies like The Limited, with more than 3000 units in all of their divisions, the managerial opportunity increases.

Training in the chains is less structured than in the department store operation. Learning is generally provided on the job with some instruction provided at company headquarters. Chains as a rule require less formal education than do their department store counterparts and therefore are excellent outlets for those who do not have baccalaureate degrees.

Fashion Job Classifications

The careers in retailing are generally divided into four separate categories. They are **merchandising**, **management**, **advertising and promotion**, and **control**. The first three classifications offer opportunities to the vast majority of applicants; the

fourth, with its financial emphasis, is generally reserved for individuals with accounting and finance backgrounds. It is the primary areas of fashion employment that will be explored along with positions that are available in organizations that serve the retail industry.

Merchandising

Those interested in buying and the positions that are advisory to buyers and merchandisers may be employed in any of the following.

General Merchandise Manager

The merchandising division is headed by a general merchandise manager (GMM) who oversees and makes decisions concerning the store's merchandising philosophy and future plans. Such areas of responsibility as determining the company's merchandise mix, pricing strategies, fashion focus, and others are those of the general merchandise manager. Since each company has but one GMM, it is unlikely that this is within reach of many aspirants.

Divisional Merchandise Manager

Major department stores and chain organizations divide their merchandising responsibilities according to product classifications. For example, there might be individual divisions for men's wear, women's apparel, accessories, home furnishings, and children's wear. Each division is headed by a divisional merchandise manager (DMM) who has the responsibility to divide the division's merchandise budget among the buyers in the area, coordinate the activities of the buyers, make trips to the marketplace along with the buyer when major purchasing decisions need attention, advise on markup and markdown goals, and anything else of a merchandising nature. He or she reports to the GMM and is responsible for the buyers in the division. Although there are more divisional than general merchandise managers, reaching this level is quite difficult.

Buyer

The buyer is responsible for all of the department's purchasing decisions, which include development of a model stock, resource evaluation, market visits, merchandise acquisition, and pricing. With the larger retailers offering so many product lines, many buyers are needed to accomplish the purchasing task. This level of employment is certainly within reach of those displaying ability and ambition, and is often reached within five years of employment.

Assistant Buyer

Those who successfully complete the store's formal training program and are placed in the merchandising division often begin as assistant buyers. Performing many of the buying duties such as stock replenishment, special ordering of merchandise, following up orders that have been placed, directing markdowns, and sometimes working on the selling floor, this person is groomed to become a buyer.

Fashion Director

This is a staff position that assists the buyers and merchandisers with their tasks. Fashion directors often scout the market prior to buyer visits so they can make the buyers aware of market conditions, new resources, and potentially hot items; coordinate the fashion image for the store; prepare and direct fashion shows; and sometimes accessorize apparel that is featured in the departments. Some companies use the term "fashion coordinator" in place of fashion director.

Comparison Shopper

A staff position that involves visits to competitors to evaluate their merchandise assortment prices and promotions. By providing this useful information to the store's buyers and merchandisers, the company will be prepared to better address their competition.

Management

There are many areas of employment for management personnel. Some of the more typical positions are explored in the following paragraphs.

Store Manager

Major retail organizations such as department stores and chains have managers in each of their units. The size of the specific operations determines the extent of the activities for which the manager is responsible. In the department store flagships and branches, responsibility usually includes management of personnel, store services, traffic, security, maintenance, and seeing to it that the store's procedures and policies are satisfactorily carried out. In the individual chain units, which are typically smaller than those found in department store organizational structures, they perform some additional activities. They hire assistant managers and sales personnel, schedule employee hours, handle customer complaints, change visual presentations, prepare unit control reports, keep inventory records, tally sales receipts, and do anything else of a management nature that is necessary. In the chain, they perform duties that parallel those of self-employed retailers.

In both retail classifications, store managers usually receive straight salaries as well as bonuses based upon the profitability of their individual units.

Department Manager

Large stores require individual managers to help run the store. For their respective departments they schedule employee hours, working within the framework of a predetermined budget, arrange merchandise on the selling floor, assist salespeople with customer complaints, make display changes within the department, and sell during peak periods.

Some large department stores have group managers who supervise a number of departments.

Assistant Manager

Before one can become a manager, the first stop is to be an assistant. Performing many managerial chores, the assistant takes charge when the manager is away from the sales floor and spends a good deal of the time selling. Many major retailers use this as the initial placement of an executive trainee who has successfully completed the training program.

Advertising Manager

The larger organizations spend considerable sums motivating shoppers through advertising. At the helm of this division is the advertising manager. He or she directs the store's promotional endeavors through the development of creative concepts and manages the various personnel in the department. Most individuals who reach this step in the store's structure have not studied retailing but have been advertising majors in college where they learned the artistic and business aspects of the field.

Visual Merchandising Director

One of the most important ways in which to motivate purchasing is by providing the customer with formal as well as informal merchandise displays. As the head of the unit responsible for such promotional activities, the visual director is the one who plans the various window and interior displays, oversees their installations, and has the responsibility for hiring artists, trimmers, and others who install the presentations. The job demands a great deal of creativity as well as an understanding of consumer motivation. The people generally best suited for such positions are those with backgrounds that combine retailing comprehension and a knowledge of art.

Human Resources Manager

The major role played by the human resources or personnel manager or director is that of providing the store with competent employees. In smaller companies they are jacks of all trades, handling such chores as interviewing, training, settling disputes, planning remuneration changes, promoting employees, and anything else of a labor-relations nature. In larger stores they are called upon to oversee a number of specialists who perform specific human resources tasks. A background in retailing and psychology, coupled with courses in industrial labor relations, is important for this person to possess.

Retail-related Fashion Careers

In addition to the positions that are available in stores, there are other career opportunities that are equally exciting and financially rewarding.

Resident Buyer

Unlike the buyer who is employed by the store to make its purchases, resident buyers are primarily employed by resident offices to provide advisory assistance to the retailer. They scan the market for new resources and hot items, communicate with the store buyers about market conditions, follow up orders that were placed by the retailers, prepare for the store's visit during market week, and anything else that can help the store buyer make better decisions on purchasing.

Assistant Resident Buyer

Primary responsibility focuses upon calling on vendors to check the status of the store's deliveries. Other duties include placing of special orders, reordering merchandise, and handling complaints for member stores.

Product Developer

Many resident buying offices feature separate divisions that develop private-label merchandise for their members. These people are knowledgeable about the fashion state of the market and understand the style and construction of apparel and accessories. With this ability, they are called upon to design items that will serve the needs of their member stores and find manufacturers to produce them.

Fashion Scout

Fashion forecasters, reporting services, and market consultants provide information for retailers concerning market conditions, style trends, color forecasts, price

adjustments, and other things that will help retailers learn more about their industry. The fashion scout is employed by these companies and visits textile mills, designer studios, fashion periodicals, and other industry groups to feel the pulse of the market and report it to their subscribers.

Securing an Interview

After carefully exploring the various career opportunities and assessing each in terms of personal abilities and educational background, it is time to secure interviews.

Gaining an interview may involve a number of approaches. By far the most desirable method is called networking. Calling upon friends, relatives, and acquaintances with access to retail organizations and parallel industries to help open the doors is an excellent approach. While you might have the necessary credentials for the job, securing the interview is not always an easy task. With that personal pitch, potential employers often quickly agree to a meeting.

Without such connections, other routes to gaining an interview include careful examination of the classified ads in both consumer and trade papers, employment agency contacts, cold canvassing of potential employers, and attendance at trade shows, which often have booths that feature current employment opportunities.

Whichever technique is employed, the applicant must always be prepared with a current resume that categorizes information on education and experience, an appropriate cover letter that could be adjusted to any situation, and a follow-up letter showing appreciation to the interviewer for the meeting.

Resumes

The resume is probably the most important element needed to obtain an interview. Generally, those responsible for hiring have little time to spend interviewing every potential candidate for the job. The resume gives the employer the opportunity to examine each applicant's credentials and offers those who seem qualified an opportunity to provide further information through a personal meeting. Therefore, the resume must be carefully developed and professionally drawn.

If the individual is not totally competent in the preparation of such tools, a professional should be considered. Not only do they have expertise in writing the resumes, but they also can direct the individual to a company that carefully transforms the information into an attractive format. Since the resume may be one of many received for a particular position, it must be able to capture the reader's attention.

BARBARA FITZGERALD
1803 Colbie Street
Chicago, IL 60614

EDUCATION:	FORBES COMMUNITY COLLEGE	Chicago, IL
	AAS-Fashion Retailing, June 1992	

MAJOR
SUBJECTS:

Marketing	Retailing Principles
Buying	Accessories & Apparel
Business Math	Merchandising
Selling	Advertising & Promotion
Communications	Visual Merchandising

SPECIAL
EXPERIENCE:
Studied abroad for one summer session at London's Polytechnical Institute. Took classes in fashion and worked as an intern for Harrods.

HONORS:
Dean's List, 4 semesters
Magna cum laude

COLLEGE
ACTIVITIES:
Tutor, Textile laboratory
Fashion Coordinator, Annual Fashion Show
Senate representative

WORK EXPERIENCE:

5/88–8/88 **The Gap**: Duties included checking inventory, making price changes, and straightening stock.
Location: Water Tower, Chicago, IL

5/89–8/89 **The Limited**: Sold merchandise, restocked inventory, and assisted with making interior display changes.
Location: Water Tower, Chicago, IL

9/90–8/91 **Carson Pirie Scott**: Part-time salesperson in the Junior Sportswear Department.
Location: State Street, Chicago, IL

9/91–11/91 **Marshall Field:** Participated in a school-sponsored internship program. Worked as an assistant to the Men's Wear Department manager. Duties included selling, taking markdowns, changing counter displays, taking inventory, and training new salespeople hired for the Christmas period.

INTERESTS: Art, Music, Theater, Travel

REFERENCES: Will be furnished upon request.

Cover Letters

A simple letter that accompanies the resume should be prepared. It should be brief and simple. It is not necessary for the letter to explore any particular strengths, since that will be obvious in the accompanying resume. The letter should be typed on stationery that is identical to that used for the resume. In this way, an attractive package will reach the hands of the company representative.

> 1803 Colbie Street
> Chicago, IL 60614

Ms. Sara Philips
Personnel Manager
Carson Pirie Scott
1 State Street
Chicago, IL 60614

Dear Ms. Philips:

During the period of September 1990 through August 1991 I was employed at Carson Pirie Scott as a part-time salesperson in the Junior Sportswear Department in the flagship store. The experience was personally rewarding.

I have since completed my degree in Fashion Retailing at Forbes Community College and would like to begin a career with your company. I believe my past record at Carson's indicates my initiative and desire to work.

I would appreciate the opportunity to discuss a position with your company at your convenience.

Enclosed is a copy of my resume which should give you some background information about me.

Sincerely,

Barbara Fitzgerald

Barbara Fitzgerald

Preparing for the Interview

A good resume merely opens the door to the company. Once entrance has been granted, it is time for the applicant to put his or her best foot forward. Preparation for such a performance might include investigation of the company, appearance refinement, and role playing.

Investigation of the Company

Oftentimes, a personnel manager or employment director is impressed by a candidate's knowledge of the company. Not only does it show individual initiative but it sends a message to the interviewer that the applicant really knows about the company and its philosophies. One might acquire information about a specific organization through current articles in trade papers, books that might have been written about it, discussions with friends and relatives who might be employed there, examination of advertisements, or by merely visiting the store to assess its operation.

Appearance

The first impression is the most important. Proper attire and grooming might mean different things to different people. The best way to determine what is appropriate for the particular store is to pay it a visit. Examine the employees' dress and simulate it for the interview. Another approach might be to read a book on proper appearance so that the fundamental concepts could be explored. If the individual's appearance is unacceptable, he or she will not have the opportunity to convince the manager of personal abilities and potential for the job.

Role Playing

One of the best ways to practice an inventory delivery is through role playing. By asking someone with interview experience to conduct a session, the prospective employee can make a trial run. Questions that are not properly answered can be discussed, communication ability can be assessed, appearance can be evaluated and general refinement can be accomplished during this warm-up. Rarely is a second chance available to make a better impression.

Follow-up Letter

After the completion of the interview it is appropriate to immediately send a letter of appreciation to the interviewer. Not only does this show courtesy, but it also serves as a reminder that there is interest in the job. It should be sent the day of the interview, or at the latest, the next day.

1803 Colbie Street
Chicago, IL 60614

Ms. Sara Philips
Personnel Manager
Carson Pirie Scott
1 State Street
Chicago, IL 60614

Dear Ms. Philips:

My meeting with you rekindled my memories of working for Carson Pirie Scott. The time we spent together makes me want to return to the company as a full-time employee. I know that I can be an asset to Carson's and, given the opportunity, would like to demonstrate my abilities.

I understand that there are many applicants for the position we discussed, but I believe I can satisfy the company's needs better than most because of my previous experience in the store.

If you have any questions, please feel free to call me.

Sincerely,

Barbara Fitzgerald

Barbara Fitzgerald

Appendix B

Retail-oriented Mathemathical Problems

In order to successfully participate in fashion retailing, or for that matter in any aspect of retailing, it is important to understand the computational requirements of the industry. While it is true that many computer packages are available to the retailer for use in particular mathematical areas, it is appropriate for each participant to be able to solve such problems on his or her own. The smaller retail organization might not utilize a computer and in some situations—on buying trips, for example—the computer will not be available to those buyers who might find it necessary to do some preliminary calculations.

Throughout the text, a variety of mathematical concepts, formulas, and illustrative examples have been presented. The following problems should be solved using the formulas that have been explored. Each set of problems will be presented as a group as they were introduced in the text.

Chapter 9

Accounting Procedures and Operational Controls

1. If Jeffrey's Men's Shop reported assets of $125,000 and liabilities of $35,000, what is its net worth or capital?

2. The Classic Child is a children's store that reports the following figures: cash-on-hand, $18,000; merchandise inventory, $55,000; accounts receivable (from regular charge accounts), $15,000; fixtures, $20,000; accounts payable

(monies owed to vendors), $27,000; notes payable (on fixtures), $8,000; and salaries payable of $1,000. What is the store's net worth?

3. With a gross profit of $225,000 and expenses of $150,000, what was Penrod Shop's net profit?

4. At the Innovative Male, retailers of fine men's foot wear, the following purchases of boots were made for the year.

Feb. 15	20 pairs @ $ 60
May 20	40 pairs @ $ 80
Sept. 15	60 pairs @ $ 90
Dec. 1	50 pairs @ $100

When the physical inventory was taken on December 31, Innovative Male had 80 pairs of boots on hand. Calculate the value of the boots inventory at the end of the year using both FIFO and LIFO.

5. The following figures were reported by the shirt department at Walker's Department store for the past year.

Opening inventory (Jan. 1)	$ 660,000
Closing inventory (Dec. 31)	540,000
Year's sales	2,400,000

What was the shirt department's stock turnover rate?

Chapter 10

Buying Principles and Procedures

1. How much merchandise was needed by the sweater buyer at Atlas, Inc., if the planned inventory at the end of the month was $180,000, planned sales were $72,000, and planned markdowns were $6,000?

2. If a buyer had $144,000 on hand and $36,000 on order, how much merchandise was available?

3. The infant's wear buyer at Peabody's wanted to know how much money was still available for additional purchases on July 1 for the period ending July 31. On July 1 her figures showed the following: Merchandise on hand, $36,000; merchandise on order, $9,000; inventory planned for the end of the month, $45,000; planned sales, $18,000; and planned markdowns, $1,500.

What was the infant's wear buyer's open-to-buy on July 1?

Chapter 11

Inventory Pricing

1. What is the dollar markup on a suit if the retail is $400 and the cost is $225?

2. If the suit did not sell at the original price of $400 and was reduced to $325, what was the maintained markup achieved by the store when the garment sold?

3. If a tuxedo sold for $320 that cost the store $160, what is the markup percent on retail?

4. If a dozen pairs of panty hose sold for $6 each but cost the store $36 per dozen, what is the markup on retail?

5. What is the markdown percent on a swimsuit that originally was priced at $60 and was marked down to $45?

Chapter 12

Advertising and Promoting Fashion

1. Under a cooperative advertising agreement where Parade Formals offers a 10 percent allowance on the store's purchases for such purposes and is willing to pay up to 50 percent of the cost of the ad, how much will Parade contribute to an ad costing $10,000 if purchases amounted to $200,000?

2. *The Herald* sells advertising space for $.90 per agate line and has a circulation of 900,000. Their competitor, *The Atlas*, charges $.80 per agate line and has 800,000 readers. What is the milline rate for each newspaper?

Glossary

Language of the Trade

The following terms are used in retailing. Knowledge of them enables the student to understand the various aspects of the industry, and the practitioner to ably participate in the field.

accounts payable. Monies owed by the retailer for merchandise, supplies and equipment.

accounts receivable. The dollars owed to the store from credit card purchases.

advertising. The nonpersonal presentation of the facts about goods or services to a group.

advertising agency. A professional organization that assists the retailer with preparing an ad, planning campaigns, choosing appropriate media, and any other promotional task. For their services they receive remuneration based upon a percentage of the advertisements they place in the media.

analogous color scheme. A color harmony that employs two adjacent hues on the color wheel.

arcade window. A structure that recesses the store's entrance a number of feet back from the building line with two windows on either side of the entrance. It is used where the retailer has a small amount of frontage.

assistant buyer. An individual who assists the buyer with such tasks as reordering merchandise, purchasing staple items, following up purchase orders, selling, and advising the buyer on merchandising decisions.

automatic markdown. A plan that periodically lowers the selling price. Initiated by Filene's Basement, it guarantees a predetermined stock turnover.

backlit transparency. A type of signage featuring a transparent photograph that is illuminated by a lightbox.

balance sheet. A financial statement that is prepared by an accountant that shows the store's assets, liabilities, and equity or capital.

bank cards. These are third-party credit cards such as VISA and MasterCard. Individual banks issue cards to consumers who, when they use them for merchandise and service purchases, owe the amount charged to the bank.

blind check method. A quantity checking method used by retailers that supplies the checker with a sheet containing the merchandise expected but requires the insertion of such information as colors and sizes.

boutique. A small, highly specialized apparel or accessories shop that generally offers higher priced, innovative fashion in limited quantities.

branches. Stores that are part of a department store organization that feature a representation of the main store's offerings.

broadcast media. Communication outlets such as radio and television.

buyer. The individual responsible for the purchase of merchandise.

buying motives. Reasons such as price, convenience, image, status, and prestige that

influence consumer purchasing.

cable television sales. Networks such as QVC that are on the air solely for the purpose of displaying and selling merchandise.

cash reward card. An incentive credit card that provides the consumer with a small percentage of the merchandise purchased. The Discover Card is the leading cash reward card.

catalog operation. A retail business that uses catalogs exclusively to sell to the consumer.

centralization. A concept utilized by chain organizations where all decision making is accomplished at a central office rather than in individual stores.

centralized management. A concept where all decision making is accomplished in the home office by a management team.

centralized receiving. A concept where chain organizations receive their merchandise at a central warehouse where it is checked, sorted and priced before it is delivered to the individual stores.

centralized visual merchandising. A concept where some chains prepare their displays and other visual presentations at company headquarters where they are photographed and sent to the stores for their installations.

charge account. A system that enables the shopper to buy without cash but requires that full payment for the purchase be made when the bill is received. It is unlike other credit systems that enable the consumer to either pay in full or finance the purchases over a period of time.

combination advertising. A blend of promotional and institutional advertising.

commercial list house. A marketing research company that generates lists of consumers that retailers use for direct mail purposes.

comparison shopper. An individual who checks the inventories and advertisements of competing retailers to assess their inventories, prices, and promotional endeavors.

control function. The division in a major retail operation that is responsible for the company's financial involvement.

complementary color scheme. Two colors that are directly opposite each other on the wheel and that produce a strong color harmony.

computer-aided instruction. Programs that are used to train people in a variety of tasks such as computations and selling approaches.

computerized marking system. A system that generates labels for use on merchandise.

controlled shopping center. A mall that controls its tenant mix by deciding how many of each type of store may occupy space. This limits competition and provides greater opportunity for success.

conveyor system. An automated operation that moves the merchandise from receiving to the selling floor.

cooperative advertising. A type of ad that concentrates on promoting a store's image rather that directly selling merchandise.

cooperative resident buying office. A buying office that is owned by a group of retailers.

credit limit. The amount of money that a consumer is restricted to for purchases.

cycle billing. Large retailers separate their customers' accounts into groups so that all bills will not have to be processed at the same time.

decentralization. A system used by some department stores and chain organizations that permits some decision making to take place at the store's individual units.

demographics. The study of population characteristics.

department. A separate section in a store that is confined to an individual merchandise classification or activity.

department store. A retail operation that fea-

tures a wide assortment of hard goods and soft goods in individual sections or areas.

descriptive billing. A statement that retailers send to their credit card customers that indicates characteristics of the purchases such as individual items, prices, and dates of purchase.

designer collection. A line of merchandise created by the designer.

Designer Collective. A group of quality men's wear designers who show their collections in one facility during market week. Admission to the group is obtained through acceptance by a panel of peers.

designer outlet mall. A facility that features individual retail outlets for designers who wish to dispose of merchandise at discount prices.

designer salon. Separate departments in prestigious stores that feature individual designer collections.

DINKS. *Double income, no kids*; a term used to describe married couples without children.

direct checking method. A quantity checking system that provides the checker with all of the information about the merchandise received. The task under this system is to make certain the shipment is accurate.

direct retailing. Selling to the consumer in the home by way of catalogs and cable television.

direct retailing company. A retail organization that exclusively reaches its market by way of catalogs and cable television.

discounter. A company that sells its merchandise to the consumer at lower than traditional prices.

display. The physical presentation of goods in a window or store interior.

division. A major function of a store's operation.

divisional merchandise manager. An individual who is responsible for the merchandising of a large segment of the store's product mix such as men's wear, children's wear or home furnishings.

dollar control. An inventory control system that encompasses sales, purchases, markdowns, and inventory.

double complementary color scheme. A color harmony that employs two sets of colors that are directly opposite on a color wheel.

electronic surveillance system. Tagging merchandise with discs that are activated when they pass specific stations in the store. If not removed by the cashier, an alarm is sounded to signal possible pilferage by a shoplifter.

elements of buying. The four areas of decision making that buyers investigate in the planning of purchases. They are the quantitative and qualitative considerations, the resources to be used, and the timing of the purchases.

emotional motives. Reasons such as status and prestige that motivate consumer purchasing.

environmental concept. A visual merchandising philosophy that features a specific look that doesn't change with the seasons. Banana Republic and Aeropostale are two proponents of this plan.

equal credit opportunity act. A law that forbids credit decisions based upon race and sex.

expense classifications. All of the specific expense categories of retail operations.

expense budget. A plan that predetermines the amounts allocated for different expenses based upon past and planned sales.

external mailing list. A compilation of prospective customers with specific characteristics. Commercial list houses and marketing research companies sell these lists to retailers.

family life cycle. A concept that traces the lives of individuals through the various stages of life, addressing income and how they spend it.

fashion coordinator. A retail staff person who has responsibilities such as forecasting fashion, directing fashion shows, accessorizing interior displays, and advising buyers about merchandise.

fashion count. This is an observation tool used by researchers to determine customer preferences for specific merchandise.

fashion director. Another term used to describe a fashion coordinator. The duties and responsibilities remain the same.

fashion forecaster. Predictor of fashion trends.

fashion "streets." Locations that have a concentration of fashion retailers.

FIFO. *First in-first out.* Cost method of determining inventory value. It presupposes that the merchandise first bought by the store sells first.

flagship store. The main or parent store of a major retail organization.

flea market. A carnival-type environment where individual vendors sell merchandise to retailers at lower than traditional prices.

fluorescent lights. Tube-like bulbs that are used for general illumination purposes. The major advantage is moderate expense.

focus group. A consumer panel that is used by businesses such as retailers to help the company with image building, philosophy, and merchandise decision making.

formal fashion show. An elaborate presentation that utilizes live music, scenery, and a script to show the latest fashions.

franchisee. An individual who purchases the rights to operate a business under an established name.

franchiser. The person who develops the idea for a business and expands it by selling rights to individuals to own and operate units according to predetermined guidelines.

free-lance visual merchandiser. Someone in his or her own business that provides visual presentations for stores for a fee.

full-line department store. A store that is divided into separate departments that feature a wide assortment of hard goods and soft goods.

function. A term used to describe a division in a store's organizational structure.

general merchandise manager. The senior member of a retailer's merchandising division.

general store. One of the early types of retail operations that featured a small assortment of unrelated merchandise such as food, clothing, tools, and fabrics.

geographic exclusivity. An arrangement where a manufacturer sells his merchandise exclusively to one store in an area.

halogen/quartz lighting. A type of illumination that features very bright, intense highlighting.

incandescents. Bulbs that are either recessed into the ceiling or used in tracks for the purposes of overall illumination or spotlighting.

income statement. A financial document that spells out a company's profit and loss.

independent resident buying office. A business that serves retailers by providing information to its buyers concerning the state of the market, hot items, new vendors, and so forth.

in-home shopping. A direct marketing approach that sells to consumers in their homes by way of catalogs and cable television.

in-house display staff. Visual merchandisers who are on a specific retailer's payroll.

in-house "separate" shop. An individual department that features exclusively the merchandise of one specific manufacturer.

in-house video. A system that utilizes video tapes and programs to sell specific items or shows how merchandise might be used by the consumer.

initial markup. The difference between the cost and the retail.

Inktag. The registered name for a shoplifting deterrent that is attached to a product and, if removed by force, will spill ink all over the garment.

installment credit. A method of offering merchandise to the consumer that is paid for over a predetermined period of time.

institutional advertising. A method of promoting a store's image.

internal mailing list. A list of customer names that is generated by the store from past sales receipts or charge accounts.

job analysis. A scientific method that investigates a specific job to reveal its specifications and requirements.

job description. A concise statement that lists all of the specifications of a job.

job specifications. The individual duties and responsibilities of the job.

landmark centers. Reclaimed areas of historical distinction that have been transformed into shopping facilities.

LIFO. *Last in-first out*. A cost method of determining the value of inventory that presupposes the last merchandise purchased by the store sells first.

limited-line store. A retail organization that restricts its merchandise to one classification.

line and staff. An organizational structure that features decision makers or producers for a company and advisory personnel.

line of credit. The dollar limit that a consumer is allowed to spend on credit purchases.

line position. The decision maker in an organization.

maintained markup. The difference between the cost of the merchandise and the amount the store actually receives when it is sold.

mall walkers. A technique used by some retailers to attract potential employees by walking through the malls and approaching those who seem appropriate for the store's needs.

manufacturer's outlet. A retail operation that is owned by the producer that sells his or her line at less than the regular store price.

markdown. A reduction in the selling price.

market week. The period of time when the buyers visit the market to purchase merchandise for the next season.

markup. The difference between the cost and the retail.

Maslow's hierarchy of needs. An ordering of needs fulfillment.

Mazur Plan. A four-function line and staff organizational structure used by some department stores.

media. Communication outlets such as newspapers, magazines, radio, and television.

merchandise mix. The assortment of goods in terms of sizes, colors, styles, and price lines that is needed to satisfy the customer.

merchandise resource. Supplier of merchandise.

merchandising division. The retailing function that supplies the store with its inventory.

milline rate. A formula used by advertisers to evaluate comparative advertising costs.

mixed-use center. A facility that houses shops, offices, restaurants, and apartments.

model stock. An inventory that features the appropriate assortment to satisfy customer needs.

monochromatic color scheme. An arrangement that uses only one color.

multimarket approach. An approach to distribution where a manufacturer or designer sells merchandise in traditional stores, via catalogs, in franchises, or in company-owned outlets.

NADI. The National Association of the Display Industry.

NAMSB. The National Association of Men's Sportswear Buyers.

Nation Retail Federation. The retail industry's largest trade association.

New York Prêt. A trade show that features women's

wear and accessories from all over the world.

nonselling departments. Sales-supporting and administrative departments.

notes payable. Amounts owed to suppliers for equipment bought on time.

objective and task method. An advertising budgeting technique that requires the store to establish its objectives and then to determine the tasks necessary to achieve them.

observation method. A research tool that utilizes counts to acquire data.

off price. A merchandise philosophy that has merchants buying goods at lower than original prices and reselling them at less than the traditional retail prices.

off-price centers. Clusters of stores that exclusively sell merchandise off price.

off-price merchant. A retailer who buys for less and sells for less.

one-price store. A retail operation that sells merchandise exclusively at one price.

on-the-job training. A method that trains people in the actual selling environment.

open-to-buy. The amount of money a buyer has left in his budget to spend at a given time. It is the difference between the merchandise needed to do business and the merchandise that is available.

organization chart. A graphic presentation of the company's organizational structure.

parallel-to-sidewalk window. A configuration used by retailers with large frontages that places windows parallel to the street.

percentage of sales method. A term used to describe advertising budgeting. It requires that the advertising expenditure be tied to a percent of anticipated sales.

periodic inventory system. A system that requires the physical counting of merchandise to determine the actual inventory.

perpetual inventory method. An ongoing system that estimates the store's inventory.

personal shopper. An individual who escorts the customer through the store and provides advice on purchases.

portable table. A piece of equipment that is used in receiving rooms.

power center. A type of retail location that houses major retailers and has the potential to attract large groups of shoppers.

preferred position. A location in the newspaper for which advertisers pay premiums to have their ads printed.

preliminary interview. Also known as a rail interview; a very brief conversations used to evaluate appearance and communication skills.

premarking. A service provided by some manufacturers that marks the merchandise for the retailer before it comes to the store.

price agreement plan. This is a method of centralized purchasing that gives a certain degree of autonomy to individual stores in a chain.

price point. The price range or price line carried by the store.

primary data. Information that researchers get through original investigative techniques such as personal interviews and observations.

print media. The communication outlets of newspapers and magazines.

private label. Merchandise that is featured exclusively by one retailer.

private research organization. An outside company that conducts studies for businesses.

private resident buying office. A division of a retailer that assists the store buyers with purchasing plans.

prize money. Also known as PMs; rewards to sales personnel for selling slow-moving merchandise.

promotional advertising. The technique used to sell specific items.

proprietary credit cards. Credit cards that are offered by the retailer for exclusive use in the store.

psychographics. A type of market segmentation

that addresses life-styles, occupations, and other personal consumer characteristics.

publicity. The attention that the store gets in the press because of something that it does that is newsworthy.

publicity division. The function of a store that is concerned with advertising and promotion.

quota bonus plan. An incentive plan that rewards salespeople with extra income for sales over a prescribed amount.

rational motives. Reasoned motivation for purchasing such as price and quality.

regional mall. A large shopping center that serves a wide geographic area and features a host of different stores.

regional receiving. When chains are located in many geographic areas, receiving is often accomplished in specific centers that serve particular areas.

regular position. A term used in advertising to indicate the usual location of a store's advertisement.

reporting service. A company that keeps the retail industry abreast of market conditions.

research process. The stages that make up the research procedure used to study a problem.

resident buyer. An individual who assists the store buyer with purchasing decisions.

resident buying office. A company that is in business to provide assistance to retail buyers.

resource. A merchandise vendor.

revolving credit. A system that sets a limit on customer purchases and permits the partial payment of merchandise.

role playing. A method used to train individuals in specific tasks such as selling and that requires participants to assume certain roles.

run of press (ROP). Advertisement placement that allows the advertiser to place ads wherever space is available in a newspaper.

runway fashion show. A presentation that features models who parade before an audience on a runway.

sales per square foot. A formula used to assess the amount of sales a store generates in one square foot of space.

secondary data. Information used by researchers from available sources such as past sales, trade association reports, and previous studies.

shopping district. An area such as a mall, neighborhood cluster, power center, or downtown where retailers locate.

shopping publication. A periodical that is published expressly for advertising purposes.

shoplifting. Stealing by individuals who pose as customers.

sociological groupings. Divisions of the population into upper, middle, and lower classes.

specialized department store. A term used by the National Retail Federation to describe a large retailer who specializes in one merchandise classification rather than both hard goods and soft goods.

specialty store. A company that restricts its merchandise to one classification. It is sometimes called a limited-line store.

spinoff store. A specialty store that features the merchandise of one department of a department store.

spot check method. A time-saving quantity check method that requires the counting of only some merchandise rather than everything.

staff position. An advisory job.

stationary table. The most commonly used piece of equipment in a receiving room.

stock turnover. The number of times an inventory sells in a year.

store management function. The division that is concerned with the management of the selling departments, alterations, security, purchase of supplies, etc.

storewide markup. A method that requires that every item in the store be marked up at the same percentage.

subspecialty store. A retail operation that carries a very narrow product line. For example, a store that sells ties exclusively is a subspecialty store.

target market. The group that a business earmarks as potential customers.

testing bureau. A department that tests merchandise to make certain that it is durable and will withstand typical use.

third-party credit card. A credit card offered to consumers by banks and travel companies, such as VISA and American Express, for use in many retail establishments.

trade association. An organization that is composed of businesses with similar characteristics and interests.

trade publication. A periodical that is directed to a specific industry.

trade show. A group of manufacturers that show their product lines for a specific period in one facility.

trading area. The geographic area from which retailers expect to attract customers.

trading post. The first retailing institution.

traffic count. An observation method that is used to assess the amount of traffic that passes by a particular site.

truth-in-lending law. A piece of legislation that requires the retailer and other lenders to notify customers about their financing terms.

twig store. A specialty store that belongs to a department store.

unit control. An inventory system that counts units in terms of sizes, colors, and styles.

vertical mall. A shopping center that is built in places where land is scarce.

vestibule training. A technique that trains individuals under conditions that simulate the actual retail business environment.

visual merchandising. The activity that involves formal window installations, interior display, and merchandise placement in the store.

yes, but method. When handling customer objections, salespeople often use a technique that allows for customer objections but counterattacks with other selling points: "Yes, the price is high, but the quality more than makes up for the price."

Index

A

accounting, 216–23
advertising, 49, 94, 295–314
advertising agencies, 297
advertising costs, 312–14
advertising evaluation, 314–15
agate line rate, 313–14
application forms, 177
arcade store fronts, 141–42

B

balance sheet, 218–19
blind ads, 167
boutiques, 12
branch store, 9
branch store expansion, 51
branch store organization, 54–55
British retailing, 19–21
broadcast media, 310–12
buyer duties and responsibility, 243–46
buying principles, 242–67

C

cable television, 374–75
cash reward cards, 393–94
catalog divisions, 4
catalog operation, 10–12
catalog organizations, 372–75
 direct retailing companies, 373
 retailer catalog divisions, 372–73
catalog selling, 51–52
celebrity promotions, 319–21
centralization, 57–58
centralized receiving, 195
centralized visual merchandising, 331–32
chain organizations, 2
Chain Store Age Executive, 98

chain store organization, 55–58
charge accounts, 392
checking merchandise, 198–200
 quality, 200
 quantity, 198–200
Chicago Apparel Center, 259
Civil Rights Act of 1964, 172
classified advertising, 167–68
classroom training, 177–78
collection areas, 149
collections, 396
color, 341–43
 rules, 342–43
 terms, 342–43
 analogous, 342
 complementary, 342
 hue, 342
 monochromatic, 342
combination advertising, 298, 302
commission sales, 31
comparison shopper, 47
comparison shopping, 49
competition research, 95
computer-aided instruction, 180
computerized accounting, 232–33
computerized inventory control, 232–33
computerized marking, 201
consumer motivation, 64–65
consumer research, 93
control function, 49
controlled malls, 121–22
conveyor systems, 197–98
cooperative advertising, 303
cooperative resident offices, 266
cost methods of determining inventory, 221–23
 FIFO, 222–23
 LIFO, 223

country club billing, 395
credit, 49, 390–97
credit department, 394–96
 billing, 395–96
 collections, 396
 opening accounts, 394–95
 purchase authorization, 395
customer service, 48, 94, 357–58, 381–89
customized services, 383–87
 child care, 387
 executive retreats, 387
 fitting specialists, 385
 personal shoppers, 384
 special shops, 338

D

Daily News Record, 98, 251
decentralization, 57–58
decision-making, 67–68
decorative materials, 150–52
demographics, 77–84
 age groups, 78–81
 special size group, 82–84
 working women, 81–82
department layout, 155–56
department store, 3, 4, 6–10, 26–27
descriptive billing, 396
design concept planning, 137–40
designer salons, 148–49
direct catalog selling, 369–72
direct mail, 307–10
direct selling, 369–76
display, 49
display design principles, 344–47
 balance, 344–46
 emphasis, 346
 harmony, 346–47
 rhythm, 346
 proportion, 346
display materials, 338–39
display props, 338–39
divisional merchandise manager, 46

dollar control, 224–26
 periodic inventory, 226
 perpetual inventory, 225–26
downtown central districts, 119–21
downtown multi-level retailing, 130–31

E

elements of fashion buying, 253–58
 qualitative, 253
 quantitative, 254–55
 resource selection, 255–56
 timing, 257–58
emotional motives, 65
employee benefits, 185–87
employee discounts, 186
employee evaluation, 180–81
employee networking, 170
employee retraining, 176–77
employee services, 185–87
employee theft, 208–10
 controls, 209–10
 deterrents, 209–10
employee training, 174–79
employment agencies, 168
entertainment cards, 393
esteem needs, 66–67
Equal Credit Opportunity Act, 397
European based American stores, 22–26
executive training, 174–75
expense budgeting, 231
expense classifications, 231
expense controls, 230–31
external lists, 374
evaluation plans, 180

F

Fair Credit Billing Act, 397
Fair Credit Reporting Act, 397
family life cycle, 73–77
fashion consumers, 63–86
fashion coordinator, 46–47
fashion count, 103–105

fashion department classifications, 146–49
fashion department designs, 146–49
fashion forecasters, 251
fashion manufacturers' specialty stores, 14–16
fashion retail buyers, 243–61
fashion shows, 315–17
fashion streets, 127
Fashion Watch, 251
final interviews, 173
financial statements, 217–19
 balance sheet, 218–19
 income statement, 219
fixturing, 152–54
flagship store, 8
flea markets, 16–17
flea market vendors, 16–17
flyers, 310
focus groups, 105
formal fashion shows, 316
four division organization plan, 45–49
franchises, 16
freelance advertising designers, 297
freelance visual merchandising, 332
French retailing, 21
functional materials, 150–52

G

general merchandise manager, 46
general store, 2, 6
government credit legislation, 396–97
 federal, 396–97
 state, 397

H

halogen/quartz lighting, 154
hand marking, 201–202
high-intensity discharge lighting, 154
hiring procedure, 170–73
Home Shopping Network, 374–75
human resources, 95
human resources department, 48
human resources management, 164–87

I

image promotion, 358
incandescent lighting, 154
income statement, 218–19
independent resident buying offices, 266
information coding, 202
in-home shopping, 32
in-house separate shops, 149
in-house video, 321
in-house visual merchandising, 328–31
installment credit, 392–93
institutional advertising, 298
institutional promotions, 319
interior displays, 335–36
interior layout, 142–49
internal lists, 373
International Kids' Show, 259
international retailing, 19–26
interviews, 172, 173
inventory control, 223
inventory control systems, 224–30
inventory pricing, 273–86
Italian retailing, 21

J

job analysis, 166
job descriptions, 38, 166

L

landmark centers, 126–27
large department store organization, 45–55
licenses, 16
lighting, 153–54, 341
lighting fixtures, 153–54
limited line store, 2, 5
line and staff organizations, 40
line positions, 38–39
line relationships, 39
locating nonselling departments, 145–46
locating selling departments, 142–49
 multilevel stores, 143–45
 single-level stores, 142–43

M

magazines, 306–307
MAGIC, 258
mail questionnaires, 100–101
maintained markup, 280
maintenance, 48
mall revitalization, 130
mall walkers, 169–70
mannequins, 339–41
manufacturers' outlets, 32
markdowns, 280–84
market week, 264
markup, 279–80
markup by item, 285–86
markup classification, 285
marking merchandise, 200–202
Maslow's Hierarchy of Needs, 65–67
 esteem, 66–67
 safety, 65–66
 self-actualization, 67
 social, 66
 status, 66–67
 survival, 65
Mazur Plan, 45–55
Mazur Plan variations, 52–55
media, 297–98, 304–12
merchandise budgets, 47
merchandise fixtures, 153
merchandise handling, 193–202
merchandise handling systems, 193
merchandise shortages, 202–203
merchandise statistician, 47
merchandising, 93–94
merchandising function, 46–47
methods of compensation, 181–85
mid-management training, 176
milline rate, 313–14
mill's outlet centers, 125
mixed-use centers, 123
model stock development, 252–53
Monthly Catalog of U.S. Govt. Publications, 97
morale building, 187

multimarket fashion retailing, 18–19

N

NADI, 341
NAMSB, 258
National Retail Federation, 97
neighborhood clusters, 127
new employee training, 174–76
newspapers, 304–306

O

observations, 103–105
off-price centers, 125
off-price merchants, 12–14, 30
on-the-job training, 178, 363–64
open ads, 167
organization structures, 35–59
organization chart, 37–40
outlet malls, 274–75
outlets, 15

P

parallel-to-sidewalk windows, 140
periodicals, 98
personal interview questionnaires, 101–103
personal shopping, 384
personnel department, 48
planning purchases, 246–52
power centers, 124–25, 131
preliminary interviews, 172
premarking, 200
price points, 286
pricing, 244
pricing considerations, 274–79
pricing policies, 284–86
primary data, 98–105
print media, 304–10
private label, 31, 278
private research organizations, 98
private resident buying offices, 266
prize money, 185
profit sharing, 184

promotional advertising, 298
promotional programs, 315–22
protection, 48, 202–10
psychographics, 84–86
psychographic segmentation, 84–86
publicity, 322
publicity function, 49
purchase orders, 259–61
purchasing, 48

Q
quality checking, 200
quantity checking, 198–200
 blind, 198
 direct, 198
 semi-blind, 199
 spot, 199
questionnaires, 100–103
 mail, 100–101
 personal interview, 100–103
 telephone, 101
quota bonus remuneration, 184
QVC Network, 374–75

R
radio, 311
rail interviews, 172
rational motives, 65
receiving equipment, 196–98
conveyor systems, 197–98
portable tables, 197
stationary tables, 196
receiving facilities, 195
receiving merchandise, 194–98
recruitment process, 165–73
references, 173
regional malls, 121–22
regional receiving, 195
remarking merchandise, 202
research process, 96–105
resident buying offices, 250, 261–66
retail credit types, 392–94

proprietary cards, 392–93
 third party cards, 393–94
retailers abroad, 19–26
retailing research, 91–107
retailing trends, 26–32
retail method of estimating inventory, 220–21
retirement center recruitment, 170
revolving credit accounts, 392
Robinson-Patman Act, 303
role playing, 362–63
run-of-press placement, 314
runway parades, 316

S
safety needs, 65–66
salary plus commission compensation, 182–83
sales methods, 95
salesperson's role, 357–62
sales personnel training, 176
sales per square feet evaluation, 230
sales presentation, 364–68
 closing the sale, 367–68
 customer approach, 365
 determining needs, 365
 merchandise presentation, 365–66
 overcoming objections, 366–67
sales program essentials, 368
sales promotion, 94
sales training methodology, 362–64
 on-the-job training, 363–64
 role playing, 362–63
 video cassettes, 363
 vestibule training, 364
secondary data, 97–98
security tags, 206
 fashion tags, 206
 inktags, 206
 tempo tags, 206
 signature tags, 206
self-actualization needs, 67
self-concept theory, 68
 ideal other, 68

ideal self, 68
other self, 68
real self, 68
seller characteristics, 359–62
appearance, 359–60
communication, 360
company loyalty, 361
knowledge, 360–61
selling, 355–76
separation of buying and selling, 50–51
Seventh Avenue, 259
shoplifting, 203–208, 277
control, 205–208
deterrents, 205–208
shopping districts, 119–27
shopping publications, 310
site selection, 127–29
small department store organizations, 42–44
divisions and departments, 42–44
specialization, 42–44
small specialty store organizations, 40–42
social needs, 66
sociological groupings, 69–73
lower-lower, 72–73
lower-middle, 71–72
lower-upper, 69–71
upper-lower, 72
upper-middle, 71
upper-upper, 69
sources of personnel supply, 167–70
special campaigns, 317–19
specialized department stores, 8
specialty chain, 4
specialty store, 2, 5
spinoff store, 10, 28–30, 51
staff personnel, 39–40
staff positions, 39–40
status needs, 66–67
stock options, 185
stock turnover, 228–29, 276
store design, 136–56
store fronts, 140–42

store location, 92–93, 114–31
store location trends, 129–31
store management function, 48
store receiving, 194–95
store selling, 356–68
store services, 277
storewide celebrations, 317–19
storewide markup, 284
straight commission compensation, 183
straight salary remuneration, 182
subspecialty stores, 30–31
survival needs, 65
swap meets, 16–17

T
telephone questionnaires, 101
telephone selling, 375–76
television, 311
testing, 173
testing bureau, 47
timing markdowns, 282–84
trade associations, 97
trading area analysis, 115–20
traditional fashion departments, 147
traditional services, 387–88
alterations, 388
delivery, 388–89
eating facilities, 389
gift wrapping, 387–88
training methodology, 177,180
traffic department, 48
travel cards, 393
Truth-in-Lending Law, 396–97
twig store, 9–10

U
unions, 187–88
unit control, 47, 227–28

V
vertical malls, 122–23
vestibule training, 177, 364

video instruction, 178–80
video surveillance systems, 205
visual environments, 332–36
 interiors, 335–36
 windows, 332–35
visual merchandising, 49, 327–49
Visual Merchandising and Store Design, 98
visual merchandising function, 328–32
visual presentation elements, 336–44
 color, 341–43
 graphics, 343–44
 lighting, 341
 mannequins, 339–41
 materials, 338–39
 merchandise, 336–37
 props, 338–39
 signage, 343–44

W
walk-in recruitment, 168–69
window displays, 332–35
windowless store fronts, 141
window structures, 140–42
Women's Wear Daily, 98, 247, 251